HOW TO PAINT

HOW TO PAINT

A Course in the Art of Oil Painting

GLORIA FOSS

WATSON-GUPTILL PUBLICATIONS/NEW YORK

ACKNOWLEDGMENTS

The following people have my unending gratitude for their support and assistance in the preparation of this book:

Nationally known color consultant Walter Granville, who was especially generous in lending his technical expertise and, along with Virginia Granville, made many editorial contributions to the manuscript.

Rebekah Luke, for her fine photographs of all products and step-by-step demonstrations, and portrait photographer Patience Street, for pictures of the author.

Graphic artist Susie Anderson of Visually Speaking, for the computer graphics in chapter 1, plus encouragement and advice of inestimable value over many years of friendship.

Ruth and Roger Stebbins, for their assistance in editing the manuscript at different stages.

Artist Roy Ichishita, for some of the drawings in chapter 1, and artist John Kobelansky, for all of the perspective drawings in chapter 2.

My associate art teachers, Vickie Kula, Helen Iaea, Rita Gustie, and Peggy Chun, who have taught my two basic color courses in recent years, thus enabling me to write and illustrate this book.

Chris Hudson of Hawaiian Graphics, who provided invaluable technical information about art materials.

Marian Appellof and the editorial staff at Watson-Guptill Publications, who so cheerfully and expertly edited my material.

Most of all, I am grateful to my beloved husband, Walt, who aided me in countless ways during the many years this project encompassed, always providing a loving, serene environment in which I could work.

First published in 1991 in the United States by Watson-Guptill Publications, a division of BPI Communications, Inc., 1515 Broadway, New York, New York, 10036.

Library of Congress Cataloging-in-Publication Data

Foss, Gloria.
 How to paint : a course in the art of oil painting / Gloria Foss.
 p. cm.
 includes bibliographical references and index.
 ISBN 0-8230-2456-3
 1. Painting—Technique. I. Title.
ND1500.F67 1991
751.45′435—dc 20

 91-20306
 CIP

Manufactured in Malaysia

2 3 4 5 6 7 / 97 96 95 94 93

This book is dedicated to the hundreds of enthusiastic adult art students who have gone through my basic color courses, and in so doing, forced me to grow as a teacher and as an artist. From the very first classes, they would say, "You must write it all down," and I would say, "When I have taught for twenty years, I will write it all down." That time has come.

CONTENTS

FOREWORD

I first met Gloria Foss when I was giving an oil painting workshop as a guest instructor for her Foss School of Fine Arts in Hawaii. Not only was she a warm, giving person and a very fine artist, but what really impressed me was her deep understanding of the principles of art and her dedication to serious art instruction.

Most of the students in my workshop had studied with her for some time, and they had acquired more than the mere basics of painting. Gloria had taken them beyond the fundamentals taught in most schools and given them a working knowledge of line and form, of values, of color temperatures and much, much more. They were the most informed students I had ever taught!

I am delighted that Watson-Guptill Publications is publishing her extensive knowledge. Art students everywhere will be blessed, and the quality of their work will be much improved, if they will but apply themselves diligently to the principles contained in this book.

E. John Robinson
Mendocino, CA
June, 1990

Editor's Note: E. John Robinson is the author of four popular books on marine painting that have been published by Watson-Guptill Publications since 1977.

INTRODUCTION

I have written this book with one mission in mind: to help beginning and intermediate art students who are having rough going. Instead of allowing sheepishly that you "dabble in art," wouldn't you like to speak right up and say confidently, "Yes, I am an artist"? Then here is the solid foundation upon which you must build. Even if you have been painting for some time but have never had any basics, this book can help you to pull yourself out of the shifting sand on which you've been working.

Art students are hungry for good solid instruction and will go to great lengths to find it. This was true of me years ago. Some of my early teachers wandered about the classroom from easel to easel, nodding their heads sagely, saying things like, "Make it a little darker there," or "Add some blue here." I wanted to know *why*, but was often afraid to ask for fear it would be a dumb question improperly phrased. Eventually, after years of painting and studying and making mistakes, the pieces finally came together for me like a jigsaw puzzle—but I couldn't help thinking that there should have been an easier way to learn.

Years later, when I received an invitation to teach a class of adults, I welcomed the opportunity to impart all I wished I had been taught. My course eventually became known as the Foss Color Course and I earned a reputation for teaching the basics and a whole lot more.

In this book, and in my course, I often refer to common mistakes in the classroom, and I illustrate points with incorrect and correct versions. These are in no way intended as put-downs. The mistakes were honest ones, made not by inept students, but by intelligent, well-educated men and women. Their learning mistakes may well be the same ones you'll

make if you take time to do the exercises at the end of each chapter—and I urge you to do them in sequential order. Even if you don't do them, you'll learn a great deal about how to assess your own or other people's paintings.

Part One of this book teaches not only drawing but also values—the logic of light and shadow. It is crucial to learn to express form in black and white before moving ahead to color. Part Two introduces basic color theory and shows how to apply color to form. You will use various color sequences to paint several still lifes. By Part Three you will be using a full palette of colors while applying the principles of design and composition to still lifes and landscapes, as well as learning some advanced painting techniques.

You will frequently benefit from reading later chapters in this book while working on early assignments. While the consecutive approach to learning basics one step at a time is logical, it may be frustrating for you as you struggle with your early still-life exercises. You really need to learn everything about values at once in order to render light and shadow successfully, so please do read ahead of your assignments.

Certainly it is the emotional content of any seasoned artist's work that eventually elevates that work above the average. For the beginning artist, however, the most exalted visions of our world will be wasted if the drawing is poor or the color and values inappropriate. This book can teach you the basic techniques of representational drawing and oil painting; you can then use that knowledge to express yourself freely.

May this book become an oil-stained, dog-eared companion in your studio, rather than just another once-perused, pristine book on your bookshelf.

Part One

THE WORLD IN BLACK AND WHITE

Drawing and painting are immediate means of communicating your ideas, your perceptions, and your inspirations to others. You can communicate awkwardly or expertly, depending upon how much effort you put into your study of this form of communication. The importance of drawing well should not be glossed over if you want to be a fine representational painter, since a painting is usually only as good as the drawing on which it is based.

If you think you have no talent, take heart: You can learn to draw just as you learned to write as a child. Drawing is simply a matter of learning to see correctly. The *desire* to express oneself is more important than any inherent talent. Perhaps you visualize an artist drawing a precise contour on a pristine page, coming up with a superb drawing every time. Maybe so, after years and years of practice, but all artists start out with drawing exercises. The exercises in this book are actually relaxing, as you will find in the next few chapters, and any mental block you may have now will dissolve before you know it.

Part One of this book will give you a thorough understanding of how light and shadow logically define form. Chapters 1 and 2 are the ABCs of drawing in perspective, expressed in as easy language as I can

muster. Assignments at the end of each chapter should help fix the relatively few principles of perspective in your mind if you will conscientiously do them in sequence. Chapter 3 will help you perceive shapes as an artist perceives them. Chapters 4 and 5 will introduce you to values, which are crucial to producing the illusion of three-dimensional form. Chapter 6 shows how to model the four basic forms from which nearly all objects are constructed. Chapters 7 and 8 look more specifically at how various directions of light define form and how cast shadows behave. Once you have mastered these basics of the world in black and white, you will understand how to convey three-dimensional form on a flat piece of paper or canvas.

DRAWING MATERIALS NEEDED FOR CHAPTERS 1 THROUGH 4

Drawing is the most economical of all art forms, since many materials are readily available around the house. You can get started on the drawing exercises at the end of chapter 1 with a few sheets of typing paper and ordinary pencils. The figure on the right shows some additional materials you will need eventually to support your new interest in drawing:

- A selection of pencils including an HB, 2B, 3B, and a 4B
- A pink or white eraser for erasing graphite (pencil)
- An inexpensive black pen with a metal or nylon tip (not ball point) for drawing in your daily diary
- Some sticks of vine (thin) charcoal
- A few pieces of white Conté chalk
- A gray kneaded (malleable) eraser for erasing charcoal
- A couple of stumps (rolled paper sticks for blending charcoal)
- 2 spiral-bound all-purpose drawing pads: $8 \times 10''$ and $14 \times 17''$, or similar sizes
- One smaller sketch diary for daily use
- Several sheets of gray charcoal/pastel paper
- Several sheets of tracing paper

- A red marker to use in correcting your drawings
- A pencil sharpener, a ruler, and a compass

OIL PAINTING MATERIALS NEEDED FOR CHAPTERS 5 THROUGH 8

From chapter 5 through chapter 8, the painting lessons at the end of each chapter are to be done only with black and white oil paint (or acrylic), plus all the grays mixed from them. Although this book is written primarily for the oil painter, the principles governing light and shadow contained in Part One are the bedrock basics of realism and they are applicable to all mediums.

If you are a beginning artist, a visit to a well-stocked art store can be a fascinating but intimidating experience. Most art materials

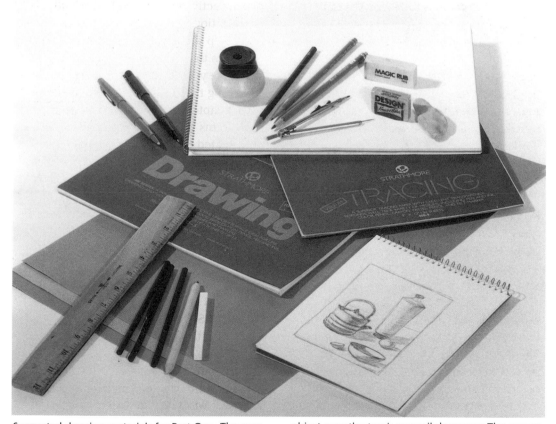

Suggested drawing materials for Part One. The gray charcoal paper shown in the foreground is a great surface to draw on with charcoal and white chalk to get the effects of light and shadow. The odd round object near the top is a pencil sharpener. The square eraser with the word "Design" on it becomes the lump on the right as you knead it, continually turning the dirty part inside as you use it.

are expensive, and therefore you will want to shop selectively. The best way to start buying art supplies is to have a required list from a specific course, or, in this case, a self-teaching book. Ask a store clerk to help you, and with luck you'll have a knowledgeable salesperson who knows the stock well. I avoided mentioning specific brands for the most part in the following list because they will only complicate your shopping. Where I do name brands it is because I think the items are unique or superior. The figure below shows the painting supplies that are listed below to start you on your way in Part One.

- A one-pound tube of white, either Weber's Permalba, Grumbacher's Soft Formula white, or any brand of titanium white
- A tube of ivory black
- A small bottle of linseed oil, to be used only to blend into stiff white oil paint to make it workable
- Three brushes, preferably white synthetics. I like Grumbacher's Bristlette brushes (no. 4720) best, either the short, square-ended "bright" type or the longer-haired "flat." (Look for the letter B on the handle of brights, and the letter F on the handle of flats.) Choose one small, one medium, and one large brush between sizes 4 and 8.
- A no. 6 or no. 8 painting knife, trowel-shaped with a wooden handle and a bent shank
- A canvas paper pad, $16 \times 20''$, Grumbacher if available
- A $12 \times 16''$ white disposable paper palette; a waxed paper surface is preferable to a parchment one
- Turpentine or mineral spirits (mineral spirits are much cheaper)

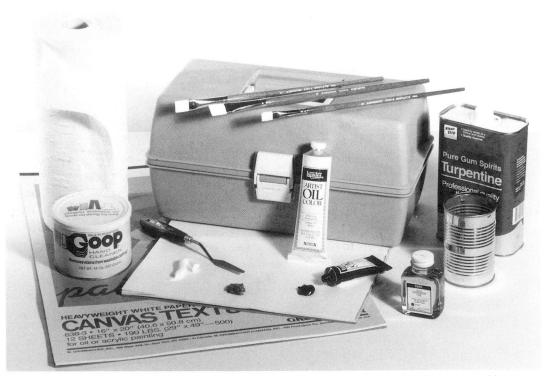

Suggested painting materials for Part One. The brushes pictured are no. 5, no. 7, and no. 8 white synthetic brights. The fine painting knife on the left side of the palette is made in Italy by Tara (the number on the handle is #7070), and it is a good all-purpose size to buy.

- A can (not a tiny clip-on cup) in which to put the turpentine
- Paper towels and a bag for trash
- A waterless hand cleaner (like Goop, which is sold in art stores)
- An easel—the best standing tripod type you can afford

Two conveniences that you might want to purchase, especially if you attend classes or paint on location, are a plastic box with a lid in which to seal your palette full of wet paint, and a carrying case (such as Artbin) for all your paints, brushes, and miscellaneous art materials. If you purchase one, make sure it is long enough to carry your brushes without bending their bristles. If you can't find a palette carrier, a film of plastic wrap over the palette will do just as well for the time being.

Brushes

There are three basic types for oil painting:

1. Natural ivory-colored hog-hair bristles that are rather stiff
2. Sable bristles that are silky and brown in color
3. Pure white synthetic brushes that are springy when you bend the bristles back and forth

Hog-hair bristle brushes are the traditional oil painting brushes, but in recent decades the modern synthetics made of nylon filaments have gained favor with many artists. I prefer the synthetics, chiefly because they outlast the bristle brushes by about five to one. When you are about to use any brush for the first time, gently flex it in your fingers to break the sizing that protects it during shipment and storage.

There are many schools of thought on how to clean oil brushes. Various commercial brush cleaners are sold in the art stores, but I can't see that they justify their expense. Nothing seems to do as good a job as scrubbing the brush across a bar of Ivory soap, and then rinsing it thoroughly. Natural bristles can't take such vigorous scrubbing very often, though, so they are best cleaned routinely by wiping off the excess paint first, then rubbing them across a screen (in the bottom of a jar of turpentine) to help dislodge additional paint. Finally, swish them through a jar of clean turpentine or kerosene (not mineral spirits) and shape them carefully. Synthetic brushes, on the other hand, will hold up well under repeated soap-and-water scrubbings. Some oil colors are based on dye pigments, however (notably the phthalocyanine colors, phthalo blue and green, and the quinacridone reds and violets). These kinds of paints will leave a stain of color on your brushes no matter how you clean them.

The only sable brush I recommend that you buy eventually is a tiny round pointed number 1 or number 2 with which to sign your name when a painting is finished. Sables are used by other artists primarily for the smooth blending of strokes and tiny precise detail work. Since this book will consistently encourage you to experiment with broad painterly effects, I suggest that you avoid buying sable brushes, except for the signature brush. Having a tiny brush in your hand may tempt you to indulge in a lot of fussy, time-consuming detail. My hope is that you will strive instead to become a painterly painter, not one in competition with the camera.

Chapter 1
BASIC STRUCTURAL DRAWING

Nature presents to our eyes an overwhelming profusion of details and ever-changing variables. A great part of an artist's task is to simplify, to distill that profusion into understandable images. Since it is virtually impossible to compress all the three-dimensional data out there onto a two-dimensional surface, a certain amount of editing has to take place. Quick one- or two-minute sketches of anything, anywhere, are a good way to get right to the essentials of a scene.

Start right now to cultivate a keen eye by drawing daily in a small sketchbook of some sort, although any paper that comes to hand will do. The most convenient sketchbooks are those with a ring binder that will fold flat. The black hardcover books are nice too because you can sketch more unobtrusively in them, pretending to read a book when you are noticed by passersby. In either case, hasty squiggles may be enough to show the branching system of a tree, the sweep of a cloud, or the gesture of a playing child. Contrary to what I said earlier about learning to draw well, give no thought to whether or not you can draw when working in your sketchbook. Like a diary, your sketchbook can be a private matter and not for anyone else's eyes. Just keep sketching in it, and your notations will surely become more accurate with time.

CONTOUR DRAWINGS VERSUS MODELED (SHADED) DRAWINGS

Rapidly drawn observations are usually contour drawings, outlines around flat shapes similar to children's coloring books. If you have more time, a sketch may be quickly shaded with the side of the pencil lead or charcoal to suggest light and shadow. A soft pencil or a piece of vine charcoal will model forms much more easily than a pen, so I suggest you start out with pencil for small sketchbooks and charcoal for larger pads. Later on try drawing with your black pen, using cross-hatching strokes to indicate shaded areas. Art students are invariably eager to learn shading, the modeling of forms with different tones. Something that is equally important, and too often overlooked, is the basic structure of the thing you want to shade.

Let me distinguish right off between a fine drawing that reports what one sees and feels about a subject, and a preliminary structural drawing that is to serve as the foundation for a representational painting. Because this book is primarily about oil painting, I will emphasize structural drawings, not drawings intended to be finished, signed, and framed works of art.

Because of timidity, beginning art students usually draw everything much too small, include too much of the setup on the table, and huddle everything smack in the middle of the paper or canvas. A tight little composition will mark you as a rank beginner, so the first thing you can do to lift yourself above that status is to draw everything as close to life-size as possible, especially on your $16 \times 20''$ canvas paper pad. Fill the paper with subject matter, not empty space. It is much harder to paint huge backgrounds interestingly than the objects themselves. Compare the drawings of the same setup in Figs. 1-1A and 1-1B.

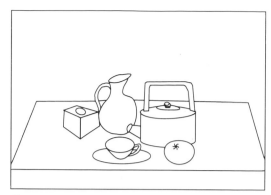

Fig. 1-1A. *INCORRECT:* Beginning students tend to huddle still-life objects in a little group in the middle of the canvas. That usually means trying to fill the extra space with too much of the table and surroundings, thereby downplaying the actual subject, the still life itself.

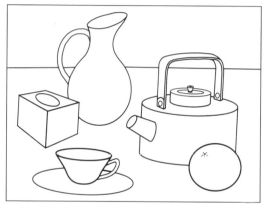

Fig. 1-1B. *CORRECT:* Whatever your format or surface, fill your paper or canvas with the subject, not background material. Aim to work life-size. Make a teacup and a teakettle believable and in good proportion to whatever produce you use in your setups.

THE FOUR BASIC FORMS

The cylinder, cone, sphere, and cube are the four basic forms in nature. All natural and man-made forms are based on these four distinct volumes, either singly or in combination. Imagine that every three-dimensional form in this world has an interior framework that supports it structurally. Study the elliptical lines in the cylinder, cone, and sphere in Fig. 1-2, and also the vertical and diagonal lines in the cube. Note how the ellipses immediately convey the illusion of depth on the two-dimensional page because

we can see both the front and back edges of each form. The moment you really understand how ellipses behave in all rounded forms and how cubic forms appear to diminish in the third dimension, you are home free where drawing is concerned. For now let's concentrate on ellipses in the three rounded forms: the cylinder, cone, and sphere.

Imagine cutting across rounded objects with a knife and making a lot of slices. These cross-sections become ellipses as we look at them from different viewpoints. Even irregular slices of things with fluted contours like the green pepper and squash in Fig. 1-3 are considered ellipses. All such ellipses vary from nearly round to nearly flat, depending on how they relate to your eye level at that moment.

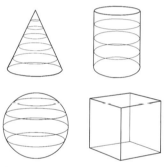

Fig. 1-2. This illustration shows the interior structures of the four basic forms—the cone, cylinder, sphere, and cube—from which all other forms are derived.

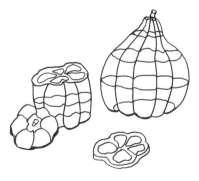

Fig. 1-3. The interior structure of the four basic geometric forms applies as well to organic forms like the squash and pepper shown here, but note that the structural ellipses echo the produce's irregular shape.

ESTABLISH YOUR EYE LEVEL

Look around the room and fix a specific line on a wall that you guess is your eye level. It could be in line with a bookshelf, the top of a picture frame, or the bottom sill of a window, depending on whether you are standing or sitting. Here is a way to prove whether that is indeed your eye level, or horizon line, as it is usually called in perspective language, while verifying basic principles about ellipses.

Hold a dinner plate in your hand and view it from different angles. Your dinner plate will appear to be a smooth ellipse without a single straight segment or corner on its contours, except under the following circumstances:

1. Circles are absolutely round only when you look straight down on them, or straight up at them over your head. (First put the plate on the floor at your feet, and then hold it high overhead.) The first position is known as the bird's-eye view, and the second, the worm's-eye view; both are standard, self-explanatory art terms for those viewpoints.

2. All circles (horizontal to the ground plane) appear to be an absolutely straight line only when they are on the eye level of the viewer. (Raise the flat plate slowly until you see its rim become a straight line. That should happen precisely on the level of your previously determined point. If they don't coincide, then you misjudged your eye level.) Since it is the most important element in perspective drawing, practice fixing your eye level in other situations, and then prove it with any round plate or bowl. Study the gradual change in the elliptical plates in Fig. 1-4.

3. All circles facing you are round only at eye level on your center line of sight, an imaginary vertical line straight ahead of you. (Hold your dinner plate vertically and straight out in front of you at arm's length, as though you were looking in a mirror.) Circles become more and more elliptical as they are raised above eye level, or lowered below it, just the opposite of what happens to horizontal ellipses. Vertical circles also

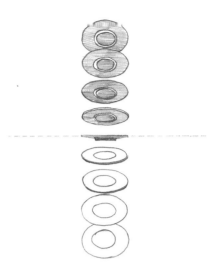

Fig. 1-4. Dinner plates shown as they would appear below, at, and above eye level.

become ellipses as they move to your left or right. (Slide your dinner plate at arm's length to your left and right sides.) Imagine a wrought-iron fence that incorporates a row of circles that stretches to your right and left.

We encounter vertical circles and ellipses much less often than horizontal ones, but the important point to understand about all ellipses is that they are always progressively flattening toward or away from the imaginary cross point where your horizon line and vertical line of vision meet. The top and bottom ellipses of any single rounded object anywhere, anytime, are never the same degree of arc. You can't draw even a tiny thimble in any position and get away with having the top and bottom ellipses the same.

THE ESSENTIAL ELLIPSE

Since most objects are based on rounded forms, our first drawing lesson is how to draw good ellipses. The only way to draw them (without mechanical aids) is to swing your whole wrist and arm in a continuous movement over the paper, going over and over the oval until you groove into a perfectly smooth ellipse. If you fail to swing your wrist

and arm, you will inevitably draw sharp corners, ending up with an eyelike shape, an absolutely glaring error on an ellipse. This freehand kind of drawing is not just for practice, but will serve when drawing ellipses at any time. In fact, a favorite method of warming up in life drawing classes is to do a lot of one-minute elliptical scribble drawings of the model in various action poses. If there is enough time, a contour is added to the gestural drawing, as I have done in the figure

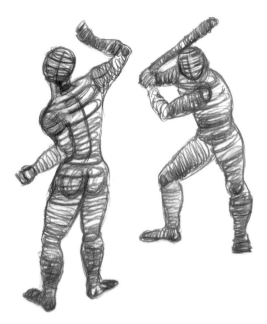

Fig. 1-5. Action figures drawn as series of ellipses to indicate internal structure; contours were added later.

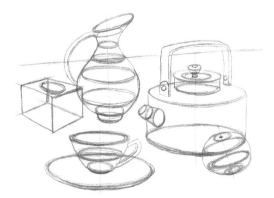

Fig. 1-6. Let scribbled ellipses describe the forms of objects before you add outer contours.

sketches in Fig. 1-5. Similarly, you can scribble ellipses freely until they flow smoothly when drawing your first still-life objects, and then search out their contours. With this freehand approach even the most intimidated art students are usually drawing well before they realize it.

Note how my scribbled ellipses described the top and bottom, front and back boundaries of each of the still-life objects in Fig. 1-6 even before I drew a single contour. Each time an object's contour became wider or narrower, I drew an ellipse to describe that change in shape. In the case of things like a pitcher, teapot, or cooking pot, the ellipses describe their function as well. When all the main ellipses were drawn in, I merely connected the outer edges of them and suddenly, magically, there was a well-drawn, well-constructed group of objects. The "magic ellipses," as I sometimes call them, are good friends when you understand them, but they'll betray you when you don't.

PRACTICE

Gather four or five rounded still-life objects together and start composing them on your sketch pad by roughly plotting the bottom ellipses of all objects first, immediately establishing their position in space. The lowest ellipse on the paper will mark the position of the still-life prop that is closest to you on the table. The bottom ellipse of the farthest-back object will be the highest one on the page. All other base ellipses will fall between those two ellipses. Be sure to draw the back table line early on, noting where it intersects the objects. Obviously you can't place an ellipse above that, because the object would be hanging in air unsupported. Then draw all top ellipses, noting the relative height of each object to its neighbor. Now you are ready to find the interior ellipses you need to show wider or narrower changes in the shapes of all items. Finally, with freehand lines, connect the outer edges of all ellipses to

find the contours of each object. This is a little like coming in the back door of learning to draw, but it works well every time. One thing you want to be absolutely clear about is that the higher you place the bottom ellipse of something, the further back in illusory space that object is.

AVOID OVERCROWDING

If any of the bottom ellipses of the still-life objects you've drawn overlap, the objects will appear to occupy the same space on your table surface—a physical impossibility, as shown in Fig. 1-7A. To correct the problem, first look closely at their actual relationships. Probably you positioned the front object's bottom ellipse higher than it should be so that it crowded the thing behind it. Move one of the objects either higher or lower on the paper, or off to one side, so that each base ellipse occupies its own clear space, as in Fig. 1-7B. Oddly enough, if the top ellipses overlap there is generally no problem, just so long as their bases stand free of one another.

ADDING A PLUMB LINE FOR SYMMETRY

If something you are drawing looks lopsided, like the left-hand bottle in Fig. 1-8, draw a freehand or ruled plumb line from the middle

Fig. 1-8. *Left, INCORRECT:* Out-of-plumb drawing of bottle. *Right, CORRECT:* Symmetrical drawing achieved with the aid of a plumb line.

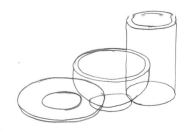

Fig. 1-7A. *INCORRECT:* Don't let objects occupy the same square inches of space on the table the way they seem to here, an impossible situation unless there's a big gash in the front of the bowl for the back edge of the saucer to fit into, and a hole in the vase to accommodate the backside of the bowl.

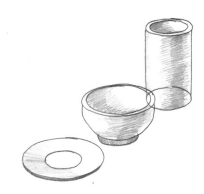

Fig. 1-7B. *CORRECT:* You can avoid the problem of overcrowding by separating objects in space, either by stepping them higher and higher on the page or moving them apart laterally to achieve more depth and breadth.

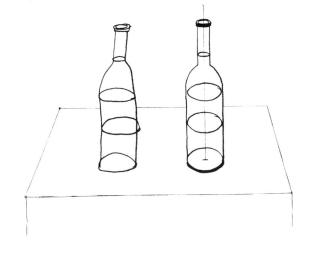

of the top ellipse straight down to the bottom ellipse. Chances are you'll find that your ellipses aren't centered on the plumb line. Adjust any off-center ellipses until everything is equal on both sides of the plumb line, with the right-hand bottle. Despite your corrected drawing, you may still end up with asymmetrical painted objects, because things have a tendency to "grow" in paint. The easiest way to make those adjustments then is to work on the drawing or painting upside down until you have achieved symmetry. Another way is to look through a hand-held mirror at the drawing when it is behind you on the easel. Lopsided proportions will be instantly apparent.

ELLIPSES ABOVE AND BELOW EYE LEVEL

An ideal distance to stand when drawing your first still lifes is 6 to 8 feet away from the setup. If you stand too close to the still-life table, you'll be looking down too much on round things and will see nearly full circles, the bird's-eye view. While that isn't wrong, it would be better to try such an unusual vantage point later on, when you have mastered the conventional point of view. From a comfortable distance away, you should see that all ellipses arc down at the bottom of rounded objects while the top ellipses become progressively flatter as they approach your eye level. If you have to sit to draw and paint, your eye level drops lower too, and you will see flatter ellipses than the standing artist does. Even standing, students have different eye levels depending on whether they are tall or short. Eye level is quite a personal thing, not a standard across-the-board concept.

The single most common drawing mistake art students make (for a long time) is to draw ellipses with straight lines at the base of still-life objects below eye level, as in Fig. 1-9. Apparently a stubborn mind-set insists that if the table is flat, the object must certainly be flat on the bottom too. Yes indeed, the base of the bowl or whatever is physically flat, but it does not appear so when viewed from above. Arc every ellipse *down* below eye level, as with the right-hand bowl below. The further below eye level it is, the deeper the arc must be.

Something interesting begins to happen when rounded objects are raised above eye level. Their ellipses begin to arc higher and higher, as you noticed with the dinner plate experiment. Unfortunately, we seldom have the opportunity to paint still-life objects that rise above eye level, but the principle must be understood right along with the arcing below eye level. It will be much more useful in landscape painting later on when trees, poles,

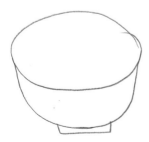 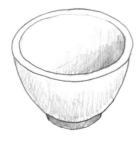

Fig. 1-9. *Left, INCORRECT:* The base of a bowl viewed at this angle couldn't possibly be the flat, straight line shown here. *Right, CORRECT:* Here the bowl's base is rounded in correct relation to its top ellipse and the viewer's angle.

chimneys, round towers, and buildings will rise way above your horizon line. The gazebo in Fig. 1-10A shows the way students often draw ellipses above eye level incorrectly, and then Fig. 1-10B shows how they should be drawn: arcing higher and higher above the eye level that is indicated here as running through the lower part of the windows.

ELLIPSES IN DEPTH

How wide open or how flat an ellipse is indicates two things: one, how far above or below eye level it is, and two, whether it is close to you or far back in space. In the latter case, its diminishing size is the primary indicator of distance, but it must also flatten out at the same time. To see how ellipses change as they go into depth, try placing your dinner plate on the near end of a long table or

counter and note how round the ellipse is. Then push it back gradually to the far end, returning to your original vantage point several times to check its ever-flattening ellipse. Compare the changing ellipses in your plate to the series of plates on a long dinner table in Fig. 1-11. If you push your plate back far enough, it would eventually become a straight line at your eye level. You may well be puzzled about this, because you didn't lift the plate up to eye level, nor did the table rise up to your horizon line. It is just part of what happens when we compress the third dimension onto a two-dimensional surface.

You can see perspective in ellipses on the still-life table much better if you stand to draw or paint. The lower eye level of the seated artist reduces the visible area of the table plane, and all ellipses tend to be thin, flat slivers. I tell my students (in jest) that I expect

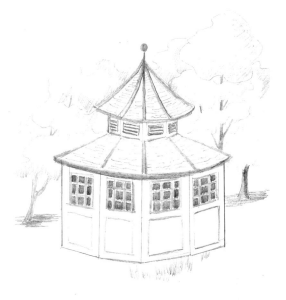

Fig. 1-10A. *INCORRECT:* Be on the lookout for ellipses that arc up above your eye level when you are drawing or painting outdoors. Most students will forget to look for their horizon line first and will draw the roof lines of a structure like this gazebo so they arc down. That tendency can be attributed in part to a habit ingrained from still-life study, where everything usually is below eye level.

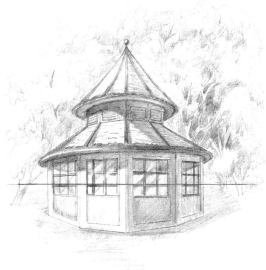

Fig. 1-10B. *CORRECT:* After determining that my eye level ran right through the lower mullions of the windows, I had to be sure to make the window and roof lines arc up increasingly above that point. When you expect that to happen, according to perspective rules, it is easy to see that indeed the roof lines do arc upward.

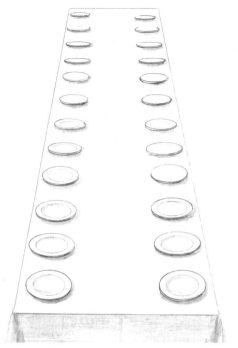

Fig. 1-11. Having twenty-four guests for dinner? Here is how the dinner plates would look from a high vantage point. The plates are roundest close to you, and get progressively smaller and flatter as they near your eye level, as do all ellipses as they recede in distance.

them to stand at their easels unless they have a note from their doctor. Besides the better vantage point, when you stand up you are more likely to move back and look at your work from a distance. Viewed from afar, distortions are easy to spot, but a seated artist seldom realizes what strange things are happening in his work. A teacher moving around the classroom has a great advantage in that respect.

THE DOUBLE ELLIPSE

All hollow rounded objects, such as bowls, cups, and vases, have a wall thickness that must be accounted for when you draw their top ellipses. Picture the difference between a china teacup, which is thin and delicate, and an earthenware pot, which is considerably thicker. When indicating the dimension

between the outside wall and inside wall of a hollow object, draw two ellipses to establish the rim rather than just one. Despite the fact that they are physically parallel, in perspective the two ellipses cannot be drawn parallel to each other. The front half of the double ellipse has quite a narrow space, and the back half is the narrowest of all, sometimes disappearing altogether. The widest space between the two lines is at the point where it turns from the front to the back. This nuance doesn't seem important, but enlarge this drawing concept to include landscape elements such as a curving sidewalk, road, beach, or wall, and you will see that it is. The winding road in Fig. 1-12 illustrates how the road is always widest at the point where it is about to turn. Speaking of a beach reminds me of a bay, a partial ellipse if there ever was one. Standing on the shore of a bay, students invariably draw the contour of the bay as a half-ellipse so round (so open) that one would have to be standing on a high hill nearby looking down on it to see it that way. Only by relating the curve of the bay to the horizon, and by having the students hold a brush up horizontally against it, can I convince them that the bay is quite a flat ellipse, a flat plate, so to speak. Everything we learn in still life has relevance to the larger world that beckons outdoors.

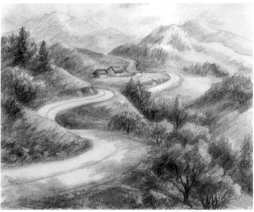

Fig. 1-12. A winding road is like the double ellipse that curves around a bowl or platter in that it is widest just at the turning point. It narrows in perspective between the turns except where it goes uphill, as at left.

ELLIPSES IN RELATION TO YOUR VERTICAL LINE OF SIGHT

We've covered horizontal ellipses as they change in the dimensions of height and depth. Now let's consider what happens to ellipses as they move to left or right of an imaginary vertical plumb line straight in front of us. Just as our eye level moves up or down when we do, our line of vision moves to the left or right as we turn our heads. And as horizontal ellipses are open or nearly closed in relation to our eye level, vertical ellipses will change also in relation to our line of sight. I am referring now to those upright in front of us on edge, not flat as in the earlier idea of looking at a mirror. It may be too difficult to hold your dinner plate like a flat disk with its edge toward you, so try this experiment instead. Put four or five rubber bands (narrow tapes are better) around a wine bottle without labels and place it on its side on a table right in front of you. Make it parallel to the edge of the table, and line it up so that your imaginary plumb line of vision falls right in line with one of the middle bands. And how will you know that that is your center line of vision? You will know it because the front and back parts of the rubber band will be superimposed on each other in a straight line. (See Fig. 1-13.) The visible curves of the other bands will be elliptical, each revealing more of the ellipse as

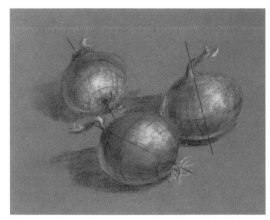

Fig. 1-14. These three onions show how the ellipses change when the axis is tipped in various positions. Onions are great subjects because they have lines on their skins that suggest ellipses from top to bottom.

they move away from the straight line in the center. It is exactly the same progression as horizontal ellipses have in relation to the horizon. They go from rounder to flatter as they approach the horizon until they too are a straight line. Here, the further things go to the left or right of the central line of sight, the rounder the ellipses will be. This continual change in the perspective of ellipses along the width, length, or height of *any* rounded form is often very subtle, but knowing that it should happen, you will more likely see it happening.

DIAGONALS

Many half-spherical or spherical objects lean over rather than sit bolt upright on the table, so that an imaginary pole running through their centers would be a diagonal line. Onions that loll every which way on a still-life table as, for example, in Fig. 1-14, all have diagonal axes and ellipses tipped in alignment with them. Another prime example of tipped axes would be flowers that bend this way and that, their structural ellipses always in agreement with the angle of their stems.

ELLIPSES IN FORESHORTENED AND BACKSHORTENED OBJECTS

Most still-life props cooperate nicely; they sit

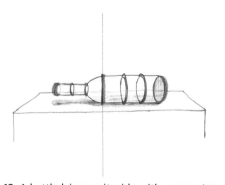

Fig. 1-13. A bottle lying on its side with narrow tapes wrapped around it will help you find your line of sight, the imaginary vertical line right in front of you that corresponds to your horizontal eye level. Now turn this page so the bottle is vertical. You'll see that the straight line also works as the marker for your horizontal eye level.

upright, lean over slightly, or lie horizontally on the table plane without presenting any undue problems in perspective. Sometimes, though, they have a disconcerting way of projecting toward the viewer or away from the viewer into depth, as they do in the drawing of the bottle and lemon in Fig. 1-15A. This is called foreshortening. Whereas the bottle in Fig. 1-15B is about three and one-half times taller than the lemon when standing next to it, the foreshortened bottle in Fig. 1-15A is only twice as tall as the lemon. Although the bottle is a rather extreme case of foreshortening, do arrange some objects in your drawing exercises so that you can practice these strange proportions.

FINDING ACCURATE PROPORTIONS

Have you ever seen artists hold up their pencil or brush and squint, and wondered what they were doing? They were measuring the relative proportions of the height to the width of an object, or the proportion of one object to another. This traditional device is especially helpful in verifying the unusual proportions of foreshortened objects. Practice foreshortening. Set up two objects—a bottle and a lemon, as in my example—and then try the following experiment:

1. Draw the objects first as you think you see them, doing your best to get their proportions right. Next, without moving from your position, compare what you have just drawn against the actual subjects by holding your pencil or brush vertically at stiff arm's length with one eye closed. Line up the tip of the brush with the top of the foreshortened bottle, and then slide your thumbnail up so that it marks the height of the bottle in that position. (If you opened both eyes and looked at that measurement, it would probably be within the top two inches of the brush.)
2. Next, with thumbnail still in place, turn the brush horizontally—still with stiff arm extension and one eye closed—and check

Fig. 1-15A. Here a bottle and lemon are placed on a table in foreshortened position, that is, they are pointing at us. Most beginning students will draw that bottle as a long form going uphill, and they'll draw the lemon in profile, even though it becomes round in this position. You can determine the objects' relative proportions by holding a pencil or brush out at arm's length, squinting, and measuring first the height of the lemon, and then finding how many lemons high the lying-down bottle is. Then measure the height and width of the foreshortened bottle, and you should get all proportions just right. The visual truth is that both are shortened (that's the important clue) to only a fraction of their usual dimensions.

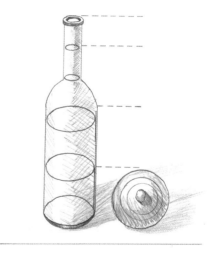

Fig. 1-15B. Compare the dimensions of the foreshortened bottle and lemon with this standing bottle and lemon. We can readily see that the bottle is about three and one-half times the height of the lemon, whereas in Fig. 1-15A, the bottle was only about twice its height. The important thing to understand is that not only have their proportions changed, but the bottles' ellipses have changed drastically too.

the width of the bottle in relation to its height. You will see that the bottle is perhaps twice as tall as it is wide. (If you stooped lower and looked right into the opening of it, it would be exactly as tall as it is wide, wouldn't it?) Now check the foreshortened height and width of the lemon in the same manner. Next, compare the height of the foreshortened bottle to the height of the foreshortened lemon. Perhaps they are the same height, or maybe the lemon is only three-quarters of the height of the bottle.

3. Turning back to your drawing, apply the proportions you gained by laying the brush against the drawing you attempted already. (You can let go of the measurement your thumbnail was holding.) Now, place your thumbnail on the brush handle to mark the height of the drawn object, and then turn it horizontally to check the width of it. Although these measurements will take up many inches on your brush handle, they will be in the same proportion as the miniature measurements found at arm's length. Chances are, you were off on your first drawing and must now correct it to get the same proportions you found by squinting and sighting at arm's length.

The third step is very important. There is no point in checking the visual proportions of something, or of one object to another, if you don't apply that information to your drawing. However, in time you shouldn't need to go through this drill because your eyes will be trained to accept the reality of what they see, ignoring what the mind says.

The outstanding factor in making all foreshortened rounded objects believable is that their ellipses must be full or near-full circles that "look" at you. Note the radical changes that take place in the ellipses of the bottle in Figs. 1-15A and 15B. It is not only its proportions that change, but its ellipses are completely different too.

One of the most frequent drawing errors students make in still life is misjudging the proper ellipse for a large platter of fruit. The ellipse is usually much too round (much too open), as though you were standing next to the table looking down on it. Assuming an ideal distance of 6 to 8 feet from the setup, the plate's ellipse should be a wide, shallow oval as you see in Fig. 1-16. While checking the proportion of the height to width of the platter, try measuring one lemon (or any other single fruit) on the large platter. Hold your brush at arm's length, squint, and put your thumbnail on the brush marking the width of that lemon. Then find out how many lemons wide the plate is. Next check how high the lemon is, and how many lemons high the plate is from the front rim to its back rim. I'll wager that you will find the back edge of the plate intercepting the lemon, or perhaps just skimming over the top of it.

Admittedly, checking for accurate proportions is not often necessary in still life, but when working with the figure in life drawing classes, gross distortions result when the limbs and torso of a person are not in proportion to the whole figure. Even worse is when the ellipses fail to convey the proper foreshortening of the limbs. Another drawing aid to getting everything right is to hold your

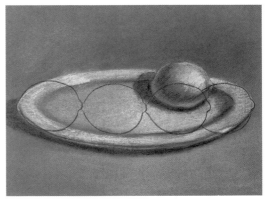

Fig. 1-16. When drawing a platter of fruit, first draw what you think you see. Then check to see how accurate your proportions are by measuring with outstretched arm to see how wide one fruit is, in this case, a lemon again. You might find that the plate is about three and two-thirds lemons wide, as this one is, and almost two lemons tall, a nice wide oval. Chances are your first drawing of the plate would be too narrow and much taller. In other words, the plate's ellipse would be too round for your vantage point of 6 to 8 feet away, a common error.

pencil or brush up like a vertical plumb line, squint, and then check to see how the parts of the body line up. Before you ever start going to a life drawing class, become conscious of ellipses on people in everyday life. Look at people who are wearing watches and short sleeves; notice how the ellipse of the watch wraps around the wrist, and the sleeve wraps around the arm when the arm is straight down at a person's side. Then look at how the ellipses of the watch and sleeve change as the arm and wrist raise toward you, as if to shake hands. Better yet, look for a lady in a horizontally striped T-shirt or dress and notice how the elliptical stripes change with different positions of the torso and limbs. If you can sketch her and the way the stripes go over the bumps and hollows that describe bosom, abdomen, and thighs, you are using cross contour drawing, one of the best ways to understand ellipses and convex and concave curves on the figure or any other complex subject.

ELLIPSES IN LANDSCAPE SUBJECTS

Besides still-life objects and people, literally everything in nature obeys the laws of perspective—clouds, trees, buildings, waves, beaches, rocks, fences, and anything else you can think of. Much of it is so subtle that it requires careful observation to see how everything relates to your horizon. A wonderful exercise in ellipses in all their variances can be found in the trunk and major branches of a tree. (See Figs. 1-17A and B.) Notice how the ellipses arc down when the trunk is below your eye level, are straight lines at your eye level, and arc up as the trunk rises above that imaginary line. Let your viewer feel that he or she is looking *up* into the branches of a tall tree, *at* the trunk, and *down* at the base of the trunk.

PERSPECTIVE IN CLOUDS

Beginning landscapists tend to paint clouds as if they were on a flat surface, like a backdrop

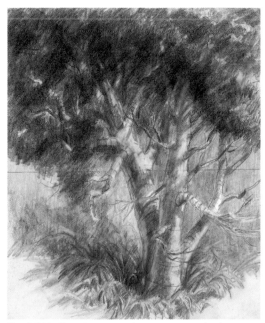

Fig. 1-17A. Drawing a tree is a great exercise in practicing the way ellipses change from bottom to top of the trunk, and from limb to limb. By the slightest elliptical movement of pencil or brush you can indicate whether branches are foreshortened toward you, backshortened away from you, are in profile, or somewhere in between. If there are no physical clues, look for cast shadows from nearby branches to see how they create partial ellipses as they wrap around limbs.

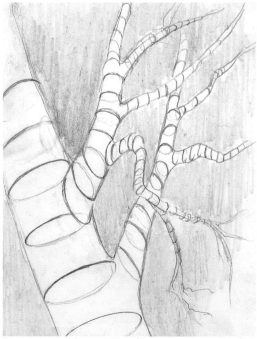

Fig. 1-17B. In this more literal image, you can clearly see how ellipses work in natural subjects.

Fig. 1-18A. *INCORRECT:* Fair-weather clouds are basically spherical mounds with flat bottoms. Many inexperienced landscapists either ignore the overlaps and paint single clouds like these, or they overlap them incorrectly.

Fig. 1-18B. *CORRECT:* Here the clouds overlap one another logically, with clouds farther away tucking behind nearer clouds. Still-life objects on a table overlap while moving in depth *up* to the horizon; clouds overlap while moving *down* to the horizon.

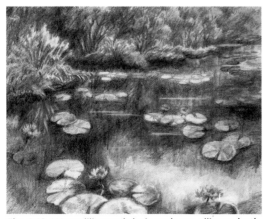

Fig. 1-19. Water lilies and their pads are ellipses, both singly and in floating masses. The pond itself is an irregular ellipse.

in a theater. (See Fig. 1-18A.) Begin to think of the sky as domelike, and pull that sky and those clouds over your head as you draw or paint them. If we look straight up overhead on a cloudy day, we see more or less elliptical shadowed bottoms of clouds, just like the bottom of the dinner plate held above your head. As the clouds approach the horizon, we see less of their elliptical bottoms and more of their sides. Near the horizon, the bottom ellipses of the clouds are practically straight lines. In terms of the four basic forms, they are strung-out spherical masses that have flat elliptical bottoms—like a mound of shaving lather piled up on your hand.

Nature is the best teacher you will ever have, so observe the perspective in clouds on a cloudy day, the way they overlap each other as they recede in depth down to the horizon line, as in Fig. 1-18B. Sketch them quickly on your sketch pad and become absolutely convinced of the logic of the way they overlap so that later you won't make the error of putting clouds farther away in front of clouds closer to you.

If you are lucky enough to live near ponds of water lilies, you couldn't ask for a better example of ellipses moving from the ground plane to the horizon. Pads and flowers near you are very round as you look down on them, and they gradually become flatter ellipses as they move away toward your horizon. Lily pads also grow in large elliptical groups, and those floating masses will inevitably become progressively flatter until they are thin lines of pads as they approach your horizon line, as in Fig. 1-19.

The times and places when you will need to know how ellipses work in perspective are legion. Please draw lots of elliptical things in your sketchbook. Look hard at all conical, cylindrical, and spherical forms both indoors and out. Do whatever it takes to become thoroughly convinced that all ellipses are rounder below eye level, are straight lines precisely at eye level, and arc ever higher above eye level.

Drawing Assignments

1. Fill two whole sheets of paper in your 14 × 17″ drawing pad with practice ellipses, using your whole wrist and arm. Use charcoal on the first sheet and pencil on the second, going over and over each ellipse until it becomes perfect. Make large ellipses and small ones, vertical and horizontal ones, open (nearly circular) and closed (nearly flat) ones. When you are finished, check to see whether you inadvertently ended up with any eye-shapes with sharp corners. Correct those with your bright red marker.

2. Turn your 14 × 17″ drawing pad horizontally and draw the four basic forms freehand, just as they are in Fig. 1-20, using either pencil or charcoal. Make your forms as large as you can, at least 4″ (10 cm) tall, and draw as many structural ellipses and lines as you need. (To avoid smudging your homework drawings, place a clean piece of paper under your drawing hand at all times.) Don't cheat by drawing the basic forms first and then filling them with ellipses! It is virtually impossible to draw a symmetrical shape by starting at one point and going around the entire contour. Try it yourself with a vase.

3. Select three or four rounded household items like a mug, plate, bowl, bottle, and clay pot or vase, and arrange them casually on a table. With your 14 × 17″ pad placed horizontally, begin to draw the bottom and top ellipses of as many objects as you can so that they will fill your page comfortably. When satisfied with their placement on the page, draw the interior ellipses, and then connect the outer contours. Drop a plumb line down through tall objects if necessary. If two objects overlap, be sure that their base ellipses don't intrude on each other.

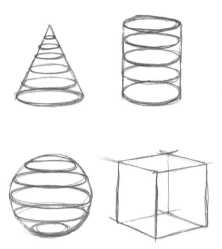

Fig. 1-20. The four basic forms drawn freehand. Draw the structural ellipses and lines first, then the outer contours.

4. Cut half of a cucumber in circular slices, leaving the other half of it whole, and then slice an onion into one half plus several slices. Arrange all the pieces casually on a bread board or a plate. Let the slices fall every which way and overlap in some cases. Draw the setup life-size in pencil on the top third of a page of your large sketch pad. Rather than shading and finishing the sketch, turn the plate and draw the same setup two more times from different vantage points. Put all three sketches on the same page, if possible.

5. Set up a tall object like a bottle or vase and place a bunch of carrots leaning against it, preferably with their green leafy tops tied together so that the carrots splay out. Check the length of the side carrots in proportion to the carrots pointing toward you by sighting along each carrot with your pencil held at arm's length. Something is wrong if you have drawn them all the same length! Check again and make corrections boldly on your drawing with your red marker. Look for natural ellipses on the outer skin of the carrots.

Chapter 2
LINEAR PERSPECTIVE IN CUBIC OBJECTS

Let's turn our attention now to the fourth basic form, the cube, and all the rectilinear objects that derive from it. Many otherwise advanced art students fail miserably when it comes to drawing a simple cube in linear perspective. The very term "linear perspective" often provokes anxiety in the hearts of those who have had no formal training in it. However, linear perspective is an entirely logical system based on just a few simple principles, so once you understand them, they should pose few problems. This chapter will cover just the rudiments of linear perspective, as they are sufficient for most fine arts subjects. If you choose to draw or paint architectural subjects, interiors, or cityscapes, then I recommend that you study books on perspective to gain more in-depth knowledge.

Not one, but two systems of perspective help to achieve three-dimensionality in our paintings: aerial (or atmospheric) perspective and linear perspective. The former governs the gradual recession of values and colors into distance; this will be covered in chapter 19. The latter governs the recession and converging of lines in space.

THE PICTURE PLANE
The first concept to grasp in studying all two-dimensional drawing and painting is that the surface of your paper or canvas is called the picture plane. Think of it as the front plane of an imaginary cube (or rectangular prism) of space that protrudes behind the picture plane. It could also be called the window pane if that

helps you understand that the surface of the paper is like a window through which you, and all subsequent observers, will view the scene behind it. When you are painting a still life, the cube of space behind the picture plane might be two to three feet deep. In a landscape or seascape, the cube of space could be twenty or thirty miles deep. There can be an infinite number of planes in that imaginary space, some horizontal, some vertical, and others slanted at various angles. If the dimensions of any plane remain parallel, that plane will appear to stay flat (up front) in the picture. Be clear about the concept of various planes in space, because how they tilt toward or away from the light governs how you will use values and colors when drawing and painting later on.

In addition to planes appearing to diminish as they push into space, every single form must become progressively smaller in every dimension as it recedes from the viewer. (See Fig. 2-1.) Let's see how to go about achieving this.

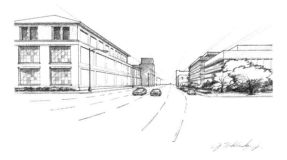

Fig. 2-1. Everything in this scene becomes smaller in the distance—the buildings, light poles, cars, and trees. This is also a splendid example of one-point perspective.

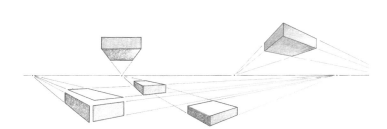

Fig. 2-2. The left-hand box and the third one from the right show the two sides having unequal rates of convergence to the horizon line. You see less of their left sides than their right, and extended lines from their left sides converge rapidly to the viewer's eye level. The box at left has been exploded so that you can more easily see its three different planes in space.

ESTABLISH EYE LEVEL FIRST

Just as rounded objects have elliptical changes in relation to your eye level, all planes on cubic forms relate to that important horizon line. Therefore, the first thing you have to do before starting any of the drawing assignments at the end of this chapter is to establish your eye level. If you sit to draw, your eye level is not very far above the tallest object you have in the still life setup. When standing at an easel, mark your actual eye level on your canvas paper pad (if it rises above your eye level) and then follow that line across to the still life.

As you know, any cubic form has three dimensions—height, width, and depth. Height normally stays parallel to the side edges of your paper or canvas, while width and depth normally thrust into the distance and converge at points on your horizon line. Although I will refer to these in-depth lines as converging diagonals or "obliques," because that is how they look visually, in reality we know that the opposite sides of a cube are forever parallel. Like railroad tracks or roads going into the distance, their diagonal convergence is an optical illusion.

No matter where you place boxes, books, chairs, cars, buildings, or whatever, on the picture plane, their diagonal lines will all converge at points on your eye level, your horizon line (HL). All such points are called vanishing points (VP). There can be any number of them on your horizon line, as well as some beyond the picture plane on either side, as shown in Fig. 2-2. Some vanishing points will be above or below the horizon, but only because of the following unusual vantage points of the viewer.

THREE-POINT PERSPECTIVE

Vertical lines on rectilinear objects always remain parallel to each other and to the picture plane with just these two exceptions:

1. When buildings, trees, poles, and so on are extraordinarily tall, their vertical lines, seen from a ground-level point of view, will begin to converge toward an imaginary point way above the horizon. (See Fig. 2-3.)

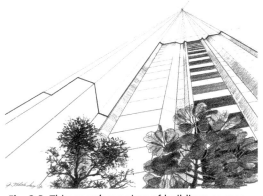

Fig. 2-3. This worm's-eye view of buildings as seen from the sidewalk right below is a dynamic example of three-point perspective. Everything diminishes in size as it goes farther up, rather than farther in depth.

This is the worm's-eye view that we encountered in ellipses above eye level. You will see this third-point convergence only if you (or "the worm") are close to the building and look up at it from a dynamic angle, tilting your head back to look up. As you move back away from the building and look at it from a block or two away, its vertical sides will gradually become parallel.

2. Likewise, the sides of tall buildings, trees, or poles viewed from above will diminish in their vertical dimension and appear to converge at a vanishing point somewhere below ground, as in Fig. 2-4. This vantage point is the bird's-eye view. Again, the viewer has to be physically looking down on the tall object at a dramatic angle, as from a helicopter, in order to see the downward convergence. Artists frequently exaggerate this kind of perspective to advantage in all kinds of illustrations.

You can forget about three-point perspective in regard to normal still lifes, but later on you may want to draw objects on a shelf high over your head or, conversely, arrange a group of things on the floor near a chair or table and look down on them. Also, you'll need to use worm's-eye three-point perspective in life drawing classes if you have to sit close to a standing model who is posing on a three-foot-high model stand. He or she will appear to have large feet and legs and a relatively small head. Exaggerate this perspective rather than diminish it. Reckon with three-point perspective right from the start of your study of linear perspective, and look for ways to use it.

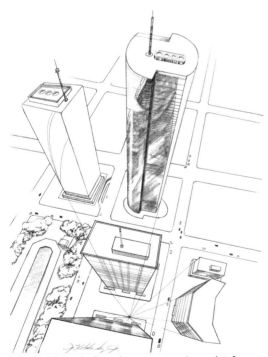

Fig. 2-4. Here is the other extreme viewpoint for three-point perspective, the bird's-eye view. The viewer is bending over looking straight down at a dizzying angle.

ONE-POINT PERSPECTIVE

In one-point perspective, all the diagonal (oblique) lines of all cubic objects in your subject will converge to only one point on your eye level if the base of the cube is parallel to the bottom of your page or canvas. In still life, such frontal objects will probably be lined up with the edge of the table too. In a still-life setup, when a box faces you squarely, you may see only two of its six planes, the top and the front. If that same box is raised so that it blocks out the cross point where your horizon line and center line of vision meet, you will see only one plane, the front, but of course that would rarely happen. In Fig. 2-5 note that all the boxes, no matter where they are placed, have in-depth diagonals that go to a single point on the artist's eye level. The converging of the lines causes the back of each box to be backshortened into depth. All horizontal and vertical lines are precisely parallel to the margins of the picture plane.

TWO-POINT PERSPECTIVE

In two-point perspective, all in-depth diagonals on cubes divide and converge to points on the right and left sides of that center point, instead of converging at one point on the middle of the horizon line. What caused the change from one-point to two-point perspective? The answer is that the boxes'

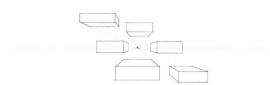

Fig. 2-5. Here are six boxes in one-point perspective. Notice the grid of radiating lines from the central vanishing point created by the extended oblique lines of the six boxes. You could draw additional boxes in one-point perspective anywhere in this illustration and be sure that their oblique lines would join the radiating grid from the single vanishing point.

Fig. 2-6A. Here is a single cube in two-point perspective. This time the viewer sees the front corner of the box, not a flat side as before in one-point perspective.

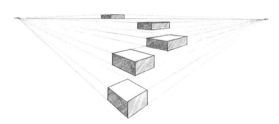

Fig. 2-6B. The top of a box on the horizon line begins to peak ever so slightly, since it is now above eye level. Notice how our view of the top planes changes from looking down on the box in the foreground, to seeing less and less of them until the top plane virtually disappears by the fourth box.

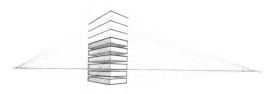

Fig. 2-7. This stack of boxes in two-point perspective begins to look like a building under construction. Additional floors below eye level would look like V-shaped chevrons in reverse.

bases are no longer parallel to the picture plane. (Compare the base lines of the boxes in Fig. 2-5 with those in Figs. 2-6A and B.) We now look at the front corners of cubes and see three oblique planes. Nothing is parallel to the picture plane anymore except the vertical lines formed by the boxes' edges, indicated by the arrows in Fig. 2-6A.

The closer things are to you (farther below eye level), the more acute the corner angles will be; the farther back in space, the less acute they will be. This is also visible in Fig. 2-6B. A box that is pushed back in space so far that its base line coincides with the viewer's eye level will be (what else?) a straight line. Its lower corner angles would each be 90 degrees. The top of the box would begin to angle up a little bit, and the taller the box, the more acute would its top angles become, just the opposite of the boxes below eye level. (Refer to floating box at right in Fig. 2-2.) It may be helpful to think of these upper corners above eye level and the lower corners below eye level in two-point perspective as a series of chevrons, or V shapes, when they are stacked, as they would be in a building. Can you relate the changing angles in the floors of the building in Fig. 2-7 with the way ellipses arc ever higher above eye level and arc down increasingly below eye level? The base lines on a cube can never be the same angle as the lines that define its top plane. Even in cubes as small as a pair of dice, the bottom and top angles will be different.

Most often the two visible sides of a cube in two-point perspective are not equal, as Fig. 2-7 demonstrates. If they were, the vanishing points would be equidistant from the building. Sometimes the difference between the sides is more extreme, and the imaginary extended lines for one side will converge sharply and quickly up to the horizon line very near the cube. The opposite side will look very nearly square, and its diagonal lines will converge so slowly that its vanishing point on the horizon line will be way beyond the confines of your paper or canvas. When that happens, I tell my students that the lines will converge "a block

or two away." In perspective terminology, the narrow plane of the box has a fast recession; the nearly-square side has a slow recession. Refer back to Fig. 2-2 and note in particular the third box from the left, the one just below the horizon line. Not only are its two side planes radically different, but its vanishing points are, too, in relation to the box.

LOCATING VANISHING POINTS ON THE HORIZON LINE

When drawing a box in two-point perspective, how do you know exactly where to place vanishing points on the horizon? This puzzles many art students. The easiest way is first to draw the vertical corner of your box and judge as best you can its base diagonal lines as they go off to left and right of it. Draw what you think you see. These three lines will look like an arrow pointing down. Now compare what you've drawn with the real object by holding your brush or pencil at arm's length, closing one eye, and lining your brush up with the right diagonal on the object. Then open both eyes and look at the angle of the brush in the air. Check it against the right diagonal line you have already drawn.

You may have misjudged the diagonal, making it either too horizontal or slanting uphill too much. Then check the diagonal line on the left the same way. Perhaps it does indeed slant uphill more sharply in a fast

recession, and you find that you were right about that one. Then simply extend those base lines with a dotted line, one to the left and the other to the right, to vanishing points on your previously established eye level. Those two points, plus the dotted lines going to them, are the beginning of a grid that will help you determine where all other lines on the box will go. From here on all you have to do is draw lines in the sequence shown in Fig. 2-8. I urge you to take a piece of paper and pencil right now and draw a box on it as you read the following sequence of instructions:

1. The Top Row: Draw the down-pointing "arrow" of the front corner and base lines, as at left. Extend lines from the top end of the front corner to the same vanishing points established by the base lines. Then drop two verticals for the left and right side corners. The two side planes of the box have been completed now.

2. The Second Row: Extend lines from the tops of those two vertical lines so that the left-hand side corner goes to the right vanishing point, and the right-hand one goes to the left point. You have now created the top plane of the box. Drop one more vertical for the fourth normally unseen corner of the cube where the two previous diagonals intersected. It will be near the original front corner. Now extend lines from the two lower ends of the side corners, again connecting the left side

Fig. 2-8. When you draw square objects in two-point perspective, think of "building" them plane by plane in a logical sequence like this one. First comes the front corner, then the two side planes. Next do the top plane, which helps you find the back corner. When you draw that vertical, you have completed the two hidden side planes behind the box. Two more connecting oblique lines complete the floor plane.

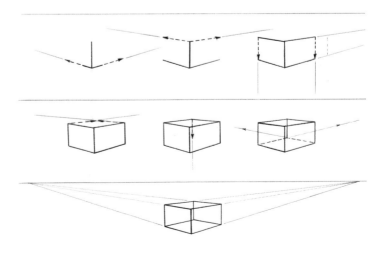

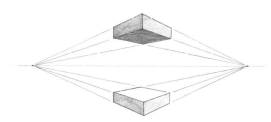

Fig. 2-9. Because these two boxes are solid, showing only three planes rather than the six we saw in the transparent box, they have only three extended lines to the left and right, not four. Compare the diamond-shaped grid of the twelve extended lines created by these two boxes in two-point perspective with the radiating lines from a single vanishing point in Fig. 2-5. If you are clear about these two systems of lines and how they came about, you should have no trouble knowing where vanishing points go on the horizon line.

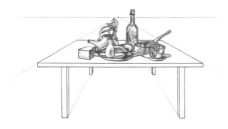

Fig. 2-10A. This table in one-point perspective looks as it might to a person seated about 6 to 8 feet away from the front of it. A standing person would have a higher horizon line and would see more of the top of the table. The oblique in-depth lines would then not converge quite as fast as these do.

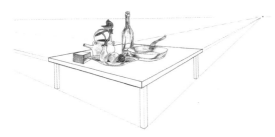

Fig. 2-10B. Imagine you are in an art class and the table and still life look like this to you. Where are you located? Probably standing about 8 to 10 feet from the closest corner of the table. You should recognize by now that it is in two-point perspective. You would also have to figure out your eye level. A clue here is that the cork and top of the bottle arc upward, and so your eye level would be a little below that. By sighting with your brush along the bottom of the legs and the top edges of the table you would find the angles that indicate a fast recession to the horizon line on the right side, and a slower one on the left side.

corner to the right vanishing point, and the right one to the left vanishing point. That step completes the floor plane.

The completed box, with all six planes visible, is shown with four extended lines on both the right and left sides, all converging up to the horizon line.

If a box is drawn above eye level just above the lower completed cube with all of its lines extended down to the horizon line, you would see a matrix of lines that will look like a long diamond shape, as in Fig. 2-9. It would be so simple if all cubic forms in two-point perspective would fit within this matrix, just as things in one-point perspective fit in the grid of radiating lines. But unfortunately, in a typical scene square or oblong objects are turned different degrees from the viewer, so they each have to have their own pair of vanishing points and accompanying matrix of extended lines.

LINEAR PERSPECTIVE IN STILL-LIFE SUBJECTS

You may not think of it at first, but the table upon which a still-life setup rests is a large cube or oblong form. Since at least the top part of it will be visible in your still life, determine immediately whether the table is parallel to you and the picture plane in one-point perspective (Fig. 2-10A), or whether you see one corner and two sides in two-point perspective (Fig. 2-10B). As I pointed out in chapter 1, the front edge of the table is better left out of the drawing or painting, at least if you are working on a format as small as your $16 \times 20''$ canvas paper pad. In a large painting, the bare table itself or the drop of a tablecloth over its edges can be interesting, provided that they are foils for the still life, and not scene-stealers.

LINEAR PERSPECTIVE IN OUTDOOR SUBJECTS

Two-point perspective seems to be not only the most prevalent but the most advantageous

kind of perspective. Why? Because the diagonal thrust of the turned box is more dynamic as it pushes into the imaginary cube of space, rather than staying parallel to it. Compare the two houses in Fig. 2-11.

High-rise buildings are classic subjects for studying linear perspective. Notice how the bottom floors and windows angle up to your horizon line, while higher floors and windows above eye level angle down at an increasingly steeper angle. This is all according to the idea of V-shaped upper and lower chevrons in what I call the "Chevron Principle."

Finding your eye level when you are out in the country can work on a more modest level too. If there is a house in your landscape, find your eye level by checking the windows as they run across two planes of the building. If there are no obvious clues to finding your eye level, simply hold your hand horizontally about 6 inches in front of your eyes, and then observe the scene above, below, and on either side of it. Of course, if you can see the ocean's

Fig. 2-11. *Top:* To see this house as it appears here, drawn in one-point perspective, the viewer has to be across the street on flat ground. His or her eye level runs right through the middle of the windows, and the vanishing point for all of the (unseen) converging lines is a little to the left of the front door. Although in real life a frontal view like this offers few perspective problems, it makes for a static composition. *Bottom:* The oblique view of the house, seen from a hill nearby, is more dynamic, more three-dimensional, as it pushes into the imaginary cube of space behind the picture plane.

horizon, you are in clover, because it is the truest indicator of all. In any case, never start drawing or painting until you know where that imaginary line is.

CHECKING YOUR PERSPECTIVE RECESSIONS

Once you start to draw on canvas in preparation for a painting, don't take the time to draw dotted line extensions of cubic forms up to your eye level. Instead just draw the forms as you see them and then double-check your perspective with these quick tests:

1. Check your drawing to see whether the front corner is a greater dimension than the back corner of any object, even using a ruler if you want to be precise in measuring them. Then check the top plane of every object below eye level. Is it wider in front and narrower in back as it should be? Everything has to diminish as it goes into distance.

2. When your perspective still doesn't look quite right and you don't know why, take two pencils or two paintbrushes and line them up, one in each hand, against a pair of diagonal lines that you have already drawn to represent the top and bottom of whatever cubic form you are working on. Perhaps the brushes are parallel, or worse, they diverge. Then check the diagonals on the other side. When your perspective is accurate, you'll see that the lower brush angles uphill a bit more steeply than the upper brush. The upper brush should be flatter because it is the one that is approaching eye level. I call this easy test "two-brush perspective." Use it often in your beginning still-life setups and landscapes. If you learn to use the two visual aids given in this chapter—sighting with arm extended to find the angles and proportions of the actual subject, and then checking your drawing of them with the help of your brushes—you'll manage fine.

Despite countless repetitions about lines converging up to eye level, diverging

perspective lines show up in the classroom more times than I can believe! Students frequently make the bottom chevron diagonals much too steep, that is, going uphill too sharply to the horizon line. That might be right if you are towering over your subject (the bird's-eye view), but it is not appropriate if you are at ground level and at a normal viewing distance, no matter whether the subject is outdoors or indoors. This point relates to the ellipses that students frequently draw too round for their point of view.

Once you have a good grip on linear perspective, you can use it to solve the perspective problems of unusual or irregular-shaped subjects. Any subject will look right if you'll draw a box around it and figure where the box's vanishing points are on your eye level. Furniture, bicycles, boats, animals, and human figures will automatically be foreshortened or backshortened when boxed in first. Consult a good drawing book for reference to solutions for these more complicated perspective problems.

Drawing Assignments

1. Begin to collect magazine pictures that show three-point perspective, both worm's-eye view and bird's-eye view. Clip them for an ongoing file, or else just trace the bare perspective lines of the compositions. Then draw an actual view of a tall building from a close vantage point. You might not realize visually how dramatically the verticals converge toward the third point without studying other references first.

2. With a ruler, establish an imaginary eye level across the middle of the page in your large drawing pad. Starting with a VP in the middle of the horizon line, draw six boxes in one-point perspective that correspond roughly to the even hours on the clock, for example, 12:00 noon, 2:00, 4:00, 6:00, 8:00, and 10:00 P.M. Let your center point represent the pivot point for the clock's hands. Whether you draw them freehand quickly, or carefully with a ruler, is up to you. Be sure that all of their base lines are parallel to the page, and their oblique lines converge to that one central vanishing point. Let some boxes be cubes and others oblong, but avoid placing them all equidistant from the center point, ignoring for the moment the symmetry of the numbers on the clock. When you are

finished, your diagram should have radiating lines of different lengths going to individual cubes.

3. On another sheet of paper, establish a horizon line again across the middle of the page with a ruler. This time, draw six boxes in two-point perspective with three above the line and three below. Be sure to turn them different degrees so they do not all have equal sides. Let some vanishing points be off the page. When finished, check to see if all back corners are shorter in height than the front corners nearest you. Are the widths of the top planes wider in front than in back? Are you looking down on the top planes of boxes below the horizon, and up at the bottom planes (floors) of those above eye level? If your drawing has perspective errors, correct them with a bright red marker.

4. Now you are ready to tackle an actual subject with a variety of boxy and rounded forms. If possible, sit near a desk with a lot of clutter on it. A blotter, papers, books, lamp, telephone, radio, file boxes, a computer with its components, and a drawer pulled open would all give excellent practice in one- and two-point perspective, as well as a variety of ellipses above and below eye level.

Chapter 3
LEARNING SHAPE AWARENESS

Ordinary things like eggs, fruits, vegetables, bottles, vases, and so on can provide your first lessons in learning to see shapes accurately. Is an egg or an apple really spherical? Eggs have one rounder and one more pointed end; lemons also have differently shaped ends. Delicious apples have round contours on top, are straight and taper in on the sides, and then round off again to a lumpy bottom—and they are often slightly out of plumb besides. Working at home with your own setups, and positioning yourself at an ideal distance of 6 to 8 feet, your eyes will take in the nuances more quickly. No teacher or book can train you better than this kind of firsthand experience.

PERSPECTIVE AND SHAPE RELATIONSHIPS

Learning to read shapes is another way of learning to draw well that can either augment the laws of perspective or replace them altogether. Begin to look for the diamond shapes that result when cubes are in two-point perspective. (An exception to that is when a side plane has such a slow recession that it is nearly square, or oblong.) Fig. 3-1 shows four cubes, the lower three in two-point perspective, and the upper one on the left in one-point perspective. Its top and bottom planes are more like wedge shapes than diamond shapes. The top plane of a cube will be a wide diamond if you are looking down on it, or a narrow diamond if it is higher or further back in space. In either case, that means closer to eye level. The four points of the diamond will usually not be equidistant and so it may look out of kilter, but let's call them diamond shapes nonetheless.

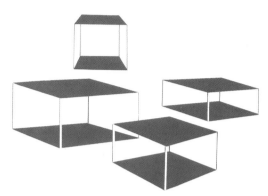

Fig. 3-1. The three lower cubes are in two-point perspective, and the box at upper left is in one-point perspective. Compare the diamond and wedge shapes of their top and bottom planes.

Fig. 3-2. *Above, INCORRECT:* Here the artist perceived incorrectly that the back edges of the box rose higher than the top of the egg, and consequently the top of the box is drawn with incorrect perspective. *Below, CORRECT:* Here we see that the back edge of the box intercepts the egg at a certain point down from the top of the egg, that the egg is not sitting right in the middle of the box plane, and that there are different distances from the bottom of the egg to each side edge.

POSITIVE AND NEGATIVE SHAPES

In Fig. 3-2 I've put an egg on top of the box, so that the egg creates a "hole" in the diamond shape of the box's top plane. From a vantage point of 7 or 8 feet away from the still life, a student should see that the back edge of the box's top plane intercepts the egg, as in the lower version, but nine times out of ten, it will be drawn or painted like the upper one. The egg is called a positive shape, and the shapes on the top of the box, as well as other shapes behind it in the surrounding area, are called negative shapes.

Let's back off a bit and start to build the box itself entirely through shape relationships with the egg. Try drawing the vertical front corner and bottom angles of the box, thinking only of the down-pointing "arrow" I mentioned in chapter 2. Then draw the egg approximately where it rests in relation to that front corner, and build the diamond-shaped top plane around it by judging the distance from egg to edges. If you draw all shapes correctly, the box will never suffer from that common mistake of looking down on the top of it while looking at the sides, as you see in the top of Fig. 3-2.

Start now to study the shapes of things, not only the precise shape of an object itself, but also the shapes that flow around it. For instance, with a bowl of fruit, pay particular attention to the little dark negative shapes between the objects themselves and the interior sides of the container, as in the bottom of Fig. 3-3. (Novice artists frequently pile things in containers that could never actually accommodate them, as you see in the top of Fig. 3-3.) When drawing a very shallow bowl or platter with fruit, many students make the ellipse too circular rather than accurately making the front edge of the bowl skim across in front of the bottom of the fruit.

POSITIVE AND NEGATIVE INTERLOCKING SHAPES

It is important to understand that positive and negative shapes are interchangeable terms; a

piece of fruit is positive to a plate's negative shape, and the plate itself becomes positive in respect to the negative shapes of the table. Every shape in a painting relates to its neighboring shapes like pieces in a jigsaw puzzle. Study the positive and negative shapes in the still life in Fig. 3-4. As with some of the other illustrations in this chapter, I resorted to glued-down collage shapes to emphasize the shapeliness of things, both positive and negative. The moment you begin to be aware of interlocking shapes as you paint, your work should vault over years of slavish devotion to painting just the positive things you see.

Fig. 3-3. *Above, INCORRECT:* This wide, shallow bowl was drawn too narrow and deep. *Below, CORRECT:* The negative dark shapes around the fruit will help you draw the bowl and the fruit more accurately.

Fig. 3-4. Study the positive and negative shapes in this collage still life. Especially note how the black placemat creates negative areas for the fruit and basket, and the dark bottle is negative for the white label. All the shapes reinforce each other.

When you start the painting exercises, let the negative shapes determine the positive shapes just as easily as you instinctively, but unknowingly at first, let positive shapes dictate negative shapes.

DESIGNING ATTRACTIVE SHAPES

First must come the awareness of shapes, and then must come a new recognition: Some shapes are more pleasing to look at than others. All shapes should be interesting, varied, and even beautiful throughout a painting. That includes positive as well as negative shapes. Generally speaking, good shapes have a variety of straight and rounded contours, and if they are negative shapes in realism, they should not look like recognizable things. For example, a negative shape in a still life or landscape that accidentally looks like a derby hat, an arm, a crescent moon, or Bugs Bunny ears is something you should avoid. Even geometric shapes like a circle, square, or triangle are best changed in some way so that they are not so obvious. Look at the abstract design of the collage in Fig. 3-5A, which is filled with mostly undesirable white positive shapes. Even the negative dark areas are not much better. Positive shapes in realism will of course look like recognizable things, but let them all be as well designed as you can make them, whatever they are. Compare the shapes in Fig. 3-5A with the better shapes, both positive and negative, in Fig. 3-5B.

Design principles dictate that shapes should be varied in size; some should be large, others medium-size, and still others, little flurries of small shapes. Whether a painting is representational or abstract, variety in size and shape more likely holds the viewer's interest, subliminally if not consciously. Large shapes in particular add to our viewing comfort because they are restful areas in what might otherwise be a too-busy painting. Compare Figs. 3-5A and 3-5B again to see the difference between the size relationships of the white shapes and their consequent negative shapes.

Fig. 3-5A. *INCORRECT:* Neither the white positive shapes nor the gray negative shapes in this semiabstract illustration are visually pleasing. They are also too similar and too equally spaced.

Fig. 3-5B. *CORRECT:* This time notice the difference in sizes of both positive white shapes and negative gray ones, the stabilizing effect of the straight lines, and the variety of sizes. I've also tried to avoid shapes that look even remotely like familiar objects.

Ironically, I know of no better way to learn shape awareness in realism than to work in semiabstraction for a while. Years ago I took a painting course from a teacher who had the class paint flat shapes derived from a cluttered pile of still-life objects. It seemed like so much dreary coloring-book work. But the next time I went on location to paint, suddenly I was delighted to discover all kinds of beautiful and exciting shapes out there. The ordinary landscape elements of trees, hills, mountains, clouds, and sky looked so much fresher and clearer to me with my new shape

awareness. My landscapes leaped to a new plateau, and so did my still lifes and other subjects. Awareness of beautiful shapes will be sure to enhance your work, unless you eventually choose an impressionistic style that dissolves those shapes with many tiny brushstrokes.

SEEING INTERESTING SHAPES IN NATURE

Study the patches of blue sky amid billowing cloud shapes, the constantly changing shapes of exposed rocks and foaming water along a

Fig. 3-6A. *INCORRECT:* These trees are graphic examples, and not very much exaggerated ones at that, of some students' insensitivity to good shapes. Or are they simply being influenced by the left brain's need to make everything symmetrical and tidy? The shapes of the cast shadows are as poor as the trees.

Fig. 3-6B. *CORRECT:* These two trees not only have more interesting, asymmetrical shapes, but they overlap and create a couple of good negative shapes by so doing. Their cast shadows are also better shapes.

seacoast, the little snow blankets on heavily laden pine branches, and so on. Teach yourself about nature's endless variety of shapes by drawing them in your sketch diary at every opportunity. The more you observe, the more you will notice how rarely nature's shapes are perfectly symmetrical.

Lollipop-shaped trees are the hallmark of children and amateur painters who haven't learned to see yet. True, there are some lollipop trees in nature that are symmetrical, but in the interest of more exciting shapes, look at other trees for inspiration. Compare the collaged tree shapes in Figs. 3-6A with those in 3-6B. Any tree that leans into the wind is more dynamic than a static upright tree. Any tree with multiple trunks provides more interesting negative shapes than a simple upright tree does. Overlapping trees also are a source of interesting negative shapes, as are their cast shadows on the ground and the shapes between them. Fill your sketch diary with drawings of trees so that you have a ready catalog of good shapes to refer to when nature falls short on location some day. When you have only a brief moment to sketch, just draw the negative sky shapes between the foliage and branches of a multi-limbed tree.

It must be the left brain with its affinity for symmetry and balance that makes us all tend to round things out like the two poor tree shapes in Fig. 3-6A. Overrule it and let the creative right brain exaggerate the contours and gestures suggested by nature, even to caricaturing a bit if necessary. Give a rock more angles than rounded contours, a pear a Mae West figure, and a peach two fuzzy cheeks. Idealize for your viewer's pleasure rather than generalize. How things actually were often has little to do with good design and composition.

REARRANGING SHAPES FOR BETTER COMPOSITION

Objects in a still life or parts of a landscape often need to be rearranged on your canvas

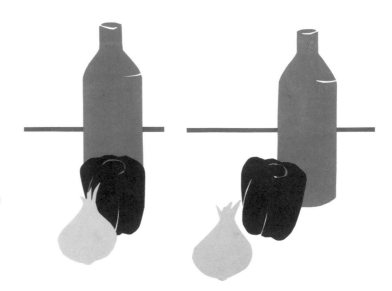

Fig. 3-7. *Left, INCORRECT:* Sometimes still-life objects will line up badly from your viewpoint, as the pepper and bottle do in this case. Without seeing the bottom of the bottle, it is impossible to know exactly where it exists in space. We do understand the spatial relationship of the onion and pepper, however. *Right, CORRECT:* By separating the pepper and bottle, we know exactly where they are in the imaginary cube of space. Moving the onion over a bit provides a negative shape, though here not a great one.

for better composition. For instance, suppose that from your viewpoint in an art class you see a green pepper precisely lined up in front of a vase so that the vase appears to be growing out of the pepper, as you see on the left in Fig. 3-7. Common sense should tell you to offset the two so they read better spatially, as they do on the right. Admittedly, seeing positive and negative shapes accurately will work best if you set up a perfect still-life composition for yourself at home and stay rooted in the most advantageous spot, drawing everything as you actually see it. Later on, when you are faced with an undesirable composition and must work imaginatively to move elements around, your home study will stand you in good stead.

CORRECTING POSITIVE SHAPES WITH NEGATIVE ONES

One of the best ways to achieve interesting positive shapes is to push into them with neighboring negative shapes. In drawing, you would change positive shapes by reaching for your eraser and changing the contour of something. Although you're not working with oil paint yet, this seems like the best place to discuss a similar principle for oil painting. Let's say that you suddenly realize that you have painted a round-as-a-ball apple in

still life, or a childlike round tree in your landscape. In oil paint the corrections are easily made by painting out parts of the apple with the adjacent tablecloth (negative shape) color, or, in the case of the tree, cutting into its outer contour with sky or other background information so that it becomes a more dynamic shape. See how the shape correction for the tree in Fig. 3-8A has been made in Fig. 3-8B, both in the contour and also its interior, to suggest breathing space around tree trunks. I have also added extra foliage to the tree's positive shape to relax it a bit more. Don't be intimidated by what you've already painted. Don't think of it as set in concrete, something not to be meddled with. Be in control; push the negative paint decisively into the positive areas, and vice versa.

Transparent watercolorists who are purists about saving the white of the paper for their light values are forced to do much of their painting negatively in order to accomplish this aim. They automatically work negatively around eggs, white daisies, clouds, and other high-value subjects. Oil painters, on the other hand, have to work consciously at negative painting because they do not have the same technical necessity for leaving the white canvas showing. A side foray into the world of watercolor later on will do wonders for your

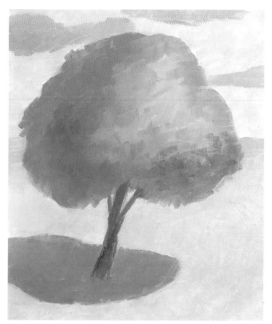

Fig. 3-8A. *INCORRECT:* This is the way a beautifully shaped tree might look by the time a student has carefully rounded it out, all the while ignoring any interior branches and sky holes.

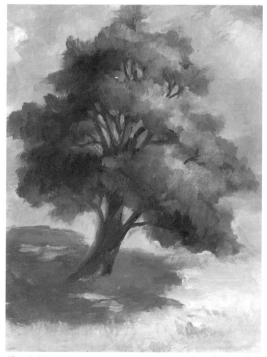

Fig. 3-8B. *CORRECT:* You can improve the shape of a tree very quickly by adding some extra foliage or subtracting it with negative paint strokes. Then try adding glimpses of trunk, branches, or twigs with positive strokes. Finally put in some sky holes with negative paint, but keep them dark enough not to pop out in value.

understanding of negative painting when you return to oils. It may also cause you to loosen up a great deal.

Negative painting in oils or acrylics—that is, cutting into positive shapes to improve them—can take place only after you have painted the positive shapes first. This is just one of the reasons why I advocate painting the subject first and then the background around it: The minute you stop painting positive things as inviolate entities and begin to correct them with vigorous negative shapes or strokes, I promise that your work will take a giant step forward. Unfortunately, negative painting does not come naturally to the logical, methodical left brain, which wants to paint only the nice symmetrical positive subjects that it recognizes. Shape awareness and negative painting are functions of the right brain, the hemisphere that is more creative and intuitive. Dr. Betty Edwards, in her book *Drawing on the Right Side of the Brain*, assures us that our right brain performs unconventional tasks brilliantly compared to the left brain, and she writes of ways to switch from one hemisphere to the other. Hers is the definitive art book on this subject and it should be in every art student's library.

Varying Edges

The continual interchange between positive and negative areas of wet paint is what makes for a good variety of "lost" and "found" edges between neighboring shapes. You don't want all hard edges throughout your painting, or all soft, blurry lost edges. A phrase I sometimes use to refer to this pushing of paint between positive and negative shapes is "destroy and recover." For instance, suppose you are painting the back edge of the table (a positive shape) in a still-life composition, and then you start to paint the wall behind it (the negative shape). Rather than leaving a laboriously painted edge between the two, soften this relatively unimportant area of the painting in some places by dragging the wall color down

right over the neatly painted hard table edge and destroy it. Then take a quick horizontal stroke or two to recover the table edge in a casual manner. That kind of edge can spell the difference between an amateur look and a professional look, so cultivate it early on in your work. Compare the handling of the table's back edge in Figs. 3-9A and 3-9B.

Another instance when the softening of edges works to advantage is in landscape. Suppose you have painted distant mountain peaks against a clear blue sky. If you're a novice painter, I'll lay odds that your mountains are too dark, too hard-edged, and contrast too sharply against the sky. They may have looked that way to you, but the painting will probably have that hard-edged amateur look. The remedy is simple: Drag some wet

Fig. 3-9A. *INCORRECT:* This round copper box with its perforations and etched lines is not the point here; the handling of the back table edge is. Someone would have to paint those edges very precisely to get them that neat, but why emphasize that unimportant area so much?

Fig. 3-9B. *CORRECT:* Here the eye can focus on the copper box because I destroyed the distracting table edge by pulling the wet background right down over it, and then restored it slightly with a casual stroke or two. This approach is what I call "destroy and recover."

Figs. 3-10A. *INCORRECT:* Even if you see distant mountains crisp-edged and very dark against the sky because of cloud shadows on them, as they appear here, they will look less amateurish the moment you pull some of the blue sky color right over them wet-in-wet and ruin that edge for a moment.

Fig. 3-10B. *CORRECT:* When you recover the mountain contours slightly here and there, as in this illustration, not only will you give the effect of more atmosphere between you and the mountaintops, but perhaps you will accidentally leave a little wisp of cloud hovering over the summit.

sky color down over the wet paint of the mountains. This will lighten their value and soften the edge at the same time. Then recover the mountain's contours with a quick stroke or two (Figs. 3-10A and 3-10B). This works best wet-in-wet, so if you want to correct an old painting, you'll have to match both mountain and sky colors first with new fresh paint in order to effect the atmospheric edge. This same principle works beautifully when you are painting a bouquet of flowers in still life. If the flowers in back of the bouquet are just as hard-edged as the front flowers, pull your background into and over the contours of the back flowers a bit and push them out of focus. This is the "Camera Principle" at work: sharp focus in front and in the middle ground, but out of focus in back.

DEVELOPING AN IMAGE ALL OVER AT THE SAME RATE

Alternately painting positive and negative shapes coincides with my conviction that the painting must be developed at the same rate all over the canvas. Don't finish any one area; move continuously around the painting, establishing all values and colors throughout. Resist the temptation to finish one still-life item before moving on to another. If you make correct color and value notations all over the canvas instead, it is easy to knit them together later on.

Many art students have come into my classes with a legacy from some previous teacher who taught them to "pull down the shade," that is, to start at the top of the canvas and work systematically across and down to the bottom, ending with a more or less finished painting. This means putting in the background of all paintings first and then working forward, so that the foreground goes in last. It is far better to make color and value notations in all areas of the canvas while in the presence of the subject. Think of Cézanne, who left countless unfinished watercolors and oils with color notes sufficient to suggest the whole landscape or still life.

As you draw (or later paint), play with shapes all over your paper or canvas. Be constantly aware of how the positive and negative shapes interact, as if they are engaged in a visual tug-of-war that continues until you decide the painting is finished.

Drawing Assignments

1. Trace five paintings in art magazines or art books, drawing the four border lines first, and then outlining each shape, mass, or value that you can see. If possible, close every shape within the format—that is, let every line meet another line or the edge of the format so that every shape is complete. When you are finished, you should have something that looks like a jigsaw puzzle with interlocking shapes. Now label obvious positive shapes with a P and obvious negatives shapes with an N. Analyze your five tracings. Look for interesting versus boring shapes, symmetrical versus asymmetrical ones, instantly recognizable shapes and more abstract ones.

2. Do a skyscape on a partly cloudy day. With pencil or charcoal, draw cloud shapes and then shade in all blue sky shapes between the clouds with the side of your drawing tool until you end up with a two-value design: gray sky areas and white clouds. Then indicate on your clouds some additional shading to give an indication of their shaded bottoms. Check to see whether they overlap properly. Do they tuck behind one another as they move from the top of the canvas down toward the horizon line?

Chapter 4
UNDERSTANDING VALUES

Anxious though you might be to begin expressing the world in color, slow down and learn about one of color's primary characteristics: value. To plunge into color before you can first recognize everything's proper value is to build on a shaky foundation. And what exactly are values? They are the degree of lightness or darkness of things relative to the extremes of white and black. An egg, a white onion, clouds, and the foam of the sea are high values close to white; lemons, oranges, and bananas are a little lower in value; tomatoes, potatoes, green peppers, and red roses average out to middle values. Plums and black grapes are dark, but not as dark as an eggplant. Fig. 4-1 shows how such things fall roughly into the high, middle, or low value ranges of a graduated scale between white and black. That broad classification doesn't include small things like the shiny highlights on the tomato and eggplant, the dark accents in the onion's roots, or the eyes of the potato. Those small extra light and dark factors are common to many subjects.

Fig. 4-1. Here is how various kinds of produce fall into the high, middle, and dark ranges of the value scale. Even if you choose the proper colors with which to paint these items, it wouldn't do to have the wrong values for them. A dark gray egg, brown lemon, pastel green pepper, or lavender eggplant simply wouldn't work in terms of realism.

The easiest way to learn to see values, or tones—either term is correct—is to forget about color for a while and just work with black and white and the scale of grays in between. Although this book is addressed to oil painters, the basic tonal principles set forth in these next few chapters are applicable to all mediums and will unfailingly express the three-dimensional world on your two-dimensional surface, providing your values are right. Artists have known and used these principles since the Renaissance. Careful study of the masters' drawings and paintings reveals the same conventions in rendering light and shade to achieve the illusion of volume that today's finest representational artists use, with perhaps minor personal or semantic variations.

THE OLD MASTER APPROACH

Prior to the eighteenth century, the basics of drawing and painting were learned through years of apprenticeship to a master, sometimes from childhood to young manhood. In those days color was traditionally applied with many transparent layers (glazes) over a thoroughly dry grisaille underpainting. *Grisaille* (gree-zai) is derived from *gris*, the French word for gray, and it refers to a complete underpainting in tones of black, white, and gray. For generations of artists, value and color applications were two distinctly separate stages in the execution of paintings. The combined color and value approach that most artists have favored since about the middle of the nineteenth century is called *alla prima*, an Italian phrase that means (in its broadest interpretation) all at once, or in one layer. Though few artists manage to say what they want to say in one go at the canvas, it is still the prevailing mode of painting today.

VALUE SPEAKS MORE LOUDLY THAN COLOR

I cannot emphasize enough the importance of learning to see values correctly first, and then setting them down as accurately as possible in your drawing or painting. We comprehend black-and-white television, or look at news photos in newspapers, understanding them perfectly well because their values are right. Once you have mastered a subject in black, gray, and white values, translating them into colored values is the next step. While artists frequently exaggerate and take license with color, values can hardly ever be tampered with successfully in representational art.

NATURE'S VALUE RANGE

In our physical world, the infinite brilliance of the sun and the deep recesses of the earth are maximums of light and darkness far greater than we can achieve with man-made pigments. It isn't even possible to illustrate this phenomenon of light using only the white of the printed page and black printing ink, which, incidentally, is viewed with light falling on it. (A true black, I once read, is what you see if you peer closely into a tiny aperture in a black velvet-lined box with a hood over your head.) While there are an infinite number of gray tones between the extremes of the lightest light and the darkest dark in nature, we are forced to work with a limited number of value steps between white and black, and that limitation depends on the medium you are working with. The darkest value you can achieve with a pencil is nowhere near as dark as the blackest black in oil paint. The white of drawing or watercolor paper may not be as white as the brilliant opaque whites of oils, alkyds, or acrylics.

THE NINE-STEP VALUE SCALE

Throughout this book I will use a nine-step value scale with white as #1, black as #9, and with seven gray steps in between, as shown in Fig. 4-2A. An odd number of steps works well because it provides a clear #5 middle tone in the center with an equal number of steps up to white and down to black. All references to value numbers in this book will be based on

Fig. 4-2A. *Right:* The numbers of this nine-step value scale will be referred to throughout the book.

Fig. 4-2B. *Far right:* The Munsell Value Scale has eleven steps; white is designated #10 and black #0, with nine steps in between.

this nine-step scale, with occasional mention of half- or even quarter-steps between the nine major steps. Some teachers advocate a five-step value scale, or even just three major values for the beginning artist, but regardless of how few or how many you start with, they inevitably result in more values when blended into each other.

THE MUNSELL VALUE SCALE

You should also become familiar with the Munsell value scale shown in Fig. 4-2B. Most paint manufacturers use it to designate the value of each color in their series of paints. The Munsell scale reverses the numbering system so that white is #10 and black is #0, accounting for eleven value steps altogether. The theory behind reversing the numbers is that white reflects 100 percent of the available light and black reflects none, thus rating a zero. Logically, then, any middle tone reflects approximately 50 percent of the available light. In the printing trade, all values and colors are referred to as having "reflectance" of a certain percentage. In practice, though, as I mentioned before, neither 100 percent reflectance nor 0 percent reflectance is quite attainable in artists' pigments. A tube of Liquitex titanium white has a value of Munsell 9.5, while ivory black is numbered 0.2. The Munsell numbering system uses precise decimals to describe ultramarine blue's value as 0.6, that is, not quite as dark as the ivory black, while a cadmium yellow medium is an 8.1, almost one and one-half steps below white. This information is printed on all Liquitex (Binney & Smith) tubes of paint, and other paint companies are following suit.

VALUES AND AVAILABLE LIGHT

All values, no matter whether black and white (achromatic) or colored (chromatic), are the result of the existing light. If the light is dimmed or brightened, the values change. Therefore, it isn't possible to say that lemons are always a #2 light yellow on our standard nine-step value scale, grass is always a #4 green, or all cast shadows are a #7 value. There are no formulas of this kind, thank goodness, or there would be too much memory work involved in learning to paint. Instead, drawing and painting are all about learning to recognize values under the prevailing illumination, how they relate to other values around them, and how they relate to the value scale. As you do the black, white, and gray painting assignments in Part One, work to get a good grip on what #5 middle tone looks like. Match yours frequently to the middle values in the two value scales shown here until you are thoroughly familiar with #5. It will help you judge all other values relative to it forevermore. Some artists work with a glass palette painted on the reverse side with a #5 neutral gray for that purpose.

If I were to invent something helpful for art students, it would be a pair of magic glasses that would filter out all color, allowing the wearer to see only achromatic values. Without them, however, the only alternative is to squint your eyes while studying subjects. Squinting cuts down color somewhat and allows you to see relative values more clearly. If you find it difficult to squint, roll your fingers into a little telescope and peer through that. Also, if you wear glasses, it may help to remove them. Lacking the ability to focus on detail, your eyes will see things as simplified masses of value and color. Get in the habit of carrying on a silent dialogue with yourself, in reflective moments, about which of several objects in your view is the lightest or the darkest. The further you get into color, the more fiercely determined you must be to see all things in terms of their relative values first . . . that is, providing your goal is to give the illusion of three dimensions on your paper or canvas.

THE TEN USES OF VALUE

Representational artists use the range of values to achieve a variety of effects in their work. Here are ten of the most important:

1. *Achieving Gradation.* Light is clearly lighter and more intense close to a light source such as a light bulb or the sun. It gradually diminishes until it fades into darkness some distance away. Natural daylight filtering through a window gradually loses its strength as it wanders into the corners of a room. These are logical and observable phenomena. Start looking, *really* looking, at floor, wall, and ceiling surfaces in your home, office, or studio to see the subtle gradations that play across them as one light source fades and another light picks up where the other one left off. Lampshades, on the other hand, cast shadows and create pools of specific light on tables, walls, and ceiling surfaces, as shown in Fig. 4-3.

Now look specifically at the top of a table or desk with a lamp near it and notice how the light diminishes from one side of the table to the other, and also from the front of the table to the back of it, as in Fig. 4-4. Photographs taken of a lighted horizontal surface pick up this gradation beautifully. Gradation across any plane is indeed a fact of life and light, and I deem it worthy of a good deal of effort to achieve some sense of this passage of light. If you achieve it in your still-life exercises, it will help later on when you are painting outdoors where such gradations are negligible. Because the sun's enormous candlepower sheds its light more evenly over the landscape, gradation away from the light is, in fact, a myth. Nevertheless, flat, unvarying areas that look as though they were painted with a roller simply do not exist in nature. Such flat boring areas effectively deny the existence of a specific light source, and for most representational artists it is light that excites, inspires, and motivates them to spend their whole lives trying to interpret nature's incredible beauty. Use gradation toward or away from light as one of your most powerful tools, even outdoors.

2. *Modeling Forms.* A sculptor models clay with his hands or on a wheel to make

Fig. 4-3. Notice the relatively abrupt changes of value between the circles of light and shadowed areas caused by lampshades. The edges between the light and shade become progressively softer with increasing distance from the light source.

Fig. 4-4. The direct light of the clamp-on lamp causes tonal gradations on both the wall plane and the flat table plane. Light progressively diminishes as it moves away from its source.

volumetric forms, but a painter has only changing values and perspective to create the illusion of three-dimensional form. This turning of forms into the third dimension could be called gradation too, but it is more forceful than the gentle gradation of close values on a lighted plane. *Modeling* or *modulation* are better words for this emphatic shift of values from light to shadow. The illusion of depth is achieved because light values are aggressive and appear to come forward toward the viewer, while dark values appear to recede away from the viewer.

The following sequence of values has been used since the Renaissance to describe light and shade on solid volumes:

- **highlight**
- **light**
- **middle tone**
- **dark**
- **reflected light**

From here on, I have deliberately set off these five major light and shade phenomena in boldface in order to distinguish them from casual references to things like a light source, a middle-tone blue, or a dark corner.

Just three values—**light**, **middle tone**, and **dark**—will model forms sufficiently but crudely, as in Fig. 4-5 (left). When the three values are blended slightly, the resulting five or so values achieve a more convincing roundness (center). If the cylinder is shiny, a higher-value **highlight** is needed. **Reflected light** on the right-hand edge of that cylinder is light that has bounced back into the dark shadow from nearby light-struck objects or planes, making yet another value change (right). Note that the first four light factors listed above are in descending order, but **reflected light** breaks that sequence because

it is always slightly lighter than **dark** and goes up the value scale a notch, perhaps a half step or even a whole step.

Highlight, **light**, **middle tone**, **dark**, and **reflected light** are the backbone of this book, and everything relating to color and value on three-dimensional objects will be an embellishment of this basic formula. Once you learn to use it to model forms with controlled values, you are on the way to realism.

Again, it is impossible to assign value numbers to the five light and shadow factors listed above, since they spring from the actual (local) value of each object under consideration. Remember the egg, tomato, eggplant, and other produce in Fig. 4-1 when considering something's range of values. From now on, **middle tone** and local tone are synonymous terms in all of Part One. **Middle tone** is the jumping-off place for modeling all forms from light to dark.

3. *Providing Contrast.* Notice the gray stripe that runs along the horizontal value scale in Fig. 4-6, particularly how it gradates from darker on the left to lighter on the right. It is, believe it or not, a strip of a single #5 value.

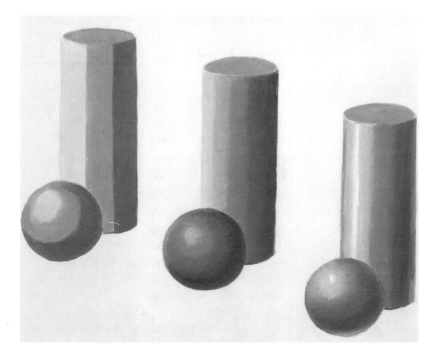

Fig. 4-5. *Left*: A crude and faceted modeling of a cylinder and sphere with only three values, **light, middle tone**, and **dark**. *Center:* The three major values are blended here into at least five tones on the cylinder and sphere. *Right:* Full modeling of the two forms with seven changes of value include **highlight** (in the middle of the **light** area) and **reflected light**. A subtle refinement, **reflected light** helps convey a greater sense of solidity.

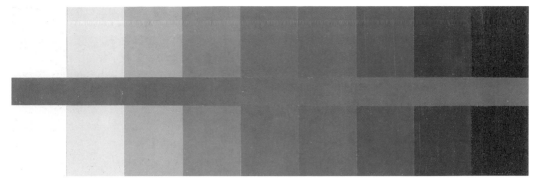

Fig. 4-6. This value scale has a strip of #5 gray superimposed on it to show simultaneous contrast. The gradation from light to dark on the strip is an optical illusion, as is the fluted effect of each value appearing lighter next to its darker neighbor and darker next to its lighter neighbor.

Fig. 4-7. Values become progressively lighter on each plane as it recedes into the distance due to the intervening atmosphere. A further nuance is the slightly lighter value at the ground level of each range, where pollution is denser.

Because of a phenomenon called simultaneous contrast, it appears darker in contrast with the light values, and lighter in contrast with the dark values of the scale. You may also see this happening in the "fluted" effect between steps of the value scale itself. Each single value appears darker on the left and lighter on the right as it contrasts with its neighboring value (provided the value steps touch). The important point here is that if you want to make something appear lighter for a certain effect, put something darker around it, and vice versa.

4. *Establishing Aerial Perspective.* Simply stated, aerial perspective is the gradual diminishing of value (and color) contrasts from the front of a painting to the implied distance in the back. The foreground of a landscape may contain the whole gamut of values. Moving back into the middle distance, values tend to lose their upper and lower registers and hover in the middle range of the value scale, from about #4 to #6. Far distance is achieved by moving up higher on the value scale and keeping all values close, as in Fig. 4-7. Haven't we all marveled at the beauty of multiple mountain ranges falling back in space, each one lighter than the one before it because of the intervening atmosphere? Chapter 19 is all about aerial perspective, the recession of colors as well as values.

5. *Providing "Readability."* This is related somewhat to the use of value contrasts for striking effects in item 3 above, but this is more subtle, often just a small arbitrary shift in values. In nature, values are often nearly indistinguishable from one another, especially on a gray, overcast day. For example, imagine that in Fig. 4-8, the tree is in front of a house of the same color and value, and it is a gray day. Besides those close value problems, there is a second part of the house in the background, and all are surrounded by grass of the same value as everything else. It would be bad enough in color, but in black and white achromatic values only, explaining just what is going on calls for arbitrary value shifts from one area to another. In real life our eyes accept such close relationships and understand the space and volumes that separate them, but on the two-dimensional picture plane, you will often have to make things read distinctly by a change in values here and there to help the viewer out.

6. *Achieving Balance.* Dark values have visual weight in a drawing or painting. If there are a lot of dark #7, #8, and #9 values on one side of a composition and none on the other, a painting can appear to hang askew on the wall. Even if Fig. 4-9A shows how the values actually were for this lakeshore scene, its values are woefully out of balance. But balance does not imply perfect symmetry; in fact, preferably the distribution of values will not be the same on both sides of a painting.

A large area of middle tone can balance a smaller area of dark values on the other side. A small isolated area of dark value surrounded by light values will have visual weight equal to a larger mass of middle or dark values on the opposite side. This is called steelyard balance, named after a scale in which a large weight on the short end of a suspended bar is balanced by a small weight on the longer end of the bar. The small island added on the right side of Fig. 4-9B provides an example of steelyard balance, though the darker clouds on that side help too.

Fig. 4-8. When values are very close together, as they tend to be on a gray day, we sometimes have to make arbitrary value adjustments in order to separate forms and planes so they make better sense to the viewer. The X's mark several such spots that have nothing to do with light source and shadow.

Fig. 4-9A. It would have been tempting to print this picture askew so that the weight of its dark values on the left would be felt more graphically.

Fig. 4-9B. Shoreline scenes always tend to be out of balance with heavy values on one side, so look for ways to compensate on the opposite side. Here dark cloud shadows and troughs in the water do the job.

7. *Establishing (Keying) a Mood.* If you were composing lighthearted, happy music, would you use a lively tempo and a major key, or a slow tempo and a minor key? Obviously, the former would be more appropriate. In a similar way, high-key paintings with a lot of pastel values convey a lighthearted, cheerful mood, while low-key paintings in the lower value range convey a somber, depressing mood. It would be a folly to attempt to paint children playing in a sunny park in predominantly dark values of #7, #8, and #9 or, conversely, to paint a deathbed scene, a derelict, or the horrors of war in pastel values of #1 through #4.

In regard to weather, a foggy, rainy or snowy day calls for fractionally close values and muted colors, such as the minor-key painting in Fig. 4-10A. On the other hand, a bright, sunny day demands a lot of value contrasts and bright colors. The painting in Fig. 4-10B would therefore be a major-key painting, assuming the colors were as forceful as the values.

Fig. 4-10A. Foggy, rainy, and snowy weather cause all values to blur together toward the middle of the value scale. The denser the fog, rain, and snow become, the closer the values become.

Fig. 4-10B. Between the sunstruck areas on a sunny day and their accompanying shadows, a lot of value contrast exists in a landscape, just the opposite of the foggy effect. How you "spend" your values is critical in setting the mood of your painting.

Fig. 4-11. Note the movement from the right foreground through the tree masses to the far hill and then the return to the left front of the landscape. You can enter via the road and reverse your course, but nowhere is the eye allowed to escape; the sequence of values keeps it in.

8. *Creating Eye Movement.* A gradation from light to dark values will move the eye automatically from point A to point B, and from thence on to point C. Even a sequence of values that is not entirely connected will cause the eye to leap the intervals in between. This is frequently referred to as closure. Analyze how values influence the way your eyes scan the scene in Fig. 4-11.

Conversely, values must be controlled carefully so that they won't lead the eye out of the picture, an inexcusable error in composition. Strong value contrasts on the frame edges of the painting can attract attention unduly, as can light values in the corners. A very slight shading (or muting of colors) in the corners is all it takes to keep the eye circulating within the painting.

9. *Establishing Emphasis.* An essential ingredient in good composition is setting up one area to be more important than the rest, a center of interest. There is an adage in art tradition that says if you want your viewer to look at a certain place, put your lightest light, your darkest dark, and your brightest color there. According to item 4 above, that would always be in the foreground, where maximum contrasts belong. However, since the center of interest is usually and most comfortably in the middle distance of a landscape, as it is in Fig. 4-12, this rule contradicts the earlier one. With experience you'll learn when to break that rule to advantage by diminishing the importance of the less interesting foreground, often throwing it in cloud shadow, so that you can give value (and color) emphasis on the center of interest

Fig. 4-12. The light mountain peak just left of center in the middle ground becomes the focal point in this scene because of the greater contrast of values there than in any other area.

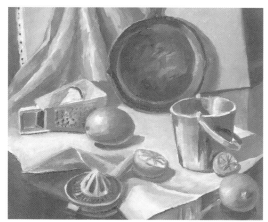

Fig. 4-13A. In realism, the modeling of forms and their cast shadows tends to break up areas with many little value shifts, and as a result, the painting looks too busy, too confusing.

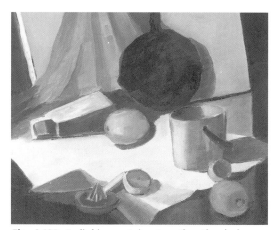

Fig. 4-13B. By linking or tying together the dark shapes around the perimeter of the canvas on three sides, as well as some of the shadow shapes, a simpler, all-over value statement is achieved. However, the "arrow" of contrasting light and dark values in the upper left corner shoots the eye up and out of the picture—a flaw in design. Reducing the values in that unimportant area would ensure an easier visual path through the grater and around the composition.

farther back in the composition. Be careful where you shoot your "big guns," your lightest light and darkest dark values (and later on, bright colors). Make them count for something special when you use them.

10. *Organizing an Underlying Abstract Pattern.* If we faithfully reproduce every single value change we see in the physical world, our paintings are apt to become a busy jumble of shifting lights, middle tones, and darks, as exemplified in Fig. 4-13A. The effect is a busy confusion bordering on chaos. The professional artist has learned to simplify the overall big pattern of light, middle-tone, and dark values in the painting, connecting the light areas wherever possible, and even more carefully linking the darks together. The middle tones simply act as transition areas. Compare Figs. 4-13A and 4-13B. The latter is almost semi-abstract in its bold pattern of values.

A painting with a strong light and dark pattern will have an impact on the viewer from a greater distance than one that has to be scrutinized close up because of finicky detail and minute value changes. One could say that a good painting will read as well from 30 feet as it does from 3 feet. Without that organized pattern of values, it will fall apart and be unreadable from even a little distance. This underlying abstract value pattern in any painting, no matter whether it is representational or abstract, is one of the criteria that judges of juried exhibits usually look for when selecting entries.

Please review the ten functions of values listed above and note that four of them— gradation, modeling forms, contrast, and aerial perspective—are observable facts about the visual world. The remaining six are devices used by experienced artists to lift their work beyond simply reporting what they see. These tricks of the trade can be learned from good teachers, from the study of art books and magazines, and from careful analysis of works in galleries and museums.

Drawing Assignments

1. Search for photographs in magazines that illustrate good use of values in the ten functions listed above. If you are serious about your art, subscribe to one or two art magazines and clip articles of similar interest. Use an X-Acto or similar type of blade to slice neatly, rather than cut or tear, pictures and articles for your files. The files will serve as reference material and inspiration in the future, but never as a source for copying. All published materials are protected by copyright, and it is blatant plagiarism to copy from anything but your own photographs.

2. Find several newspaper photographs with simple shapes and strong values and, using tracing paper, trace the major shapes. Then try to simplify all values into three major tones, the lights, middle tones, and darks. Leave all the light shapes as the white of the paper, and then use the side of your soft lead pencil to get evenly shaded middle-tone and dark values. Absolutely ignore subject matter, and concentrate on shapes and values so that your drawings will be quite abstract. You can do this more easily by copying the photographs upside down so that the subjects are not distracting. When you have finished three drawings, analyze which of them has the strongest light/middle tone/dark value pattern. Improve them by linking up the lightest lights and the darkest darks a little more so they flow throughout the composition.

Chapter 5

TRANSLATING VALUES INTO LIGHT AND SHADOW

For the beginning representational painter, the most important of the ten functions of values listed in the preceding chapter is the modeling of forms to achieve the illusion of three-dimensionality. Light and shadow are how we perceive the volume of objects. It's not enough to see shapes clearly; their volume must also be expressed if we are to create a convincing illusion of three dimensions on two-dimensional paper or canvas.

Chiaroscuro is the traditional word to describe the modeling of forms in terms of light and shadow. (The word comes from the Italian *chiaro*, meaning clear or light, and *oscuro*, meaning obscure or dark.) You may come across terminology like sculptural or

plastic form, or of painting in relief mode, all of which refer to the same thing. In the classroom I speak of modeling with light and shade simply as "turning the form." Modeling is necessary to create the illusion of volume on a two-dimensional surface, and achieving it takes practice. It is one thing if flattening forms is a stylistic mannerism of an artist such as Gauguin or Modigliani, but it's another matter when such sophistication is clearly not the intent of the novice artist.

Given a single light source, the formula for achieving good solid volumes given on page 68 will work every time on any subject, providing the values are right. Note that Figs. 6-2 and 6-6 in the next chapter contain letters

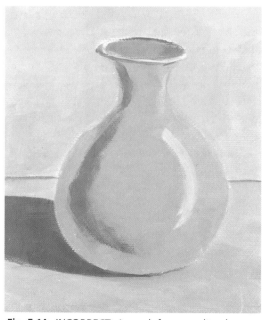

Fig. 5-1A. *INCORRECT*: A weak form results when an object is painted with one flat tone first and then light and dark streaks are added in an effort to give the illusion of volume.

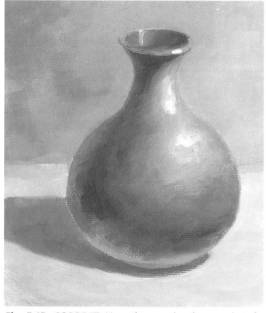

Fig. 5-1B. *CORRECT*: Here the vase has been painted with a succession of different values set down decisively and cleanly right from the start, resulting in a solid-looking volume.

Fig. 5-2. Many forms are based on the sphere, as represented here by the tennis ball. All are modeled the same way with values, even though they have unique variations. The peach has two "cheeks," the orange has an irregular contour with straight and curved areas, and the tomato is flat on top and has several subforms.

that represent the form-building formula: HL for **highlight**, L for **light**, M for **middle tone**, D for **dark** (form shadow), and RL for **reflected light**. These five phenomena of light and shade on forms will appear in boldface type throughout the book to distinguish them from casual references to other light and dark things, colors, or values. **Light** will always refer to that part of an object that faces the light directly; **dark** will always refer to the form shadow on objects where no direct light can reach. **Reflected light** will refer specifically to light that bounces back into the **dark** side of forms. "Reflected light," however, can bounce into any other area, including cast shadows.

The form-building formula works best when the values are set down cleanly side-by-side right from the start. Many oil painting students are taught to paint flat shapes first, followed by token light and dark strokes into the wet paint to give a semblance of volume. The results of such modeling are feeble indeed. The wet paint pulls the **light** down and lifts the **dark** up so that the light and shadow effect is indiscernible, as in Fig. 5-1A. To avoid this problem, try to change value with every stroke of the brush, at least on rounded forms, as in Fig. 5-1B. Notice the difference between Fig. 5-1A and 1B.

Don't even allow yourself to think flat when you practice the still-life exercises in this book. Instead, think three-dimensionally right from the start. Take a moment to hold a round object, preferably an orange, in your hand and close your eyes. Feel its roundness first, but then explore every irregular bump and hollow that keeps it from being a perfect sphere. Your hands and fingers will feel the weight, volume, texture, and irregularities of the object better than your eyes can perceive. The three-dimensionality of a form is often destroyed visually by many light sources bombarding it from all sides. Because of this, beginning art students not only tend to flatten forms when painting them, but they are also likely to round off every spherical object into a perfectly symmetrical ball. In Fig. 5-2, note how the peach, orange, and tomato each departs in its unique way from the symmetry of a pure sphere, as represented here by the tennis ball, yet all are variations of the sphere and are modeled accordingly.

SEEING PLANES OF LIGHT AND SHADE
When doing painting demonstrations of still-life setups, I tell my students emphatically, "Turn the form first." Set each value down in a sequence to represent **highlight** (if the object

is shiny), **light**, **middle tone**, **dark**, and **reflected light** planes on the forms. I always start in the middle of the form with the object's "local" tone or color, and go up to **light** and down to **dark** from there.

One thing that keeps students from seeing solid forms is pattern of any sort on an object. Painting a basket is a classic case. Compare the two baskets in Fig. 5-3. After all, the weave on a basket or the drips of glaze on a pottery vase are easy to see, but the changes of value from **light** to **dark** are not. Only after the form is convincing should you suggest the pattern on any piece, making sure the pattern conforms to the modeling.

I encourage students to over-model forms in the beginning lessons, that is, to exaggerate the effects of light and shadow on volumes.

Fig. 5-3. *Left, INCORRECT*: Many beginners will paint a basket this way, as a flat shape with a linear pattern, rather than as a volume affected by light and shade. *Right, CORRECT*: Even though the individual willow strips appear to weave as they traverse the bumps and hollows on their way from **light** to **dark**, any such detail is subordinate to the whole form.

Fig. 5-4A. *INCORRECT*: Even with a direct light source in a classroom, students tend to be timid about modeling forms, keeping values much too close, as they are here.

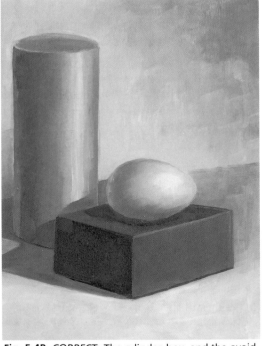

Fig. 5-4B. *CORRECT*: The cylinder, box, and the ovoid form of the egg have more substance as the result of a wider spread of values. The light also appears to be brighter here.

Fig. 5-5. This small faceted vase helps us see that one plane, the **highlight**, directly faces a light on the right/front side, while the surrounding planes receive slightly less light and constitute the **light** areas. **Middle tone** planes are next, and then finally the **dark** planes, which receive no direct light. **Reflected light** planes are on the back edge of the form.

Compare the weak values in Fig. 5-4A with the more forceful modeling of the forms in 4B. While it is easy to see separate planes and values on square objects, it is not always so easy on round things. Perhaps it will help to think of round objects as having hundreds of tiny planes. The planes closest to the light source will receive the most light, and each succeeding plane will receive less and less as it moves into the **dark** shadow. The little faceted vase in Fig. 5-5 illustrates this idea quite well. Notice the slanted plane behind the vase, and how the vase's cast shadow bends when it leaves the flat table plane and moves up the slanted plane in the background.

Short strokes set down decisively in an Impressionist manner are far more descriptive of tiny planes on rounded forms than are blended, smeary passages. With every brushstroke you make, turn that form from light into shadow with different values, and then gently knit the strokes together. Use your no. 6 or no. 7 bright brush to "chunk" in those values as if they were tiny planes. Then leave them that way—don't mop them into a flat, boring shape.

STUDYING LIGHT AND SHADOW WITH A SINGLE LIGHT SOURCE

Modeling forms according to the formula is easiest under controlled lighting conditions. This means using one light source, preferably a 75-watt flood bulb (not a spotlight), clamped to something so that the light is directed toward the subject you are going to study.

No matter what type of lamp you use for your still-life setups, think of it as the primary light source. A single light is not only essential to see the values on forms, but it unifies the painting as well. When lights strike a subject from several sides, each light source casts shadows in different directions; the effect is one of busy confusion. A single light organizes all that information into a logical order.

Turn off all lights in the room except for the primary lamp, and close the window shades. If you can't control the light during the daytime, wait until nightfall for this important first observation of ideal light and shadow.

Select six or seven objects of different sizes and textures and arrange them casually on a table. Suggested household items: a wine bottle, a bowl, an egg, an apple or tomato, a

cauliflower or pineapple, a cracker box or book. If possible, arrange them on a white tablecloth or napkin. Position your lamp at a 45-degree angle on either the left or right side of the table, and slightly toward the front of the still life. If you are using a card table, a floor lamp could be positioned just off one of the front corners; a music stand or a camera tripod would make good holders for a clamp-type lamp. Pull up a chair squarely in front of the table and look closely at the setup, observing the various factors of the form-building formula. Concentrate absolutely on values rather than color at this point.

Highlight

This is always the lightest value on the object, and indeed, often the lightest value in the whole painting. **Highlights** occur only on glossy or semiglossy surfaces. When you begin to draw and paint the exercises at the end of

each chapter, you should draw a circle around the white spots you intend to reserve for **highlights**. On shiny surfaces like a polished apple or a tomato, they will be a #1 or #1.5 on the value scale, and quite sharp-edged.

Highlights are actually tiny mirror reflections of the light source and the technical name for them is *specular reflections*. You may be able to see the actual bulb of the lamp miniaturized in the **highlight,** as in Fig. 5-6A. When daylight from the windows is the primary source of light, the windowpanes will be visible in the **highlight**, as you see in Fig. 5-6B. Frequently both types of highlights will appear on a form, as well as those from overhead lights in the room. In your early painting lessons, sort them all out and include only the **highlights** that result from the primary light source.

Highlights are usually small, specific shapes and are in predictable, logical places.

Fig. 5-6A. The **highlight**, a specular reflection of the primary light source, shows clearly on this vase. You can almost make out the shape of the light bulb itself.

Fig. 5-6B. The light coming through windows is the primary source of light here. You can see the shape and number of the windows in the specular reflection of the **highlight**. If working in daylight and using a lamp, you will probably see both kinds of **highlights** on shiny objects. Choose one light as your primary source and ignore the other for the time being.

Fig. 5-7. Highlights always occur where there are significant changes of planes. Peppers, tomatoes, and bottles are obviously shiny and all have "shoulders" to some degree. Because the box has a **highlight** on its front edge, we know that it, too, is somewhat shiny.

On rounded objects, they are always at the part of the form closest to the light source. From that sparkling point, round forms turn continuously and rapidly away from the light. It is therefore a grievous mistake to make **highlights** too large. However, the faceted vase in Fig. 5-5 is an exception to that rule, because the size of the facets dictated the size of the **highlight**.

On more complex shapes, **highlights** mark changes of planes. Bottles always have sloping shoulders; a tomato, apple, or pepper will have **highlights** on the ellipse where the planes change from their horizontal "shoulders" to their vertical sides. Note the **highlights** on the neck and ellipse of the bottle in Fig. 5-7, as well as the **highlights** on the pepper, tomato, and box. **Highlights** on cubes appear only on the sharp edges where the planes change from one to another. If you think you see **highlights** in the middle of flat planes, look again, because they are probably reflections of something nearby and not true specular reflections.

Highlights will be rather sharp-edged on a smooth, shiny tomato, soft-edged and textured on a rough-skinned orange, and nonexistent on a fuzzy peach or tennis ball. Therefore **highlights**, or the lack of them, give textural definition to all forms. On the human face, **highlights** that are improperly placed or wrong in size and shape will diminish your subject's likeness. **Highlights** give the eyes life and sparkle; the nose, shape and projection; and the lips, form and texture.

In all cases, **highlights** give critical information. Keep in mind that in a classroom situation, or in your home studio without controlled lighting, you will see all kinds of highlights in the wrong places. Learn to ignore them, and paint the logic of light as it comes from a single, direct source.

Light

Not to be confused with **highlight**, this is the larger area that faces the lamp on all light-struck objects. Both **highlight** and **light** face the light source, but the former is specific textural information, and the latter is general. If an object is shiny, the **highlight** will "sit" in the middle of the **light** area and nowhere else. To see this for yourself, study an egg carefully under the light, noting that it has a matte surface and therefore lacks a true **highlight**.

Then wet the egg with a few drops of water, and the **highlight** will appear in the middle of the **light** area. Fig. 5-8 shows the difference between a dry egg and a wet one.

Once you grasp the relationship of **light** to **highlight**, you shouldn't make the all-too-common error of placing **highlight** casually between **light** and **middle tone,** or worse, in the **middle tone** itself. I grant that you might see highlights there, reflections from overhead ceiling lights or from windows, but please

recognize them as conflicting information and edit them out. They won't help the modeling of forms one bit. Another error that shows up in classroom work is an enormous blotch of #1 value that's as large as the **light** area should be, but which the student assures me is the **highlight**. Having obliterated the normal **light** area, the **highlight** blotch meets **middle tone**, an unnatural relationship on a rounded form. Compare the onions in Figs. 5-9A and 9B.

Fig. 5-8. To learn where a **highlight** will appear, compare these two eggs. The one at left is dry and naturally matte, and has only a **light** area where it faces the lamp. When you wet the egg, as at right, a **highlight** appears in the middle of the **light** area, the logical place for it, not next to or in **middle tone**.

Fig. 5-9A. *INCORRECT*: The **highlight** on this onion is so large that it takes over the whole **light** area.

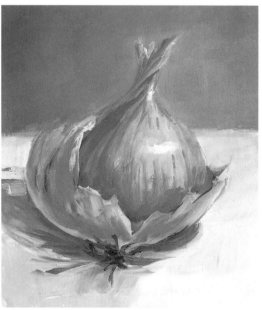

Fig. 5-9B. *CORRECT*: This **highlight** is small in the middle of the **light** area and follows the underlying structural ellipse.

Fig. 5-10. A cauliflower is a typical compound subject—one with many parts. Each small floret is modeled carefully in the **middle tone** area, where the texture of anything is most obvious. Notice the majority of light values in the **light** area, and dark values in the **dark** area. These are what make the whole form read as a volume.

Be crystal clear in your mind that **highlight** and **light** are two separate phenomena that have to do primarily with the textures of objects. Given a direct light source, there will always be a **light** area on every object, but not necessarily a **highlight**.

Middle tone

This is the area of any object halfway between **light** and **dark**, and is called half-light or half-tone. It is the actual, or local, value of the object. The best way to see pure local tones is in the ambient light of a heavily overcast day. Study your still-life objects indoors on such a day without turning the lamp on. You will see a lot of **middle tone** and only minimum changes of value on the forms.

The moment you turn a direct primary light on your selected objects, the **middle tone**, or local value, becomes much less prominent, but it is nonetheless important, especially on rounded forms. Without that **middle tone**, the **light** would meet the **dark** too abruptly and you would have a boxy-looking form rather than the rounded one you intended. When you realize that you have been overzealous in modeling forms and have lost the local tone, go back and restate it. Preserve its integrity in each element of your painting.

Does **middle tone** exist anywhere else on volumes other than between **light** and **dark**? Yes, according to the classic four basic forms shown with ideal side/front lighting in chapter 1. Notice that **middle tone** runs along the edges of the rounded forms on the side toward the lamp. Now try moving your lamp to the side of your still-life objects. You'll see that with a raking side light, **light** goes right to the edge of each form. However, when the **light** area outlines the edges of volumes, it tends to flatten them out. Instead, make the form a little rounder by adding one more change of value next to the **light** area, putting a **middle tone** on the edge toward the light.

The texture of an object is most obvious in its **middle tone** areas. For example, a pineapple, a cauliflower, a rough rock, or a tree trunk will appear bumpiest in the **middle tone**. Study the cauliflower in Fig. 5-10. Texture is less obvious in the **light** and **dark** areas because of the sidelong perspective in which we view the bumps and hollows. In the rough bark of a tree trunk, the ridges meld together in the **light** and **dark** areas, but in the **middle tone**, every ridge and hollow would be revealed sharply. Think of a rough object this way: The **middle tone** may contain minor light, medium, and dark values,

but they should not interfere with the major turning of the **light**, **middle tone**, and **dark** of the whole form. If you paint texture without form, you are flattening the object. Model the form first, then add the texture.

Dark

Also called the form shadow, this is the part of an object that receives no light from the primary light source. What value you use for your **dark** depends on the object's local value. In direct light, a good solid form results from a spread of three or four values between **light** and **dark**. On the value scale, that means a range of about a #2 to a #5 on a very light object; a #4 to a #7 on something in the middle range; and a #5 to a #8 on a dark object. On an overcast day outdoors or in ambient interior light, the values between **light**, **middle tone**, and **dark** will be much closer.

It follows, then, that if you model forms with only two or three value steps, such as the top cylinder in Fig. 5-11, you are saying that those objects exist in a twilight sort of light. If you want the sun or lamp to light up your paintings, provide a greater value spread between the **light**, **middle tone**, and **dark** areas of everything, as shown in the middle cylinder. When you have an eight- or nine-value spread between **light** and **dark**, as the bottom cylinder does, the effect is too unnatural, and too theatrical for realism. Exceptions occur, however, when an object is extremely shiny, such as patent leather, glass, or polished metallic surfaces. Although the bottom cylinder looks shiny because of the wide value spread, its normal sequence of values from **highlight** to **dark** is false. A real metallic can would reflect nearby surfaces and would therefore have many illogical value changes.

There are other times where the three-to-four value spread between **light** and **dark** on forms can be set aside. When painting the skin tones on babies, children, fair-skinned women, or delicate flowers or fabrics, values are best kept close together.

Fig. 5-11. These three cans—shallow, hollow cylinders—illustrate the differences in modeling a form with a few close values (top); with a moderate, proper number of values (center); and with an unnatural gamut of values (bottom).

Fig. 5-12. Sometimes a shiny object, such as this black pitcher, will receive enough **reflected light** (in this case, from the square white vase) to equal the **light** and **highlight** areas on the opposite side of the object. It serves little purpose to compete with the light source, though; downplay that reflected brilliance as I did here.

Reflected light

When a direct light strikes objects and planes, it bounces back toward the source into the shadowed sides of nearby objects and relieves the density of their **dark** form shadows with a subtle glow. **Reflected light** is normally a half step or even a full step lighter in value than the **dark** form shadow itself. Thus, if the **dark** is a #6 on the value scale, the **reflected light** may be a #5 or a #5.5. All reflected light is the result of light, even though an object receives it secondhand.

Reflected light on a form may sometimes be the same value as an object's **light** area, or even its **highlights**, but it's best to avoid placing equally light areas on both sides of an object you're painting. Note how I handled this problem with the black pitcher in Fig. 5-12. **Reflected light** can appear in the middle of the **dark** on a rounded form, but is most logically rendered on the back edge of the form for three reasons: There is no danger that its slightly lighter value will destroy the **dark** form shadow; it effectively turns the form one more time (one more value change)

as it slightly illumines the far side of the form; it helps separate form **dark** from cast shadow when these happen to be close in value.

If you are having trouble seeing **reflected light** as you study your still-life objects, hold your hand next to the shadowed side of a vase or bowl and note the faint color of your hand reflecting into the **dark**. Failing that, place a brightly colored napkin or paper under the object and you will surely see the color bouncing back onto the object in the **dark** area, and perhaps reflecting in the **light** and **middle tone** as well. **Reflected light** is easy to see on objects that sit on a light or brightly colored surface, but hard to perceive when the surface is a dark one; this is because dark matte surfaces absorb light rays rather than reflect them. Even when you don't actually see **reflected light** on a form, you might need to invent it sometimes for the reasons listed above.

A shiny object often has a dark value down near the table plane just where the **reflected light** normally would be. This is the reflection of the object's own cast shadow. If you record

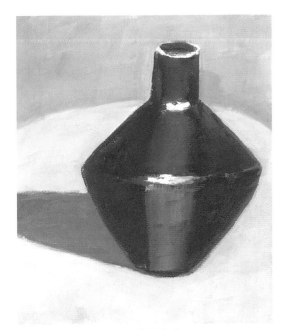

Fig. 5-13A. *INCORRECT*: This black vase appears to be lit from the front because its **highlights** are in the middle of the form. However, its cast shadow goes to the left, and that doesn't add up to one logical light source. Also, the cone shape of the vase has been misread: The **light** areas are typical of a cylinder, not a cone.

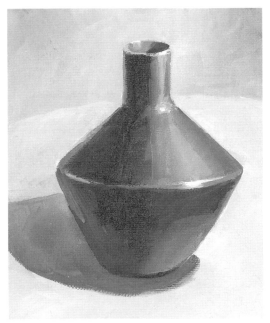

Fig. 5-13B. *CORRECT*: Here the **highlights** and **light** areas are in agreement with the cast shadow; the light comes from the right side and the shadow goes to the left as it should. Its cone shape has also been correctly identified.

it, check to see whether it is darker or lighter than the actual cast shadow. I often leave those dark spots out because they only confuse an already tight value relationship.

A word of caution: **Reflected lights** can be overdone and become too obvious a trick, so use them with care. A good way to keep them subtle is to paint them wet-in-wet. Paint the **dark** right to the edge of your object, then load your brush with the **reflected light** value and lightly deposit it into the dark wet paint, taking care not to blend it in completely.

Cast shadows

Objects hit by strong direct light block the passage of the very light rays that strike them. This causes shadow (or shade) behind them on the plane upon which they rest. Leonardo da Vinci wrote in his famous notebooks on light and shadow something to this effect: *Let the angle of the light equal the angle of the shadow.* This means that if the light comes from the right, the shadow will run toward the left; if the light is frontal, the cast shadow will be behind the object; and so on. Occasionally it appears to a student that the **highlight** on an object is in the middle of it, indicating front lighting, as in Fig. 5-13A, while the cast shadow runs to the left or right. But this relationship is illogical, according to Leonardo's axiom. You can insist forever that that's the way it was, or you can make **highlights** and cast shadows logical partners, as in Fig. 5-13B. (Chances are, the **highlight** the student saw in the middle of the form came from a ceiling light and not from the primary lamp at all.)

All objects "sit" on their own cast shadows with the help of a dark shadow underneath—with three exceptions:

1. Shadows cast by objects suspended in air are called "air shadows," and they are always some distance from the object that cast them. The most common examples are the shadows we see on the ground cast from high above by clouds or airplanes, as in Fig. 5-15. Fig. 5-14 shows an improper

use of an air shadow. Here the position of the shadow makes the apple appear to levitate above the table! Sometimes students mistakenly extend a cast shadow beyond the edge of a box or the table into the air, as shown in 5-16A. But remember, not until a surface "catches" them can we actually see shadows. The corrected shadow is in Fig. 5-16B.

2. An object will cast shadows on other parts of itself, or on a neighboring object. A tree's branches and foliage will cast shadows on the trunk and lower branches, and perhaps on a nearby house. A piece of fruit casts its

Fig. 5-14. This is what happens when an object doesn't "sit" on its own cast shadow. It will levitate off the table, as this apple does.

Fig. 5-15. An airplane casts its shadow on the landscape below, a good example of a proper air shadow some distance away from the object that cast it.

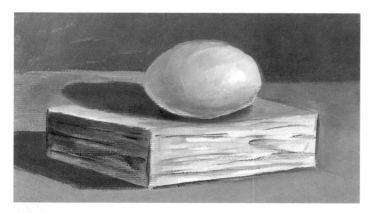

Fig. 5-16A. *INCORRECT*: The cast shadow of the egg extending in the air beyond the box looks ridiculous, but that sort of error shows up now and then among beginning students. A cast shadow cannot exist in the air!

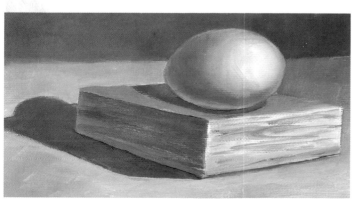

Fig. 5-16B. *CORRECT*: The egg's shadow joins the cast shadow of the box on the table plane, the first surface in line with the light rays to "catch" the shadow.

Fig. 5-17. The term "Domino Principle" describes the logical succession of cast shadows resulting from a single light source; here, the peach casts a shadow on the tall vase, which casts a shadow on folds of the drapery and the short vase, which in turn casts its shadow on the drape.

shadow on a nearby vase, which in turn casts its shadow on the drapery, and so forth, as we see in Fig. 5-17. (I sometimes call this the "Domino Principle": Visualize a standing row of dominoes, each one casting a shadow on its neighbor.)

3. When trees, plants, or rocks are embedded or rooted in the earth, they cannot be said to "sit" on it. A rock may sit on the ground, or it may be embedded, and the artist must show the difference. If there is a dark value underneath it, a rock will appear to rest on the ground just as surely as an apple will rest on the still-life table.

The behavior of cast shadows in different circumstances is so interesting and complex that I have devoted chapter 8 to them. I hope that you will become equally fascinated by cast shadows when you work with them in your still-life exercises.

SUMMARY OF THE BASIC FORMULA

From now on, the form-building formula will include cast shadows (CS), because they are indeed great indicators of volume. The term will not, for various reasons, appear in boldface type throughout the book, but it is no less important than its companions. Thus the six elements of the basic formula for depicting three-dimensional forms lit by a single light source are **highlight**, **light**, **middle tone**, **dark**, **reflected light**, and cast shadow. Though the formula might sound complicated, it is much simpler than the clutter that results when you put in each irrelevant value change you see under average light conditions. Remember to model forms with the clarity of nature; there is a principal light source in the daytime—the sun—not several equal light sources. Eliminate confusion wherever you can in your paintings.

ESTABLISH THE LIGHT SOURCE IMMEDIATELY

Before beginning a painting, always determine the direction from which your primary light source comes, and let nothing dissuade you from it. Get in the habit of putting an arrow with charcoal or thinned-out paint in the upper left- or right-hand corner of your canvas to remind you constantly where the primary light comes from. In my well-lighted classroom, I frequently have to close the blinds and turn off all ceiling lights for a few minutes to convince students that those extra light sources are obscuring the shadows on the still-life objects. Inevitably there is a chorus of surprised "Ah's!" in the room as they see, under the glow of a single lamp, the form and cast shadows of each object. Don't let incidental lighting persuade you to give up good solid form shadows on objects just because you don't see them. The location and strength of the primary light source often has to be conceptual rather than perceptual. As you remember this, your work will take on a more solid, three-dimensional look. Continue to work with still-life setups until the logical principles of light and shadow are firmly locked in your mind. I'll wager that you will end up loving painting still-life subjects in the process.

Drawing Assignment

Do a drawing of your selected still-life objects under a controlled light source. Use your largest drawing pad and either a soft pencil or charcoal, modeling the forms according to the form-building formula. Keep your structural drawing lines as light as possible, erasing them if necessary as you model the forms. If you can't work under controlled conditions with a single direct light source, model the forms you have chosen to draw according to theory rather than let ambient light or multiple light sources confuse your rendering. Try to reserve the white of the paper for the **highlights**, but if these areas become smudged, pull them back out with your eraser. Draw all cast shadow shapes right away, and make sure all your objects are anchored firmly to the table with a dark value underneath them.

Chapter 6

MODELING THE FOUR BASIC FORMS

Considering that everything in our visible world is based on one or more of these four forms, it's important that you learn how to model a good cylinder, cone, sphere, and cube right from the start.

Under anything less than ideal lighting conditions, the distinct **light**, **middle tone**, **dark**, and **reflected light** values on any form can be hard to see, but in spite of this you must learn to model the forms decisively. During class critiques, it was always obvious which students painted what they saw; their forms had patchy, indecisive modeling, like those in Fig. 6-1A. Other students reinforced what they saw with the values of the traditional formula; their four forms had dimension and solidity like those in Fig. 6-1B. I have reached the conclusion that pure intellectual theory constructs better volumes than the eye can record visually.

In drawing or painting still lifes and interior scenes, we are dealing with two factors: the real world of muddled values and multiple light sources, and the ideal world where everything is ordered, clear, and harmonious under one light source. Most artists combine the two to some degree in their work. But as closely as you must look at your subjects to render them well, you can't simply paint what you see; you have to sort out what visible information is useful and what is detrimental to your drawing and painting efforts.

As you do the still-life lessons at the end of each chapter, there is an easy test to determine whether or not your drawn or painted forms have convincing dimension. Turn your work upside down on an easel, then stand back and look at the forms. When the values are right, both on the forms themselves and on their cast shadows, your objects will

Fig. 6-1A. *INCORRECT*: A beginning art student's first attempts to model the four basic forms with values might look like this.

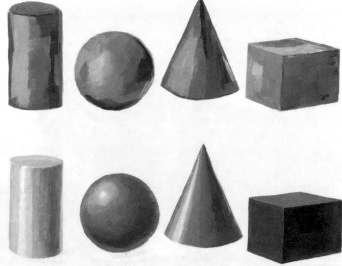

Fig. 6-1B. *CORRECT*: Here, the form-building formula of **highlight**, **light**, **middle tone**, **dark**, and **reflected light** works to organize the values so that the four forms appear three-dimensional.

look as though they are about to fall off the page. A sphere should look as if it could bounce onto the floor like a ball. When the values are wrong, your patches of paint will stay stubbornly on the page because they failed to achieve the illusion of three-dimensionality.

BEYOND THREE VALUES

Once you have managed the three basic values of **light**, **middle tone**, and **dark** on any still-life object, aim to use the two next important ones, **highlight** (assuming the object is glossy) and **reflected light.** Check the close-up of the classic shiny cylinder in Fig. 6-2, and notice that I put a **middle tone** on the edge nearest the light source rather than running the **light** right to the edge. When you leave either the **light** or **dark** on the edges of a rounded object, the form tends to flatten out at that point. You can model forms more effectively by changing value one more time on the edges, down to a **middle tone** again next to the **light**, and up slightly to **reflected light** on the **dark** side. Granted, seven or more value shifts on a single form amount to over-modeling, but in the beginning lessons, making that many shifts will help you learn to control your values precisely.

HANDLING FORM SHADOWS AND CAST SHADOWS

As described in chapter 5, there are two basic kinds of shadows. Get in the habit of mentally naming them in order to be clear about their distinct functions, especially because on complex subjects like the human face and figure, or a bouquet of flowers, shadows are interwoven and become more difficult to interpret. Remember: A *form shadow* is the shaded area on an object that receives no light from the primary light source. A *cast shadow* is the area of dark under, next to, or behind an object. The major clue to sorting them out is that form shadows are gradations (except on boxy subjects) and cast shadows

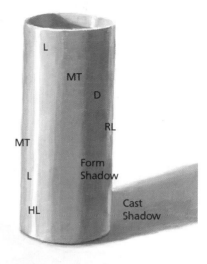

Fig. 6-2. This cylinder has been modeled according to the form-building formula, with the addition of two extra values, **light** and **middle tone**, on the left side. Changing values seven times is more a matter of discipline than necessity on most forms. It can be done only by controlling the values on the palette and frequently rinsing the brush out in turps, then blotting it dry before picking up the next value.

are definite shapes. Notice this distinction as you look at the illustrations in this book, and as you work through the exercises. Then watch shadows become an important part of your everyday world as you look at them with new eyes.

Every combination and variation of the four basic forms responds to a direct light source in a predictable, logical way because of each form's basic value pattern and cast shadow shape. Once you have identified the underlying basic forms of anything, you can know how to model that form and cast a decent shadow from it, even if the form is no longer in front of you. All you need are a few value notes.

Notice how the form shadow **dark** on each of the four vases in Fig. 6-3 follows the outer contour of that form. So also do the **light** and **middle tone** values, for that matter. This clue alone should help you complete forms when they are no longer in front of you. Students sometimes make the mistake of modeling a conical object with the light and shade pattern of a cylinder or, worse, to model a spherical

Fig. 6-3. These four vases with widely differing shapes illustrate the rule that form shadows always follow the outer contour of any object.

object straight up and down like a cylinder, such as those in Fig. 6-4A. Although the sphere in Fig. 6-4B looks funny, starting with an off-center "target" of concentric values will keep you from making it look like anything but a sphere.

LIGHT AND SHADOW ON DERIVATIVE FORMS

At first you may find it hard to recognize the four basic forms in other guises. So let's look at some random examples and consider how the form-building formula applies to them. I'll start with the cylinder because it is the easiest of the three rounded forms, and because many of the observations concerning it apply equally to the cone and sphere.

CYLINDRICAL OBJECTS

Visualize some cylindrical objects: a candle, a tin can, a pen or pencil, a toy drum; cucumbers, scallions, bananas; a neck, fingers,

an arm, a leg. All pure cylindrical objects are characterized by a sequence of values from **light** to **dark** across the top that continues straight down to the bottom of the cylinder. However, here are four circumstances when the normal value sequence might be interrupted: when a cast shadow from another object falls on the cylinder; when there are bulges and hollows on the cylinder, such as the musculature of human limbs, or the knobby joints of trees; when the cylinder is metallic and reflects everything nearby; when light bouncing up from the ground plane is strong enough to destroy the normal value sequence on the lower part of the cylinder.

Fig. 6-4A. The incorrect value patterns on this cone and sphere show up from time to time in students' attempts to paint still-life objects based on those forms.

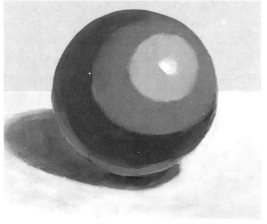

Fig. 6-4B. Painting the values on a sphere in an obvious, concentric manner, as you see here, is a good way to start painting round objects so you won't mistakenly turn them into cylinders.

Fig. 6-5. *Left, INCORRECT*: Besides the amateurish line around the top plane of the cork stopper, perhaps you can spot several other errors in this cylinder. *Right, CORRECT*: Here, the cork stopper's basic form as a cylinder is modeled first, and then the texture is added. The top plane has subtle value adjustments that make it read distinctly from the vertical side planes.

Reflected light on the **dark** side of a cylinder may not be visible at all if the form stands on a dark matte surface, like a dark green velvet cloth, rather than a light reflective surface like a white tablecloth. Inventing **reflected light** is helpful both in the first case as well as in the latter, and although it is truthful to paint the light bouncing up on the lower part of the cylinder, this light often detracts from a more important part of the painting, and is therefore better minimized.

You may have few occasions to worry about the correct value on the top plane of a solid cylinder, but a point can be made here that applies to many similar situations. Because the top is a single flat plane, it should be one single value. That value is determined by the local tone of the cylinder and the amount of light falling on its top. At one point the top plane will be the same value as one of the vertical tones, most likely **light** or **middle-tone**. You are forced either to separate the two planes with an amateurish line, or to arbitrarily adjust one of the planes by a fractional value change so that the top and side read distinctly. Beginners invariably choose the line, as in Fig. 6-5 (left), but in nature there is no such thing, so the latter solution (see 6-5, right) is the proper one.

Another way to separate planes is to leave an unpainted, negative "line" between them. This can serve as the **highlight** on the top lip of rounded forms, or on the edges of boxes. Plan ahead when you know you want to use it, and then paint carefully on both sides of the negative line.

Hollow Cylinders

Many cylindrical objects are tubular, and their hollowness sets up an interesting new value pattern. The right side of Fig. 6-6 shows what happens to such a subject under ideal side/front lighting (on the left, in this case). Note the distinct reverse in the value sequence from the front wall to the back wall of the cylinder. If the exterior convex sequence reads in the familiar descending order—**highlight**, **light**, **middle tone**, **dark**, and **reflected light**—the interior concave sequence will read in ascending order—**reflected light**, **dark**, **middle tone**, **light**, and **highlight**. The word *concave* contains a clue to this reversal of values: Look for a little "cave" of form shadow on the inside of the cylinder where no light can reach. The value pattern for hollow objects is one of the most interesting examples of how chiaroscuro works in nature, of a light value meeting a dark value. It enables us to read clearly the space between

Fig. 6-6. *INCORRECT*: Students consistently fight the notion that there can be a pocket of dark inside behind the lighted exterior of a hollow object, and will place a light value both inside and outside, as you see in the cylinder at left. *CORRECT*: On the right, the reverse in values from convex front wall to concave back wall makes this cylinder read properly as a three-dimensional volume.

the outside convex wall and the inside concave wall. I often call the reverse in values between convex and concave surfaces "flip-flop chiaroscuro." This observable counterchange of values will show up in every hollow or scooped-out form, not just cylindrical ones.

Although the value difference between the inside and outside surfaces is usually obvious in a still-life setup, countless students fight the notion that a pocket of dark can be closest to the light source. Their long-lasting impulse is to paint the hollow form as shown on the left in Fig. 6-6. That's the hard way to paint a cylinder: differentiating **light** against **light**, and **dark** against **dark**. Imagine trying to pour liquid into the two cylinders illustrated here. Doesn't the one on the right look more hollow than the other one?

When you lower the angle of the lamp shining on a hollow cylinder, you will see a shadow shape on the back concave wall cast by the cylinder's own rim. The classic hollow cylinder in Fig. 6-2 clearly illustrates what happens when its cast shadow blends with its

form shadow on the concave back wall. And how do we know which is which? Because the cast shadow is a definite shape where it meets the **middle tone** of the back wall, whereas a form shadow on a rounded surface is a gradation of values, as you see on the inside wall of the right-hand cylinder in Fig. 6-6. (Try positioning a hollow object so that you can see this change from a single type of shadow to the combined one by alternately raising and lowering your lamp a little.) Notice particularly how the **light** area on the inside back wall bounces back into the **dark** cave of combined form and cast shadow. That **reflected light** is an important aspect of all hollow forms under a direct light; it gives the inside **dark** luminosity and prevents it from being just a dense patch of paint.

I must modify the statements about the contrast of **light** outside meeting the **dark** inside with a reverse in values on the other side of hollow forms. The principle itself is inviolate, but it is most clearly seen when the form is paper thin, like the porcelain teacup in Fig. 6-7, and less so when objects have a rim of some thickness, as you see in the pitcher and the clay pot. In all cases, the top of the rim itself must be painted all one value because it is a vestige of the flat plane that would be there if it was a solid cylinder.

Highlights on Hollow Cylinders

Highlights on shiny, hollow cylinders are usually on the top lip, the place where it changes from the top plane to the vertical plane. Inevitably there will be a **highlight** on the back lip as well, in line with the direction of the light rays. By moving the lamp so that it hits lower on the cylinder, as it does in Fig. 6-2, the **highlight** becomes a streak along the entire height of the cylinder, with a corresponding one on the concave back wall. Unfortunately, shiny cylinders will show not just one but multiple streaks when two or three light sources are present. If you see a lot of them on any shiny object, sort them out and use only the one that identifies your primary light source, for the time being.

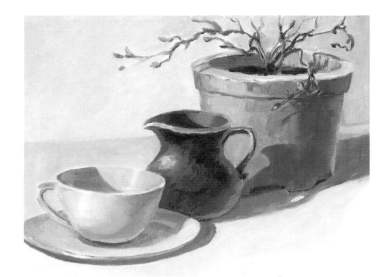

Fig. 6-7. When drawing or painting hollow forms, observe their thickness. The best way to achieve a thin and varying line around the lip of any object is to paint too thickly at first, and then reduce that extra thickness by painting negatively above and below it. Also, try twisting the brush in your fingers as you go around the ellipse, and you'll have more paint to work with.

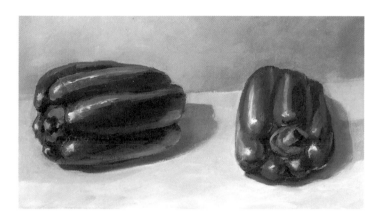

Fig. 6-8. The pepper at left is slightly foreshortened, since it is not quite parallel to the picture plane. The pepper at right is completely foreshortened. The value sequence of any cylindrical form lying on its side is always the same as when the form stands upright, always following the form's structural ellipses, regardless of position.

Cylinders Parallel to the Ground Plane

A cylinder is the only one of the three basic rounded forms that we frequently encounter lying on its side, but the sequence of values for modeling it in this position is the same as though it were standing upright. The value sequence will always follow the structural ellipses no matter what the cylinder's position. Think of a loaf of bread, a cucumber, green peppers like those in Fig. 6-8, a barrel on its side, or a fallen log as cylinders that are parallel to the ground plane. A breaking wave presents a superb example of a horizontal hollow cylinder with a concave back gathering to pour over the top of the convex front.

Cast Shadows of Cylinders

The cylinder's cast shadow starts under the whole bottom of the form with a very dark value, and starts to flare out about the middle of the bottom ellipse. It would normally be a straight-sided cast shadow, but because of the way light rays radiate from their source, the cast shadow becomes wider as it travels away from the cylinder. Nevertheless, the back edge of the shadow should intersect the **dark** side of the cylinder somewhere between one quarter to one half of the cylinder's height. That variance depends on how far away you are from the still life, whether you are sitting or standing, how tall or short you are, and also the position of the light source. Refer to the cast shadow of the classic cylinder in Fig. 6-2. Despite staring at the proper relationship of cast shadow to object for hours in class, many students paint cast shadows almost as high as the objects that cast them, and consequently have to make the back table edge too high.

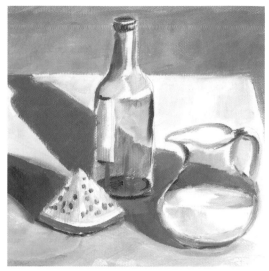

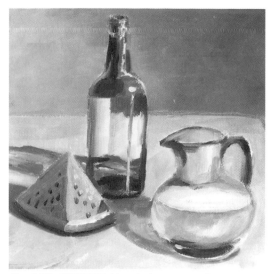

Fig. 6-9A. *INCORRECT*: These shadows are almost as high as or higher than the objects that cast them, forcing the back line of the table too high also. (Shadows could be that high when you stand right next to the table, but then the ellipses of the bottle and pitcher would be much rounder, too.)

Fig. 6-9B. *CORRECT*: Here is the corrected relationship of shadows to objects—one quarter to one half their height. Not only is the table's back line lower, but it appears flatter because the value is darker in back than up front. Compare Fig. 6-9A, where the darker value is at the front.

Fig. 6-10. The right-side-up cone at left, a funnel, receives full modeling from the light source. The rice bowl at right, an upside-down cone, is totally deprived of direct light on its exterior surface, except for a little on its cylindrical base.

Compare Figs. 6-9A and 9B. It's the same old problem of misreading shapes and shape relationships.

CONICAL OBJECTS

Visualize some conical objects: mountains, evergreen trees, strawberries, funnels, ice cream cones, bells, even drapery when suspended from a single point. The pattern of **light**, **middle-tone**, and **dark** on conical objects is similar to that on cylinders, except that all values flare out from a tiny pointed

top to the wider bottom. It is impossible to show a number of values on the slender top, so just a **light** and **dark** value will do well enough. However, few objects in nature are full cones, and the problem of tiny values in the narrow top rarely comes up.

Hollow Conical Objects

We rarely see hollow conical objects with the pointed end up, but we frequently see them with the pointed end down—visualize an ice cream cone or a rice bowl, for example. Look at the funnel at left in Fig. 6-10; note how light

strikes its slanted plane full force. The rice bowl, on the other hand, receives no light at all on its exterior surface because it is completely in its own shadow, slanting sharply down under its own wide rim. The flaring lighted interior of the rice bowl contrasts dramatically with the darkened exterior, and it takes a big value jump to show that difference. In no way could the exterior surface of the rice bowl be rendered with **light**, **middle-tone**, and **dark** modeling when no part of it faces the light. Instead, the beauty of this shadowy area is the strong **reflected light** that bounces up from the table surface and illumines the underside of the rice bowl's cone-shaped form.

Cast Shadows of Cones

The cast shadow of a cone with its pointed end up starts under its base as a very dark value, and then flares out about the middle of the form, just as the cylinder's cast shadow does. The shape of the shadow will be much wider at the base and will taper to a point, despite the radiating effect of light rays. Like all cast shadows, its edges will be firm,

contrasting with the ground plane near the light source. The shadow shape will then become soft-edged, with less value contrast, near its pointed end. The rice bowl, a cone with pointed end down, casts a completely different shadow shape because we see only the shadow of its round rim. Note how the cast shadows work in Fig. 6-10.

Pyramids

The pyramid is a boxy cone, one of those combinations of basic forms that you will encounter frequently. Picture the pyramids of Egypt, a church steeple, a wedge of watermelon, a metronome, the human nose. Instead of smoothly rounded sides, a pyramid has abrupt plane changes with less than the 90-degree angle of normal boxes. A pyramid usually has four triangular-shaped sides, only two of which we can see when it is in two-point perspective, as in Figs. 6-11A and 11B.

Pyramids must be modeled like cubes, but with even more value contrast from plane to plane. Their sides turn away from the light source more quickly because of their sharply angled corners.

Fig. 6-11A. A four-sided pyramid is a good example of combined basic forms; it is simply a cone with boxy sides.

Fig. 6-11B. Here is a clocktower with a roof of the same basic pyramidal form.

SPHERICAL AND OVOID OBJECTS

I have saved the sphere for the last of the three rounded forms because its light and shade pattern is the most complex. Picture a globe, a ball, an orange, peonies, the oval of the human head, with the somewhat rounded cheeks, chin, and tip of the nose. No other basic form turns as rapidly away from the light in every direction as the sphere does. The portion of a sphere that faces the primary source of light is relatively small, and from that point of **light** and/or **highlight**, the values shift downward quickly, not only from side to side (as with the cylinder and cone), but also from top to bottom, and on every diagonal axis. When the shadowy areas are connected, they normally result in a crescent-shaped **dark** form shadow. A notable exception can be seen when a raking side light strikes round forms. The result is a curious straightening out of the form shadow. Look carefully at the two spheres in Figs. 6-12A and 12B.

Highlights on Spheres

Highlights on a sphere or ovoid form are, like all **highlights**, very specific and not great big blobs. Although the **light** area faces the light source, don't let the area be so light in value that it is impossible to show a clear distinction between **light** and **highlight**. A **highlight** should "snap" when you put it in the middle of the **light** area, rather than blend into it subtly.

Think of the **highlight** on a sphere as the off-center spot of a target (as shown in the sample sphere in Fig. 6-4B on page 72, in which I've intentionally left hard edges between the values). The **light** value wraps around it, the **middle tone** wraps around the **light** area, and the **dark** form shadow wraps about two-thirds around the **middle tone** area, all of which is unique to spherical forms. **Reflected light** doesn't wrap around the **dark** area because it changes in value and color depending on what bounces back from nearby objects and planes. The most important place

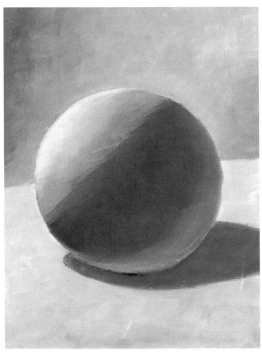

Fig. 6-12A. Strong raking light—here, coming from the left—results in a straightening out of the normal pattern of light and shade on a sphere.

Fig. 6-12B. This is the more familiar pattern on a sphere under ideal side/front lighting. The crescent-shaped **dark** shows how form shadow generally follows the outer contour of an object.

to use **reflected light** is under a sphere, where it separates the **dark** form shadow and the cast shadow. That nuance shows better than anything else the unique cupping under of any spherical form. Why jam the **dark** shadow right against the cast shadow and throw away a splendid opportunity for a beautiful **reflected light** from the table surface?

The off-center target idea, with values that wrap around the **highlight** of the sphere, should keep you from applying an errant straight streak for a **highlight**, or daubing in odd-shaped **middle tone** or **dark** areas haphazardly. But be careful that you don't let your thinking about the target show by leaving hard edges between the values.

Half Spheres

Visualize a solid half sphere: half of a cut grapefruit, tomato, or hard-boiled egg. A bowl, a cup, a scooped-out cantaloupe, an umbrella, and a hat are all hollow half spheres, as is a dome; small rowboats or sailboats are, too, though they are actually stretched-out half ovals with one square end and one pointed end.

Half spheres are somewhat like cones in that there is quite a difference in the value pattern of light and shade between the dome-like top half and the bottom half. When a sphere's top half is struck by ideal side/front light, it will have all five of the form-building values, but the bottom half of the same sphere will be short-changed because most of the values are below its "equator" in the crescent form shadow. This is evident in Fig. 6-13, where it would be inappropriate to model the lower half of the grapefruit fully from **light** to **dark** when no direct light falls on it. However, if the angle of the light is lowered, or the bottom half of the cut grapefruit is tipped on an axis away from the light, the value relationships will be reversed—the grapefruit will be shadowed on the cut face, with a great deal of light on the exterior.

All hollow half spheres, no matter how

Fig. 6-13. We come across half spheres in all sorts of guises. The top half of this cut grapefruit receives full modeling under side/front lighting, while the bottom half is mostly the crescent-shaped **dark** with some **middle tone** and **reflected light**.

irregular, have four things in common: rims with some degree of thickness; a single value on the top of a flat rim; flip-flop chiaroscuro between the concave and convex sides; and a powerful amount of light that slams into the **light** part of the concave inside. This **light** is much lighter than any value on the outside of the bowl, which is below the sphere's imaginary equator. Exceptions to the flat-rim/one-value rule occur when the rim of an object is very irregular, as in the split-open coconut in Fig. 6-14.

Hollow half-spherical forms often show up in nature in different postures rather than sitting complacently on flat planes. Capturing the forms of flowers moving gently in the breeze is simply a matter of good structural drawing of tipped and foreshortened ellipses, and of painting the proper value sequences according to the direction of the light. See the poppies in Fig. 6-15.

Fig. 6-14. Modeling the jagged-edged rim of this coconut calls for more than one value, unlike the way you would handle a smooth rim.

Fig. 6-15. These poppies are representative of many flowers that are bowl-like, hollow half spheres. Try to sort out the form and cast shadows that interact on the different flowers, and how the tipped ellipses of the blossoms relate to the slanted and curving stems.

Cast Shadows of Spheres

The cast shadow of a sphere is distinctive because it starts out as a "puddle" of shade underneath the form, rather than hugging the base tightly as with cylinders and cones. The puddle shadow is proper except when the light source is very low, in which case the shadow becomes an extension of the dark #9 value underneath the sphere.

CUBIC OBJECTS

Consider some boxy forms: buildings, cars, chairs, tables, beds, trunks, books, storage boxes, and so on. Either two or three planes are visible on most boxy forms, each one a different value—one **light**, one **middle-tone**, one **dark**. Always accentuate the value differences where planes meet, rather than making them very close in value. **Reflected**

light from the ground plane may bounce onto the side planes, but if kept subtle, this will not threaten their basic one-value flatness. Occasionally a shiny box—a car is a perfect example—will reflect so much of its surroundings that its appearance of volume is lost. Except in flashy commercial illustration, I suggest that you minimize such reflections and let the values read decisively where the planes meet. It is another case of turning the form first. The reflections are mere details, while the value changes from plane to plane reveal the larger truth about light and shadow on that form.

Occasionally you will see two adjacent planes that are absolutely the same value. This happens when light hits the corner of a cube, as it does the house in Fig. 6-16A. As it is difficult to read the three-dimensionality of such a box or building, you should wait until the sun moves, or invent a value shift from one side or the other as I did in Fig. 6-16B. If you are working on a still life at home, simply move the lamp slightly and avoid the problem of two planes of the same value.

Highlights on Cubes

The only places there can be any **highlights** on shiny cubic forms is on the edges where two planes meet. However, it is possible for the whole top plane to be mirror bright under top lighting, or for a side plane to be one brilliant, reflective square if the light source is low. But ordinarily, if you think you see a small **highlight** isolated in the middle of any plane, rest assured that it is a reflection of something nearby and not a true specular **highlight** from the light source.

Cast Shadows of Cubes

The shape of a cubic object's cast shadow will depend on whether the object is in one- or two-point perspective. If you remember, a cube seen in one-point perspective has its base parallel to the picture plane, while a cube in two-point perspective has a diagonal base. Fig. 6-17 shows the cast shadows of two boxes in one-point perspective, and two in

Fig. 6-16A. *INCORRECT*: The house's 90-degree change of plane at the corner is ill-defined, presumably because the sun was hitting precisely on the corner (but more likely because the artist failed to note an actual value change).

Fig. 6-16B. *CORRECT*: Gone is the flatness of the house of Fig. 6-16A. Not only do the values define the modeling of this "box," but also the perspective supports its three-dimensionality. In this example, the horizon line runs just across the middle of the windows.

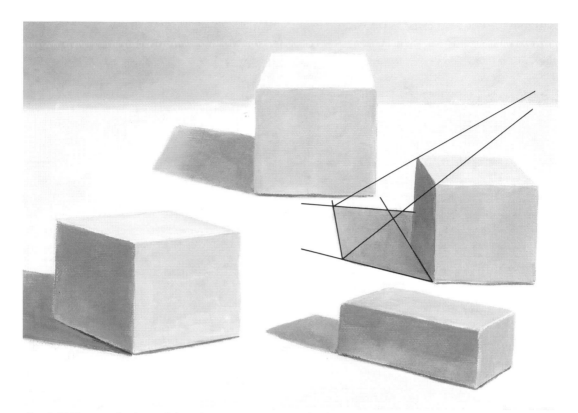

Fig. 6-17. The cast shadows of these boxes are slightly different shapes, depending on whether they are in one- or two-point perspective. The lines on the box at right represent light rays hitting the top of that box and then the table surface, leaving an area of shadow untouched by the direct light source. The shadow has its own linear perspective lines that recede into the imaginary third dimension.

two-point perspective. You can determine the shadow shape of any cubic form by imagining lines extending from the bulb of a lamp to the back edge of the form. The higher the lamp, the shorter the cast shadow.

USING THE BASIC FORMULA

With the basic formula for good volumes firmly in mind, you have three options when working with any kind of subject matter:

1. Use the formula rigidly on all objects, regardless of what you see.
2. Ignore the formula and faithfully report every nuance of color and value you see.
3. Compromise intelligently; paint what you see, coupled with what you know, editing out confusing, extraneous information.

Drawing and painting are a combination of what we see, what we know, and how we feel about the subject, plus one more thing: what we must do to make it read well. You have to know how light and shadow behave before you can depict your emotions about a subject realistically. All you have to do is model the cylinder, cone, sphere, and cube with appropriate values, according to how the light strikes them. All curving surfaces are revealed by a single light source to be either convex or concave; and all flat planes receive different amounts of light depending on whether they are vertical, horizontal, or slanted in relation to the light source.

When you are working on location outdoors and feel overwhelmed by nature's seeming chaos, think how you would handle the various elements if they were in a still life illuminated by a lamp in your home studio. Working with still life is not the mundane exercise you might think it is. Indeed, it is the best way to learn how to describe three-dimensional volumes on a flat canvas.

Drawing Assignments

1. With either pencil or charcoal, draw the four basic forms freehand on your sketch pad, using as many ellipses as needed to find their outer contours. Imagine that the light strikes each form from the right front/side, and model each one accordingly with the side of the pencil or charcoal. Leave the white of the paper for the **highlight** areas facing the light source. Use a rolled paper stump to blend values, rather than using your fingers. Start with a different **middle tone** for each form and work lightly up in value first, and then down to the **dark** form shadow.

2. Do a second version of the four basic forms on your sketch pad using your black pen. Achieve a variety of values with the pen by making crisscross lines, a process known as cross-hatching. Make fewer lines for the light values, and crowd them closer and closer together for the **middle tone** and **dark** areas. You can also achieve different tones with dots, or any other mark you may want to make with the pen, but cross-hatching is faster.

Painting Lesson #1
The Four Basic Forms in
Black and White Oil Paint

Divide a whole sheet of 16 × 20″ textured canvas paper in quarters and draw one of the four basic forms in each section. Make them at least five inches tall and use your no. 6 or no. 8 brush to stroke in the different values. Hold the brush as you would a pencil, that is, with your thumb and index finger on the top of the handle about halfway back on its length. Relax your hand, step back a bit, and be painterly. Develop controlled sloppiness, rather than obsessive neatness.

On your palette, squeeze out one large knob of white paint, and one of black. Then mix a generous amount of #5 value and let it become the third point of a big triangle with the pure black and white mounds. Between the white and the #5, mix the #2, #3, and #4 values. Make separate homogenized piles (solid tones of paint well mixed) for each at first, even though they will eventually blend into one another as you paint. Then mix downward from the #5 to the black, finding a #6, #7, and #8. The only value you need to be precise in mixing is the #5. Check yours against the nine-step gray scale on page 46. Once that is right, judge all other values as being relatively lighter or darker than it is.

Start out by giving the cylinder a local tone of #3, the cone and sphere a local tone of #5, and the box a local value of #7, so that you end up with one light form, one dark form, and two middle-value forms. Always start by putting in your local tones (**middle tones**) first. Then work up and down in value on all forms simultaneously, making as few drastic value jumps as possible to avoid washing out your brush constantly.

If the bottom ellipse of your cylinder or cone is too flat and has (heaven forbid!) corners, usually two corrections are needed: Arc the bottom ellipse downward in the middle part with paint that matches the object. Then load your brush with white paint and carefully round off the two offending corners.

Chapter 7
VARIOUS LIGHT DIRECTIONS

As you have no doubt observed, different types of illumination—tungsten light bulbs, natural light from windows, overhead fluorescent or incandescent lights—affect still-life setups uniquely. Previous chapters have considered setups in which light was directed frontally at a subject from either the left or the right side; now we will look at the specifics of light coming from different directions. As you read through this chapter, refer to the illustrations of the still-life objects under four lighting conditions in Figs. 7-1A through 1D, and refer also to the landscape illustrations in Figs. 7-2A through 2D. Learn to approximate the brilliance of light through proper values; without these values, you can't even come close to rendering the effect of light's radiance.

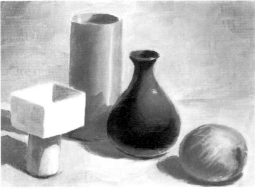

Fig. 7-1A. Four still-life objects are illuminated with ideal light coming from the right side and toward the front of the table. Form is always fullest and most classic under side/front lighting.

Fig. 7-1B. The same four objects now receive full light from a lamp placed directly in front of them. Front lighting tends to flatten out forms because it floods the objects with **light**, causes **middle tone** to crowd their edges, and virtually eliminates form **dark**.

Fig. 7-1C. Top lighting is difficult to arrange over still lifes, but it can be attractive and a welcome change from side/front lighting.

Fig. 7-1D. Back lighting is the most dramatic, providing you are willing to lower the key of your painting and play up the contrast extremes of silhouettes and halo-like edges of forms.

Fig. 7-2A. This line of trees on the brow of a hill and the surrounding landscape are lit by the sun from the right. In landscape, don't worry about capturing ideal side/front lighting, because it is transient. A general kind of side lighting is good enough when you're painting on location.

Fig. 7-2B. Front lighting on this little landscape shows the consequent flattening of form and lighter key of the whole painting. With sunrise or sunset behind you, the landscape will be flooded with a beautiful glow of color that is scarcely dimmed by form shadows.

Fig. 7-2C. Top lighting is characterized by strong **dark** form shadows, a lot of reflected light underneath, and tight, dark cast shadows underneath everything. Painting on a gray, overcast day means working with top lighting, too, but in a subtler way, as it is diffused and nearly shadowless.

Fig. 7-2D. Compare the dark values in this backlit landscape with the light values in Fig. 7-2B. I may have exaggerated somewhat, but when you're on location, colors may distract you from values. If you understand the values in black and white now, you will be more apt to see them as they really are in nature.

SIDE/FRONT LIGHTING

The volume of a form is at its fullest with side/front lighting because **light**, **middle-tone**, **dark**, **reflected light**, and cast shadow are all clearly visible. (See Figs. 7-1A and 2A.) Ideally, your lamp should be positioned so that it creates a 45-degree angle with the table plane. If the lamp is is too high, the cast shadows will be too short; if it is too low, the shadows will be too long. The time to capture ideal outdoor lighting is 9:00 A.M., and during mid-afternoon hours. Although 9:00 A.M. is too late to catch the beautiful early-morning light, by ideal light, I mean those times of day when the sun casts moderate shadows—neither very short nor uncommonly long.

FRONT LIGHTING

Typical front lighting can be obtained when a lamp is positioned directly in front of the objects in a still-life setup—head on, as in Fig. 7-1B. Form and cast shadows are practically nonexistent under front lighting. In landscape painting, front lighting exists if the sun is behind your back, as in Fig. 7-2B. In either case, this illumination could just as well be called "flat" lighting because of the effect it has on forms. All objects are bathed with so much light that the **light** area occupies the bulk of the volume, with just a small amount of **middle tone** on the edges of forms. Because **dark** form shadows hardly exist, you can forget about trying to use **reflected light**, except possibly under the weak crescent shadow of spherical forms. A compensating virtue of front lighting is that it results in a high-key painting, a painting rendered mostly in light values.

Cast shadows are virtually nonexistent in front lighting; they hug the objects tightly and darkly at the base, while the rest of the

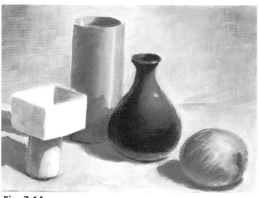

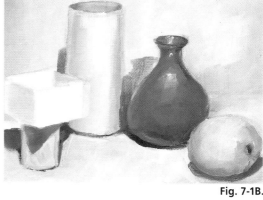

Fig. 7-1A.

Fig. 7-1B.

Fig. 7-2A.

Fig. 7-2B.

shadow is hidden behind the object that casts it. A landscape can be very powerful when lit frontally, although I suggest that you avoid front lighting on a figure or a still life. Outdoors, because you must work in early morning or in late afternoon to have the sun at your back, the paintings produced during these sessions tend to be colorful and have large, simplified masses of foliage, mountains, and clouds.

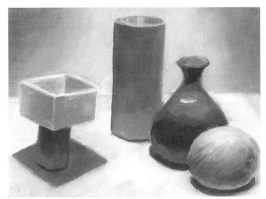

Fig. 7-1C.

Top Lighting

In the studio, to create the effect of sunlight at high noon, as in Fig. 7-1C, you would have to suspend a lamp over your still-life setup. Failing that challenging task, set up objects under an existing suspended light, such as a dining room light fixture, as long as overlapping shadows from multiple light sources do not appear.

Two special effects come from a single top light. First are the interesting cast shadow shapes you get from complex subjects like a plant or a bouquet of flowers positioned directly underneath the lamp. These shadows radiate equally in all directions. The second effect is the tremendous amount of **reflected light** that bounces up on objects as the light pours straight down on your setup. That bouncing **reflected light** is quite capable of destroying the normal crescent-shaped shadow **dark** on spherical forms if the plane of your table is very light in value. Because **reflected light** shows up much better next to a dark value, why give up that valuable form **dark**? Model spherical forms with at least a vestige of a crescent shadow to get more impact from the beautiful bouncing light.

Most artists avoid painting outdoors at noon because the intense sunlight bleaches out color. Also, cast shadows are too small and too dark to obtain a good effect during that brief period, as you see in Fig. 7-2C.

Consider flat, diffused light outdoors in relation to top lighting. Conjure up a gray, overcast day, and you will be visualizing flat,

Fig. 7-2C.

diffused light from above. Imagine that the cloud layers are an infinitely large panel of thick frosted glass in the sky, through which the sunlight, drained of its warmth and power, is dispersed evenly over the landscape. The world is nearly without form or cast shadows. The only significant dark areas would be under large trees, overhanging roofs, or anything else protected from that great expanse of top gray light. Yet those dark areas are shapeless, unlike the definite shapes of real cast shadows. Everything else is mostly **middle tone** (local tone), with just a little modeling, always in close values.

Back Lighting

When you find yourself staring into the light source uncomfortably, you'll know that you are positioned to paint a scene with back lighting. If you can bear the discomfort, your final

result should be very dramatic. Figs. 7-1D and 2D show the startling contrasts between the halo-like **light** edges, and the large mass of **dark** form shadow. These are the hallmarks of back lighting; everything is virtually silhouetted. **Middle tone** hardly exists in back lighting. However, without a token **middle tone**, the **light** value would meet the **dark** too crisply, making round objects appear faceted or even boxy.

The effect of back lighting is exactly the opposite of the effect of front lighting. Back lighting has a preponderance of dark values, and therefore will yield a low-key painting. Unfortunately, besides the primary lamp, the average home studio or classroom has one or more secondary light sources that are necessary to illuminate the room. These lights often equal or exceed the strength of the back lighting. The result is neither effective back lighting nor convincing lighting of any other

kind. The halo effect and dramatic cast shadows streaming toward you are significantly weakened. If you can't get good enough light control in the daylight hours to try back lighting, wait until nightfall. Then turn off all secondary lights for a few moments to see just how much **dark** there is on each form. You will also see, if your objects rest on a light surface, a glowing **reflected light** bouncing back into the **dark** parts of the objects. After seeing the values under controlled back lighting, never again should you be tempted to dilute its dramatic effect with an equal light from another source.

The interesting thing about cast shadows in both back and front lighting is their radiating nature. Actually, it is the light that radiates, not the shadows, but the effect is that the shadows appear to fan out from the central light source. However, the source of the sun's rays is so far from earth that scientists consider the rays parallel rather than radiating. Nevertheless, we do see radiating rays of light passing through cloud holes (as in Fig. 7-3), stands of trees, or narrow apertures of any kind. From both a perspective and design standpoint, radiating light and shadows of this kind are much more exciting than parallel light and shadows. Besides, they make far more interesting positive and negative shapes.

Fig. 7-1D.

Fig. 7-2D.

LOW LIGHTING

Although this type of lighting may be associated with eerie effects (think of the fiendish appearance of a face illuminated from below), the sight of buildings and trees illuminated by floodlights in the evening is beautiful, as Fig. 7-4 shows. And think of the effect of dawn's first light or the setting sun's last display illuminating the undersides of clouds and architectural structures. Although low lighting is seldom utilized in still-life setups, it has creative possibilities—consider objects high up on shelves, dramatically illuminated from below.

Fig. 7-3. During sunset the sun blasts through sky holes between clouds and sends out ever-widening rays.

Fig. 7-4. Lighting the exterior of a building from below creates lovely dramatic effects. Unfortunately, low lighting has limited application to painting indoor subjects, but it's worth experimenting with.

EDGE LIGHTING

This extreme, raking side light, also known as "rim" lighting, positions the **light** right on the edges on forms. **Light** and **middle tone** are only narrow bands in this kind of light, and then there is a sudden turning into the **dark** area, followed by a great deal of **reflected light** bouncing back into it, as you see in Fig. 7-5. A raking side light, with its stylized effect, is related to back lighting, since in both instances objects have a lot of **dark** and **reflected light** and very little **light**.

EMANATING LIGHT

When the source of light is included in a drawing or painting, a gradation from **light** to **dark** away from the source is a must. The light could be a candle or table lamp in a still life, or any number of different lights found in

Fig. 7-5. A raking side light causes edges to be outlined with **light** and **highlights**, and it comes close to creating the same value pattern as back lighting. Both are characterized by a lot of **reflected light** as the primary light hits surfaces behind the objects and then bounces back into their form **darks.**

Fig. 7-6. Depicting your light source in a painting is an interesting challenge. Try a still life with a candle in it. To render the effects of the light rays emanating from the flame, you must work your way down from the **light** very gradually using a wide range of values.

a studio or home. Outdoors, a campfire, street lamps, store signs, and the sun, moon, and stars are all sources of light. Emanating light usually has a visible field of radiance around it, but occasionally this is difficult to see. Nevertheless, exaggerate this radiant light with as wide a range of value steps from **light** to **dark** as you can manage. Note the effect of the candle's illumination in Fig. 7-6.

OTHER TYPES OF LIGHTING
The following types of lighting are imaginary, creative, or merely expedient:

Symbolic radiance
For centuries artists have depicted a radiance emanating from religious figures. The value gradation from light to dark away from the central divine figure is a far more effective device than the medieval practice of painting a gilt halo above a head to indicate divinity. Sometimes the radiance encompasses just the divine figure, and other times it spills over onto nearby figures, uniting them into a radiant group. Rembrandt's powerful ink and wash drawings show this dramatic effect beautifully and are worth careful study.

Arbitrary lighting
Large public spaces with modern lighting come under this category, with the virtual bombardment of light coming from all directions. Visualize department stores, shopping malls, modern building lobbies, and train and airline terminals. These settings are simply awash with light; walls, floors, and ceilings are nearly without gradation. The modeling of objects and people in a painting with such lighting might therefore be quite arbitrary, and not exactly following the logic of light from one source.

Sculptural light
As an invented, imaginary light source, sculptural light is characterized by a strong **light** in the middle of a form, which would normally indicate flat frontal lighting. In Fig. 7-7 we see a sphere, cone, and two cylinders as they might appear under this imaginary sculptural light. These forms are over-modeled, with powerful **middle tone** and **dark** values moving toward all edges, not just on one side of each form. Forms modeled in sculptural light tend to look bulbous if they are spherical, or tubular if they are cylindrical. Sometimes the implied light is from the side, but nevertheless, the value spread is too great to be believable realism. The style is subject to harsh criticism by some who consider it gross, vulgar (when applied to figures), and lacking in sensitivity. On the flip side of the coin, other artists have made their reputations by under-modeling

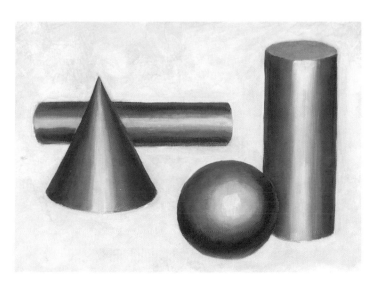

Fig. 7-7. These four rounded forms have been given "sculptural" light treatment from an imaginary light source that looks like front lighting. Yet, instead of appearing flattened out as they would in front lighting, the forms have been modeled with exaggerated **light**, **middle tone**, and **dark** values.

figures, using only one or two value steps between **light** and **dark**. In recent decades contemporary artists have been exceedingly successful in combining monumental, flat, clothed figures with lightly modeled heads, hands, and feet. These are options open to all of us, but I hope you'll consider them only after you've learned to model forms with a normal range of values.

A SPECIAL SITUATION

There are landscape situations where you can see two or three types of lighting simultaneously. Imagine standing in the middle of a dead-end street one morning, with a house directly on your left, one straight ahead, and one directly on your right. With the sun coming from the left about 8:00 A.M., the house on the left is mostly in its own shade because it is backlit from your viewpoint. The house straight ahead of you has side lighting, and the house on your right is brightly lit because it faces the sun and is therefore front lit. To paint all three of the houses with the same side lighting would be a poor representation of the situation. Now imagine looking at a mountain range in middle distance that curves and sort of wraps slightly around your position. The range on the left would be shadowy, while the mountains straight ahead would have definite contrast between the lighted and shadowed ridges, because the sun hitting them from the side reveals each ridge and valley. The range on the right would be very light, and less interesting. I've compressed and overlapped a lot of mountains into Fig. 7-8A to try to convey that idea. Assuming that you could take in only one third or one half of that vast landscape on your canvas, I feel sure you would find the side-lit mountains most inspiring. If the mountain range curves the opposite way, being convex from your standpoint, the big value pattern would be reversed, just as it would be on the outside of a bowl in a still-life setup. The mountains would be lightest on the left end curving away from you, have a lot of

Fig. 7-8A. With the sun on the left at about 4:00 P.M., this mountain-enclosed valley includes shadowed forms on the left, side lighting ahead, and front lighting on the right.

Fig. 7-8B. The late afternoon (or early morning) sun is again on the left, but here the mountain range is a convex curve seen from atop a hill. Overall value patterns like these are not always easy to see.

value contrasts in the middle part straight ahead, and be shaded on the right end, as you see in Fig. 7-8B. It is always helpful to shade part of a long mountain range because it allows you to play up other parts of it more dramatically.

COPING WITH CHANGING LIGHT DIRECTIONS OUTDOORS

Working with a lamp in the studio or classroom is gratifying because the light is always constant. Outdoors the sun marches inexorably across the sky, ducking in and out of clouds, changing the landscape minute by

minute. Granting four or five hours of oil-painting time on location, the sun is in the east in the morning when you start, high overhead when you're ready to quit for lunch, and edging over toward the west by the time you're ready to fold up your gear. To continually change the light and shadows of a painting over four or five hours is to court disaster, to end up with muddy, overworked color. Yet a short painting session is frustrating for oil painters, whose set-up and break-down time is usually greater than that for artists of other mediums.

Many artists are purists who insist that you can't paint for more than an hour or two on location because the light changes too drastically. I must point out that light changes from moment to moment even during that brief painting session. All artists are forced to paint a composite of the passing scene before them, except on heavily overcast days that look ominous and remain virtually unchanged for hours on end. On a fine day you have four ways to cope with the sun's movement:

1. You can dash off a small quick oil sketch, perhaps a 9″ x 12″ or a 12″ x 16″ canvas, and later transpose the sketch to a larger canvas in the studio.
2. Immediately after drawing on your larger canvas on site, you can make color and value "shorthand" notes when the light is perfect, then develop them during the remaining time of the painting session.

Staying on site gives you a better opportunity to get perspective, shapes, and details set, even if the light has changed.

3. You can return to the site several times at the same time of day until the painting is finished, à la Monet, providing that the weather remains consistent.
4. You can take photographs of the scene. Make a few quick pen or pencil sketches with color and value notations, then work up a full-scale painting in the studio, using only your own resource materials. (Copying or even adapting published materials of any kind is plagiarism.)

In photographs, the values are all worked out for you, but in working from three-dimensional reality, you have to figure them out for yourself. I trust that you are seeing values everywhere with new eyes by now.

Assignment

Collect examples of paintings or photographs that incorporate unusual light directions, labeling each one with the type of lighting it features. You may want to start a file of these clippings merely for reference—but never for the purpose of copying them.

Painting Lesson #2

Divide a 16 × 20″ sheet of canvas paper into four equal sections. Apply narrow masking tape firmly over the drawn lines. This is so that you will have neat edges once you pull the tape off after the four sections have been painted. Select three small still-life objects and position your lamp in these four positions: front lighting, top lighting, back lighting, and edge

lighting. Paint the still lifes in succession, using only black, white, and the various grays. Be sure to include the cast shadows right from the start. These four vignettes (where the corners are left unpainted) can be rough sketches, rather than finished paintings. If your four vignettes look too much alike, you have probably missed the high key of front lighting, the low key of back lighting, and the dramatic impact of the edge light.

Chapter 8
THE BEHAVIOR OF CAST SHADOWS

So helpful are cast shadows in achieving the illusion of reality that I feel they deserve a chapter of their own. They are also downright fascinating. My eyes seek them out everywhere and I ponder their origins, complexities, colors, and values. Clearly, certain cast shadow patterns occur over and over, not only in still life but in landscape, seascape, figures, flowers, and every other subject you can name. Learn to recognize these classic shadow patterns under a controlled light, and you will have no trouble seeing them (or inventing them) under less favorable circumstances.

Let me say that cast shadows should not be obvious in a painting. If the viewer sees them even before the objects that cast them, they are too dark and hard-edged. That would be akin to the tail wagging the dog. When painted with finesse, cast shadows should be scarcely noticeable yet apparent to a discerning viewer. At first your cast shadows may be rather crude, but in time you will learn to render them spontaneously and without undue concern for the principles spelled out here. Although I have already mentioned some of the most basic facts about shadows in previous chapters, I'll repeat them here for reference.

CAST SHADOW PATTERNS

The first five rules governing cast shadow patterns encompass what I call "the anatomy of a cast shadow." These five and the rest address the specific problems that countless art students have had to resolve.

1. Cast shadows are always darker than the surface they fall upon. How much darker? As a general rule, a contrast of three or four value steps between the lighted surface and the cast shadow is about right when there is a direct light source, like the sun or a lamp. With closer value steps, we can deduce that the light source is weak. With a much wider spread of values, say six or seven steps, the contrast is too theatrical, too unnatural. Compare the weak shadow in Fig. 8-1A with the normal contrast of values under a direct light source in 1B. Fig. 8-1C shows the theatrical contrast between light and shadow, in this case, a jump from a #1 value to a #8.

A good way to study value contrasts between light and shade is to go out on a partly cloudy day when the sun alternately shines and then hides behind a bank of clouds. Keep checking a patch of ground right in front of you for ten minutes or so. Watch the cast shadows from nearby trees or buildings contrast boldly with the light areas for a few moments, and then soften by degrees to little or no differentiation as the sun passes behind a cloud. When there are no cast shadows at all, then everything is pure local **middle tone** on flat planes, the actual value of the grass, concrete, or whatever you are studying. When the sun shines brightly again, the local tone of everything on a flat plane disappears, becoming either lighter in the sun-dappled areas, or darker in the cast shadows. To retain the local value and the light and shade would make three values, but since single flat planes can't be modeled per se, the local tone gives way to the contrasts of light and shadow. All

Fig. 8-1A. For each of the three illustrations shown here, assume a direct light source—a lamp indoors, or the sun outdoors. Under such conditions, this first example shows too little contrast between the lighted table surface and the cast shadow on it, indicating a very weak light source.

Fig. 8-1B. Here you see the proper amount of value contrast.

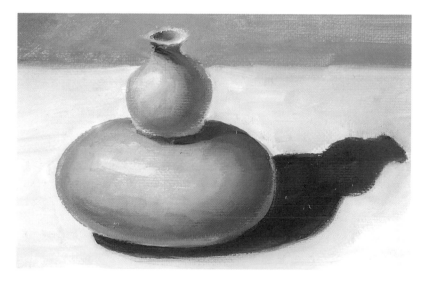

Fig. 8-1C. Here the contrast is too great, indicating a powerful theatrical light.

three-dimensional forms would need the basic **light**, **middle tone** (local tone), and **dark** modeling values, plus the cast shadow values, to read as volumes when the sun is shining.

While you are observing cast shadow patterns outdoors, compare the softer-edged shadows that come from passing clouds with the darker, sharper-edged shadows that come from nearby trees or buildings.

2. Cast shadows are dark and hard-edged close to objects that cast them and become slightly lighter and softer-edged as they move away from the light. This happens because the primary light source flows around and behind the object and weakens the back edge of the shadow; other light sources exert their influence; and reflected light bounces into the cast shadows from objects nearby.

Accordingly, rule #1 above should be modified slightly to accommodate these conditions. There may be three or four value steps of contrast at the beginning of a cast shadow, but only two or three steps at the tail end of it. Cast shadows of objects farther away from the light source will always have less contrast with their lighted planes.

3. Cast shadows start under, not next to, the objects that cast them. The cast shadow of a cone, cylinder, or cube starts with a #8 or #9 value contact point under the whole form, although occasionally an object will rest so precisely on a surface that there isn't a dark shadow underneath. In such cases you can cheat a little and add the assumed dark value to anchor the object solidly. The cast shadows of cones and cylinders begin to flare out about the middle of the bottom ellipse. A cube has a continuous line of contact with the surface on which it rests. Part of this demarcation will melt into the larger cast shadow. When painting any contact points, render them with bold, dark lines, diminishing their thickness with brushstrokes placed above and below as you paint the lighted table surface and the rest of the cast shadow.

Spherical forms cast an entirely different kind of shadow than the others, a "puddle" of shadow, due to the way the upper part of the form projects over the base. When the sphere is well below your eye level, the small contact point is so far underneath the form that you won't see it. So don't put one there unless you *can* see it.

Fig. 8-2. All cast shadows mold themselves to the forms and planes they traverse, but never as dramatically as in landscape, where cloud shadows eclipse some parts of the terrain and make the sun seem to spotlight others.

4. Cast shadows conform to the planes and forms they fall upon. When cast shadows fall upon a surface with wrinkles, undulations, or any other contour, they conform to that contour, be it folds of cloth, ocean waves, or the crenellations of mountains. I call this the "Wet Blanket Principle," particularly in reference to landscape painting, where cloud shadows mold themselves to mountains, foothills, and fields as in Fig. 8-2.

Study how this phenomenon works by setting up objects in a still life so they cast shadows on other props, especially on folds of cloth. Note the way cast shadows conform to the three major planes in space by looking closely at, say, a vase. Look at how its shadow stays flat and goes into perspective on a flat plane, and how it becomes vertical on a wall plane. Then prop a canvas behind the vase to create a slanted plane and observe the way the vase's shadow slants also, and how the far edge of it blurs as it goes away from the light.

5 Fractional value changes within a cast shadow are necessary to explain forms, planes, and reflected lights within it. Beginning students invariably make the mistake of obliterating every detail inside the area of a cast shadow so that it looks like a piece of cut-out gray or black paper, as in Fig. 8-3A. When they do, I point out that a cast shadow is nothing but the absence of light. The real substance is the tablecloth, napkin, or objects within the darkness of the shadow. Indicate form subtly by keeping reflected light, detail, contact points, and so on close in value so they won't pop out of the shadow's basic value. This helps to give cast shadows luminosity, rather than dense opacity. Fig. 8-3B shows the corrected shadow.

6. Cast shadows run in the opposite direction from the light source. Although covered in the previous chapter, here is another approach to studying this phenomenon. Pick a stationary subject outdoors on a sunny day—for instance, a chair on a patio or a potted plant in the middle of a table—and place it on

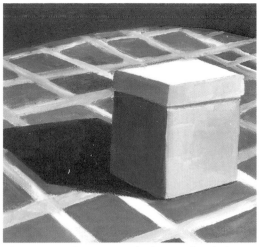

Fig. 8-3A. Don't paint cast shadows as flat, dark patches like the shadow of the box shown here, which obliterates everything in its path. A shadow is merely an absence of light, not a lack of substance that looks like a dark hole in the painting.

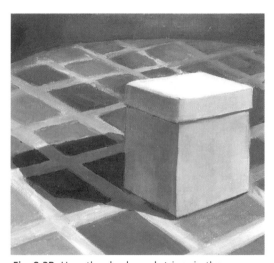

Fig. 8-3B. Here the checks and stripes in the tablecloth continue right through the cast shadow, but in a lower range of values.

several sheets of newspaper taped down securely. With different colored markers, outline the object's cast shadow at three-hour intervals, placing a few approximate value numbers here and there to determine degrees of contrast.

7. The closer an object is to the ground plane, the darker its cast shadow will be; conversely, the farther an object is from the ground, the lighter its shadow. For example, leaves high up

Fig. 8-4. Note how the uppermost blossoms of this hydrangea plant cast slightly lighter, softer-edged shadows on the table than the lower leaves. To create this effect, I placed the lamp at a higher angle than usual, something I often do anyway to add the enlivening cast shadow shapes to an otherwise boring area of tablecloth.

on a tree cast slightly lighter, vaguer shapes on the ground than leaves on the lower limbs, which cast shadows whose shapes are crisp in outline. A flower pot will cast a darker shadow than the flowers and leaves of the plant it contains simply because it is closer to the ground plane. Note in Fig. 8-4 how the higher leaves and flowers cast shadows of lesser value contrast.

Another application of this rule involves objects that lean against vertical planes. For example, the darkest shadows cast by a bicycle leaning against a fence will occur at the contact points between object and surface—for instance, the handlebars. The #9

contact point at the precise place where the handlebars touch the fence is equivalent to the sit-down line on a flat plane.

8. A cast shadow from an arching form is darkest at the two points where it contacts its base plane and is lightest under the span. I call this the "Bridge Principle," for obvious reasons. It applies to such unlikely things as a spoon, fork, or knife resting on a cutting block or plate, a crooknecked squash lying on its side, or a piece of driftwood on the beach. Even chairs and tables have cast shadows that conform to the Bridge Principle. Fig. 8-5 illustrates how the principle works.

9. *Radiating light rays cause cast shadows to fan out away from the light source.* As noted in the last chapter, this effect is easily observed in front or back lighting, while it is negligible with ideal side/front lighting. While you are working with still life under ideal lighting, it is better to minimize any apparent diverging of shadows.

Fig. 8-5. According to the "Bridge Principle," which applies to any arching form, the higher the span, the softer and lighter its cast shadow will be underneath it. The ends of the "bridge" are normally anchored to the ground plane with a dark value under them.

Fig. 8-6. The cast shadow of the handle of this cast-iron teapot contrasts sharply in value with the **light** area of the white vase. Then the value contrast lessens as the cast shadow runs across the **middle tone** areas, finally blending completely into the **dark** form shadow of the vase.

Fig. 8-7. This lighthouse is a perfect example of what happens to cast shadows falling on a cube as well as on a cylinder. Note what a marvelous blend of basic forms the structure consists of: The base is a pyramid, the second segment is a box, the third is a cylinder, and the top is a dome-shaped half-sphere way above eye level. Would you see it that way if you were painting it?

10. *Shadows cast from one object onto an adjacent object blend into the **dark** form shadow on a rounded form, but may disappear abruptly on a boxy surface.* Notice in Fig. 8-6 how the shadow the iron teapot casts on the white vase contrasts sharply in its **light** area, has less contrast in the **middle tone**, and blends into the **dark** without distinction between the two types of shadows. To hold on to that cast shadow shape in the **dark** would be wrong under single-source lighting. (Exception: If the cast shadow falls on a wide cylindrical form, say a huge gas tank, it will not blend with the form shadow.) On a cube, the cast shadow will usually contrast sharply with the **light** plane and then disappear when it hits the corner, as it does on the lighthouse in Fig. 8-7. This depends on the angle of the light, though. A cast shadow can fall right on the corner of the cube and

split in two directions, shadowing both sides of the form. Note how cast shadows blend into form shadows on rounded tree trunks, or disappear abruptly on square posts and buildings.

11. An object struck by two or more light sources will cast multiple shadows that are darkest in value where they overlap. Study the cast shadow of the ink bottle in Fig. 8-8. When you see dark patches like this one in your cast shadows, edit them out; they serve no purpose and only complicate the painting. Fascinating though crossing shadow patterns may be, they call undue attention to the supporting players in the drama of your painting. (Some artists who aim for a degree of abstraction in their subject matter

Fig. 8-8. A humble bottle of India ink assumes prestige when enhanced by shadows from two light sources. The dark patch that appears where the two shadows overlap illustrates the doubling of values that results.

Fig. 8-9. Every time a cast shadow encounters an obstacle in its path, or a gap between two planes, it deviates from a straight line, sometimes toward the light, as on the rolling pin, where the shadow follows the roll back toward the light, but more usually away from the light.

deliberately record multiple form and cast shadows from several light sources.)

12. When a cast shadow rolls over planes and forms, or leaps over a gap onto another plane, the shadow is always offset away from the light. The illustration in Fig. 8-9 shows how the bottle's shadow, as it goes to the back edge of the table and onto the wall plane, is offset by the distance between the table and the wall. The greater the gap, the farther away the shadow appears on the wall. You can also see that there are offsets where the cast shadow of the bottle rolls over the rolling pin. By the time the shadow has gone under the rolling pin, backed out, and then curved over the top of it, blending momentarily with its form shadow and then reappearing on the table, it has already been offset twice away from its original path.

13. A shadow cast by an object resting on a plane cannot suddenly appear some distance away without being connected to the object. This is related to rule #12 above and Fig. 8-9. It simply means that the bottle's cast shadow on the wall must tie in with its cast shadow on the table, however tenuously, despite undulations or gaps in its path. Block out the bottle's cast shadow on the back of the table in Fig. 8-9 to see how illogical its sudden appearance on the wall would be. The exception to this rule is, of course, the air shadow that is cast by an airborne or suspended object.

14. Don't "nail" an object to an adjacent surface by outlining it with a hard, dark cast shadow of the kind you might see in a photo taken with a flash. Compare Figs. 8-10A and 10B. Study how the leaf shadows of the plant relate to the pot itself and to the wall behind it. The farther away a shadow is from the object that casts it, the more the illusion of space is enhanced around the object.

15. Cast shadows on a flat plane become progressively flatter as they recede into the

Fig. 8-10A. *INCORRECT*: Students sometimes outline objects tightly with a harsh black line to indicate cast shadows, which makes the image look suspiciously like a photograph taken with a flash. Note how the painting of the plant shown here fails to convey a three-dimensional effect because of the too-tight shadows, and how distracting the pattern of veins in the leaves is.

Fig. 8-10B. *CORRECT*: Here the plant exists in a generous amount of space, and the leaves are painted with concern for light and shade rather than pattern. Notice how the front leaf projects forward from the pot; this is because its cast shadow appears some distance away, indicating space between it and the leaf.

distance. This follows the rule that says an ellipse flattens as it nears the horizon. Given a number of apples in a still life, or trees, horses, or cows stretching from foreground to distance in a landscape, each succeeding cast shadow will be flatter as it nears our imaginary eye level. The back edge of a cast shadow in the foreground shouldn't intercept the object any higher than one-half of its height (from a normal viewing distance of six to eight feet), and one-third is even better. The

back edge of a cast shadow in middle distance will intercept an object at one-third to one-quarter of its height, and a shadow in the far distance will intercept the object that casts it at only one-quarter to one-eighth of its height. Eventually cast shadows become a mere sliver as they recede toward the horizon—an important principle to keep in mind as you observe and paint the landscape.

16. When light strikes a hollow rounded form at a certain angle, the rim will cast a shadow on the object's interior. The cast shadow becomes part of the reverse in values from inside to outside that gives the illusion of hollowness.

This cast shadow pattern is apparent in many illustrations of cups, bowls, and pots throughout the book, but in Fig. 8-11A, I've applied the principle to a shallow bowl and its convex lid that are propped up vertically. The lid can't have a cast shadow on itself (except from the knob) because of its convex turning away from the light, but the concave bowl does cast a shadow on its interior. When applied to daisies, as you see in Fig. 8-11B, note that concavity looks natural for them (as well as all saucer or bowl-like flowers of that type), but convexity does not. Yet students persist for a long time in putting the **light** area on the side of the light source, thus

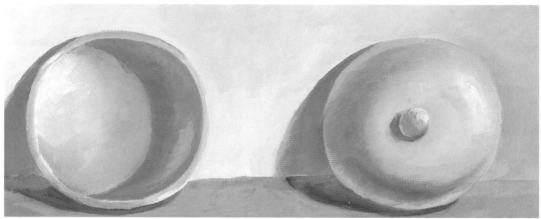

Fig. 8-11A. Read across this illustration first, studying the different value patterns for the concave bowl at left, with its reverse in values inside, and its convex lid at right. The lip of the bowl casts a generous shadow on its interior, and merges with its form shadow. A bit of **reflected light** helps to more or less separate the two types of shadows. The convex lid does not cast a shadow on itself.

Fig. 8-11B. The bowl-like daisy at left echoes the concavity of the bowl in Fig. 8-11A, and looks natural. The daisy at right looks convex with its petals falling away from the center button—although that value pattern will work for the back of a daisy on the far side of a bouquet.

Fig. 8-12A. The triangular cast shadow inside the hollow cube is an angular version of the curving cast shadow inside a bowl, a hollow half-sphere.

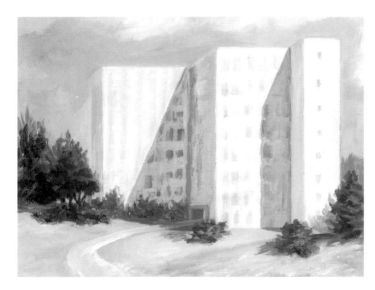

Fig. 8-12B. We see the same triangle-shaped cast shadows on many buildings at midday, as at the center of this illustration, or the slightly altered shape at right.

making their flowers appear convex like the lid of the bowl above. Notice how the **reflected light** I've rendered on the inside of the bowl and the daisy at left serves to separate cast from form shadows, as well as to reflect the lighted side.

17. The walls of hollow cubic forms cast a triangular shadow on other interior walls. This corresponds to the way the rim of a hollow rounded form casts a shadow on the inside of the object, but is angular rather than curving. The small triangular shadow in the square box in Fig. 8-12A is a miniature of the shadow visible on an enclosed fenced yard, or on highrise buildings on a sunny day (except

when the sun is directly overhead). Just two walls at right angles to each other are enough to demonstrate the principle, as you can see in Fig. 8-12B. The beauty of this triangular cast shadow pattern is the soft, glowing **reflected light** that bounces back into the wall that cast the shadow, providing that always helpful value separation between the two shadowed planes. Moreover, a subtle "second-generation" bounce of light can usually be seen as well in the adjacent triangular cast shadow.

Let me expand that idea to cover all faceted adjacent planes, even those that exist at a variety of angles to one another. First, look at the facets of simple leaf shapes, most of which angle inward and down to a central vein

(though some may be quite flat and hardly faceted at all). Few leaves angle down and away from a central vein as the leaf appears to do in Fig. 8-13A, and yet students who are painting a close-up of foliage on a plant will frequently paint them that way, just as they paint daisies with the wrong values. (Our mind-set apparently insists that the values closest to the light source must be the lightest, no matter what our eyes see.) Now compare the values in these little leaf facets to great mountains with sharp ridges and downward planes falling away from them. The ridge in Fig. 8-13A works well, even if the leaf below it doesn't. In Fig. 8-13B, the light falls on the ridge in such a way that it casts its own shadow on the next facet, just as the right-hand facet of the leaf does in this illustration. How you place the values of any two facets tells a big story about the light source, no matter whether it is in regard to leaves, faceted buildings, or craggy mountains.

18. Transparent objects cast "transparent" shadows. The main characteristic of the cast shadow of any transparent glass object is a dark, soft outline that echoes the shape of the glass. Inside the outline the glass throws a light and shade pattern unique to itself and related to its local color. For an example, refer to Fig. 8-9 on page 100 to see the value pattern of the bottle's cast shadow. (This phenomenon of transparent shadows will be covered more completely in chapter 12, where various visual textures are explored.)

19. Simplify the shadows cast by busy subjects. For instance, when trees cast lacy shadows on the ground, avoid an all-over, polka-dot look by linking some light dappled areas together, as well as tying the shadowed areas into larger, simpler shapes. Study the difference between the spotty shadows in Fig. 8-14A and the tied-together ones in 14B. Isn't the simplified version far more effective?

Fig. 8-13A. The leaf shown here looks strange because leaf facets almost never fall away from a center vein; they generally angle in toward it. However, the same value pattern works well on a mountain ridge, as you see in the background.

Fig. 8-13B. The slightly curving leaf facets shown here angle inward to the center vein, and when the light comes from the side, the dark facet will cast a shadow on the light-struck one. Translating that to the mountain in the background, one ridge casts a shadow partially on the next ridge, while small side ridges slant down to a crevice between them, just as veins in a leaf slant down to the central vein. Reflected light plays its part in separating form and cast shadows, as usual.

Fig. 8-14A.
INCORRECT: Don't translate dappled light as a lot of polka dots on the ground, as this illustration shows.

Fig. 8-14B. *CORRECT*: Simplify the light and shadow pattern by tying the dark, shadowed areas together as much as possible, using the trunk and branches as a grid, and then connect some of the dappled areas, too.

20. A projecting roof on a building will cast a shadow on the walls below at an angle determined by the sun's position. Notice in Fig. 8-15 the bounce of light from the wall plane (and/or ground plane) up to the underside form **dark** of the roof overhang, and how that **reflected light** in turn bounces "second-generation" light into the cast shadow underneath.

21. A large spherical form on top of a cylindrical or conical form will cast a shadow on its supporting base. The bowl of the compote in Fig. 8-16 is the lower part of a sphere and the base is a cone. Where light falls on the lower part of the base, the conical form is modeled with the usual **highlight**,

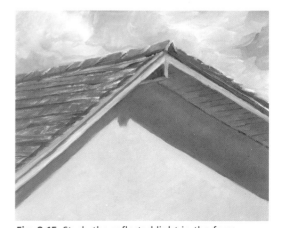

Fig. 8-15. Study the reflected light in the form shadow on the underside of this roof, and then the roof's cast shadow on the walls of the house. The form shadow receives the bounce of bright sunlight first from the walls, and then reflects some of that into the adjacent cast shadow.

Fig. 8-16. Notice the amount of reflected light under the bowl part of this compote. This particular piece is quite shallow, and its underside "looks" down at the table surface more than most such forms. A lot of light bounces up from the table surface, whose color would thus greatly influence the **reflected light**. It in turn would throw a bit of color into the cast shadow on the supporting base, not unlike the second generation bounce into the cast shadow on the wall in Fig. 8-15.

light, **middle tone**, **dark**, and **reflected light** formula. The cast shadow's curving shape, generated by the bowl above, blends into the cone's form shadow in agreement with principle #10.

This compote has the same exchange of **reflected light** as the roof overhang mentioned above. Although it may be easy to see such bouncing light and color on your little still-life stage, it is much harder to see it in nature, where, for example, sunlight striking bare earth or green grass under a wide-spreading tree will be just as likely to bounce up onto the undersides of the bottom branches and foliage.

Deciduous leafy trees are typical combined forms, the limbs and foliage taking the shape of an irregular sphere supported by a cylinder, the trunk. Other such combinations include flowers on their stems, mushrooms, umbrellas, and, most importantly, the human head and neck. My name for this light and shadow pattern of a sphere on top of a supporting column is the "Umbrella Principle." The cast shadow of the human head on the neck clearly shows the head's projection over the supporting column. **Reflected light** and color

are almost always visible bouncing up from the clothing of the model to the underside of the chin.

When the light source is at "high noon" above any of the umbrella-like forms, the stem is quite logically all in shadow. In that case, forget about modeling with **light**, **middle tone**, and **dark** values and go all out for **reflected light** on one or both edges of the stem (neck, tree trunk, etc.) where possible. Let some light fall on the supporting column, as I did in Fig. 8-16. It is always easier to perceive the volume of an object when both light and cast shadow are present. Shadows help explain the direction and strength of the light, and light explains the existence of the shadows.

22. Some parts of a subject composed of many units will cast shadows on other parts of it. Thus, some grapes in a bunch will cast shadows on other grapes; some flowers in a bouquet will cast shadows on other flowers, and so on. These small cast shadows will appear in the **light** and **middle tone** areas of the large mass, but never in the form **dark** area, because it is already in shadow.

23. Foreshortened parts of a compound subject will project convincingly when they are shown to cast shadows on forms underneath them. Many spiky, bladed shrubs project outward in all directions from a basically elliptical base, causing foreshortening problems. An art pupil will avoid foreshortening to the bitter end, placing everything in profile going to the left and right. Foil that tendency in your work; set up tonguelike shapes by casting dark shadows on the leaves underneath or next to them, depending on the direction of the light source. The pineapple in Fig. 8-17 has many such foreshortened tips on its spiky top, which, incidentally, is a compound subject, even though the fruit part isn't.

A palm tree is a classic case requiring a lot of foreshortening in its foliage. Study the difference between the flat palm tree in Fig. 8-18A and the three-dimensional one in Fig. 8-18B. The idea of setting up a light value of one component by putting dark ones next to it usually has a fortuitous relationship to the light source, but as pointed out earlier, this value separation can be arbitrary.

24. Blades of grass, a patch of weeds, or a beach full of pebbles are best handled by clumping components together into compound subjects with sizable cast shadows. Although many artists happily paint every blade of grass and pebble with a tiny brush and a steady hand, it is much more painterly, as well as faster, to translate them into compound

Fig. 8-17. A pineapple top is typical of compound subjects with many smaller parts. Its foreshortened tips, the ones that come toward us, are like so many pointed tongues. Notice how their light values contrast with the dark values of cast shadows underneath. This little value trick will be useful in many foreshortened forms, but will not work unless it is based on proper drawing.

subjects with form and cast shadows. This "Clumping Theory," as I call it, is a matter of simplifying a lot of clutter—of conveying a general impression and letting the viewer's imagination supply the details.

In time you should be able to expect shadows to occur in certain places, even though conflicting light sources keep you from seeing them. Remember that ideal side/front lighting will allow you to see most clearly how all of these principles work. In diffused ambient light, you can forget entirely about the rules regarding cast shadow behavior, because there simply won't be any.

Drawing Assignment

Confirm the foregoing rules about cast shadows by drawing many quick fragments of subjects around you that illustrate these principles. Let these be simple line drawings of buildings, trees, people, or interior subjects, for example, with just the cast shadows shaded in boldly with the side of the pencil. Label each little sketch with the number of the rule or rules it illustrates.

Fig. 8-18A. *INCORRECT:* Palm trees, familiar elements in the Hawaiian landscape, trip up many art students, who often paint flat trees like this with every blade of every frond carefully articulated.

Fig. 8-18B. *CORRECT:* Drawing the fronds so that they are properly foreshortened and backshortened, as well as setting them up with contrasting values, will result in a more natural-looking, three-dimensional palm tree. Notice the "Umbrella Theory" at work on the top part of the trunk. Its logical cast shadow contrasts with Fig. 8-18A, where there is no sense of the bulk of the top casting a shadow on its supporting trunk.

Painting Lesson #3

Set up a still life with at least one tall object, one at middle height, and several shorter objects, perhaps with one lying on its side. Arrange them so cast shadows flow over obstacles in their paths. Tape or pin a flat white cloth behind the setup, if possible, so that the objects cast shadows on it. Refer to the black-and-white photographs of still lifes shown here. Try to use gray, black, and white objects, but if you must work with colored props, conscientiously ignore their hue. Determine each object's actual **middle tone** (local tone) first, and then model it with appropriate values. Do your best to express light flooding into this painting, remembering that proper values will perform the magic.

Paint this setup on a full sheet of 16 × 20″ canvas paper, drawing everything life-size as much as possible. Start with a structural drawing in charcoal, using ellipses to describe the rounded forms. Flick the excess charcoal off with a paper towel before starting to paint.

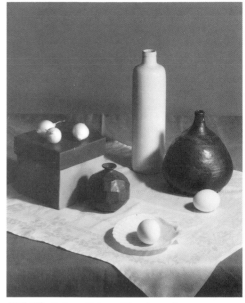

Still-Life Setup. *Below*: The clamp lamp, my single controlled light source, is clipped atop an old easel and positioned off the right corner of the card table with the black, gray, and white setup on it. *Above*: The close-up of the props reveals dark areas of form and cast shadow, purposely unrelieved by a secondary light source. However, when you stare at dark areas for a few moments, your eyes adjust to the lesser light so that you can then see more values in it, just as when entering a dark room you wait a few moments for your eyes to adjust to the surroundings.

Step 1. Here the drawing in charcoal includes all ellipses needed to describe the rounded forms. The preliminary drawing should also include the shapes and angles of cast shadows, the back table line, and any napkin folds or creases.

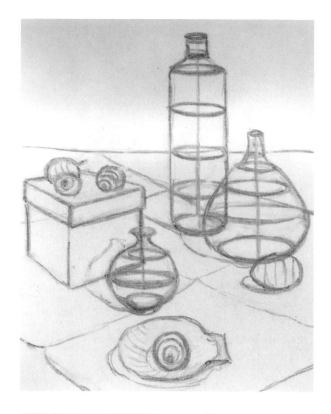

Step 2. I've begun to lay in the **light**, **middle tone**, and **dark** values for the various items, paying attention to their particular ranges on the value scale. The box, with a darker value on the lid, requires special attention.

Step 3. I finish laying in all the values and then begin to coax the **highlight**, **light**, **middle tone**, **dark**, and **reflected light** values together without over-blending. The background gradation is laid in quickly with enough contrast to emphasize the whiteness of the tall vase, and yet with a need to balance the dark vase on the right. The actual black vase, by the way, had a lighter brown, drippy glaze pattern on it that I had to ignore when I painted it.

Step 4. The completed painting of the setup. I decided to let the **highlight** ring the **light** area of the faceted vase (due to a highly glazed area that I could see around each facet), rather than make the whole shape a #1 **highlight**. The cast shadows are luminous, with a lot of reflected light in them, bouncing light that I could see even if the camera couldn't.

Part Two

THE WORLD IN LIMITED COLOR

After working in white, gray, and black values up till now, I'm sure you are eager to get into color. And so we shall, but slowly. When unseasoned artists jump into full color too quickly, their values become confused. It takes a while to learn how to translate the modeling of forms into *color* values. Students will often have the right colors but the wrong values, or vice versa. Compare the three background pottery pieces with the foreground one, the only piece that has the proper local color (the equivalent of **middle tone**) and value for that particular piece, and good modeling as well. Many times a student will make **middle tone** and **dark** just about the same value, resulting in weak modeling. Working in achromatic grays, the same student might have had little trouble judging the values.

Part Two introduces basic color theory and explores the many functions and physical properties of color. Particular emphasis is placed on gaining color knowledge cumulatively by working with color in limited combinations—monochromatic schemes, analogous sequences, pairs of complements, and so on—and on learning at the same time how they apply to the form-building formula. The color lessons and still-life exercises that conclude each of the next six chapters are designed to help you master both of these key elements of working in a realistic style. As you go through the still-life assignments, you will work with an increasing number of colors, and your previously clear, I trust, understanding of

the form-building formula may blur. Keep in mind that in realism, the right values are always more important than the right colors. Later you may enhance or diminish color as it suits the particular mood of a painting, but you can seldom alter values without jeopardizing the qualities of light and three-dimensionality.

COLOR CHARTS AND STILL-LIFE LESSONS

Each limited color lesson in Part Two consists of two parts: a color chart, and an accompanying still-life setup based on those specific colors. You will find the still lifes much easier to do if you take time to do the color charts for each lesson first. Use either a half sheet or a whole sheet of canvas paper for the color charts, depending on how many color swatches, or "chips," as they are called in the color industry, you choose to do. You may elect to rule out lines for 25 (five rows across, five rows up) or 49 (seven across, seven up) immaculate color chips, or just make any number of messy swatches hurriedly. You can cut them out later and mount them neatly.

Work for smooth color and value intervals from chip to chip both horizontally and vertically. If you suddenly realize that the intervals are too close or too far apart, scrape the wet paint off your color chart, remix it on the palette, and paint the chip again. It is

much easier to get it right at this point than to try to match wrong color chips in the middle of rows later on.

For the time being, when mixing paints, make all transparent colors opaque by adding a bit of white or a neighboring opaque color on your palette. (Not until Part Three will we begin to use transparent colors in their natural state for underpainting and glazing techniques.)

When modeling forms, mix three distinct color values for the **light**, **middle tone**, and **dark** of your subject on your palette first, rather than trying to coax a **middle tone** up slowly by adding white to it, or down to **dark** by adding increments of black or the complement. In other words, be decisive right away about your values.

In setting up the still lifes for each of the color lessons, refer to the step-by-step photographic sequences at the end of each chapter for clues to arranging the objects you will paint. Given a choice, use more still-life props rather than fewer in your setups. That way you will have more practice in finding local colors, modeling forms, and handling cast shadows, all in one lesson. It would be ideal if you could find objects within the specific color range being taught. If that is impractical, just do the best you can with what you have handy, or try pooling resources

with one or two painting buddies. The most important thing is to keep within the limited color range of the lesson you are working on; don't be distracted by irrelevant colors. This means translating the real color of an object into whatever colors serve as the focus of a given lesson. For instance, in the monochromatic lesson, which is based on a blue-green palette, translate a brown bean pot of your own into a deep blue-green and model it with appropriate values. It will be a challenge, to be sure, but cherish each challenge for the learning experience it will provide. These lessons are designed to wring every possible nuance out of the few colors you have to work with. If you don't play fair, you are missing the whole point and will not stretch your color knowledge. Don't work for weeks on one lesson. When the fruit and vegetables for one setup have expired, move on to the next. As you begin to make better color value decisions and more telling strokes, you can go back later and try again.

At all times be careful not to mop and muddy your colors by blending them too much. Overblending, especially when there is a paucity of paint, deadens not only the colors but also the painting's surface quality. Keep your oil brushstrokes alive, buttery, fresh! Making your brushstrokes invisible is not what this book is about.

Fig. 1. I painted this illustration with the colors of Color Lesson 1, the yellow, black, and white lesson following chapter 9. The background shows three wrong "student" examples that you can compare with the right one in the foreground. From left to right, the background attempts are incorrect for many reasons, including: a value sequence from **dark** to **light** to **middle-tone**; too little contrast between **middle tone** and **dark**; incorrect local color in spite of good three-dimensional modeling.

MATERIALS AND TECHNIQUES NEEDED FOR PART TWO

Continue to use your 16 × 20″ canvas paper pad for the early limited color lessons, and also for the color charts (these can be on a half sheet). Use a full sheet for each still life, and always try to draw everything life-size. Do not miniaturize; it forces you to work with little brushes and itty-bitty strokes. Don't paint with a brush smaller than a no. 6 or no. 7.

For each of the still lifes, spend a few minutes doing several small (2 × 3″ or 3 × 5″) "thumbnail" pencil sketches in your sketchbook to work out your composition. A cardboard viewfinder, the little square mat shown in Fig. 2, is a great help in deciding how much you want to include and whether you want to work vertically or horizontally.

After you gain some confidence in your structural drawing, stop using charcoal on your canvas paper and use instead a no. 5 or no. 6 brush with turpentine-thinned brown or gray paint (mixed from the colors on your palette) for the initial drawing. If you make mistakes, wipe them away with a paper towel moistened with turpentine and start drawing again. Or you can redraw with a different colored line so you can see the correction, as I sometimes do. In any case, do not labor over the drawing on your canvas. Let it be loose, even sloppy, rather than precise. Impose upon yourself a limit of about 30 minutes for the drawing stage, and then get on with the painting. As the still-life lessons in Part Two gradually introduce more colors and become more beautiful, switch from canvas paper to either canvas board or stretched canvas. Stay with the 16 × 20″ size.

Brushes and Brushstrokes

Besides the synthetic square-ended bright brushes you have been using, buy a no. 6, no. 7, or no. 8 filbert. It, too, is a flat brush, but its bristles taper to an oval; note the brush with the tan handle at front center of Fig. 2. Try to get one with natural bristles, as synthetic filberts don't seem to hold up as well to the kind of vigorous scrubbing we'll do with it. Whereas you've probably been holding the square-ended brushes as you would a pencil, that is, underhand with the end of the handle pointing upward, hold the filbert in an overhand position, tucking the end of the brush under your palm. The back of your hand will be up and your index finger will extend on top of the handle. (See Figs. 3 and 4.)

Instead of applying paint with the controlled "chunk-chunk" strokes you've been making with the bright or flat brushes, scrub pigment on quickly with the filbert in a free, waving motion. Use the filbert to render background gradations and table surfaces, as it covers faster and pulls values of a gradation together more easily. Scrubbing does, however, lack the paint quality of controlled brushstrokes. Note the difference between the scrubby background and the shell in Fig. 5. To create a transition, after scrubbing in an area rapidly, work back into parts of the rough background paint with some buttery strokes using a loaded bright brush. Don't inadvertently scrub with your square-ended brush or you'll ruin its nice chiseled edge in a minute.

Using a Medium

When working with a filbert brush, you need to thin the paint slightly with a medium, a prepared mixture of resin, oil, and turpentine. I find Winsor & Newton's Liquin to be the best.

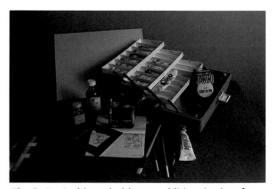

Fig. 2. An Artbin to hold your additional colors for Part Two is a good investment, as is the Tube Wringer, that paint-stained square thing standing in the middle of the picture. It will squeeze out every last bit of paint in a tube.

Fig. 3. Here I am holding the brush as I would hold a pencil, with the handle above my hand. This is the best way to control your strokes.

Fig. 4. This overhand hold allows for a lot of freedom in my wrist as I scrub in large areas quickly.

This somewhat viscous liquid can either be poured directly onto your palette, or into a little cup that clips to the edge of the palette. With a clean brush, dip into the medium and swirl a little of it into your paint mixtures in the center of the palette. Be careful not to rinse out your brush in the medium between colors; continue to use turps for that. Once you begin to use Liquin, or any other medium, you'll find that you have to continue using it for that painting session because it makes the paint congeal within 15 minutes or so, and only more medium will make it workable again. It's better to work instead with buttery, tube-consistency paint as long as possible, using a medium only for scrubbing in large areas. (A little plain, clean turps will thin out paint, too, in the early stages of a painting.) As you did in the black-and-white painting exercises, whip your white with linseed oil if necessary to make it move easily.

Paint-Saving Tips

If you have a lot of leftover paint from your color charts, save it in the freezer, covered with plastic wrap, and you'll be able to use it when you do the corresponding still-life lesson. Better yet, buy a $9 \times 12''$ paper palette in addition to your larger $12 \times 16''$ palette. Squeeze generous mounds of paint on the small one, freezing the whole thing between painting sessions. Oil paint thaws out quickly because it can't really freeze solidly, and storing it in the freezer doesn't affect its performance in any way. When you are ready to begin painting, on your work surface place the small palette loaded with paint next to the larger palette. Use the larger one only for mixing paint; never transfer the large knobs of paint from the small storage palette to the larger mixing palette. When I finish painting for the day, I scrape leftover piles of pigment—usually lovely grays—from my mixing palette and put them onto the small freezer palette, taking care to keep them separate from the pure, unused colors. I find this labor-saving two-palette system more convenient than any other method I've tried over the years.

Always squeeze out huge blobs of paint, not small ones. Little knobs dry out quickly, while large mounds (of most colors) will stay fresh

for days, even when not put in the freezer. They may, however, form a skin that you must remove to get down to the fresh paint. Never start painting with a palette full of old, dried mounds from a few days back, scratching to find a morsel of paint like a chicken scratching in bare dirt. Oil paint loses its adhesiveness as it dries, and it is technically unsound to use it, not to mention frustrating.

Easels

Don't even start using a table easel unless you are handicapped and must sit down. Instead, borrow or purchase the best standing easel you can afford. You will have a better view of the subject and will be much more in command of what you are doing. Position your easel so that your shoulder is slightly toward the still-life setup and you have to turn your head to look at it. Placing the easel squarely between you and whatever you are painting forces you to bob to the left or right of the canvas to see, a most inefficient way to paint.

Safety Concerns

It behooves all artists to practice good hygiene in the studio and classroom to avoid ingesting, inhaling, or experiencing excessive skin contact with paint and solvents. Some pigments, like the cadmiums and manganese colors, may be toxic, no matter what your medium, be it oil, watercolor, or acrylic. But thanks to extensive testing by The Art & Craft Materials Institute of Boston, Massachusetts, all types of art materials bear seals that indicate whether a product is toxic or nontoxic and advise as to its safe use. In addition, some seals certify that a product has met specific performance standards that measure quality. You can send for a free, complete list of all tested materials from ACMI by writing to them at 100 Boylston St., Suite 1050, Boston, Mass. 02116. Also consult Michael McCann's book *Artist Beware* (New York: Watson-Guptill Publications, 1979) or Steven L. Saitzyk's *Art Hardware* (Watson-Guptill, 1987) for more information about toxic pigments and how to handle them safely.

Oil painters must be especially careful in working with solvents. Good ventilation in the studio is essential. Avoid using turpentine or mineral spirits to wipe paint off your hands. Always use a waterless hand cleaner for that; keep a container of it nearby while painting and use it often to keep from spreading stray paint everywhere. After a painting session, wash your hands thoroughly with soap and water, scrubbing your fingernails with a small brush before preparing food or eating.

OIL COLORS NEEDED FOR COLOR LESSONS IN PART TWO

Do the lessons that follow each chapter at your own pace, but take time to really do them. Each one is designed to enlarge your color vocabulary. If you are a beginner, consider buying the colors listed here for just one or two lessons at a time to soften the financial blow. Any make of oil color is fine except for a few instances where I do recommend a specific brand. In case you already have a lot of oil colors, I have listed some alternates that will do as well as the preferred ones. Use up what you have. Oil paint has a remarkably long shelf life, as long as the tubes are capped properly. After squeezing out paint, wipe off any excess from the mouth of the tube and the inside of the cap's threads.

Color Lesson 1: Monochromatic Color (Chapter 9)

- ivory black
- titanium white
- viridian
- phthalocyanine green (such as Grumbacher's Thalo green, or Winsor & Newton's Winsor green)

This lesson explores monochromatic color through the use of blue-green. Viridian and phthalo green are about the same blue-green hue, but viridian is a weak color and phthalo is extremely strong. If you want to buy only one of them, make it a phthalo green, as it will yield much brighter color and darker values.

Color Lesson 2: Analogous Color (Chapter 10)

- ivory black
- white
- cadmium yellow pale (or lemon or Liquitex Hansa yellow pale, all cool yellows with a hint of yellow-green in them)
- cadmium yellow light (or cadmium yellow medium or Liquitex Hansa yellow light, all yellows tending toward orange)
- yellow ochre

This lesson explores the yellows. Yellows vary in hue from brand to brand. A cadmium light in one brand may be similar to a cadmium pale or medium in another. If possible, open caps to be sure that you are not buying two identical ones. Hansa yellows are less expensive than the cadmiums, but are semitransparent and lack the cadmiums' power. Hansa yellow medium, an exception, is an extremely chromatic yellow-orange.

Color Lesson 3: Blue-green/Red-orange Complements (Chapter 11)

- phthalo green (and/or viridian)
- cadmium red light
- white

Color Lesson 4: Blue/Orange Complements (Chapter 12)

- cadmium red light
- cadmium yellow light
- cadmium orange (optional)
- white
- manganese blue (or cerulean or Grumbacher's Thalo blue, all greenish blues similar in hue, differing in transparency and strength)
- cobalt blue (optional)
- ultramarine blue (or French ultramarine blue, or Grumbacher's Permanent blue, all in the blue-violet range)

This lesson explores the blues. Cerulean is a stiff, dull, opaque paint compared to the more intense, semitransparent manganese blue. Phthalocyanine blue is the most intense of all, but because it can overpower all mixtures, it must be used with great caution. Use cobalt

blue if you already own it, but do not buy it otherwise. Real cobalt blue is expensive, and you can easily approximate it by mixing one of the greenish blues listed above with ultramarine blue.

Color Lesson 5: Yellow/Violet Complements (Chapter 13)

- white
- cadmium yellow pale
- cadmium yellow light (or medium)
- yellow ochre
- Liquitex's Dioxazine violet
- quinacridone red (Liquitex's ACRA red or Grumbacher's Thalo red rose)
- ultramarine blue

This lesson explores the three violets at the bottom of the color wheel. To get red-violet, mix your quinacridone red with Dioxazine violet. You can use alizarin crimson if you already have that, but don't buy it, since it is not lightfast compared to the quinacridone reds. To make blue-violet, add either a little Dioxazine violet or mix a little of your cool quinacridone red to ultramarine blue to make it a more definite bluish purple.

Color Lesson 6: Red/Green Complements (Chapter 14)

- white
- cadmium yellow pale
- cadmium yellow light (and/or cadmium yellow medium)
- yellow ochre
- cadmium red light
- Liquitex's ACRA red
- Liquitex's Dioxazine violet
- ultramarine blue
- manganese blue
- phthalo green (and/or viridian)

This lesson explores the reds and the greens. Find a wide variety of greens by mixing your two blues (ultramarine and manganese) with the different yellows, and also your blue-greens (viridian and/or phthalo green) with the yellows. Incredibly bright greens can be mixed from phthalo green and the two bright yellows.

Chapter 9
BASIC COLOR THEORY

Here, briefly stated, are the ABCs of color. They will be expanded more fully in Part Three, but what follows is enough to start you off on the limited-palette lessons. As you read this section, refer often to Fig. 9-1, my Complementary Color Wheel, the 12-hue color wheel used by most artists. The colors in the left column roughly comprise the warm hues of the spectrum. Those on the right are considered cool hues.

yellow	violet
yellow-orange	blue-violet
orange	blue
red-orange	blue-green
red	green
red-violet	yellow-green

Red, yellow, and blue constitute the three primary colors—colors that cannot be mixed from any others. The triangle they form on the color wheel is called the primary triad. When mixed, red and yellow make orange, red and blue make violet, and yellow and blue produce green. Orange, violet, and green are called the secondary colors, and they form the secondary triad. When a primary is mixed with a secondary color, that is, yellow with green, green with blue, blue with violet, violet with red, and red with orange, the six colors that result—yellow-green, blue-green, blue-violet, red-violet, red-orange, and yellow-orange—are called the tertiary, or intermediate, colors. It is easy to remember these because they all have compound names.

Complementary colors are those that lie opposite each other on the color wheel. When mixed, complements produce a great many beautiful muted versions of themselves, and ultimately an off-gray neutral. The three major complementary pairs are yellow and violet, blue and orange, and red and green. Intermediate colors all have intermediate

complements: red-orange and blue-green, yellow-orange and blue-violet, and yellow-green and red-violet.

When white is added to a spectrum color to bring it up to a #2 or #3 value, it becomes a tint of that color. These are what we also call pastels. When a spectrum color has been lowered in value, either by the addition of its complement, by black, or by a neighboring dark color, it is called a shade of that color. Therefore, technically speaking, it is incorrect to speak of a shade of pink, or a shade of lavender.

Monochromatic color is a scheme using any one color plus black and white, or it can be variations of one hue (several blues, for example) plus black and white. Analogous colors are three, four, or five adjacent hues on the color wheel. They relate more harmoniously when a common primary color is present in all of them. For example, yellow is common to all colors in a sequence of orange, yellow-orange, yellow, yellow-green, green.

The basic color theory outlined above can be found in almost any art book or color course, but its practical application to achieving the effects of light and shadow and three-dimensional volume is not often spelled out. Nonetheless, in realism, color's relationship to light and shadow is logical, and as you progress through the book you will come to understand that logic and know how to use your pigments to express any kind of light and shade effects.

LOCAL COLOR
We have been concerned before this with finding local value, the **middle tone**, for all objects. From now on that becomes local

color, meaning the actual color of an object. Tomatoes are red, green peppers are green, lemons are yellow, and so on. We see almost pure local color whenever there is diffused, or ambient, lighting. Local color can be characterized in these four ways: by *hue* (red, blue, yellow, green, etc.); *value* (lightness or darkness); *intensity* (brightness or dullness); and *temperature* (warmth or coolness).

When trying to find and mix a specific local color, use the same sequence listed above. Decide on its hue family first, selecting the nearest equivalent from among your tubes of color. Then raise or lower it to its proper local value. Use white to lift its value, and lower it with black or with its complement. Next, consider the color's intensity, its chroma. Relatively few things in our world are pure, intense hues; most are somewhat muted in color. Use a bit of black in the early lessons, and a touch of the color's complement in later lessons. A local color is intrinsically either warm or cool in temperature by virtue of its position on the color wheel. When modeling

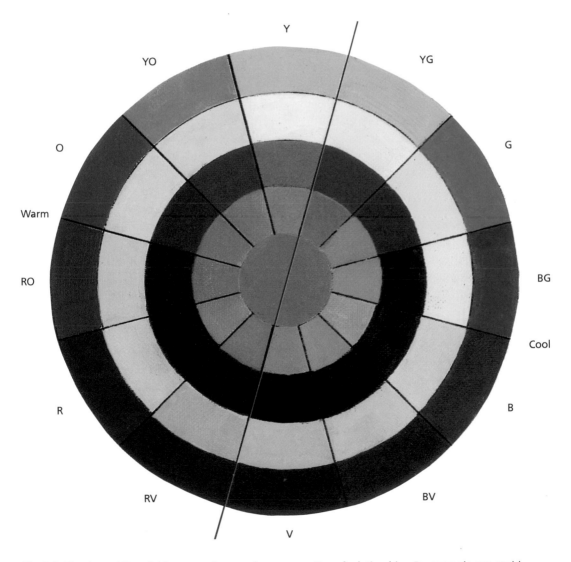

Fig. 9-1. The slanted line divides warm from cool colors on this Complementary Color Wheel in only the broadest sense. Color temperature is always a matter of relationships. For example, we could arrange five slightly different red papers in a warm-to-cool sequence.

forms you must further warm or cool the color according to the temperature of your light source. Train your eyes to see that local colors get warmer and lighter in the **light** areas of forms under an incandescent lamp (or the sun) and, conversely, cooler and darker in the **dark** areas of all forms. Imagine the vast difference between radiant hot sunlight and cool deep shade. Your color temperatures should be that well defined.

An incredible number of both muted colors and neutrals can be mixed from one pair of complements plus white. Those subtle intermixes between two bright parent colors should become the very backbone of your color vocabulary. If you follow the exercises diligently, gradually you'll learn to control color, keeping your local hues bright and pure when that's called for, slightly muted for other subjects, or completely neutralized when needed, just as if they were regulated by a dimmer switch on a light fixture.

THE FORM-BUILDING FORMULA IN COLOR

Let's consider how different light sources affect the basic form-building formula. In incandescent light or sunlight, **highlights** on objects will be warm white tinged with yellow, yellow-orange, orange, red-orange, or red. In very cool fluorescent light, reflected outdoor light from the sky, or light from a window, **highlights** will be a cool white tinged with blue-green, blue, blue-gray, blue-violet, or violet. Study the three blue vases in Fig. 9-2. The cool blue **highlight** on the vase at left appears to reflect blue sky coming through a nearby window. The middle vase (and its table plane) is struck by a warm light, while the gray, weak **highlight** on the right-hand vase denotes the diffused light of a gray, overcast day.

When an object is bathed in a warm light, the **light** area logically becomes warmer and lighter than the local color. Notice how I've changed blues, as well as values, to show that in the middle vase. Under a cool light source, it follows that the **light** area would be cooler and lighter than local color, as it is in the vase at left. No matter what the temperature of the light source is, remember that **highlight** and **light** are two separate factors in the form-building formula. Their difference always has to do with whether an object's surface is matte, semiglossy, or very glossy. Given a direct light source of any kind, there will always be a **light** area, but not necessarily a **highlight**.

In the context of the form-building formula, local color (in the black-and-white lessons, **middle tone**) is the one factor that serves as a constant, even though the other factors

Fig. 9-2. These three vases were painted using only the blue and orange complements in Color Lesson 4. Still, I was able to show (from left to right) a cool light, a warm light, and a diffused neutral light.

Fig. 9-3. These two pottery vases were painted with only the yellow and violet complements of Color Lesson 5. The left-hand vase is bathed in a warm light and has cool form and cast shadows. A softer, cooler light envelopes the right-hand vase, so that its **dark** form shadow and cast shadow are warmer. Note the warm **reflected light** on its back edge.

Fig. 9-4. The local color of both these clay pots (painted with only the red-orange and blue-green complements of Color Lesson 3) is the same, but one is lit by warm light and the other by cool light. The left-hand pot has a **light** area warmer than its local color because the cool viridian was removed. The **light** area of the right-hand pot contains more viridian than necessary because I was exaggerating the cool light.

change according to the temperature of the light source. Note the slightly muted (with orange) ultramarine blue I used for the local color of all three vases in Fig. 9-2. Then study the similar local colors of the two pottery vases in Fig. 9-3. Exceptions occur when the light source itself is strongly colored. Local colors are definitely rosier during a dramatic sunset, and are altered strangely by some kinds of street lamps.

Local color occupies a large part of a form seen in neutral ambient light, but the moment a direct light is turned on a subject, the area of local color diminishes in size, though not in importance. When modeling forms in light and shadow, take care not to lose that essential

ingredient, or your viewer will be puzzled by your illogical color notations. When you become overzealous in warming and cooling the **light** and **dark** areas, the local color can disappear. Restate it, if necessary. Always preserve the integrity of the local colors in your paintings.

Under a warm, direct light source, a form shadow (**dark**) is cooler, darker, and more muted in color than the object itself. Conversely, under a cool light source, a form shadow is warmer, not very much darker, and more muted than the object's local color. Compare the form **darks** of the vases in Fig. 9-2 and those in Fig. 9-3. Then look at the two clay pots in Fig. 9-4.

An object, especially a spherical one, may have two or three **reflected lights** in the **dark** area, but these have little to do with the local color of the object itself. One may be a reflection of the surface on which the object rests; another may be a bounce of color from a brightly lit object nearby. A third may show the influence of another surface behind the object, as shown in the green apple in Fig. 9-5A. Sometimes you may actually see these **reflected lights** and other times you won't, but you may want to invent them to enhance the form; just don't overdo it. A good way to keep **reflected lights** subtle is to paint them wet-in-wet. That means bringing the **dark** to the edge of an object, then loading a brush with the slightly lighter **reflected light** color and depositing it into the wet **dark** paint, taking care not to blend it in completely. Setting logic aside for the moment, consider making **reflected light** a completely arbitrary color with no reference whatever to objects or surfaces nearby, if it suits your purpose. Do you need to repeat a color that is elsewhere

in the painting to tie it in with the color harmony? Fudge a little by adding a subtle touch of it as **reflected light** in the **dark** area of one or more objects.

In sunlight or incandescent lighting, cast shadows, like form shadows, will be a somewhat cooler, darker, and more muted version of the local color of the surface or object they fall on. In cool fluorescent lighting they will be relatively warmer than the color of the surface or object. Nearby objects and planes often bounce reflected light and color into cast shadows, thus relieving their density. The very object that casts the shadow may reflect a subtle touch of its own color down into it. Even if it doesn't, I invent it sometimes just to keep the cast shadow luminous. As with all reflected color, the value must be slightly lighter than the cast shadow itself, as in the apple's cast shadow in Fig. 9-5A. If it is too light, it will pop out and destroy the shadow. If it is darker than the shadow, it will look merely strange, just as it does in Fig. 9-5B.

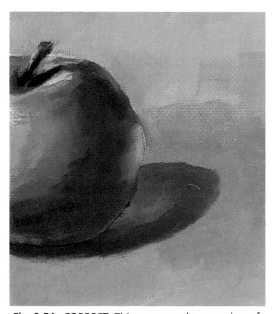

Fig. 9-5A. *CORRECT*: This green apple, a preview of the red/green complementary colors, has three reflected colors: one from the tablecloth underneath, blue on the right-hand edge, and orange near the top from other objects nearby. Its cast shadow also has reflected color in it, this time from its own local color.

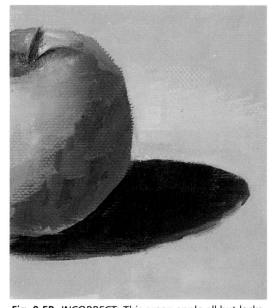

Fig. 9-5B. *INCORRECT*: This green apple all but lacks the nuances of reflected colors. Where an attempt was made by this hypothetical student to throw some of the apple's local color into the cast shadow, the value was too dark. Instead of a luminous cast shadow, the reflected color looks more like a green stain on the tablecloth.

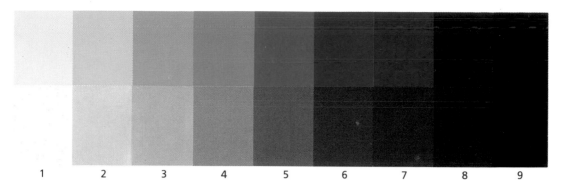

<div style="text-align:center">1 2 3 4 5 6 7 8 9</div>

Fig. 9-6. Here is a monochromatic blue-green sequence matched value for value with an achromatic gray scale. From the intense #5 value chip on the scale, the color becomes progressively less intense when more white is added, and less intense again when black is added.

In the first two color lessons, you will create cast shadows by adding a small amount of black to the color of the surface they fall on. Subsequently, you will render cast shadows with the complement of the surface color.

As you work your way toward using more and more colors in each successive lesson, you may become confused when trying to model forms with value and temperature changes simultaneously. If that happens, always opt for the proper values of the form-building formula. Forget about warm and cool temperatures for the moment. I promise that everything will eventually fall into place.

MONOCHROMATIC COLOR

The monochromatic sequence is the logical first step into color after the black-and-white lessons of Part One because values are still easy to control. Since both the subtle gradations of light on flat planes and the modeling of forms are indeed sequences of color and value, begin to think sequentially from now on. Use sequences that flow logically from one step to the next—from light to dark, warm to cool, bright to dull, or combinations of these. As you do the color charts at the end of the next few chapters, you will be building a vocabulary of sequences that should influence your color thinking in the future.

A simple monochromatic scale is similar to the achromatic gray scale except that each value step is colored with the selected hue, as you see in the blue-green scale in Fig. 9-6. Each one of the 12 spectrum colors has its own intrinsic value level when at its maximum intensity, and that of blue-green is usually a #5, as it is on this scale. In the process of changing values by adding increasing amounts of white above the point of maximum intensity, and black below it, you significantly reduce any hue's intensity.

Because of this, a monochromatic sequence—for instance, light blue, middle-tone blue, and dark blue—is always the most monotonous approach to modeling forms or creating gradations on flat surfaces. More significantly, it doesn't allow for any change in color temperature, which must happen to color if the light source is a warm one. Thus, you should use a monochromatic sequence only under a very few conditions. You can do so when the prevailing light on your subject is neutral, as on a heavily overcast gray day when no warming and cooling of colors can take place because the sun is solidly obscured. On such a day the values would be closer than usual when modeling forms, and cast shadows would be nonexistent. Look again at the blue vase at right in Fig. 9-2. To gain practice in handling monochromatic color, when you do the exercise that follows this chapter, focus the lamp on your setup so that you can see form and cast shadows easily, but ignore whatever temperature changes you detect from the lamp's warm influence.

Monochromatic color is sometimes a necessary limitation in various printing methods. In the book and magazine industries, a publisher may require that illustrations be done in monochrome, sometimes in part to avoid the extra cost of full-color reproduction. Fine artists who work in lithography, etching, and silkscreen often limit themselves for esthetic as well as practical reasons to one color, black, and the white of the paper.

THE BEHAVIOR OF MONOCHROMATIC COLOR

Monochromatic color is inherently weak in the upper values. To understand this, look at the red cone and its corresponding monochromatic red scale on the left in Fig. 9-7. In both, the local color is ACRA red (Liquitex) of a #5 value. Restricted to a monochromatic palette, I had no choice but to lift the red with white in the **light** and to

darken it with black in the **dark** form shadow of the cone. The addition of white alone results in the chalky, bleached-out look that is the hallmark of the inexperienced artist. Note the weakness of the pinks at the high end of the left-hand scale. The addition of black in the **dark** form of the cone results in a dull maroon color, as it does in the bottom values of the scale. In the sense that the **light**, **middle-tone**, and **dark** values are right, the left-hand cone is certainly an acceptable three-dimensional volume, though it does not measure up to one that also expresses the warmth of the lamp that illuminates it, as the right-hand one appears to do.

HUE VARIATIONS IN MONOCHROMATIC SEQUENCES

That sounds like a contradiction in terms, but in its broader sense, the word monochromatic includes variations of a single hue—for

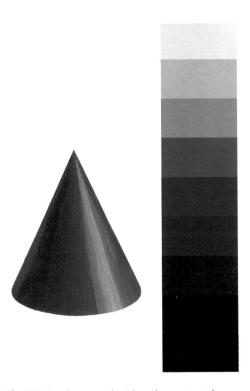

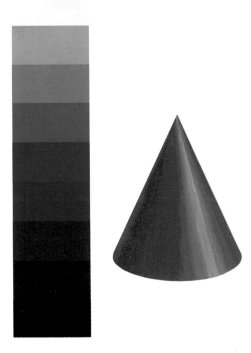

Fig. 9-7. See how much richer the cone and accompanying value scale look on the right, where I've used two reds. I call this an expanded

monochromatic sequence, and use it often to keep red things saturated with color rather than letting them turn into weak pinks in the **light** area.

Fig. 9-8. Here again is the difference between a simple monochromatic sequence and an expanded one. The left-hand cylinder has a cobalt blue **middle tone** that has simply been lifted with white and darkened with black to model the form. The right-hand one is enriched by a sequence of blues, from the greenish-blue manganese in the **light**, to the **middle tone** cobalt, and then down to the blue-violet ultramarine in the **dark**, thereby needing very little black.

example, as here, the ACRA red on the left half of Fig. 9-7 and the cadmium red light on the right half—plus black and white. The local color of both scales is ACRA red, but in the right-hand one I mixed a little cadmium red light with it in the upper values so that the pure red changes to a more orange red, thus reinforcing the tints. The lower values are still just the ACRA red plus black, so they remain the relatively cooler maroon. That means that a modest warm-to-cool temperature shift is taking place in both the scale and the cone at right.

I will refer sometimes to working with slight hue variations as an "expanded monochromatic sequence." That is just the beginning of my oft-repeated conviction that good rich color comes from changing the hue, value, intensity, and temperature at the same time when modeling forms or running gradations across a plane.

Blues are a special case on the color wheel in that a nearly pure, "true" blue like cobalt is warmed in either direction—by a bit of yellow in the greenish blues (cerulean, manganese, or phthalo blue) that go up the wheel, and by a bit of red in the blue-violets that descend the wheel from cobalt blue. In theory, then, cobalt should be the coldest blue of all, but that isn't

necessarily true, since all color temperature is relative. Some artists think of the range of greenish blues as being colder than cobalt and ultramarine, but I think of them as being warmer because they're closer to the greens and yellows at the top of the circle. Compare the two blue cylinders in Figs. 9-8. The left-hand one was painted in a simple monochromatic sequence with just cobalt blue, black, and white. I painted the right-hand one using a sequence of three blues— manganese in the **light**, cobalt in the **middle tone**, and ultramarine plus a little bit of black in the **dark**. Manganese serves quite well as a warmer bright blue that could indeed result from a warm lamp focused on it. Remember this expanded monochromatic blue sequence when you do the blue/orange lesson in chapter 11.

An absolutely essential case for lightening and darkening a color with versions of itself is yellow. As you will find in the color lesson in the next chapter, a bright yellow turns olive greenish or chartreuse if it even bumps up against a bit of black on the palette. More than any other hue, it loses its identity in mixtures with black. To keep yellows from turning green when modeling forms, use an expanded monochromatic sequence.

Color Lesson 1: Monochromatic Color

Color Chart Assignment

Do a nine-step simple monochromatic value scale like the one in Fig. 9-6 using black, white, and phthalo green (or viridian). Make the chips approximately 1 × 2″ wide, and match their values to the nine-step black-and-white value scale you did in Part One. Because phthalo green is very transparent and comes out of the tube way below its maximum intensity, lift it with a little white until you find its brightest color, which should be about a #5 value. Mix a lot of that color, and then add more and more white to find the four steps above it. Then add increasing amounts of black to find values #6 through #9.

phthalocyanine green

viridian

ivory black

titanium white

Still-Life Assignment

Beg, borrow, or buy in thrift shops several objects that are blue-greenish (aqua, teal, turquoise, etc.). You will find that some are greenish blue-greens (as mine are in the accompanying step-by-step photos), while others may be bluish blue-greens. No matter, treat them all as if they were exactly the same hue and use your viridian and/or phthalo green in all their values and intensities. Though they are virtually the same hue, be aware that viridian is a weak color and phthalo green is a powerful staining pigment.

Group the objects with one or two of your black, gray, and white props from Part One. Use eggs or white onions for organic contrast, placing them on a turquoise napkin, mat, or piece of paper. Look for that color to bounce up as **reflected light** under or on the back edge of the eggs and onions. If you are using a glass or silver item in this lesson, consult chapter 12 for help in rendering these exceptional materials. Stay with simple shapes that show their basic forms.

First find the correct local color for each item in your setup before beginning to model any forms. In the background, run a gradation from pale aqua to a medium dark gray or, conversely, from a pale neutral gray to a medium dark blue-green. Avoid (forever!) a boring monochromatic gradation of pale, middle tone, and dark viridian or phthalo green. At least let the neutral grays provide a modest relief from the sameness of one hue in this lesson.

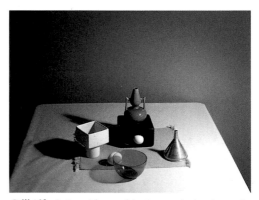

Still-Life Setup. These objects are obviously made up of basic forms. Look for your own props with basic forms in mind, as well as a single color to combine with black and white.

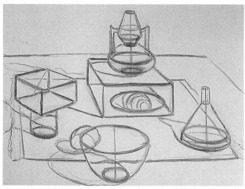

Step 1. The drawing shows structural ellipses on the rounded forms, as well as the converging lines that diminish the square forms in space. There are examples of both one-point and two-point perspective in this composition.

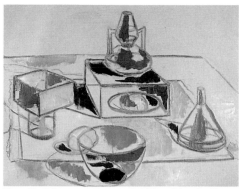

Step 2. Color swatches are laid in with a knife to show local colors for all objects, as well as a few dark values for the cast shadows. I compare colors and values constantly with one another and with the actual props.

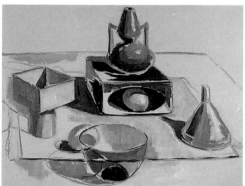

Step 3. Satisfied with all the color relationships, I begin to model the forms, looking for **highlight**, **light, middle tone, dark**, and **reflected light**. I could see the egg casting its subtle shadow on the "floor" of the black box.

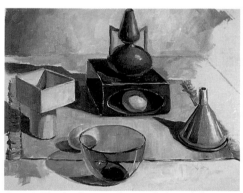

Step 4. The background, a gradation of the black, white, and blue-green, is laid in now. When working monochromatically, weave your single hue throughout the painting to tie subject and background together.

Step 5. Studying the finished painting afterward, I see areas that could be softened, especially the lines of fringe on the placemat on both sides. It was fun to do the texture of the fringe but, perhaps as a result of the challenge, it attracts unnecessary attention. What's more, it is too parallel to both the white vase on the left, and the funnel on the right, real compositional problems.

Chapter 10
HOW COLOR FUNCTIONS IN REALISM

In works abstracted from nature, color can be arbitrary, even extraordinary—color for the pure exhilaration of it and not for any descriptive or form-building qualities. In abstract art we can accept large areas of flat color, or even, in more figurative work, a purple sky, pink trees, and orange grass. But this approach to color simply doesn't work in classic representational art. Instead, realism demands what I call *functional color*—color that describes three-dimensional volumes and planes under specific light conditions. Anyone intent on accurately recording the natural world in paint must understand the inseparable relationship of the light source to the colors of subjects bathed in that light.

The difficulty in teaching about color and light is that they are seldom absolute constants. In nature colors change continuously according to the direction, intensity, and temperature of light sources, the time of day or night, and the weather conditions. Adjacent colors also affect a given color. And two individuals observing the same subject from different vantage points will have divergent perceptions about its color. How, then, is it possible to say that an object is a definite, specific color, and that the color should be mixed with such-and-such pigments? We can come to terms with the problem by building on conventions that have come down to us from our art ancestors, and by honing our perceptual skills. As you may have discovered already, working with still life under a controlled light is a great way to begin to nail down basic truths about color and light; this approach will enable us to deal more assuredly with capricious outdoor light.

WITHOUT LIGHT COLOR DOESN'T EXIST

Without light there simply isn't any color at all. None whatever. Imagine a pirate chest open to reveal a treasure of gleaming gold and silver coins, sparkling jewels, rich-hued fabrics. Now mentally close the lid. Do you imagine that the treasures retain their full spectral splendor in the darkness of the chest? They do not. They are absolutely colorless. Only when the lid is lifted a crack will the contents begin to have a bit of color. The same thing is true of a garden full of flowers viewed on a dark moonless night. It isn't that we can't see the yellow, orange, red, and violet flowers because of the darkness; it is rather that they actually are colorless without light. In landscapes, diminishing light causes continuous color changes; imagine a rosy sunset fading gradually into a luminous twilight that deepens into colorless darkness.

White light includes all colors in the spectrum. When light rays strike an object, some of the spectrum colors are selectively absorbed by its surface. The remainder of the light rays bounce off it and are reflected. A red object absorbs all colors in the spectrum except red; that is why the object is red. When all spectrum colors are totally reflected, the object looks white to us. Conversely, when all colors are equally absorbed, the object will appear to be gray or black. Light is the cause of color, and color is the effect of light.

HOW COLOR IS AFFECTED BY DIFFERENT KINDS OF ILLUMINATION

Before the 1950s, street lamps were incandescent bulbs in globes that glowed

softly yellow. They were replaced by cool, bluish mercury bars of light. In the last decade or so, these have been largely replaced by orange-hued sodium vapor lights that do strange things to natural colors. Under a sodium lamp, the gray cement sidewalk looks peach, green grass and trees look olive-brown, and the blue car parked at the curb looks decidedly gray. Many people are not even aware of these weird and unnatural color changes. Thanks to a phenomenon called color constancy, the natural color of an object, rather than distorted color, is perceived.

Colored lamps help us understand a problem called *metamerism*. A manufacturer may create a line of consumer products—such as towels, sheets, draperies, and rugs—that are designed and dyed to coordinate with one another. But when the various goods are assembled, their colors don't match. The matches may hold in some lighting situations but not in others. Colors are said to be metameric when this happens. Before you purchase matching accessories or anything else in a store with fluorescent lighting, ask to look at them in daylight and tungsten light.

Artists are sometimes jolted by the color transformation that takes place when a painting executed in a studio under cool north light conditions is then hung in a gallery under warm spotlights. The opposite can happen too; the exhibition space may have daylight or fluorescent lighting, while the works were painted under studio lighting, which is usually a combination of fluorescent and incandescent lights. The best way to beat that problem is to work under both daylight and studio lighting conditions on your paintings so that they are less likely to be shocking in another context. By the same token, if you are considering purchasing a painting, ask if you can first hang it in your home for a few days.

Study the influence of strongly colored blue-green mercury lamps and orange sodium lights on various surfaces at night, compared to natural sunlight in the daytime. Notice how everything loses its normal local color/**middle tone** entirely under the colored lights at night, and how **highlight**, **light**, **dark**, and **reflected light** areas are also affected. Then note carefully how local colors retain their natural color under normal sunlight, and to a great extent, under the influence of warm tungsten lighting. What happens to the modeling of forms after that is a simple matter of addition: **Middle tone**/local color plus a warm light source equals warm **light** and **highlights** on forms, but cool **dark** form shadows and cast shadows. Conversely, **middle tone**/local color plus a cool light equals cool **light** and **highlights**, but warm **dark** form shadows and cast shadows.

That's what functional color is all about. However, to achieve good results, your values have to be right according to the form-building formula, no matter what. Be sure to always lift the **light** area high enough in value above **middle tone** if there is a direct light source. Adding yellow alone in the **light** sometimes brings the value up high enough, but most often you will also need that bit of white. (Not every color should be warmed with yellow, as you will see later.) If you are ever unsure about the lamp's influence on your still life, turn the light off for a moment, and see how surprisingly dull the setup looks without it. It is the difference between a gray day and a sunny one.

While bright sunlight or incandescent light suffuse everything with a warm yellowish glow, cool daylight and most fluorescent lights bathe objects in a cool bluish light. It is an oversimplification to imply that you should add blue to everything that is in cool light, but let that stand for now.

When there is no direct light source, either warm or cool, the diffused ambient daylight would be simply neutral. That happens when the weather is cloudy, and during the last gasps of twilight, in the neutral monochromatic grayness that exists just before night falls. Except under those conditions, the **light** and **highlight** areas of your subjects should always be warmed or cooled. Using white straight out of the tube

denies a warm light source, though it will do for a cool light in a pinch. Although some oil whites are warmer than others, that little bit of warmth is not sufficient to convey a warm light source. You'll need to reach specifically for a touch of yellow, yellow-orange, orange, red-orange, or red, plus white, to achieve the desired effect.

FUNCTIONAL LOCAL COLOR

Compare the four pottery goblets in Fig. 10-1 to see how far we've come in translating achromatic values into color under three different lighting conditions. The three goblets on the right could not exist side by side that way, but their proximity makes the color and value differences among them quite obvious. The goblet on the left is like a review of our earlier lessons in modeling forms with achromatic values. I established its **middle tone** first; in this case, about a #5 value. Then I modeled it from **light** to **dark**, and put in

highlights and **reflected lights** where applicable. Remember, all rounded three-dimensional forms under a single light source need those five values to make a satisfying volume.

The basic formula becomes a framework that from now on will be clothed with color as well as value changes. Think of local color as a given that must be understood and accepted instantly by the viewer. Model each form with as distinct color and value shifts as you dare, but don't ever lose the basic ingredient of the recipe, local color. Need I remind you that it will follow the pattern of **middle tone** for the four basic forms and all things derived from them? The pattern, the shape, of local color on a cylinder is utterly different from the shape of local color on a sphere, cone, or cube.

Warm local color in the **light** and cool it in the shade. With the black, white, and yellow lesson accompanying this chapter, you will have the means to warm everything beautifully. With each succeeding lesson you

Fig. 10-1. The pottery goblet on the far left shows how this particular piece would look when translated into the achromatic values of Part One. The other three goblets represent different light conditions, painted with only the blue and orange complements of Color Lesson 4. A warm light hits the goblet on the left, causing it to cast a cool shadow. The middle goblet languishes in a neutral kind of twilight and has no cast shadow to speak of. The right-hand goblet shows the influence of cool daylight and therefore has a softer value modulation and warm cast shadow.

will have some ability to warm colors in the **light**, and to cool them in the **dark** form and cast shadows. When you change color and value simultaneously across any form or plane, you are inevitably warming and cooling colors to some degree. That's what will turn the light on in your paintings.

AVOIDING CHALKY COLOR

A common flaw in amateur artwork is weak, chalky color, the primary cause of which is failing to take into account the temperature of the light source. When you add only white to the local color of an object, you are regressing to monochromatic color and effectively negating the warm light of your lamp or the sun. Chalky color also results when you judge the local color of an object to be lighter in value than it really is. The top lemon in Fig. 10-2, for example, was rendered with a weak, #2-value pale yellow as the local color instead of a proper rich #3 yellow. This lemon is a pastel fruit that does not exist. Compare it with the lemon below it. If anything, enhance your local colors; make them richer in color and slightly lower in value, rather than higher in value and weaker in color. Equate white paint with bleach and ask yourself, "Do I really want weak, bleached-out colors in this painting?" No! Plan carefully when finding local colors. Don't let a pasty color force you too high in value too soon. On the other hand, don't make local colors so dark that you are forced down into the wrong range of values for that object.

My continual warning against using too much white paint often boomerangs. When students finally get the message, they overreact and are afraid to add white under any circumstance. They downgrade the values of objects that belong in the top third of the value scale, making them too dark to start with. Never hesitate to put the needed amount of white in a local color to place it clearly in the upper range of the value scale! Students also become timid about adding that bit of

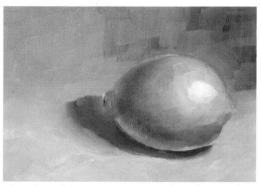

Fig. 10-2. *Above, INCORRECT*: Students frequently think a lemon's local color is cadmium yellow pale (or lemon), but if you smear a bit of that color on an actual lemon, you will be surprised. *Below, CORRECT*: I used cadmium yellow light here and then the lighter cadmium yellow pale in the **light** area. Always plan ahead, remembering that **highlights** won't "snap" if placed in a chalky environment.

white in the **light**, along with the warm color, which lifts it higher than **middle tone**. Study the differences in the three eggs in Fig. 10-3. The top two have faulty local color and modeling problems. The bottom egg has proper colors and values for something in the top third of the value scale.

MODELING FORMS IS A THREE-STAGE PROCESS

Get into the habit of finding and mixing colors to represent the basic formula this way:
1. Judge and mix correctly as best you can each local color of all major elements in your painting. Use any pigments necessary. With your painting knife, put a large color swatch in the middle of each object in your

Fig. 10-3. The local color of the top two eggs is darker than the light neutral value they should be. In the top example the hypothetical student also failed to model the form of the egg, though an attempt was made to warm the egg in the **light**. The middle egg is better modeled, but the whole range of values is too dark. In the bottom example, the student started off with a light pearl gray for the white egg and maintained the proper value range while modeling the form.

composition. Follow its basic value pattern somewhat, a straight swath of color on a cylinder, a curving one on a round object, and so on. A knife mixes color cleanly and also lifts more paint up onto the canvas for further manipulation with a brush. Compare all color swatches in your painting to one another and to the actual objects in the still-life setup. Even try

holding the paint-loaded knife blade against the fruit, the vase, etc., to see how well the color matches.

2. Mix the color values for the **light** and then the **dark**, warming or cooling them according to the light source. You should have three different colors of different values that work in a pleasing sequence, as they do on the potato, onion, and salt shaker in Fig. 10-4.

3. Finally, coax (don't mop) all those color swatches together with a brush, not the knife. Model all forms with brushstrokes that follow the contours of the objects. For example, strokes on cylinders will be vertical and rather long, while strokes on round objects tend to follow the contours of the sides and the bottom crescent, but straighten out in the middle section. This is a fairly natural instinct. Occasionally stroke across rounded forms, following the ellipses rather than the contours to convey perspective. A piece of hand-thrown pottery often shows those ellipses clearly.

The foregoing is a system of color notation, a kind of shorthand, that will be helpful for years to come. When time runs short as you paint, use your color swatches later on to finish the painting with a fair degree of

Fig. 10-4. Mix three distinct color values that represent the basic warm **light**, **middle tone**, and cool **dark** for each major object in your setup. If you only mix the local color/**middle tone** and then try to coax it up to **light** and down to **dark**, the modeling may not be decisive enough.

Fig. 10-5. *Left, INCORRECT:* The cast shadow tells us that the light is coming from the left, but the light yellow and green blotch on the right contradicts that. Even if the apple really looks this way, we still can't get away with anything so illogical as lighter values in the **dark** area than there are in the **light**. *Right, CORRECT:* The green and yellow have been dropped in value and intensity to fit into the **dark** form shadow.

accuracy. Especially make color value notes about anything that departs from the classic pattern on a form, such as a shadow cast on it, a bit of reflection from another object, or a particularly striking **reflected light** bouncing back into the **dark**. If your color value notations are accurate in the first place, you have only to coax them together and you may be finished, having achieved an enviable fresh alla prima painting. Then leave all successful passages alone! Right the first time is what we are all striving for in our color notations, like a golfer shooting for the green.

MULTIPLE LOCAL COLORS

The three-stage process of modeling forms doesn't cover the problem of painting objects that have several local colors. Imagine a red apple that has yellow-green patches on it, or a peach that has blushes of red. They present no problem when the lighter colors fall handily in the **light**, and the darker patches are in the **dark** of a form. But frequently you'll be faced with dark patches of color in the **light** area and light patches on the **dark** side of an uncooperative fruit. The easiest solution, of course, is to simply turn the fruit around. If that isn't possible in a class situation, don't fall into the trap of painting improper values, as in the left-hand apple in Fig. 10-5, just because that's what you see.

Fig. 10-6. This silk scarf was painted with the black, white, and yellow colors of the lesson at the end of this chapter. Keep a print like this subordinate to form, and make the printed pattern conform to the perspective of the rolling folds and the table plane.

Instead, sacrifice those bright colors and adjust them to keep the modeling consistent with the direction of light in your painting, as I have in the right-hand apple.

There is yet the more difficult problem of modeling a print fabric, a woven basket with many colors, or a tree trunk alive with patches of lichen. No matter how many local colors there are in a single subject, each one should be established in **middle tone** and then modeled with appropriate color values . . . to a point. When there are too many colors, as in the print scarf in Fig. 10-6, it is better to model the folds with one solid color and then lightly dash in the other colors wet-in-wet. When

Still-Life Assignment

Because yellow changes to another hue when mixed with black, instead of this being a simple monochromatic lesson, it becomes an analogous lesson that goes from almost yellow-orange to yellow to yellow-green on the color wheel. Beginning with this color lesson, get in the habit of mixing color in large "puddles" of similar hues on your palette. For this lesson you might have one puddle of pure yellows and yellow tints; one puddle of bright chartreuse-like greens (cadmium yellow pale and a little black) and their tints; one puddle of olive greens (cadmium yellow light or medium and black) and their tints; one puddle of ivory, beige, ochre, tan, and browns. Finally, have one last puddle of black and white and the achromatic grays in between.

Produce is easy to find for this lesson. Lemons, grapefruit (more interesting when cut in half), avocados, yellow crookneck squash, bosc pears, and even bananas will work well. The ideal setup would be one with something from each color group listed above, even if you have to mix fruit and vegetables, as I did in the step-by-step photos shown here. Just remember that if you are not careful about keeping yellow objects bright and clean by using the three yellows in a sequence, you will have too much green in the painting. For the background, plan a gradation that goes either from yellow to green, or from one color to a neutral gray, changing both hue and value in the gradation for more interest. Use your colors and values to balance the painting and to play off your objects to best advantage.

Still-Life Setup. I've chosen a glass jar with split peas, a dark green bottle, and a vase with dried weeds.

Step 1. Notice how much I've relied on ellipses in doing this drawing. I've already drawn in all cast shadow shapes, but note that the vase's reflection is what I see on the top of the shiny box, not its cast shadow.

Step 2. I laid in all local color/**middle tones** with a knife. The gray-green rice bowl was mixed from black, white, and just a little cadmium yellow pale. The tablecloth, the split peas, and the dark bottle are all variations of olive green.

Step 3. I continue by laying **light** and **dark** values on the various forms with the knife, and then, putting the knife aside, I begin to coax the values together with a #7 bright brush. Note that I am beginning to paint what's behind the tall dark bottle, even to model the lemon behind it. I can't model the top part of the jar of split peas because it is transparent, so I have to make the peas themselves show the jar's cylindrical form.

Step 4. I've indicated a cast shadow on the apple behind the vase and black box, but kept more of the apple in light than is shown in the actual setup. The clumps of dried weeds are modeled slightly as small subforms within the mass. At this stage I decided to paint a dark background behind the light beige weeds, and a lighter value against the dark green bottle.

Step 5. I revised the background completely in this finished painting because the contrast between the dark bottle and the light background was too eye-catching. This softer gradation, going from a gray to an olive brown, works well against the beige weeds and the green bottle. At the last moment, I added the pattern of glazes to the pottery vase, according to those on the original vase, but now feel that they unnecessarily complicate the form.

#2	#8
#3	#7
#4	#6
#5	#5
#6	#4.5
#7	#4

Fig. 11-2. This chart shows the comparative values for each of the six pairs of opposite colors on the color wheel. Yellow and violet have the greatest contrast. Red-orange and blue-green are equally intense (#5 value) and therefore seem to vibrate the most where their edges meet.

focus on them. The full explanation of this visual vibration lies in the science of optics and is beyond the scope of this book, but its application to painting is significant. If you are painting a bouquet of yellow flowers, for example, you can make them appear brighter yellow by making the background a muted violet. A vivid purple would enhance the yellows even more, but the color contrast would be too uncomfortable optically and, for most viewers, esthetically as well.

COMPARATIVE VALUES OF COMPLEMENTS

Study the value differences between each of the six complementary pairs in Fig. 11-2, which shows the colors at their maximum intensity against a gray scale that indicates their value. As you do the complementary charts in this and the next few chapters, you

will find that you have to adjust values in the upper rows much more with some pairs of colors than others. The closer the values of a pair of complements are, the easier it is to find their neutral no-color. That's one of the reasons I've chosen red-orange and blue-green for the first complementary lesson, even though neither half of the pair is a primary color; these two tertiary colors just happen to be infallible in canceling each other out to a beautiful silvery gray.

The two parent colors you'll need for your first complementary color chart, viridian and cadmium red light, are nearly perfect complements just as they come from the tube. What's more, they are relatively constant from brand to brand. I must clarify viridian's position on the color wheel, though; its precise hue is actually green-blue-green. It needs a bit of cobalt or ultramarine blue in it to qualify as a true blue-green, the exact complement of red-orange. However, viridian will work well enough in this lesson, and you should have no problem in finding gray with it when you mix it with cadmium red light.

Observe that in any of the complementary charts in this book, the warm complement is placed in the lower left corner and the cool one in the lower right. The bottom row is the result of mixing the two parent hues into each other gradually. By adding white vertically, in increments, to each bottom chip, we arrive at a matrix of color values with horizontal rows that flow from warm colors on the left, through browns of some sort, then grays, and finally into the muted cool colors on the right. You may well question calling some of the neutral color samples "gray" when they are far from a true achromatic gray. In theory, any pair of complements mixes to become a gray, but color scientists refer to complementary grays as the "lively grays," a forgiving term for the off-beat neutrals that often result from mixing opposite colors.

Depending on which brands of paint you use, you may not nail down the gray neutral immediately, or you many never find it. Warm

rusts and browns, on the other hand, are easy to find. That's because two of the three primary colors involved in any pair of complements, red and yellow, are warm colors. When you keep getting browns in your search for gray, it's because there is not enough blue in one of the parent colors to neutralize the brown. Other times you may find that the mixture is too greenish, meaning that it needs a spot of red. Still other times, the mixture will be too purplish and needs a bit more yellow. When doing your complementary charts, find the best neutral you can with your pigments for the middle vertical row. The idea is to have an equal number of warm vertical rows left of center and cool ones to the right. Cheat slightly to achieve a better gray in the center row, if you wish, but please, don't reach for your tube of black or you'll defeat our purpose. While doing these complementary charts, you will be fine-tuning your sensitivity to color and value as you compare color chips horizontally and vertically.

Now refer to Fig. 11-3, the red-orange/blue-green chart. Note that each vertical row is a monochromatic value sequence for the bottom color chip. There are no changes in hue vertically, save for the slight cooling effect that adding white often has on colors. Always start any complementary chart by mixing the bottom row first, then lift each color up in value with increasing amounts of white.

In the horizontal rows, color changes hue, temperature, intensity, and value from the left to the right, at least in the lower rows. The color chips in the upper horizontal rows should be adjusted so that they are as close in value as possible. Aim to make all chips in the top row a #2 value.

Notice in the bottom rows that complements not only neutralize each other by degrees, but they get darker in the process, causing the lower horizontal rows to "sag" in value in the middle. You can counteract the natural drop in values by adding a little extra white to the middle rows as you go up vertically.

Fig. 11-3. This red-orange and blue-green complementary chart is the easiest one to do because the two parent colors, cadmium red light and viridian, come straight out of the tube. (However, I added a little of Grumbacher's Thalo green to the weak viridian to strengthen the cool side of the chart.) Notice that three of the bottom color chips appear to be blackish, but additions of white reveal their color differences as they proceed vertically up the chart.

USEFUL SEQUENCES IN THE COMPLEMENTARY CHARTS

Study the various complementary color charts in this and the next three chapters to see the great number of horizontal, vertical, and diagonal sequences, or color paths, that they contain. Since all pairs of complements are composed of one warm and one cool color, horizontal and diagonal paths through the chart automatically move from warm to neutral to cool, or vice versa. Although the vertical and horizontal bands can be useful in certain situations, it is the diagonal paths throughout the matrix that produce the richest and most beautiful color sequences. If you plot a steep diagonal path, the value spread is strong enough for modeling forms whose local colors fall along that diagonal. Consider how well the gradations in a sunset sky might be served by working with the colors found along a steep diagonal in the orange and blue chart. Starting with orange and peach at the horizon, the colors in the sky would melt into a neutral and then into a muted blue twilight overhead.

Any lesser angle or horizontal path across the chart will make beautiful gradations across flat planes. Subtle though they are, these gradations help to give the illusion of planes going into depth, or of planes that show the passage of light, as the table and wall in Fig. 11-4 illustrate. Limited though I was to using just the red-orange and blue-green complements, I managed nevertheless to use a gradation from either warm to cool, or chromatic to dull, or a combination of them, on every plane in the illustration.

I call the diagonal paths through the complementary color charts "complementary splits," because the two parent colors obviously split on either side of some neutralized color between them. Color becomes warmer and lighter toward the upper left corner, and cooler and darker toward the lower right corner. A local color anywhere along the reverse diagonal path becomes cooler and lighter on the right side of neutral and warmer and darker on the left side. Which diagonal to use depends entirely on the basic local color of your subject and the temperature of the light source that strikes it. A diagonal path is always more beautiful than a monochromatic sequence. Learn to wring every color and value nuance you can out of the complementary lessons in this and the following three chapters.

Fig. 11-4. Look at the warm to cool gradation (with barely any value change) on the table plane from left to right, and also the same thing on the floor plane. Both are subtle indications that the light source is on the left. The back wall plane has a very subtle warm to cool gradation too, while the two doors have gradations from a muted color to an even more muted version of it. All these color gradations could be traced along some nonvertical path on Fig. 11-3.

EARTH COLORS VERSUS COMPLEMENTARY COLORS

Looking at the bottom horizontal rows of the color chart in Fig. 11-3 again, notice that on either side of the neutral center row, the hue remains the same, even though the color chips are darker, grayed-down versions of the parent colors. In other words, the sequence from bright red-orange on the left to rust to a reddish brown (found by additions of more and more blue-green) are all variations of the hue red-orange. Many artists use tubes of earth colors like Indian red, mars red, English red, or terra rosa to get those muted reds, but once you know your complementary mixes, you can manage very well without them.

yellow ochre	yellow/violet complements
raw sienna	blue/orange complements
English red	red-orange/blue-green complements
burnt sienna	red-orange/blue-green complements
raw umber	red-orange/blue-green plus yellow
burnt umber	red-orange/blue-green plus yellow

Fig. 11-5. This chart compares actual earth colors right out of the tube (in the left column) with their equivalents found through mixtures of complements (the right column). If you learn to work with puddles of complementary intermixes on your palette the earth colors you need will be right there.

Using opposite pure colors instead of those manufactured hues simplifies your palette and, in the bargain, lightens your paint box. The other earth colors, raw and burnt sienna, raw and burnt umber, and a host of other muted colors can all be found in the other complementary charts. Fig. 11-5 shows the complementary equivalencies in the right column for the major earth colors shown in the left column. Any purchased color is a convenience, of course, but we literally pay for that convenience in several other ways.

Suppose that you faithfully learn your complementary mixes now, but later revert to using ready-made earth colors because you already own them. Or perhaps they will be required for an art course you'll take in the future. That presents no problem, as long as you remember to warm and cool the colors on forms, as usual, according to the temperature of the light source. Unfortunately, some of my former students revert to adding plain white to earth colors to find the **light** area on forms. Rather than fuss with complements to find the color of a brown tree trunk, they'll use burnt umber as the local color and then lighten it with white, as you see on the left in Fig. 11-6. Had the same student mixed that brown with red-orange and blue-green (or blue and orange, or yellow and violet), as I did on the right, he or she would have remembered to warm and cool the local color. Burnt umber in

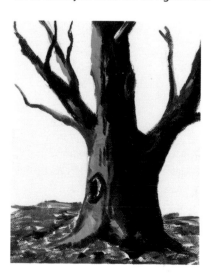

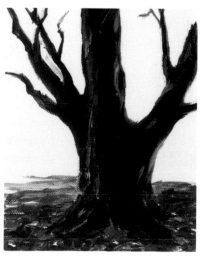

Fig. 11-6. The brown local color of the right-hand tree was mixed from red-orange and blue-green. It was then warmed in the **light** and cooled in the **dark** with a complementary split, a diagonal on the chart in Fig. 11-3. This limited palette gives the impression that the sun is setting, but that seems preferable to the dead color of the burnt umber monochromatic tree on the left.

particular doesn't seem to suggest a color path through any chart. So, use the earth colors later on, if they suit you, but remember to relate them to their theoretical complementary parents. It makes all the difference in the world between good rich color and dead color.

FINDING THE COLOR OF CAST SHADOWS

As a rule of thumb, the color of a cast shadow is best achieved by adding the complement to the color of the surface it falls on. If you've rendered a pale blue-green tablecloth using a mixture of viridian plus white, believe it or not, a little red-orange mixed into plain viridian (with perhaps a touch of white in it) will be about right for cast shadows on that surface. Your tendency may be to use viridian by itself, but that would result in a too-intense shadow, and shadows are never (well, hardly ever) intense. By adding the red-orange to mute the viridian, you have avoided the monochromatic vertical row on the complementary chart and moved on a slight downward diagonal. Compare tablecloths and the cast shadows on them in Fig. 11-7.

DIAGONAL PATHS PREVENT CHALKY COLOR

Eventually it may occur to you that the upper end of a complementary split along a diagonal path might end up in the pastel area where white prevails in the mixtures. You may ask, "Won't the warm **light** area on a form be chalky with all that white in it?" The answer is no, because along that diagonal, color is progressively warmed as you move toward the pure warm parent color on the left. (A color is still a pure hue if white has been added to it.) Your **light** area on a form will be chalky, though, if you bend the diagonal and start to go straight up from your local color along a monochromatic path. The logical flow from warm to cool would then be terminated. Never just add white to local color to find the **light** area on a form unless you really want washed-out color or because gray weather dictates that kind of treatment.

FINDING THE COLORS IN WHITE SUBJECTS

The complementary charts are especially useful when you are faced with a white

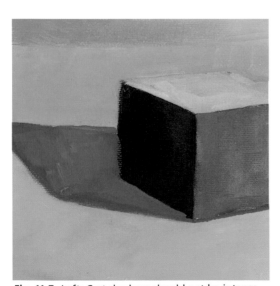
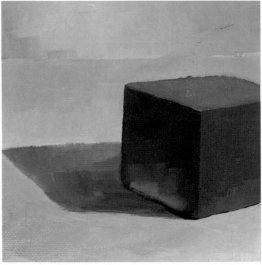

Fig. 11-7. *Left:* Cast shadows should not be intense colors, so don't merely darken the value of the tablecloth color to find the cube's shadow, as shown here. *Right*: This time the blue-green cast shadow has been muted with a little red-orange to make it

less noticeable. Then into the wet cast shadow I bounced a little lightened red-orange from the cube, to make the cast shadow slightly luminous. Note the reciprocal hint of blue-green in the cube's form shadow.

subject. With a warm light on them, they must be warmed in the **light** and cooled in the **dark** along with everything else. If you remember from the achromatic painting lesson in Part One, white eggs or onions were modeled successfully only when their local color was dropped down a notch on the value scale to a #2 or a #2.5 pearly gray. Now find that gray with the complements of the lesson you are working on, and then warm and cool it with that pair of complements, using a rather shallow diagonal on the upper part of the chart. Thus, if you put an egg in the red-orange/blue-green lesson at the end of this chapter, you would find the pearl gray first, and then warm the egg slightly in the **light** area with a tiny bit of cadmium red light, and cool it in the **dark**, lowering the gray local color with a little viridian. The local color of a white object can also be a warm neutral such as a muted beige, tan, or the soft red-browns that you see just to the left of the neutral row in the chart in Fig. 11-3. I refer to warm neutrals in a generic way as "pearly beige." Again, find it somewhere among the muted colors on the complementary chart you are working with in the lesson, and follow it down on a slight diagonal path through the neutral gray and perhaps to a slightly cooler color. When you choose a light, warm local color for white subjects because that's what you see in the still-life setup, that's fine, but it means that there will be less temperature contrast when you put the warm **light** and **highlights** on them. For that reason, I usually choose a complementary gray **middle tone** for white objects (flowers, clouds, foamy surf, and so on) so that when I apply the warm **light** color, it will snap sharply in contrast to the local color. Actually, I often use a warmer local color in clouds, knowing that it will provide a more beautiful contrast with the blue sky.

Once you've established the neutral local color of a compound subject like, for instance, a bouquet of white flowers, you can then vary the warm and cool colors as you model the individual forms that make up the mass.

Carrying that thought a step further, when you have massive amounts of white in a painting, say a skyful of clouds, a snowscape on a sunny day, or a lot of foam in the sea, use at least two pairs of complements and their neutrals to avoid monotony, not just one pair. The blue/orange pair is a good starting point in handling any large white mass, and yellow/violet would be a logical second choice, since yellow provides the maximum warmth in the **light** area of anything white. Unfortunately, the red-orange/blue-green complements have the least amount of warmth because there is only a modicum of yellow in each parent color. Nevertheless, do the best you can with them to express light and shadow, as I have in the step-by-step photographs at the end of this chapter.

FINDING THE COLORS IN BLACK SUBJECTS

Black subjects trip up a lot of students. They'll mix a black #9 value from the complements in the lesson all right, and use it for the local color of whatever black object they're painting. Then they'll add white to that for the **light** area. Such a student has already made two strikes against a successful result. First, the local color of a black object has to be about a #7.5 value so that you are able to go down to almost a #9 in the **dark**. As with white subjects, above, you have to plan ahead so you can model them adequately without running out of values. Anything black, when warmed by a lamp or the sun, becomes a muted rust, brown, rose, perhaps even red-violet. You'll find that you can always warm and cool dark brown or black objects easily with a pair of complements. The choice of which pair should depend not only on the light source and your observation, but also on your painting's color harmony.

Just as working with at least two pairs of complements when you have great amounts of white is a good idea, use two pairs of complements when working with a lot of dark

blackish objects. Black fences, rocks, black earth, black roofs, and so on, need a variety of dark warms, neutrals, and cools to keep them from being boring. We have a unique problem here in Hawaii with our black, crumbling lava rocks. They look for all the world as if they should be painted with achromatic black and white values, and many a novice artist falls into that trap. But it is better to show the warmth of the sun pouring hotly down on those black rocks. What's the use of denying the sun's influence by painting gray rocks that suggest a gray day? Using only cadmium red light and viridian, plus white, I have shown warm and cool temperature changes in the black rocks and surf in Fig. 11-8.

Just outside my studio window is a black board fence, in front of which is a vibrant red bougainvillea bush. The black fence looks brown in the sunlight, not gray, and even if I had a full palette of colors, I would probably use the red-orange/blue-green complements to paint that black fence in the sunlight, as I have in Fig. 11-9.

Fig. 11-8. Using only two colors, red-orange and blue-green, I've warmed and cooled the rocks, water, and foam as best I could with this limited palette. Fortunately, the ocean is blue-green in Hawaii, but even if it weren't, I would still be more concerned with the proper values that make this little seascape work, rather than true local colors.

Fig. 11-9. Here the dark cast shadows on the black fence were mixed with mostly phthalo green and a little cadmium red light, just as the darkest areas were in the rocks in Fig. 11-8. In color parlance, that's a cool dark, while the brown rocks and the brown sun-struck part of the black fence are warm darks, both of which are found with a minor shift in proportions of the same two colors, plus a smidgen of white. Unfortunately, the bougainvillea flowering bush suffers from a monochromatic treatment that couldn't be helped with this palette.

Color Lesson 3: The Blue-green/Red-orange Complements

Color Chart Assignment

Make a color chart with at least seven color chips across the bottom and seven going up toward white. Always do the bottom row of color chips first, placing pure cadmium red light on the left, and pure viridian or phthalo green on the right. (I used a combination of them in my chart in Fig. 11-3.) Then mix them by small increments until you find the best neutral blackish color for the middle position. No white should be added to the chips in the bottom row of any complementary chart, except for the tiny bit needed to make a transparent color opaque, as in the case of viridian or phthalo green. Test the "no-color" middle chip several times by adding white to it (on the side of your palette) to see what color it is. You are searching for a gray that is neither on the reddish side nor the blue-greenish side, but is a dead neutral. When satisfied that you have found it, and have

three warm colors to the left of it, and three cool colors to the right of it, mix a large amount of each color in the bottom row. Then run them up vertically with increasing amounts of white. As much as possible, try to make the upper horizontal rows all the same value.

When first mixing complements, you will probably go overboard time and again when looking for a certain color. In this particular case, the cadmium red light is very strong and will quickly overpower the viridian in any mixture. Conversely, viridian is relatively weak in tinting strength, and you have to add a lot of it to neutralize the cadmium red light. Phthalo green, on the other hand, is a very strong tinting color and will easily overpower the cadmium red light. Be aware of the tinting strength of every pigment you work with through Part Two, and soon you will know just how much to add for a particular result.

cadmium red light

viridian

white

Still-Life Assignment

Use some of the objects from both your black-and-white setup and your blue-green monochromatic setup. Introduce red-orange props and produce such as barely ripe tomatoes and possibly red peppers or apples from the market. The spiky red-orange flowers in my round vase, so perfect for this lesson, are from a shrub called ixora that grows in Hawaii. If the local color of any of your red-orange objects is a cooler red than pure cadmium red light, add a tiny bit of viridian to darken it.

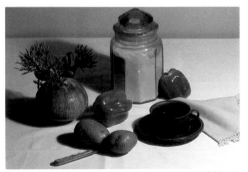

The Setup. Although I could see a range of blues and blue-greens in the glass canister, in this lesson I could use only viridian and phthalo green. Viridian alone would never give me enough intensity, but phthalo overpowers color mixtures.

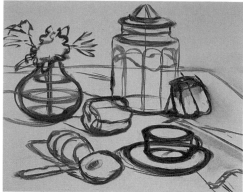

The Palette. Along the top of the palette, from left to right, are what remain from the large daubs of titanium white, cadmium red light, viridian, and phthalo green that I started out with. On the left side of the palette are four warm reddish mixtures of different values, and a neutral black mixed from cadmium red light and phthalo green. On the right are five values of blue-green, plus several neutral grays on the lower right that are lighter values of the no-color black mixture. I normally don't premix colors into separate piles like this, preferring rather to work with several large puddles of color, one for the variety of reds and browns, a second for the blue-green mixtures, and the third for the neutrals mixed from the parent colors.

Step 1. I've drawn the objects with thinned-out paint mixed from a puddle of the two complementary colors of this lesson, using brown when I draw the warm-colored objects, and blue-green for the cool-colored canister and napkin. I decided to draw the napkin so that it comes in from the lower right corner rather than from the side. It could have been a very bad arrow pointing out of the corner, but because it is wider in the corner and narrower as it goes into the composition, it now works as an arrow into the composition, not out. The napkin as now arranged also opposes the diagonal of the paring knife on the left.

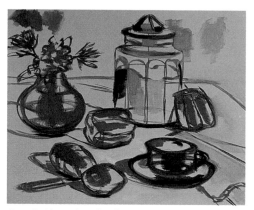

Step 2. I have just finished mixing all local colors and applying them with the painting knife. This is the stage where I check to see that the relationships are right between objects in the painting, and that they relate as accurately as possible to the actual objects in the setup.

Step 3. I've modeled all forms from **light** to **dark**, started to put in appropriate **highlights**, and just begun to put in cast shadows. The brown vase, cup and saucer, and red potatoes have all been warmed with an extra bit of cadmium red light in the **light** area because they faced the light source. They would otherwise have been dead-looking and chalky if only white had been added to their local colors.

Step 4. My tentative strokes in the background of Step 3 look right, so I develop a gradation from a muted cool blue-green in the upper left to a warm, lighter coral pink on the right, passing through a neutral gray on the way. In this painting, the blue-green in the left background was an obvious choice because it balances the glass sugar canister and the napkin on the right. Your background will tell you what it needs if you'll work on the subject first and then "listen."

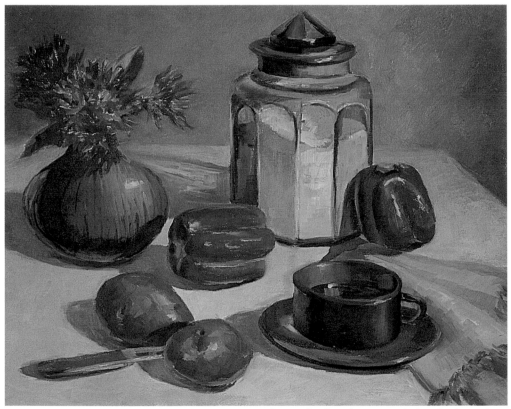

Step 5. In the finished painting, note the invented cast shadow from the flowers onto the top of the round vase, and the definite cast shadow from the red pepper. I've repeated small touches of the blue-green color here and there in this predominantly warm painting: in the paring knife, the cup and saucer, the stem end of the left pepper, and in the leaves of the ixora flowers. Their diagonal is a nice echo of the diagonals of the paring knife and the napkin.

Chapter 12
LIGHT, SHADOW, AND TEXTURE

This chapter is devoted to a further exploration of how light and shadow work, with particular emphasis on how they define the texture of all surfaces. So far I have stressed the effect of single source lighting on your subjects. Now let's add to that a secondary light source, selecting from it only what is useful in enhancing the illusion of three-dimensional form. Confusing information must still be edited out. It takes a while to know which visual information to use and which to ignore; when to paint exactly what you see, and when not to. On a fine day, nature provides us with a dominant warm light, the sun, and a secondary cool light, the sky. We can duplicate that dual light indoors during daylight hours by using a tungsten lamp on the still-life setup in addition to the light that comes in from nearby windows. Instead of ignoring the light from the windows as we have been doing so far, begin to study its effects on the setup. Ideally, the two light sources should oppose each other, as they do in nature. Set your lamp on the side of the still

life that is not illuminated by the window light. Unless you have a northern exposure, the sun will shine brilliantly through your windows for a period in the morning or late afternoon. That would provide two strong warm light sources on your subjects, an undesirable situation, so wait a while until the sun moves away.

Begin to look intently at your still-life objects for both the warm and cool color influences on them. The first few times you work with two light sources, you might confuse the cool secondary light influence with **reflected light** on objects, but they are two different things. **Reflected light** is *indirect* light that bounces back into the shadowed sides of objects from brightly lit objects or planes nearby. Secondary light is a *direct* light source, however remote it may be from the subject. Its influence is very subtle and shows up mostly in "lowlights" in the **dark** areas of objects. The cool secondary light may actually affect the whole normally shaded side of an object, but I would never

Fig. 12-1. The blue and orange complements of Color Lesson 4 work well here to show equal, if somewhat exaggerated, warm and cool lights hitting this black vase. Notice how different the two cast shadows are in color, and how they are opposite in temperature to the light source that caused them. Where the two shadows overlap, just below the vase, there is a dark black shape.

Fig. 12-2. *Left, INCORRECT*: Too many **highlights** and lowlights tend to destroy the form of this bowl, orange, and blue glass ball. The top and bottom ellipses on the bowl are flattened into straight lines, and the top one unfortunately aligns with the table line in back. *Right, CORRECT:* Here the direction and warm temperature of the primary light source on the right are clear, while lowlights and other cool touches tell us about a cool light on the left. The form-building values are organized on the bowl and orange, but they don't have to be on the blue glass ball. When you are painting a transparent subject, it works better to paint what goes on behind the glass rather than the glass itself.

let it destroy the form **dark** caused by the powerful warm lamp. Fig. 12-1 shows a rough-textured black pottery vase caught in the cross fire between equal warm and cool lights. Like almost all of the illustrations in this chapter, it was painted with just the orange and blue complements of Color Lesson 4.

LOWLIGHTS

Lowlights, small, mirrorlike reflections from the secondary light source, are the counterparts of **highlights** from the primary lamp. They are helpful because they give textural and shape information in the **dark** areas of forms. Note in Fig. 12-1 how the light blue lowlights on the left side of the vase enliven the form **dark** area and echo the vase's cone shape. Because they emanate from a light source that ideally is more remote and therefore weaker, lowlights must be downgraded in value. Let them always be subordinate to **highlights** in color as well as

value. If **highlights** on an object are a #1 or #1.5 value, then lowlights on the same form should be no higher than a #2 or #3 value. They'll work because they are in **dark** areas of a lower value, but edit them out of the **light** or **middle tone**. They are not useful there.

A glossy object will have a myriad of **highlights** and lowlights that you have to sort out, ignoring those that may come from a third, perhaps overhead, source of light. Remember that if you report each **highlight**, lowlight, and nuance of shadow from two or three light sources, the result is a confused shamble of values, mere patches of paint that do not add up to the illusion of three-dimensional volume. Compare the way the bowl, orange, and glass ball are handled in the two halves of Fig. 12-2. On the right, the lowlights consist of the soft, blue sheen inside the cast shadow of the bowl, and the blue spots on the left of the glass ball and orange. Remember: organize your values into **light**, **middle tone**, and **dark** values.

On shiny still-life props you probably will see lowlights as cool, mirror-like reflections in miniature of the window panes. They might be blue, blue-violet, blue-green, blue-gray, or neutral gray. You should have no trouble distinguishing their color and shape from the rounder, yellower reflection of the primary light. If you paint at night under ceiling fluorescent lights, you should clearly see the difference between their cooler streaks and the warm, rounder **highlights** from the primary light. I suggest playing down or eliminating those distracting streaks.

Do your best to show the difference between your two light sources with whatever pigments are available in each limited-palette lesson. Resist the temptation to reach for a color you see but aren't supposed to use in that lesson.

When the warm primary light and the cool secondary light are unavoidably on the same side of the still life, **highlights** and lowlights on shiny objects will appear side by side, or may even coincide. There is no point in showing warm and cool influences on the same side of your subject, because they cancel each other out. Ignore the information from the windows altogether, or mentally transfer the cool light to the other side of your still life. Eventually you should be able to paint what you know about an opposing

cool light even when it isn't present. In the meantime, start noticing how often you'll see the opposition of warm and cool lighting in movies, art magazines, and especially in portrait painting.

"Cast" Light

Whoever heard of "cast" light? It took me years to perceive this happening in nature, and I think the phenomenon deserves a name. In outdoor subjects it could be called "sun dapple," but in still life I refer to it as cast light. To observe it, place a piece of fruit almost entirely in the shadow of something like a plant, as I have in Fig. 12-3. Notice how a slash of light hits the orange and rolls over the form, disappearing in the **dark** area, just as a shadow would in reverse circumstances. Then move the fruit into total shadow. Note how its unnatural dark color in deep shadow makes the fruit look rotten. A slash or two of light on any object that would otherwise be altogether in cast shadow will explain the cast shadow beautifully.

A good example of cast light outdoors occurs when the trunk and lower branches of a large tree are almost all in shadow, thanks to the huge mass of summer foliage overhead. Occasional dapples of light will filter through the upper branches and cast light shapes on

Fig. 12-3. Here an orange is all in the shadow of the plant, except for a slash of cast light on it. The plant's muted green color came from mixing manganese blue with orange, plus a little white— the best I could do with the limited colors in the blue and orange lesson.

the dark trunk and limbs below. It is simply a reverse proportion of the light and shadow that would be seen on the same tree with bare winter branches. The normal difference of three or four value steps between light and shade would prevail on a sunny day, no matter what the proportion of each is.

Often we see what we expect to see instead of what is really there. When painting trees with dense overhead foliage, for instance, students will conscientiously model the trunk and branches with **light**, **middle-tone**, and **dark** values, unable to see that they are in shade and thus should not be modeled. From the standpoint of logic, how can you turn any form from **light** to **dark** when it is all in the shade of a cast shadow? There are no shadows within shadows under a single source of light. **Reflected light** from surrounding areas (like the bare ground, grass, or a building nearby, plus the cool influence from the sky) is the most significant factor in handling completely shaded forms outdoors. Sun dapples on tree trunks, branches, and foliage that receive direct light from the sun, however briefly, do need to be modeled from **light** to **dark**.

Contact Points

I call the small #8 or #9 values underneath objects where little or no light can reach *contact points*, or "sit-down lines." These tight cast shadows are usually the darkest darks in a painting or drawing. Without that little anchoring dark value, objects are apt to levitate off the table alarmingly. If you remember that most cast shadows start with the sit-down line, you will be less likely to make the common mistake of starting shadows *behind* forms. (Compare the two cast shadows in Fig. 12-4.) A contact line should blend smoothly into the cast shadow. Actually, when we look down on spherical forms, we can't see the contact point because it is tucked way under the object. It still helps, though, to anchor such forms with a subtle dark value so they won't levitate.

Fig. 12-4. *Above, INCORRECT*: This pottery bowl has a contact line under its too-straight bottom ellipse all right, but the cast shadow starts behind the bowl rather than under it. Also, the glaze pattern of ovals on this bowl is dominant, the form subordinate. *Below, CORRECT:* Since the hand-thrown pottery bowl is basically spherical, it has a "puddle" cast shadow that starts under it and includes a contact line. Note the subtle handling of the pattern here compared to the one on the left, as well as the better observation of the bowl's outer contour, its slight neck, and the irregular ellipse of the opening.

Here is a painting tip. When you load your brush with a dark value to paint one contact point, take a moment and put the rest of them under everything in the still life at the same time. Let contact points be too thick at first; gradually you'll blend some of that thickness into the bulk of the shadow, leaving just a bit of anchoring dark where it belongs. Technically speaking, each contact point should be a dark value of the color the object sits on, just like its shadow. But when anything is as dark as a #9 value, any dark will do for that initial stroke.

ACCENTS

Accents are also #8 or #9 dark values, typically appearing in such subjects as rough-barked trees, rock crevices, rutted earth, and any surface punctuated by holes or deep indentations. Heavily textured flowers like carnations, zinnias, peonies, and chrysanthemums can have dark accents deep between their layers of petals. Look closely at fruit and vegetables such as the spiky top of a pineapple, a head of broccoli, or an artichoke like the one in Fig. 12-5, and see the deep darks between the various parts. When painting compound forms like these, after establishing their local color, and their **light** and **dark** color values, immediately dash in the #9 dark accents before continuing to model the form. They might be just dots, dashes, or calligraphic strokes, only some of which will remain in the end. As a rule of thumb, no form or cast shadows should be painted so darkly in textured subjects that darker #9 crevices can't be shown. It's a matter of keeping that value in reserve for such times.

PAINTING TRANSPARENT GLASS

Capturing the transparency of objects in paint gives many beginning painters pause. Yet if you've come this far, your observations of how light and shadow define form as well as texture should serve you well. The key is always to observe light's behavior. Here I will focus specifically on how to render glass objects; with a firm grasp of the principles involved, you'll be able to apply what you learn to painting a pond full of goldfish, rocks submerged in water, or any other subject involving transparent effects.

Light bounces back to our eyes from an opaque object, but when something is transparent or translucent, the light passes *through* it—more clearly in the former, and more diffused in the latter. Light that passes through a substance is called "transmitted light." Glass bottles, vases, bowls, tumblers, and clear water in a lake are transparent. Petals of flowers, foliage, shells, balloons, and certain kinds of stained glass are translucent. The main optical difference is that transparent objects let you see what's behind them, while translucent objects generally do not.

To convey the effect of transparency, the trick is to paint the background behind the glass, its bottom ellipse, and its own cast shadow first. Then paint whatever might be in it, such as the stems of flowers and the water they are in. All such details are more important factors in expressing three-

Fig. 12-5. The artichoke is a classic case of a textured object that has many tiny dark #9 value accents in it, deep places between the triangular leaves where light can't reach. Don't confuse them with shadows cast from one triangular shape onto another. Notice that, despite the preponderance of details in the artichoke, its form has not been neglected. I used the colors of Color Lesson 6 in chapter 14 to do it justice.

dimensionality than the glass object's own volume. The harder you try to paint the glass object itself, the more maddeningly opaque it will become. On the other hand, the more you paint what you see behind and in it, the more transparent it will become.

Gather together a few colored glass pieces, like a glass bowl or a glass vase with a few stems of dried weeds in it, a wineglass, and a wine bottle, set them on a white cloth, and turn a lamp on them. The first thing to observe is that you look through only one thickness of glass in the upper ellipse of the open-mouthed bowl and wineglass, but two thicknesses of glass below that. Can you see that you would need a lighter and darker value of their local color to start with if you painted them? A wine bottle and small-necked vase would essentially be two thicknesses of glass throughout, except for the little ellipse at their open tops. Put a piece of fruit behind one of your glass objects and notice how it is distorted. This is due to the refraction, or bending, of light as it passes through the glass.

Try painting glass in this sequence:

1. Draw the structure of your glass objects using ellipses. The bottom ellipse is especially important because it will remain in the finished painting. Draw it and everything else behind the glass with wavy distorted lines to indicate refraction.

2. Find some places where pure local color can be stated on your glass objects. Forget about the rule of establishing **middle tone** in the middle of the object; that applies only to opaque volumes. Local color can be placed arbitrarily near the contours or on the shoulders of bottles—wherever it won't interfere with what's behind the glass.

3. Start to paint whatever is behind the glass object. Mix all local colors behind it with the color of the glass piece itself. (Obviously this does not apply when you are painting a clear glass object.) The white tablecloth passing behind and under a green vase becomes a light green; an orange on a white tablecloth behind a blue bottle becomes a rust-orange color on a pale blue cloth through the glass. Sometimes add a few touches of pure local color on objects behind the glass to make the glass look less dense.

4. Distort everything behind the glass to show the effect of light being refracted. Pay close attention to how the line that defines the back of the table as it recedes in space relates to the glass objects, judging whether it appears above or below its normal position as you view it through the glass. Note that even though the glass itself cannot be modeled, the forms of all opaque objects behind it must be. Record their **highlights**, **middle tones**, **darks**, cast shadows, and contact points just as though the glass wasn't there, only muted somewhat and painted in a wavy fashion.

5. Now paint the glass object's own cast shadow as you see it through itself, noting carefully how it starts to swing out from the bottom ellipse in back, on the side of the light source. Be sure to make the cast shadow behind the glass a wavy, distorted shape. Look for any colored pattern inside the cast shadow—concentric circles, irregular blotches, or long streaks. Emphasize this transmitted light to make the glass more exciting and enhance the illusion of transparency. Be sure that the glass's local color, as it is thrown down into its cast shadow, is lighter in value than the shadow's outer contour. The contour of the cast shadow, which indicates the density of the glass, should be the same color value as all other cast shadows of objects on that surface. (Note this characteristic in any of the book's photographs of still-life setups that include glass objects.)

6. Next, paint what's inside the glass object— its own bottom ellipse, the ellipse created by the top plane of liquid, or flower stems—all with distortions. If you paint a bunch of stems, model them as a unified form, not as a lot of separate lines that bear

no relation to the light source. Be sure to show their substance as well in the cast shadow pattern on the table surface.

7. You are finally ready to paint the glass object itself. It should take only about six or eight more strokes! Define the contour here and there with some very dark #8 or #9 values according to dark shapes that you might actually see. Sometimes they are not quite on the edge of the glass, but move inside a bit. The top and bottom ellipses of bottles will have a lot of these dark accents in them. Do not outline the whole piece of glass with a dark line! Rather, notice how the contour comes and goes. It may disappear completely and blend in with the background values in some places.

8. Dash in the #1 **highlights** in the appropriate, predictable places—on the top lip, neck, shoulder, waist (if there is one), and bottom ellipses. Then put in the **highlights** on the back wall of the glass. Note that these are about a #2 or #3 value and are much more colorful than the **highlights** on the front of the object.

9. Only one thing more remains before your glass is finished. Look for light streaks on the front wall and perhaps also on the back wall of the object. They are from either primary or secondary light sources, or may be reflections of nearby objects. No matter what their source, at the very last moment drag a streak or two of a warm #1 or #2 value down the form, taking care to go right past the bottom ellipse on the front surface. In so doing, you firmly establish the front wall of the glass. Sometimes students use dark streaks there, but I don't recommend them. If you actually see them, recognize that they are caused by reflections of dark objects nearby.

All of the above seems complicated, but it isn't, providing you grasp the idea of starting to paint the glass object literally from behind itself. Painting glass is an intellectual as well as a visual exercise that requires a complete turnaround in your thinking, probably a

switch from the logical left brain that urges, paint the glass bottle, to the more creative right brain that says, paint every shape and value you see in the bottle so that it becomes a little abstract painting all by itself.

TRANSPARENT VERSUS OPAQUE CAST SHADOWS

A wine bottle that has labels on it produces two different effects in its cast shadow: the transparency of the glass, and the opacity of the labels. If you can't see the distinction clearly in a bottle of your own, stretch the point a little as I have in Fig. 12-6 so that the bottle's cast shadow relates to it in a logical way.

Would it occur to you that, although you can forget about modeling the bottle itself, you must model the opaque paper labels on it? Turn the bottle so that the label is in different positions, noting how it conforms to the cylinder of the average tall bottle, or the roundness of a bulbous bottle.

Fig. 12-6. This liqueur bottle has transparent areas and opaque areas, and its cast shadow shows the difference.

Fig. 12-7. You almost can see through these balloons, but not quite. Although I couldn't model their forms, as I would with an opaque object, my contour strokes describe their roundness and give an indication of the perspective of the blue balloon going into depth.

TRANSLUCENCE

Because translucent materials have a quality that is somewhere between transparency and opacity, translucent objects can be modeled slightly, though with more delicate value changes than opaque objects require. Their cast shadows will have some light and color in them, but not nearly as much as with transparent glass. Study the two balloons in Fig. 12-7. The more air you blow into balloons, the more transparent they become. Accordingly, the orange balloon is slightly more translucent than the blue one. I've indicated the difference between them by painting what's behind the orange balloon and giving only a hint of what's behind the blue one.

Our concern with translucency is not so much for milky glass or balloons as it must be for flowers and foliage when light filters through them. There is hardly a more brilliant, singing color in nature than the sun transmitted through the petals of a bright flower or leaf. It compares to light filtering through stained glass in a cathedral. To achieve this effect, use your most chromatic warm colors for the areas of transmitted light and reduce the values, intensities, and temperature of surrounding foliage.

METALLIC OBJECTS

You can almost forget the form-building formula too when painting copper, brass, silver, or other metallic surfaces. Whether to model metallic objects at all depends on their age and condition. An old teapot, urn, or goblet that is badly tarnished will require some modeling from light to dark just as matte objects do. New, highly polished metals, on the other hand, will reflect everything in sight and will not read as a form at all. Compare the two copper pots in Fig. 12-8. A highly reflective surface is truly a hodgepodge of color values, and it is one of the few times in realism when we can paint exactly what we see. For once, copy every single value, color, and shape that plays across the metallic surface and enjoy it. Note particularly the reflection of the shiny metallic object's own dark cast shadow.

As for local color, silver is basically gray, brass more or less gold, and copper peach-pink, muted rose, or rust-colored, depending on its luster and condition. If the object you are painting is shiny, you can place the local color arbitrarily, as in the coffeepot at right in Fig. 12-8, but if the object is dull and tarnished, its local color will, of course, become the **middle tone**.

Fig. 12-8. Both the tarnished pot and the shiny new one could have been more brilliant with a full color palette, but proper values and limited colors tell the story of their textures and surface reflectance well enough.

Fig. 12-9. *Left*: The color of the cast shadow is ultramarine blue, a bit of orange, and a little white. *Middle*: The reflection is always directly below the object, unlike the cast shadow. *Right*: Now the tangerine's reflection is even sharper, but its cast shadow has been overpowered by strong reflections from a window.

REFLECTIONS ON SHINY FLAT SURFACES

Students sometimes become confused about the difference between the cast shadow of an object and its reflection. Study Fig. 12-9. On the left, we see only a simple cast shadow on the cloth surface, posing no problem. But when the tangerine is placed on a varnished wood table, as in the middle, suddenly there are two things happening; we see both its cast shadow and its reflection. On the right, the tangerine rests on a highly reflective black lacquered surface, and lo, its cast shadow has disappeared, despite the logic that says it should be there. What happened to the cast shadow? Reflections from a window behind the fruit have overpowered it. Note that in the

reflection, the tangerine's values appear in reverse. While the actual tangerine reads as **light**, **middle tone**, and **dark** from top to bottom, its reflection reads as **dark**, **middle tone**, and **light**. A shiny surface always "sees" the underside of spherical objects more than we can from our higher viewpoint. This would not be true of a cylinder, cone, or cube, because none of those forms "belly-under" as a sphere does.

A mirror is the ultimate polished surface, and it is almost equaled by a smooth body of water. A mirrored image in either one can appear to be as sharp and clean-colored as the original. If I placed the tangerine on a flat mirror, the painted fruit and its reflection would look like two tangerines stacked on top of each other. Little is gained by painting exactly what you see in a case like that. It is much better to imagine, and then paint, the mirrored image of anything slightly darker and more muted in color than the original. A piece of fruit reflected in the mirror is only a step away from painting a boat on a calm, mirrorlike lake. In the reality of working outdoors, though, a passing breeze would fracture the boat's reflection in the water so

that it would zigzag slightly, as you see in Fig. 12-10—which makes for a more lively image than the subject's perfect double in reverse. In more agitated water, the reflection of the boat would splinter into a thousand fragments, and the boat's cast shadow would appear. Why? Because in its fragmentation into tiny units, the water has ceased to be a mirror that swallows up cast shadows and has become a virtually opaque surface that receives them. Observe the reflections and cast shadows of boats, docks, and shoreline buildings on water. Confirm the principle that the presence or absence of reflections and/or shadows indicate the texture of smooth or rough, shiny or matte surfaces.

CAPTURING THE TEXTURE OF FABRICS

I might have written a whole chapter on how to render the texture of various fabrics. Much of it would be redundant, though, if you have already grasped the basic form-building formula and applied it to different situations. Tack up a cloth behind a still life from a single point on the wall. Your first observation should be that the folds are conical—that

Fig. 12-10. The water near shore is calm and mirrorlike in this scene, but a breeze has ruffled the water and splintered the reflection of the boat into wavy shapes and lines.

Fig. 12-11. Between the kinks in drapery are standard-type cylinders, cones, and even, in this case, an almost boxy form in the middle of the illustration. Just above it is an ironed crease, a useful means of leading the eye across the painting.

they are narrower at the top and wider at the bottom. A drape that hangs straight down from a curtain rod produces cylindrical folds. You know how to handle cones and cylinders, so there should be no problem in painting convincing drapery . . . or so it would seem. Unfortunately, drapery can be more complicated, as in the following situations:

1. A typical drape hung from a single point behind a still life usually flows onto the table and lies in foreshortened folds that flatten out momentarily under still-life objects and then reappear, usually as curving folds. If you are lucky, they will be conveniently wider in front and narrower toward the rear of the table, thus conforming to natural perspective. But they may not be so accommodating. When you have reverse perspective in the folds, either rearrange them or leave them out of the picture. The hardest part of dealing with such an arrangement is showing the transition from the vertical part of the drape to the horizontal table, a radical change in planes. The secret is, look carefully for kinks in the drapery, found wherever the cloth changes direction from one plane to another. Kinks are

characterized by a sudden contrast between very light and very dark values, as in Fig. 12-11. Stiff fabrics make sharp kinks; silky materials, softly rounded ones.

2. Creases due to ironing or folding of fabrics are yet more places where light and dark values meet abruptly, either as peaks or valleys, which sometimes alternate. To achieve these effects, you must render the flat plane of the tablecloth or drape as **middle tone** (at least surrounding the crease) so that the plane extending upward into **light** is lighter in value and the downward-facing plane in the **dark** on the other side of the crease is darker in value. If you reverse those values, the crease will automatically go down in the valley and up again on the other side. Creases do a good job of leading the eye into a still life and creating movement across background drapery. They also can enliven an otherwise boring empty space.

3. Look for the shadows one area of drapery casts on other nearby areas. Don't get so involved with the modeling of individual cylinders and cones in your fabrics that you fail to see the interaction of all those folds in relation to the light. Indicate the

cast shadows right away as shapes in your drawing, and then immediately begin to block in both the form and cast shadows of major folds with the thinned-out paint that you drew with, only use a larger brush.

As with all rough surfaces, the actual texture of a fabric is revealed most in its **middle tone**. Burlap, a Turkish towel, and corduroy show their characteristic weaves and naps with many tiny value changes in the glancing light of **middle tone**. The texture of such surfaces is much less noticeable toward both the **light** area and the form **dark**. In the left side of Fig. 12-12, note the difference between the linear texture and little dark negative shapes of the burlap and the tufted texture of the Turkish towel.

In contrast to rough fabrics, shiny fabrics like silk and satin are distinguished not in their **middle tone** but by countless **highlights** in appropriate places, as well as significant amounts of **reflected light**

bounced back into their **dark** areas. Look at the difference between the lustrous blue satin fabric illustrated in right side of Fig. 12-12 and the two kinds of dull, textured fabrics shown to its left.

The relevance of studying drapery in still life will be apparent when you start painting the clothed figure. If that is not your cup of tea, your drapery study will prove useful as preparation for landscape painting, when you need to depict slowly rolling foothills, the slanted planes of steep mountains, and the vertical angular ridges at their peaks— analogous to ironed drapery folds that kink and crease this way and that. You will easily see that some mountain ridges cast shadows on other ridges just as some drapery folds cast shadows on neighboring folds. Cloud shadows rolling over those mountain forms would present a challenge no greater than that of a vase casting its shadow on the folds of the drapery in the studio.

Fig. 12-12. *Left*: Compare the textures of this piece of burlap and Turkish towel. After modeling the forms with their local colors and appropriate **light** and **dark** values, I created their textures wet-into-wet with the edge of a #5 brush. Notice in both fabrics how my strokes followed the contours of their folds, but did not destroy their forms. *Right*: This length of

pale blue satin is far more fluid than the other thicker fabrics. Its luster, **highlights**, and **reflected lights** are all warmed with orange, plus quite a bit of white. The transitions from the warm **light** areas to the cool **darks** result in a variety of warm and cool grays. There is less blue here than you would expect because of satin's highly reflective nature.

COMPOUND SUBJECTS

Let's take the study of textured subjects a giant step further and consider irregular volumes composed of multiple parts. Think of a bunch of grapes or a bouquet of flowers. It is distinctly amateurish and time-consuming to paint individual grapes or flowers as precise forms of equal importance while ignoring the effects of light and shadow on the whole mass. Have you ever seen a painting in which every single grape has a tiny white dot for a **highlight**? (See Fig. 12-13.) Or in which every flower in a bouquet receives full light? If you observe reality, you'll see that some grapes are in the shadow of others, or that some flowers are in the shadow of others.

Articulating the part of your subject that is in the **light** area of the mass and generalizing in the shaded **dark** parts relieves sameness and results in a much more powerful whole.

Fig. 12-13. *Top, INCORRECT:* Here we have a bunch of flat, monochromatic grapes with unreal white highlights on every grape. Both the plate and the grapes are flat up against the picture plane, aided in their two-dimensionality by the high cast shadow of the grapes, and also the same blue on the tablecloth at top and bottom. *Bottom, CORRECT:* Now the bunch of grapes has form, and some grapes are in the shadow of others. **Highlights** appear only in those areas facing the light source to the right front. Grapes in the **dark** areas are merely suggested. Despite the limited blue and orange palette with which these examples were painted, this illustration has a great deal of warmth in it compared to the one above.

Middle tone areas in compound subjects are where you will see a busy interaction of the parts. Note the full modeling of a few grapes in the **middle-tone** and **light** areas of the whole bunch in the lower half of Fig. 12-13, and how they cast shadows on other grapes. Modeling disappears in the **dark** area, save for a few **reflected lights** and lowlights that merely suggest form. This, my so-called "Bunch of Grapes Theory," applies to the modeling of any compound subject. Some pointers:

1. Design a bunch of grapes with a contour line, making yours more interesting than the actual grapes in the setup, which may be too stiff and full or too lanky and sparse. Draw several sub-forms, smaller bunches of grapes on a common stem.

2. Mix a suitable color for the local color of the grapes. With a knife, apply a generous amount of pigment through the main **middle-tone** areas of the bunch. Find a warm, lighter color for the **light** areas, and a cooler, darker color for the **darks**, and put large swatches of those values where they belong. Here I used a sequence of manganese blue in the **light** part of the mass, ultramarine blue in the **middle tone**, and ultramarine plus orange to make a blackish no-color for the **dark** areas.

3. Pull the swatches together with your brush, making some circular movements with it to suggest specific grapes. After the bunch is well modeled as a whole mass, begin to put **highlights** in the defined grapes in the **light** area, and perhaps a few in the **middle-tone** part of the mass. Paint the shadows cast from some grapes onto others below or next to them in those areas. **Reflected light** and a few lowlights can then be added to suggest grape shapes in some areas. Stop short of defining too much. Suggestion is always more intriguing than spelled-out details.

4. Grapes (and plums too) have a grayed frost that can be applied last. If you try to paint it wet-in-wet all over the bunch, it will probably negate everything you've done. Wait until the bunch of grapes is dry, and apply a thinned-out opaque veil of grayish color (described in chapter 18). Remember to warm even the gray frost in the **light** and cool it in the shade.

If when painting any compound subject you find everything is mushing together, wait an hour or more until the paint has begun to set up slightly. This allows further work with more control. In oils your best and most painterly work is always going to be wet-in-wet, so don't despair over momentary frustrations.

OTHER COMPOUND SUBJECTS

Now let's apply the Grape Theory to a bunch of daisies. After drawing the daisies' structure, I began to apply large passages of warm white in the **light** areas, pearl-gray in the **middle-tone** areas, and blue-gray in the cast shadows and **dark** areas on all flowers with respect to their positions in the whole mass. I purposely did not render petals in the flowers at the far left in Fig. 12-14 to show you how I model individual flowers and turn the whole form of the bouquet first before I paint a single detail. Observe that the flowers in the **light** part of the whole bouquet are mostly light, warm values; those in the **middle-tone** area are busy, textural shapes defined by minor light, middle-tone, and dark values; and those in the **dark**, shadowed side of the whole bouquet are mostly cool, darker values. Occasionally there will be a bit of dappled light in the **dark**, just as there may be a bit of cast shadow in the **light** area, but on the whole the values should be organized, not placed haphazardly. The right-hand half of Fig. 12-14 shows poor handling of values, resulting in a busy pattern without form, light source, or center of interest. Particularly bad are the alternating light and dark values on single flowers, the lack of foreshortening in the petals, and the overall lack of modeling for the bouquet. Aim to organize simultaneously the values of both the whole form and the individual components

of a compound subject in order to achieve a fresh rendering in pure alla prima technique.

I have named another principle after the daisies for easy recall. The "Daisy Principle" refers to negative painting—here, meaning pushing the wet paint of the dark leaves and background into the wet paint of the flowers. You do that only after the large passages of warm **light**, **middle tone**, and cool **dark** have been coaxed into the shapes of flowers. Then, by pulling out some petals first and pushing in some background color wet-in-wet, a kind of alternation ensues that gives the flowers a natural, shaggy look rather than a hard-edged, neat look.

Sooner or later you may try rendering a brick or cinder-block wall. Having observed many students draw, and then paint, careful horizontal and vertical outlines of each component of such surfaces, as in the right-hand example in Fig. 12-14, I can only say, "There are no lines in nature." Those "lines" are really concave forms between two blocks, and they must be modeled accordingly, with **light** and **dark** areas.

With ideal side/front lighting like that implied in Fig. 12-14 (left), the values of

vertical hollows will appear in reverse to show their concavity. Similarly, horizontal hollows will say **dark**, **middle tone**, **light** from top to bottom when the light source is higher than the crevices. If you inadvertently model concavities in the normal form sequence of **light**, **middle tone**, and **dark**, you will have bulging convex mortared joints—an effect that would be appropriate only if such mortaring, a decorative motif, was what you wished to depict. It is up to you to describe with proper values whether there are convex bumps or concave hollows between the bricks or blocks. But drawn lines? Never! Be aware also of the changing perspective across any brick or block wall. The hollows or bumps right in front of you receive a different proportion of light and shadow than those that stretch to the left or right, above or below eye level. It takes a good eye to perceive those subtle perspective changes, but perceive you must.

Be fearless in selecting textured objects and produce for your still lifes. With practice and observation, you should be able to handle any texture, as defined by light and shadow, with competence.

Fig. 12-14. *Left, CORRECT:* Let's talk about the good example first, for a change. I've left the daisies on the left side of this bouquet petalless to show how I would demonstrate "form first, details last" in a compound subject. When painting a bouquet of daisies or any flower with buttonlike centers, let the centers tell the story of a light source and of proper ellipses for different positions in the bouquet. Let some centers be in full light, some half and half, some completely in the dark, and others invisible. *Right, INCORRECT:* Too many flowers face forward, a few of the flowers have peculiar ellipses, and all the centers are too bright and too large. The cool (too blue!) values in the petals either make them look convex, or they alternate indecisively. Finally, even a concrete block wall must have convincing three-dimensional form. The joints between the bricks cannot look drawn onto a flat surface.

Color Lesson 4: Blue/Orange Complements

Color Chart Assignment

Make a complementary color chart using ultramarine blue, orange, and white. The orange should be neither too yellowish nor too reddish. You will know when it is wrong if you get grayish greens or mauves instead of a gray from your combinations of orange and blue. If your middle chip in the bottom row is greenish, put a bit more cadmium red light in the parent orange. If you get a purplish color, put more yellow in the orange. The balance of the red, blue, and yellow content has to be just right to find the no-color in the middle, the one that becomes a beautiful gray when you lift it with white. The greenish blues—manganese, cerulean, and phthalo blue—do not make good neutral grays when mixed with orange but, as noted above, make interesting gray-greens. Although cobalt is the "truest" blue pigment, ultramarine blue works better for the color chart because it provides darker values in the bottom rows.

cadmium red light/cadmium yellow light

manganese blue

cobalt blue (optional)

ultramarine blue

white

Fig. 12-15. The blue and orange complements and their intermixes are, more than any other pair of complements, indispensable on my palette. The neutral grays, blacks, and blue-grays are easy to find, and the peachy-beiges, rusts, and browns are useful in all landscape subjects. It is a handsome color harmony besides, a sure winner in a painting if you stick more or less to the colors in this chart.

Still-Life Assignment

Find objects and a napkin or mat within the limited palette of the three blues and orange and their intermixes. Use a very light and a dark object in this lesson, and if possible, include a piece of silver or pewter so that you'll have to find grays with these complements. For produce, use oranges that have been dyed rather than the natural-colored, yellowish ones. Avoid multicolored objects and fabrics and fancy figurines in your still-lifes for now.

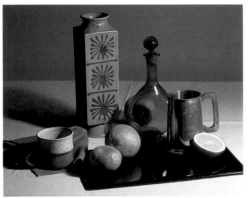

The Setup. Look at the basic forms in this setup: a tall square vase, a two-tone cylindrical mug, a blue glass decorative bottle with a spherical stopper, a conical silver tankard, a very flat box (the black lacquer base), and four spherical pieces of fruit, one cut in half. Particularly notice the beautiful warm to cool gradation from the front to the back of the table, and the cool shadow from the tall square vase under the warm light source.

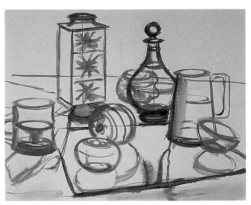

Step 1. Having decided to paint this setup on a horizontal format meant having to shorten the tall square vase. Then I mixed a brown-gray-blue puddle of turp-thinned color, using orange and ultramarine blue, and varied the color as I drew the different objects. This setup is unusual in that I had more reflections to draw (on the black lacquer base) than cast shadows. I quickly scrubbed in the patterns on the square vase with manganese blue.

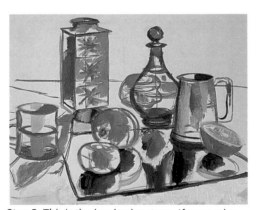

Step 2. This is the local color stage. If your color relationships are wrong compared to the original objects, or to each other, fix them now. Notice that I've used manganese blue for the folded napkin on the left (the best I could do with this palette), and ultramarine blue for the glass bottle.

Step 3. Here I have begun to model the forms and develop what's behind the glass bottle, remembering to save some white canvas areas for **highlights**. Because the silver tankard is highly reflective, it does not need to be modeled. The reflections of the orange and tangerine in the black lacquered base clearly show the reverse in modeling mentioned earlier.

Step 4. The canvas is nearly covered at this point. I am pondering my initial feeling that the gradation in the background should go from warm on the left to cool on the right in order to balance the blue objects. When we reverse the natural values and temperatures like that, putting cool, dark colors on the same side as the warm lamp, we imply a spotlight effect, or the shadow from a lampshade. It's a good ploy sometimes because it automatically focuses attention on the subject. I think it works quite well here.

Step 5. In the finished painting, I've softened the edge of the shadowed arc in the upper right. I like the way it subtly repeats the rounded contours of the bottle and fruit. Although I like the nice dark values that the black-lacquered base provides, it does tie all objects together into continuous overlapping shapes. But imagine the painting without the lacquer base, and you'll see that the same arrangement of objects wouldn't work at all.

Chapter 13
COLOR PERCEPTION AND HARMONY

Several important theories that will enhance your perceptual skills are the laws of simultaneous, successive, and mixed contrast, which the renowned French scientist Michel-Eugène Chevreul (1786–1889) set forth in his monumental treatise *The Principles of Harmony and Contrast of Colors*. As head of the dyeing department at the government-owned Royal Gobelins tapestry factory, Chevreul conducted exhaustive experiments with colored dyes, publishing his findings in 1839. Within several decades Chevreul's theories had gained wide acceptance and were translated into many languages; an English paperback edition, simplified and summarized by the noted color expert Faber Birren and published by Van Nostrand Reinhold in 1981, makes the text readily accessible. Chevreul's theories on color harmony and contrast are to this day standard elements in the teaching of color.

Chevreul's color theories contributed in great measure to the Impressionists' rejection of the academic traditions of their day. The principle of simultaneous contrast provided the impetus for the Impressionists' use of warm and cool colors to describe light and shadow, whereas the academicians traditionally worked with tonal values, adding a lot of black and white to their colors. Thus we have both Chevreul and the Impressionists to thank for the major emphasis in this book on warming and cooling colors.

SIMULTANEOUS CONTRAST

According to Chevreul, all shadows are perceived as complementary to their light source—that is, a warm light causes us to perceive relatively cool form and cast shadows on all surfaces warmed by that light.

A cool light, on the other hand, produces relatively warm shadows on surfaces cooled by that light. He termed that phenomenon *simultaneous contrast*. In a broader sense, simultaneous contrast also means that all colors tend to push away from adjacent colors rather than align with them. When two identical color samples are placed on different backgrounds, they react against their respective backgrounds until they no longer seem to be the same in hue, value, or intensity. Study the apparent difference in the two gray squares in Fig. 13-1.

Let's see how this phenomenon applies to the landscape. My advanced class and I sometimes paint the panorama from a location overlooking a golf course whose fairways are a brilliant yellow-green in the sunlight. The gray macadam-paved golf cart paths that wend their way over the course appear to be a distinctly muted red-violet in contrast to the yellow-green grass. If the same gray macadam path went through a field of red-violet flowers, it would presumably take on a gray-green cast. Can you see the complementary color shift on the left and right sides of the "path" in Fig. 13-2? At first you would probably perceive only what you expected to see, that is, simply gray macadam. But once your eyes are trained to see simultaneous contrast, you will find it happening all around you.

In translating such an image into paint, to neutralize the macadam path's tendency to look red-violet against the yellow-green grass, the antidote would be to add a bit of green to the gray macadam color. You might prefer, however, as I would, to go with the red-violet, even adding a bit on purpose to the dark gray path so that there would be that subtle spark between the two complements.

One of the most interesting effects of simultaneous contrast is the "fluted" effect that appears between contiguous color or value chips, as we saw in the nine-value gray scale in chapter 4. Each chip reacts to its neighbor with a distinct value contrast that appears greater than the normal tonal difference. It looks lighter where it shares a border with a darker chip, and darker where it borders the next lighter chip, resulting in a scalloped or fluted effect. See the violet monochromatic scale in Fig. 13-3.

Fig. 13-1. These two gray squares were cut from the same paper. Would you agree that the one on the deep purple background looks lighter and warmer than the one on the yellow background? Your eyes generate each background color's complement, thus warming up the gray square on the left and making the one on the right appear distinctly mauve.

Fig. 13-2. Since yellow-green and red-violet are complements, you should see a remarkable shift in the gray path's color as it crosses back and forth over the center white area. If you cover up one half of the design at a time, it will look as though the zigzag path were cut from two distinctly different colored papers.

Fig. 13-3. Each color chip seems darker on the left and lighter on the right. Look for this border effect in other light-meets-dark situations. Train your eyes to be sensitive to minute color and value changes.

WARMTH AND COOLNESS ARE ALWAYS RELATIVE

In the last chapter, we worked with warm and cool light influences on specific objects. Become even more aware now of the effects of simultaneous contrast on cast shadows. Turn on the lamp over a desk. If your lamp has a cool fluorescent bulb, the cast shadows should appear relatively warmer and darker compared to the cooled desk surface. Under a

warm incandescent light bulb, the shadows will appear relatively cooler and darker. Warmth and coolness of color are always relative. But how can a brownish cast shadow on a yellow surface be called cool when brown is a warm color? Relative to pure sunny yellow, brown is cool. That's easier to understand if you arrive at the brown of the cast shadow on a yellow surface by mixing violet, a cool color, into the yellow. With any

Fig. 13-4. I used Grumbacher cadmium yellow light for the yellow parent in the lower left, and Liquitex dioxazine violet for the parent in the lower right. Dioxazine is slightly on the red-violet side of true violet, and therefore I had a little trouble finding the neutral no-color in the center. I kept getting either a dark brown or a dark violet, so I had to give up and add a bit of ultramarine blue to the brown to get the grayish color in the middle row. You can add the bit of blue to the parent violet to begin with, but if you add too much, you'll get greenish color chips that certainly don't belong on this chart.

pair of complements you can control the degree of coolness of shadows. Squeezing some burnt umber out of a tube instead in no way suggests coolness, whereas the violet does. To find the color of a cast shadow on a yellow surface, locate the yellow local color on the complementary chart, Fig. 13-4, and then follow along a downward diagonal going from the warm left side to the cooler right side.

Now look at the cast shadows of the three spools of yellow thread in Fig. 13-5 to see how they follow that downward diagonal. A little bit of violet into yellow provides the light brown cast shadow at the top. The next addition of violet went into the neutral non-color, and even though I found as neutral a gray as I could and added some white to the right value, it looks like a mauve because of simultaneous contrast with the yellow tablecloth. Don't go overboard in cooling shadows by jumping to nearly pure violet, as you see in the bottom shadow. Natural light and shadow effects would never provide such a shocking color and value contrast. Somewhere in between the parent colors of any complementary sequence can be found the reality of what you see. I think the top cast shadow is probably closest to the truth, but I might sometimes opt for the cooler middle shadow to enhance the feeling of a warm light on the subject.

A little harder to explain is what happens when you're searching for the cast shadow color on a purple cloth of middle value under a warm light source. If you add too much yellow to the violet to find the cast shadow, you'll have the strange color relationship that you see in the top of Fig. 13-6. Instead, look at the color chart in Fig. 13-4 again and, after finding the violet local color of the cloth, add tiny amounts of yellow and you'll be on a steep downward diagonal. It takes only a little yellow to arrive at a muted violet shadow color. The cast shadow in the bottom of Fig. 13-6 has been cooled even more with a little ultramarine to arrive at a muted blue-violet. At the same time, I warmed the violet

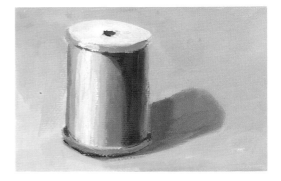

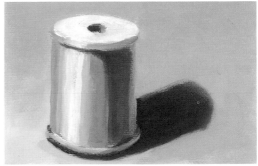

Fig. 13-5. Here are three yellow spools of thread on a yellow cloth. The best color for the cast shadow depends a lot on the brightness and temperature of the light source. Check the color chart in Fig. 13-4 to see how these three colored shadows follow a downward diagonal path from the pale yellow local color of the tablecloth in the illustration.

tablecloth with a bit of red-violet plus a little white. These are options you will have for the first time in the yellow-violet complementary lesson at the end of this chapter. Now, can we say that the purple was cooled in the shadow by additions of yellow? Not really, but we can say that the cast shadow on the violet cloth was neutralized by its complement, and then cooled by an adjacent color on the color wheel.

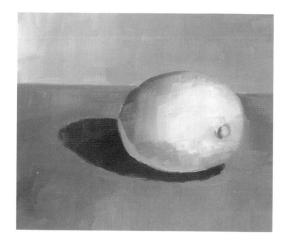

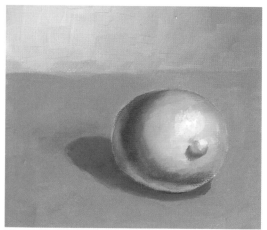

Fig. 13-6. *Top, INCORRECT:* This cast shadow obviously has too much yellow in it because it turned brown, leaping clear across the color chart in Fig. 13-4. Even under a cool light source, the shadow color wouldn't be that warm, but at least the values are right, which is more important. *Bottom, CORRECT:* This time I made the cast shadow a darker, muted violet by adding just a little yellow ochre, and cooled it with a bit of blue-violet. I warmed the purple napkin up front with a bit of red-violet.

SUCCESSIVE CONTRAST

Chevreul's second law regarding color perception is called *successive contrast*. To experience this visual phenomenon, stare fixedly at a bright color for about half a minute, and then transfer your gaze to a white background. The first color's complement—its opposite—will appear in exactly the same shape and position as the original color, only in a pale tint. Chevreul called this an accidental color; we refer to it as afterimage.

Red has a pale green afterimage; yellow's afterimage is lavender; black's is bright white.

Once you become aware of successive contrasts, you should see them frequently. I once had some bright lime-green note paper. As I wrote letters, I was constantly distracted by pink-lavender oblongs fluttering around my desk like butterflies. I haven't purchased intensely colored stationery since.

MIXED CONTRAST

Chevreul carried the successive contrast experiments a step further, using various colored backgrounds to receive afterimages. This is what he called the law of *mixed contrast*. Try this yourself. Stare first at a bright blue-green square, then look immediately at a yellow circle of about the same size. It will not appear to be green, as you might expect, but instead you'll see a pale orange. This is because blue-green's projected complement, a pale red-orange, will mix with the yellow. At least, you'll see the pale orange where the two shapes coincide, but where they do not you'll see the red-orange outside of the inner circle.

Now stare at the dot in the center of the magenta triangle in Fig. 13-7. This experiment will work better if you cover the yellow square with a piece of paper first. After half a minute or so, transfer your gaze to the dot in the center of the yellow square. You might expect to see an orangey-rust color, but no, after a few seconds, you'll see a beautiful, bright lemony yellow-green triangle appear on the yellow background as magenta's greenish complement mixes optically with the yellow. Here are two more interesting experiments to try on your own:

1. Concentrate on a red circle for about thirty seconds and quickly put up a green square to receive the green afterimage. The green square will have an astonishingly brighter green circle in the middle with duller green corners, the unenhanced natural color of the square.

2. Stare again at the red circle, remove it for an instant, and then put it back in place to receive its own afterimage. What will you see, a brighter red? No, guess again. It will be a deep red of low intensity, the result of red being mixed optically with its green complement in the afterimage.

TONALISTS VERSUS COLORISTS

Chevreul dealt at length with the need to adjust colors according to both natural and artificial light. He spoke of tonalists, who relied more on monochromatic color, as opposed to colorists, who expressed the quality of light through hue and temperature changes. The difference between the two modes of painting is easily seen today, thanks to photography. Black-and-white photos taken of paintings typical of the two different camps show that the tonalist paintings reveal the world with proper modeling of forms and aerial perspective. The same cannot be said as often of colorists' paintings, in which values might be totally scrambled or, as is more likely, so close in value that the subject hardly

shows up at all on black-and-white film. The colorist often models forms from warm to cool with few or no value changes using virtually any color sequence: strident, clashing colors, muted colors, or subtle pastels. The basic form-building formula on which this book is based melds both systems, the tonalist and colorist. As I have emphasized often, a proper sequence of values—**highlight**, **light**, **middle tone**, **dark**, and **reflected light**—is always a safe bet for achieving volumes, but it is much enhanced when there are color temperature shifts at the same time. Diagonal paths through the complementary color charts unite the two systems, and they work beautifully when you need to change hue, value, temperature, and intensity simultaneously while modeling any form or plane whose local color lies within a given color chart.

Intensity modification is especially important when you are looking for the colors of form or cast shadows, because by their very nature, shadows are never intense colors. If a strong light intensifies colors, the lack of light must, by simple deduction, make shadows muted in color.

Fig. 13-7. Stare at the dot in the magenta triangle for half a minute, and then at the dot in the yellow square. You should see a triangle of brighter yellow-green. This will work best if you have a strong light on the book's page.

THE NATURAL VALUE ORDER OF COLORS

Taking our cues from light rays that pass through a prism, or from a rainbow, we find that yellow is always the lightest value, and its adjacent hues descend in tone until violet is the darkest value of all. (At least, most local colors in nature seem to follow that value order, but not all.) The chart in Fig. 13-8 shows a seven-step vertical monochromatic scale for each of the twelve major hues of the color wheel. The square white dots denote the approximate maximum intensity of these twelve colors, which become weaker in chroma above and below the dots. The dots also indicate the natural descent in value that occurs as we follow the order of the spectrum. It is much easier to use colors in their natural value sequence than to reverse that order. It takes a lot of white to lift a dark violet up to a #2 tint, whereas using a deep velvety violet out of the tube is easy. Similarly, it is more difficult to find a satisfactory dark yellow than to squeeze out a sunny pigment yellow in its natural high value. Think of the spectrum colors this way: the colors on the left side of this chart (or along the left and top of the color wheel) naturally say sunshine and warmth; the colors on the right side (or along the right side and bottom of the color wheel) whisper coolness and shade.

We already know that warming and lightening colors in response to a warm light source is the magic that will make your paintings come alive. But will the magic work in cases where a cool light source causes nature's value order to reverse? What happens when all colors become cooler and lighter in the brightly lit areas, and warmer and darker as they go into shadows? I remember vividly a painting I saw in a European museum that literally stopped me in my tracks. It was a backlit portrait of a woman seated in front of a window. She faced the interior of the room, and the right **light** side of her head and shoulders were painted a light silvery blue from the sky's influence through the window. But the front of her face, hair, and dress in the

dark part of her form were all in deep, rich rusts, reds, and red-violets, with a smattering of lighter **reflected lights**. They appeared to come from an unseen lamp, or possibly from a fireplace. It was an unforgettable testament to the possibility of reversing the natural color and value sequence in special situations.

Generally speaking, a radiance will emanate from a painting with a lot of light warm colors;

significantly less glow comes from a painting with cool light and a dominance of cool colors throughout. Whatever colors you are using, the secret to creating exciting color in your work is to adjust the color of everything so that it shifts in hue, value, intensity, and temperature on either side of its **middle tone** (local color) position, that all-important starting point.

COLOR HARMONY

In addition to Chevreul's principles of simultaneous, successive, and mixed contrast, we have him to thank for most of the widely accepted theories of color harmony. He concluded that there are six distinct color harmonies that can be grouped into two basic categories: the harmony of analogous (closely related) colors and values, and the harmony of

Fig. 13-8. On this twelve-hue chart, the six major hues—yellow, orange, and so on—are square. The six intermediate hues—yellow-orange, red-orange, and so on—are oblongs between the squares. The white dots indicating approximate maximum intensity follow a nice descending sequence of values on the left warm side of the chart, but an uneven path upward on the right cool side. That's because most cool colors in oil paint are transparent, and they need a bit of white to bring them up to the same degree of opacity as the warm colors that come right out of the tube.

contrasting colors and values. In the first category he lists the following.

1. *Monochromatic colors*. These are a sequence of values of a single hue. The vertical scales on the chart in Fig. 13-8 are all monochromatic, with black added to each one for the darker shades. The term monochromatic generally includes variations of each hue, such as the several yellows, or the reds and blues in the expanded monochromatic sequences mentioned earlier in chapter 9.

2. *Analogous colors*. Chevreul preferred the harmony of adjacent colors that are all close to the same value. That can mean any three, four, or five adjacent colors running horizontally in the same row of Fig. 13-8, or in the upper rows of any of the complementary charts. Chevreul's preference aside, analogous colors are any sequence of colors on the color wheel, usually with a single primary color as a common denominator. Fig. 13-9A shows orange, red-orange, red, red-violet, and violet just as they are on the color wheel. An analogous color harmony is always more satisfying when it is spiked by a touch or two of a complement across the color wheel, in this case, blue-green.

3. *Dominance of one hue*. Chevreul also favored a color harmony based on what he called a "dominant colored light." Imagine viewing a group of objects under a colored light bulb; its color would then influence all the others. In color mixing, this would mean adding a little of the bulb's color, say, blue, to every other color used in the painting. An easier way to achieve this effect is to apply a single layer of transparent blue glaze over a finished painting. More about that technique can be found in chapter 18.

In his second category, the harmony of contrasting colors and values, Chevreul lists the following:

1. *Contrasting values within a hue*. This refers to the contrast of widely different values of the same hue, for example, pale blue and dark midnight blue, light pink and deep maroon, and so on.

2. *Contrasting values within adjacent hues.* This could mean pale green, middle-value blue-green, and a deep blue; or pale peach, middle-value red-orange, and a deep ruby red. (Both are obviously analogous sequences, but because they have contrasting values, they are listed here rather than in the first category.)

Fig. 13-9A. These analogous hues all have red in common. For a contrasting touch from across the color wheel, I recommend a near-complement of red rather than its direct complement.

Fig. 13-9B. This Y-shaped split-complementary harmony is composed of yellow and the two colors on either side of its opposite color, violet. It could also be called a harmony of near-complements.

Fig. 13-10. Working through one of these unusual triads in a painting later on (with a full palette) is valuable because it forces us into new color paths, new ways to model forms, and new gradations other than those we already know.

3. *Complementary colors.* Chevreul referred to the harmony of colors "very far asunder," which means any pair of opposite colors, or of split complements—one color plus the two colors on either side of its complement. In Fig. 13-9B, we see the split-complementary harmony of yellow, red-violet, and blue-violet. Any contrasting color harmony includes the intermixes between the given colors, by the way, and our series of complementary color lessons are invaluable explorations of those beautiful harmonies.

TRIADS

Triads are color harmonies based on any three colors that form an equilateral triangle on the color wheel (with three hues in between). Perhaps few interior designers would base a color scheme on a triad of the secondary colors orange, green, and violet, especially when the colors are in their natural intensities, as they are in the left triad of Fig. 13-10. But by transposing their values and intensities, as in the next triad, we arrive at something completely different, a contrast in value of colors far apart on the color circle. The last triad shows the intermediate colors yellow-orange, red-violet, and blue-green at their full intensities. Perhaps they too would

be less garish and more harmonious if they were transposed. Interior design aside, I find the secondary triad in particular extremely useful, not only as a color harmony in paintings, but in color mixing to mute colors slightly, to run a background gradation, and last but not least, as a low-key way to warm and cool colors.

It is a commonly held theory that harmony equals order, that any path, any smooth progression through a color space or an organized color chart, is harmonious. Nonetheless, for most of us, Chevreul's theories of what constitutes color harmony are virtually foolproof and probably the color harmonies most often used, while maverick combinations of colors chosen at irregular intervals on the color wheel are the most difficult to harmonize.

COLOR HARMONY FOR REPRESENTATIONAL ARTISTS

For experienced painters of realism, color harmony usually becomes a matter of responding to nature's dictates, plus relying on an intuitive sense of what looks right. But no matter whether you follow one of the above specific color harmonies or merely respond visually to your subject, there is one design principle regarding color that practically

Fig. 13-11. *The Magnificent Pali.* Oil on canvas, 28 x 22" (71 x 56 cm). Collection of Captain and Mrs. Thomas Koesters. "Pali" means cliff in Hawaiian. Like most landscapes, this one has an analogous color harmony—from yellow-green down through blue— with red-violet as the complementary relief. Blue-green is repeated many times, but in different values, intensities, sizes, and shapes.

guarantees harmony. It is to repeat each color that you introduce several times. (Don't, however, invite disaster by introducing every color in the spectrum.) It is a simple rule, but there are strings attached to it:

1. Each repetition of a hue should be a slightly different value and intensity. Example: vary a blue-green hue with a pale #2 aqua, a bright #4 turquoise, a muted #6 teal color, or a deep, nearly black #8 blue-green. If they flow in a logical sequence through the format, so much the better. In landscape painting, that logical sequence usually comes about naturally through aerial perspective. Check the progression of the blue-greens in the painting *The Magnificent Pali*, Fig. 13-11. Then analyze the subordinate yellow-greens and magentas. (All three of the hues vary in temperature too.)

2. Each repetition of a particular hue should be a different size or quantity. Example: a

large area of teal blue-green, a middle-sized area of pale aqua, and a few spots of brilliant turquoise—or any other combination thereof.

3. Colors must be balanced throughout the painting. Don't have three versions of red on one side of the painting and not a sign of it on the other side. A splash of yellow in the lower left corner won't work if it isn't repeated somewhere else. A sure-fire way to balance a color is to repeat the hue in a triangle, avoiding an obvious equilateral configuration—or any other symmetrical arrangement. I call this balanced distribution and repetition of color the "Tapestry Principle." Think of each color as a thread and weave it intermittently throughout the painting. Look how the reds and red-violets work in *Haiku Gardens Lily Pond*, Fig. 13-12.

4. You can avoid having all your colors clamor for attention and ensure color harmony if:

Fig. 13-12. *Haiku Gardens Lily Pond*. Oil on canvas, 24 x 36″ (61 x 91 cm). Collection of Mrs. Daniel Park. The Tapestry Principle is working throughout this painting. The repetitions of the brilliant red Ti leaf shrubs form a wide irregular triangle that weaves throughout the composition.

Fig. 13-13. *Above:* This scene has a sunny look with its preponderance of warm whites, yellows, browns, and warm greens, and just a few touches of violet for contrast. *Below:* This is an example of Chevreul's dominance of a single hue, as though one is looking through a colored glass—in this case, a violet one. It is harmonious all right, and establishes a dawnlike mood, but how I yearn to give it some life and color contrast!

- warm colors are dominant and cool colors subordinate, or the reverse. Compare the top half of Fig. 13-13, where warm colors dominate, with the bottom half, where cool colors dominate. The cooler painting shows a dominant color, violet, added to all colors so that they seem viewed through a tinted glass.
- light colors are dominant and dark colors subordinate, or the reverse. Middle tones can also be dominant in a painting, with only minor light and dark values for relief.
- bright colors are dominant and muted colors subordinate, or the reverse.

For more examples of the above, read chapter 17, "Design." The most important point about all of these color harmony principles can be put in a nutshell. Avoid half-and-half proportions of any color characteristic—hue, value, intensity, or temperature. Admittedly, these design principles can tie you in knots, especially when painting on location. I suggest that you respond to the scene in front of you with joy and expedience, dashing on the paint as fast as you can. Later on at home, study the painting and begin to think more about color theory and design principles. One of the virtues of working in oils is that you can revise and improve almost endlessly, although often at the expense of freshness and spontaneity.

Doesn't nature have her own infallible color harmonies? Yes, but unfortunately, most of us can't get away with mere duplication of what we see. For instance, a bright blue sky that has no relation to the green hills and foliage in the foreground and middle ground works all right in nature, but in a painting it does not. The best way to avoid that unrelated look is to weave all color threads in the landscape throughout the format. Bring the blue of the sky into the cool form and cast shadows down below. If there is a warm accent down below, repeat it subtly in the clouds overhead, and so on. In Part Three, you'll find numerous examples of the tapestry principle working in landscapes.

An easy way to test your own color harmony in a painting is to look at it upside down. When the subject is no longer readable, your eyes will concentrate on colors, values, composition, and design elements. If you become aware that there are too many major colors clamoring for attention, decide which one or two you can eliminate without too much surgery. At the same time, I feel I must defend the use of tiny color touches here and there that are not related to the major color harmony. Think of them as little color threads that in no way compete with the major shapes and colors of the tapestry. On closer inspection, these little sparks of color add interest.

Color Lesson 5: Yellow/Violet Complements

This lesson explores the three violets at the bottom of the color wheel. Mixtures of near-complements like blue-violet and yellow, and red-violet and yellow, in small amounts, are all right, just so they don't throw off the complementary color harmony.

Color Chart Assignment

Refer to Fig. 13-4, the yellow and violet complementary chart. To make your own chart, find as pure a yellow as you can mix, one without any hint of yellow-orange or yellow-green in it. As the other parent color, use Dioxazine violet with just a little ultramarine blue added to it. If you do not have Dioxazine, then mix a violet that leans toward neither red-violet nor blue-violet. With the bright yellow in the lower left corner, and the pure violet in the lower right, mix your bottom row first. Test the blackish color in the middle with some

white to find the neutral gray. If the neutral you get is too greenish, it means that there is too much blue in your violet. Add a bit of red-violet to it. If the neutral swings toward rust, it means that there is too much red in the violet. Add a bit more ultramarine to it. The antidote for any complementary pair that refuses to neutralize properly is a bit more of the complement of the color you accidentally got, instead of the neutral gray you wanted. That sounds confusing, I know, but you'll understand it better when you begin to mix these colors.

If you have time and the inclination, do two more color charts, one with red-violet and yellow, and the other with blue-violet and yellow. They could be mini-versions of the main complementary pair. You would not expect to find a no-color neutral between them, but would be rewarded by a whole range of beautiful near-complements that could become an important part of your color vocabulary.

cadmium yellow pale

cadmium yellow light

yellow ochre

ACRA red/Dioxazine violet

Dioxazine violet

ultramarine blue/Dioxazine violet

white

Still-Life Assignment

Assemble objects in the appropriate colors, as usual. Produce is easy—lemons, grapefruit (cut in half), crookneck squash, and bananas for the yellows; deep purple eggplant for the violet; mushrooms and onions for the beiges and browns. Try a gradated background based on one of the diagonal paths in the yellow and violet complementary chart. Let it go from beige through the neutral gray to darker mauve, or from pale lavender through gray down to a darker brown. Always paint the subject first, and then let your painting tell you what it needs in the background for balance and harmony.

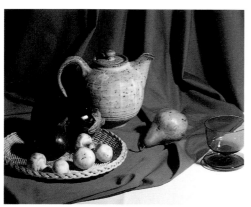

The Setup. I looked for props that included as many color values as possible in this lesson: violet (the drape and glass), yellow (the flat basket and the pear), white (the teapot and mushrooms), red-violet (the red onion has to do) and something very dark (the eggplant). There are also touches of blue-violet in the drapery and other areas cooled by a secondary light source.

Step 1. I started working with a puddle of thinned-out brown mixed from yellow and violet, and later varied the color of the lines. In the drapery, I blocked in solid areas for the cast shadows and some of the dark areas. Drapery folds are easily disturbed, so make value notes about them right away. Notice that I drew shapes, not just lines that don't connect to anything.

Step 2. This is the familiar search-for-local-color stage. I don't want to start modeling forms until I am sure I have the right color and value relationships for the whole painting. A particular challenge will be the close values between the white mushrooms and the pale yellow woven basket.

Step 3. I've begun to model the forms now, paying close attention to the three dark values that come together where the eggplant, the **dark** side of the white teapot, and its cast shadow on the drape join. By staring at the area for a few seconds, I can discern different values within that dark hole.

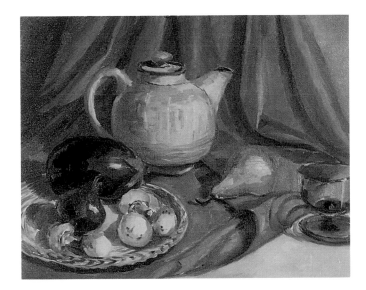

Step 4. Finally the folds of the drapery begin to take shape. I give careful attention to the kinks that ease the drape from a vertical plane to the flat plane of the table. I am not too pleased with the involved triple folds of cloth right down in front, but I enjoy the challenge of making the cast shadow of the large fold roll over the two smaller ones.

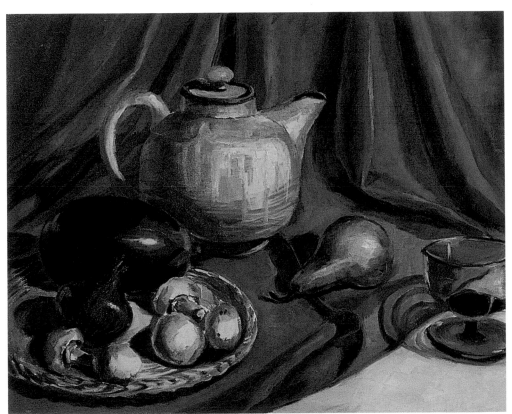

Step 5. Ochre and brown seemed to be right for the small background areas on either side of the draped cloth because there was obviously enough violet in the painting already, and the yellows needed to be better distributed throughout the composition. There is quite a lot of creamy ivory in the lower right corner, and although I feel it is too large an area, it does form a nice irregular triangle with the off-whites of the teapot and the mushrooms.

Chapter 14
ANALOGOUS COLOR SEQUENCES

Now let's consider analogous color sequences. Look at the Complementary Color Wheel shown in chapter 15, page 203. Working with an analogous sequence means using colors that are adjacent to one another on the color wheel to model forms, staying on the outer ring of intense colors as long as possible. Given a subject with a bright local color like red, when white alone is added to model that red object, the movement is in toward the pink in the second ring. If you use red's complement to find a **dark** form shadow, the movement is further in toward the shade of red in the third ring. The analogous sequence, on the other hand, moves up to red-orange for the **light** and down to red-violet for the **dark** on that object. Instead of weakness, this sequence gives your color strength, power, pow! It is the one you should use when the local color of any object you are painting is an intense color in a strong warm light.

Red-orange to red to red-violet is a natural sequence of warm light to cool dark (and an extended version of the one covered in chapter 9) that requires very little adjusting of values to model red objects with those colors. But a few other analogous sequences do require some value adjustments. Let's consider the local colors of four different subjects: a red tomato, an orange, a green pepper, and purple flowers.

Let's consider the top left tomato first in Fig. 14-1. Assuming there is a warm light on it and a local color of ACRA red, note that I carried the sequence further up the color wheel beyond red-orange to orange. That means adding a little cadmium yellow light or yellow medium to the cadmium red light to find the orange (or using cadmium orange). The **highlights** go in the orange **light** areas.

Scarcely any white is needed to attain the right value because an increasing amount of yellow is already doing the job pretty well. If you do add white in the **light** area, remember not to add so much that it becomes a tint, thereby preventing the **highlight** from "snapping" as it should.

To cool and darken the tomato's form shadow, move down from ACRA red by adding a little Dioxazine to it to make a red-violet. A little more Dioxazine brings it down to an even darker, nearly true violet. Red-violet is naturally darker than the red local color, and, inching toward violet, continues the cool dark sequence. Either one makes a much more beautiful form **dark** than if you darkened the red with black, or got a brown from muting the red with its complement, green. The semicircular analogous sequence around the top left tomato in Fig. 14-1 is the best choice for modeling a red ripe tomato in a warm light. It has an extra hue, a cooler red below the large chip of ACRA red local color, that suggests that you can cool colors more gradually than with normal hue intervals down the color wheel. Of course, you can inch up the color wheel from local color as well.

THE TOMATO THEORY
The "Tomato Theory," as I call it, applies to all analogous color sequences, no matter where you start on the color wheel. The important point to understand is that an analogous sequence keeps colors rich and saturated in hue rather than weak. In the very first color lesson, the monochromatic lesson, forms had to be modeled with just one hue, plus black and white. With such a limited palette there simply was no choice in how to find the **light**

and **dark** areas on forms. The vertical scale and the tomato to the right of it in Fig. 14-1 are monochromatic, and that tomato was modeled with just ACRA red, black, and white. The horizontal scale and bottom tomato in Fig. 14-1 show what would happen if you decided to use a complementary sequence, using red, green, and white to model the tomato. It is an inappropriate choice for a bright red tomato. But as I often say, whether the **dark** area of a tomato is ultimately maroon, brown, red-violet, or violet is entirely up to you; the important thing is whether the value is right.

Fig. 14-1. All three tomatoes in this chart share the same local color, shown in the large wedge shape and circle, but they have been darkened and lightened in different ways. *Top left:* When the local color of anything is an intense color and it is struck by a warm light, the best way to keep its color bright is to use an analogous sequence on the color wheel. *Middle right:* The vertical monochromatic color scale shown yields accurate values but gives the impression of a cool or neutral light. *Bottom left:* The horizontal red-to-green complementary scale also gives accurate values but implies a twilight environment— or even a rotten tomato. All three methods are useful depending on the light and mood.

ACHIEVING CLEAN ANALOGOUS SEQUENCES

Can the viewer of your painting accept a tomato that ranges from orange in the **light** to nearly violet in the **dark**? That depends on whether you have maintained the integrity of the local color so that it still reads as a red tomato. It depends even more on whether you went around the color wheel choosing adjacent colors without missing a single hue step, for therein lies the risk in using the Tomato Theory. If you casually mix the ACRA red local color with yellow to find the orange you need for the **light** on the tomato (skipping the hue red-orange), don't be surprised when your mixture nudges in toward rust in ring #3 of the color wheel. That would hardly be the clean, bright color you expected. Had you gone from ACRA red to red-orange, using cadmium red light by itself, and then to orange, the color sequence would have remained unsullied.

Always separate the warm and cool reds when you are working on the warm side of the color wheel and want pure, clean color. Use cadmium red light for any sequence going up the wheel above pure red, that is, red-orange to orange to yellow-orange. Conversely, use ACRA red (or Thalo red rose) by itself for any sequence going down the wheel below red, that is, red-violet to violet and even to blue-violet. Alizarin crimson will work as your cool red too, but it is not very lightfast.

Work with the warm and cool versions of the other two primary colors in the same way. For a clean, bright analogous sequence, use the cool greenish yellows, cadmium yellow pale or lemon, in a descending sequence on the color wheel from yellow-green to green and to blue-green. Use the warm orangey-yellows, cadmium yellow light or cadmium yellow medium, in a descending sequence from yellow-orange to orange to red-orange. Use the warm greenish blues (cerulean, manganese, phthalo blue) in an ascending sequence on the color wheel from blue-green to green to yellow-green. Use the cool purplish blues, cobalt and ultramarine, in a descending sequence of blue-violet to violet to red-violet.

The above suggestions would be especially helpful if you are ever limited to what is called a "double primary" palette. That means that you would have only a warm and a cool yellow, a warm and a cool red, and a warm and a cool blue. Always expect a lessening of purity as you introduce a third primary color into any mixture or sequence of colors. For example, trying to mix a pure violet from a cool red and manganese blue (which in theory has a bit of yellow in it) is a lost cause, because you'll get a grayed-down violet instead. They are closer to being opposite colors on the color wheel than analogous, and you couldn't expect a vibrant color from that near-complementary mixture. If you plot a

Fig. 14-2. *INCORRECT:* The green pepper goes from yellow at the top of the color wheel clear down to dark ultramarine blue. The tomato starts with almost pure yellow, but then goes through yellow ochre, thus breaking the pure color sequence that would pass through orange, and on down through the warm and cool reds. And the violent purple at the bottom is just too much. Both vegetables look crude, but at least they have vitality and form, if not credibility.

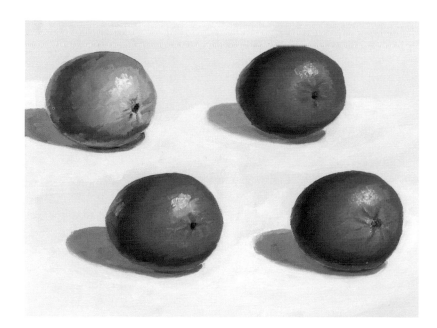

Fig. 14-3. Achromatic values (top left), monochromatic color (top right), complementary colors (bottom left), and analogous colors (bottom right). Since an orange's local color is intense, the only way to keep it bright is to use our new analogous color theory, as I have on the right. The orange goes from yellow-orange in the **light** to a cool crimson red in the **dark** form shadow.

direct line between a cool red and a greenish blue on the color wheel, it would pass below the neutral gray in the middle. A sequence of their intermixed colors along that path would yield beautiful muted near-complements, the kind of minor key colors that are needed to set off the bright colors in a painting. How far colors are from each other on the color wheel has everything to do with how intense or muted a sequence (or mixture) is between them.

WARMING AND COOLING COLORS BY DEGREES

To a certain extent, how many adjacent colors you choose to use up or down from a pure local color becomes a matter of how powerful you want your color to be. One or two hues on either side of your local color will work beautifully, but if you push your luck by using three hues on either side of the local color—that is, to run a sequence on a tomato from yellow-orange to blue-violet—the result will be wholly unrealistic. Study the bad examples of a tomato and green pepper in Fig. 14-2. Common sense tells us that we can't change hue and value too drastically and still have the subject come across believably.

Now let's try modeling an orange with analogous color. Find its local color and then advance up the color wheel a step or two to yellow-orange, and from there, to almost pure yellow in the **light**. To cool the orange, back down the color wheel to red-orange and then down to true red. If that is not quite dark enough, or is too intense for the **dark** area, either pull in just a touch of red-violet, or drop the red with a bit of its complement. In either case you will have a more beautiful orange fruit than if you used blue to arrive at a brownish form **dark**, as you had to do in the blue and orange lesson. Compare the four oranges in Fig. 14-3. They are a brief color course summary to date, progressing as they do from achromatic values (top left) to monochromatic color (top right) to complementary color (bottom left) and, finally, to glowing analogous color (bottom right).

"Wait a minute!" I think I can hear you say incredulously. "A red form shadow on an orange? I thought shadows were supposed to be cool when there is a warm light source." True, they are, but with analogous sequences, we are always working with small degrees of warmth and coolness, not huge jumps across the color wheel as with the complements. Therefore, red is relatively cooler than red-

orange (which has yellow in it); red-orange is cooler than orange (which has much more yellow in it), and so on. When working with the analogous color theory, assume that pure yellow at the top of the color wheel is the warmest and sunniest of all hues, and as you work down from it on either side, colors cool slowly and darken. The left warm sequence always works better in regard to evenly descending values than the cool sequence on the right. Values have to be adjusted a little more when modeling forms through the green, blue-green, and blue range to maintain a good **light**, **middle tone**, **dark** relationship.

COOL ANALOGOUS SEQUENCES

Let's mix colors to find the local color of a green pepper. There are several ways to arrive at that color, but make no mistake, a green pepper is not kelly green, the color that comes from mixing yellow and viridian. If you ever do get a kelly green, add a bit of red or orange to it to get the right local color. Then proceed up the color wheel to yellow-green, even daring to inch up toward yellow for the **light** area. Peppers are very smooth and shiny, and their **highlights** have to have a lot of snap, so don't make them too high in value or too yellow in

the **light** area, as we saw in Fig. 14-2. Then cool and darken your **middle-tone** green by using viridian by itself first, and then edge down toward blue in the **dark** area. Cobalt blue isn't dark enough to lower the value sufficiently, so drop it down with a touch of its complement, orange, or edge further down to ultramarine blue with a touch of *its* complement. You don't want raw color in the form shadows, in any case, so blend your colors accordingly.

You mustn't assume that you can always warm colors by going up toward yellow on the color wheel, and cool them by going down toward blue. Adding yellow to find the **light** area from a violet **middle tone**, for instance, will deaden the color, just the opposite of what you intended. Look at the African violets in Fig. 14-4. Purple local colors have to be warmed with the adjacent red-violet at the bottom of the color wheel, and above that, with a cool red. As for cooling the purple flower in the **dark**, a little blue-violet is the right and only choice, as Fig. 14-4 shows. All the colors at the bottom of the color wheel usually need a touch of white in them, both because they are too dark in value for the flowers in this case, and because they are too transparent as they come out of the tube.

Fig. 14-4. *African Violets*. Oil on canvas, 7 × 8″ (18 × 20 cm). Collection of the artist. The local color of these flowers was red-violet, and I warmed them in the **light** areas with a little ACRA Crimson, and cooled them in the **dark** with Dioxazine violet. Cast shadows on the flowers are darker areas made with blue-violet, not by adding the complement. But I did use the complement of green (red) to find cast shadows on the leaves.

Fig. 14-5. *Blue Iris.* Oil on canvas, 9 × 7" (23 × 18 cm). Collection of the artist. Blues are a special case on the color wheel in that they can be warmed up toward green and yellow or down toward violet and red. The top parts of this iris are warmed from blue-violet to violet to red-violet. The bottom parts go from blue-violet to blue to manganese blue, and finally, I used a touch of viridian, warmed with a tiny bit of yellow, for the lightest areas.

TROUBLE SPOTS

If you think through some other analogous sequences on the color wheel for a few moments, you will soon see that there are a couple of problem areas. When pure bright yellow is the **middle tone**/local color of your subject, it is awkward to try to work up to the **light** area with the adjacent yellow-orange. It is much better to handle chromatic yellows the way we have in past lessons, even though it goes against logic to use the slightly cooler cadmium yellow pale in the **light** areas of yellow objects. Its intensity and high value override its slight yellow-green cast. You might consider using a dark yellow-green for the **dark** form shadow on yellow subjects. In fact, according to the Tomato Theory, it is the logical choice for cooling yellows. But if you use it as the **dark** areas on yellow flowers, you'll find that the olive green form shadows would be too similar to the green foliage. You

might prefer the dark yellow-browns made with yellow's complement. Even so, in a whole bouquet of yellow flowers, the yellow-browns would become boring and you would need to vary the warms and cools within them as inventively as possible.

Intense blue local colors also present a bit of a problem when you attempt to warm and cool them. Should a blue vase or blue iris flower be warmed with adjacent hues going up the color wheel to blue-green, or down through blue-violet toward red? The answer depends on whether the blue local color is on the greenish side or the violetish side to begin with, and also on what will be harmonious with the rest of the painting. A true blue like cobalt is warmed more efficiently with the blue-green to green sequence rather than going the other way around the color wheel; a blue-violet is warmed more quickly through violet to red-violet. The iris flower in Fig. 14-5

is a composite of the two sequences. The three lower parts (with the tongue and crown) were warmed with an analogous sequence going up the color wheel through manganese blue, then up to viridian, which was then warmed with a touch of cadmium yellow pale in the lightest parts. The three upper-thrusting "feathers" were warmed going down the color wheel toward red-violet. Although the actual flower I painted was distinctly red-violet in all of its **light** areas, the two analogous sequences seem to work quite well together. They prove the point that we can vary our handling of color temperatures, just as long as the local color still reads consistently.

ALWAYS DETERMINE THE INTENSITY OF LOCAL COLORS

It is important that you not only identify each local color, but find its position in the different rings on the color wheel as well. Let's review the following points:

- If the local color of an object is muted (as in the inner rings of the color wheel) or nondescript, then decide immediately which pair of opposite colors on the color wheel will serve it best. After determining the temperature of the primary light source, model the object with warm and cool colors accordingly, following a diagonal sequence of colors on the appropriate complementary color chart.
- If the local color of an object is a bright color (the outside ring on the color wheel) and the light source is warm, then warm and cool it with an analogous sequence around the color circle, staying out on the outside ring of chromatic colors as long as possible. The darkest color in the sequence may have to be muted with a touch of its complement, not the complement of the local color.
- If the local color of an object is a pastel color, you can use either the analogous sequence in the second ring of the color wheel, adjusting the values slightly so they read as warm to cool with very little value

Fig. 14-6. This tomato in a cool light runs from cool lavender (at the bottom of the color wheel) in the **light** area to a warm **dark** red-orange (higher up on the wheel). Actually this study involved combining an analogous sequence on the upper part of the tomato and a complementary sequence on the bottom of it.

change, or choose a slight diagonal in the upper rows of the complementary chart.

- If the local color of an object is very dark, use either the analogous shades in the third ring of the color wheel to model it, or a slight diagonal in the lower rows of the appropriate complementary chart.

You will eventually recognize the need to apply the analogous Tomato Theory sequence in some instances but not in others. When you can't seem to get nature's brilliance and your painting seems drab, ask yourself these questions: Am I using analogous sequences wherever possible? Am I warming and cooling my colors enough? Am I changing hue and value across forms and planes? These questions all refer to the same thing—color temperatures.

COOL LIGHT, WARM DARKS

Will the analogous theory work with a cool light source? Yes, but it takes much more adjusting of the values, since it runs contrary to nature's sequence of warm light to cool dark. Fig. 14-6 shows a tomato in cool light that was modeled using a reverse Tomato Theory sequence. Cooling the tomato with pale red-violet in the **light** and then putting a

pale blue **highlight** in it wasn't too bad. But warming the **dark** area of the tomato seemed strange because I had to mute red-orange and orange with their complements to get them down low enough in value. Can we accept a tomato that ranges from pinky-lavender in the **light** to brown in the **dark**? Yes, if the local color and values are right, and the light is clearly cool.

COMBINING SEQUENCES

If you analyze the way I handled the tomato in cool light, you will find that, although I used an analogous sequence to find the **light** area, it became necessary to add some complements to darken the warm hues sufficiently for the **dark** area. You may find other instances when a combination of sequences appears to be the best solution to a gradation or to the modeling of forms. A lot depends on the colors surrounding the object and how best to set them off from each other.

SKIN COLORS

Analogous sequences work when you need to warm and cool skin tones in portraiture and figure painting. Varying proportions of cadmium red light, yellow-ochre, and some white are a good starting point for the basic pale red-orange color of Caucasian skin. Whatever you select as local color can then be warmed up to orange and then on up to a creamy yellow-orange, and even an ivory white with a touch of yellow. Then it can be cooled down through red and into red-violet for the **dark** form shadows, as in Fig. 14-7 (top). This would be a glowing color sequence for a fair-skinned woman. Another way to cool skin color is to use viridian, red-orange's complement, in the **dark** areas, as in the third sequence from the top. That would be a better option when finding the color of a man's beard in shadow. Anything is better than adding burnt umber to skin tones in the shadowed areas! The fairer the skin, by the way, the closer you will want to keep the values when

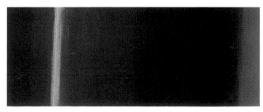

Fig. 14-7. Assuming a warm light from the left front, all sequences start with **middle tone** on the left, then **light** with **highlight** in it, **middle tone** again, and two or three steps into the **dark** area, and a cool secondary light color on the right. Most Caucasian complexions can be found by varying the proportions of cadmium red light, yellow ochre, and white, to find a more or less pale red-orange hue. Pairs of complements work better for darker skins.

modeling from warm to cool. Note this in the second sequence, an appropriate value range for infants and young children. The cool colors on the right side of all sequences represent arbitrary **reflected lights**, or light from a cool secondary light influence. If the skin of your model is shiny, there would be cool lowlights as well.

The local color of red, brown, or black skin can be found through almost any one of the complementary pairs and then warmed and cooled with a complementary split. Of course, everything depends on the temperature and proximity of the light source, so these are not formulas by any means. The bottom three color sequences are possibilities, and each one involves a different complementary pair and their intermixes.

Finding Cast Shadows with Analogous Colors
Add to the usual method of finding cast shadows (by using complements) the option of using a darker adjacent color for cast shadows. Are you painting a green lawn with tree shadows on it? Drop down the color wheel one notch to find dark, slightly muted blue-green cast shadows. Are you painting a child in a lavender dress? Use a muted blue-violet for the close cast shadow of her arm on the dress, but model the folds of the dress with violet lowered with a touch of yellow. Adjacent cast shadows won't work as well in the warmer areas of the color wheel, though, because they'll be too warm. Can we go along with red-orange cast shadows on an orange beach towel? Or even red ones? Maybe, but the red-orange or red would have to be dropped down quite a bit with their complements. As a rule, I assign complements the job of taking care of cast shadows, while analogous colors are reserved for the **darks** on bright-colored subjects. Sometimes there is a reason to reverse them because of similar colors nearby. Anyway, these will be our options now as we get into more colors in the lesson at the end of this chapter.

Fig. 14-8. The upper gradation goes from an ivory yellow (slightly in from the left) to yellow-orange to peach, muted with more and more blue to a soft blue-gray on the right. The lower gradation runs from pale peach (slightly in from the right) to red-orange to a red muted with a bit of green, brought down in value with more and more green. Analogous colors give both lighter sections a "glow."

Fig. 14-9. Here the top gradation starts with pale viridian plus a touch of yellow, with more and more cadmium red light added, as well as red-orange. The lower gradation starts with manganese blue and white. After blending cobalt blue into the manganese blue, I began to mute the cobalt blue with orange until it became brown. I seldom make the two ends of a gradation identical in value or color.

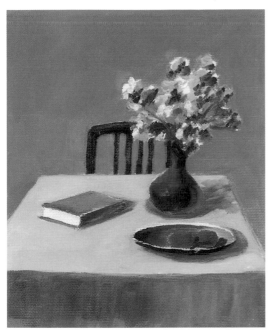

Fig. 14-10. *Left, INCORRECT:* Each object or plane in this still life is a different monochromatic color. This may tempt you at first when you are finally unleashed into a full range of colors on your palette. *Right, CORRECT:* The Tapestry Principle is working here. Even though the local colors remain essentially the same as they were on the left, they have been repeated subtly throughout the painting. This repetition will happen quite automatically if you'll keep in mind the phrase, "Warm it in the light and cool it in the shade." Notice how the repeated colors help tie the painting together.

BACKGROUND SEQUENCES

A combination of sequences is frequently helpful in painting the background of a still life. Try starting with an analogous sequence and then cut across the color wheel toward the complement of the coolest color in the sequence. Look at the two gradations in Fig. 14-8. They follow the natural sequence of warm light to cool dark, while the sequences in Fig. 14-9 run counter to that, cool light to warm dark. But in Fig. 14-9 are the lightest colors really cool? Yes and no. Notice that I warmed both "middle tones," the muted green in the upper example and the muted blue in the lower one, with a little bit of warmer adjacent colors as I approached the lightest value. If I hadn't, they would have been monochromatic and washed out. All four of the gradations shown here are combinations of analogous sequences that switch over to a complementary sequence. Although the value ranges of these examples are exaggerated, as a rule it's good to keep backgrounds within a

range of about four value steps between the light and dark ends of a gradation. If you have a huge amount of background space and want more drama, you might stretch it beyond that, as these gradations do. The risk is that a too-beautiful, too-eye-catching background will attract more attention than it should. Another good rule to observe is that if you have a busy subject, keep the background simple. Conversely, if the subject is simple, you can go for a more complicated background with actual visual details behind the subject.

OTHER USES FOR ANALOGOUS SEQUENCES

Using analogous sequences for many elements in your composition enlivens a painting considerably. It also helps to achieve the Tapestry Principle I mentioned earlier. Artists who consistently use monochromatic passages in their paintings—as in the left-hand still life Fig. 14-10, with its plain yellow

tablecloth, blue vase, pink flowers, blue-green book, and solid green background—achieve a kind of compartmentalized color with each area unrelated to the others. Although not harmonious by Chevreul's or any other criteria, handling color that way has a compensating simplicity about it that may appeal to you. My bias is obviously toward the rich intricacy of the tapestry idea. Colors interwoven throughout the painting, appearing in unexpected touches here and there, provide interest in almost every square inch of canvas. Compare the two halves of Fig. 14-10 to see how the colors support one another and contribute to an overall feeling of color harmony.

Suppose you are painting a bouquet or garden of flowers that contains flaming orange and red tulips. Nature may get away with strident, clashing colors in the garden and even in an informal bouquet of flowers in a vase. But somehow the same clashing colors frozen in a painting seem to make us uncomfortable. The solution to that problem is to use the Tomato Theory so that the orange tulips modulate down to red-orange, red, and red-violet in the shadows, while the red tulips warm up to red-orange and edge toward orange as they do in Fig. 14-11. They will relate

beautifully and still maintain their separate color identities if you are careful not to lose their local colors.

TYPICAL PROBLEMS AND HELPFUL SOLUTIONS

Here are a few of the most common things that can go wrong when you're working with analogous sequences, and some suggestions for correcting the situations:

- *Garish color.* This results when you fail to add a bit of white (if necessary) in the warmed **light** areas or to modify the last color in the **dark** with a touch of its complement to tone down its intensity.
- *Muddy color.* This comes from skipping one or two hues on the color wheel, causing the sequence to cut across it kitty-corner rather than going around it step by step. Clean, brilliant color is best achieved with a full range of colors laid out in spectrum order, a clean brush, and clear turps.
- *Unbelievable color.* This is what happens when you fail to preserve the local color, and also when you overreach hues on the color wheel. Analogous color is beautiful, but it has limits beyond which it will simply look weird.

Fig. 14-11. *Tulips.* Oil on canvas, 6 × 8″ (15 × 20 cm). Collection of the artist. If I had used complements instead of analogous colors to find the form shadows on these orange and red blossoms, a lot of browns would have diluted the intensity of the colors and snuffed out much of their vitality.

Color Lesson 6: Red/Green Complements

In this lesson we'll concentrate on the final pair in the series, the red and green complements. This lesson involves more colors than previous lessons.

Color Chart Assignment

Do a complementary chart using ACRA red as your pure red in the lower left corner. Then find as pure a green as you can— neither yellow-green nor blue-green—for the parent color in the lower right corner, using viridian and cadmium yellow pale. Again, do the bottom row first, testing the middle no-color with white to find the most neutral gray possible. Then have warm chips to the left and cool greenish chips to the right of it. This complementary pair is the hardest of all to completely neutralize to a gray. You might fudge a little, adding a bit of ultramarine blue to the middle spot of the bottom row.

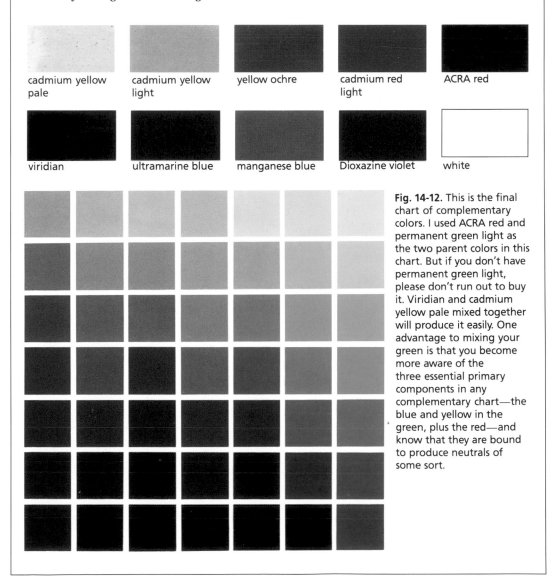

cadmium yellow pale

cadmium yellow light

yellow ochre

cadmium red light

ACRA red

viridian

ultramarine blue

manganese blue

Dioxazine violet

white

Fig. 14-12. This is the final chart of complementary colors. I used ACRA red and permanent green light as the two parent colors in this chart. But if you don't have permanent green light, please don't run out to buy it. Viridian and cadmium yellow pale mixed together will produce it easily. One advantage to mixing your green is that you become more aware of the three essential primary components in any complementary chart—the blue and yellow in the green, plus the red—and know that they are bound to produce neutrals of some sort.

Still-Life Assignment

Use tomatoes and green peppers for the produce, perhaps cutting a wedge out of one tomato as I did. It is easy to warm and cool these subjects with adjacent colors, and with any luck some of your other props can be rendered according to the Tomato Theory as well. Again, try to include as wide a range of values as possible in your objects so that you are forced to use the whole value scale. You can mix literally every color with this basic palette, but try not to stray too far from the red and green color harmony.

The Setup. Tomatoes, green peppers, beets, and radishes are my colorful choices of produce for this lesson. The raffia-covered wine bottle, an amber wine glass, a natural-colored basket, and a wooden chopping block provide a variety of textures. I painted the beet tops fresh and upright, as they were when I bought them, even though they were limp by the time the photo was taken.

Step 1. I mixed a puddle of thinned-out paint from the complements of this lesson and drew variously with brown, red, and green paint according to each object's color. This isn't necessary, of course, but it makes the drawing look more organized and readable as the painting proceeds.

Step 2. As usual, I check all color and value relationships. The transparency of the wine glass is quickly established by painting what's behind the upper part of it. The cast shadows are roughed in on the tablecloth and napkin.

Step 3. The modeling of all forms continues throughout this stage. Note the cast shadow on the raffia base of the wine bottle from the beet leaves, and also the cast shadow on the cut face of the tomato. The former is pure invention, but the latter is visible in the setup.

Step 4. I stand back and look at the distribution of colors and values to see how the background can help balance them. Amazingly, the reds are distributed well, and so are the greens, counting the dark green of the bottle on the right as balancing the mass of greens on the left. Even the beige of the basket, the raffia base of the bottle, the amber/brown of the wine glass, and the chopping block work well. I decide though to use a dark simple background since this is a busy painting.

Step 5. While scrubbing in the background with the filbert brush and a lot of paint, I worked the back leaves of the beets into the background wet-in-wet. The bottle displays a nice variety of edges. Also notice the cool touches in the **dark** side of the box, the left inside face of the cut tomato, and the right side of the raffia-wrapped bottle. These are from a window to my right, opposing the warm lamp on the left. I had a fuller palette of colors here, and it shows.

Part Three

THE WORLD IN FULL COLOR

You've learned how to model forms and mix colors; now it's time to expand your palette and your technical repertoire. From here on, you will be working with nearly all the spectrum colors, and handling them expertly will require further refinement of the skills you have learned thus far. Part Three delves into advanced color theory, both as it has been approached scientifically and as it applies to painting. But good painting means more than effective color handling; you also have to capture and hold your viewers' interest, which chapters 16 and 17, "Composition" and "Design," explain how to achieve. Learning how to apply paint in new ways can only increase your ability to express yourself artistically; underpainting, glazing, scumbling, and knife painting are just a few of the advanced techniques presented here to help you toward that end. A chapter devoted to landscape painting explores the specific requirements of that genre and shows how color and paint handling, as well as good design instincts, ultimately converge on your canvas to create convincing illusions of three-dimensional space. Finally, practical concerns like stretching your own canvases and varnishing finished work are addressed.

REVIEWING THE BASIC PALETTE

Although the basic palette developed through Part Two will suffice for all subjects in alla prima painting, additional colors will be a boon as we get into new oil painting techniques. You'll need more transparent colors; these plus a few more opaque colors will spice up your palette considerably. Here is a list of the basic colors classified by their transparency or opacity:

- *Opaque:* cadmium yellow pale or lemon; cadmium yellow light or medium; cadmium red light.
- *Semitransparent:* yellow ochre; cobalt blue; manganese blue; ultramarine blue.
- *Transparent:* Liquitex ACRA red or ACRA crimson; viridian and/or phthalo green; Liquitex Dioxazine violet.

This list includes a lot more colors than most basic palettes, but it makes it easier to mix complements or create analogous gradations. A purist would eliminate yellow ochre, since it is an earth color, not a spectrum hue, and it can be mixed, but because it is so useful in modeling yellow forms and is excellent in complementary mixes with violet, I would find it hard to give up. Many basic palettes do not include purple at all, but depend on mixtures of reds and blues to find the three violets. Those purples, however, are less vibrant than the ones you can mix with the help of Dioxazine.

WHAT TO LOOK FOR WHEN BUYING OIL PAINTS

When shopping for paints, always read the label on any tube of color you consider buying. Thanks largely to the efforts of the American Society for Testing and Materials

(ASTM) and the Art & Craft Materials Institute (ACMI), paint manufacturers now include much useful information on their packaging. A label on a tube of oil paint should tell you the color's common name and chemical composition; hue designation; relative lightfastness (rated I for excellent, II for very good, III for moderate); whether or not it is toxic, with cautions about safe handling; relative transparency or opacity; value; and chroma (intensity, rated on a scale of 0 to 20). You will also find the Colour Index name and number on the paint tube. This is an international code issued by The Society of Dyers and Colourists, London.

Lightfastness

Certainly you shouldn't lose sleep over how well colors in student-grade paintings will stand the test of time, but as you progress professionally, paying attention to the permanence of the paints you work with becomes increasingly important. For a comprehensive list of how various oil pigments rate for lightfastness, write to ASTM, 1916 Race Street, Philadelphia, Penn. 19103, and request a current copy of its publication D-4302; the $12.00 charge will be money well spent. For information about specific brands of paint, write to individual manufacturers for catalogs.

Munsell Chroma Designations

Chroma ratings are measured against a Munsell gray scale in which 0 indicates neutral, or no intensity, and 20 denotes the greatest intensity. Thus, the higher the number, the more intense the color. Should you buy a cadmium yellow medium rated 14.5, or a Hansa yellow medium rated 16? The Hansa yellow's higher intensity and lower cost make it seem the better choice, except that it falls into lightfastness category II, whereas cadmium yellow medium is in category I. There is another factor to consider. Liquitex Hansa yellow medium is labeled "transparent" (though I think semitransparent describes it better), while the cadmium is labeled

"opaque." Now which do you choose? That's up to you and your pocketbook, but I would opt for the opaque cadmium. Even though it is more expensive, it's very dense, meaning that you need less of it to achieve brilliance than you would of the translucent Hansa yellow.

EXPANDING YOUR PALETTE: OPTIONAL OPAQUE COLORS

Now that you've learned basic color mixing, you're ready to expand your palette. Here is a list of opaque colors from which you might choose at least one or two as special treats. They are beautiful, often more brilliant than what you can mix from other colors, and convenient. (All are Liquitex brand unless denoted otherwise.)

- *Brilliant purple.* A powerful middle-value violet.
- *Medium magenta.* A very opaque, deep quinacridone pink.
- *Light blue violet.* A pale ultramarine blue-violet useful in landscape painting. An equivalent is King's blue (Rembrandt).
- *Brilliant blue.* A light phthalo blue that is much more intense than manganese or cerulean blue. Working with opaque phthalocyanine colors at a higher value like this one is easier than using the dark, staining transparent phthalos, which overpower all mixtures.
- *Brilliant blue purple.* A lighter value of ultramarine blue.
- *Bright aqua green.* An intense, light phthalo green.
- *Dirty green.* A middle-value semiopaque olive green made from yellow and black. Do not confuse it with the color sold as olive green, which is a very dark, blackish green.

Aside from dirty green, there isn't a color on this list that you can't approximate if you have phthalo blue and green and the quinacridone reds and violets. The main reason to buy them is that you'll be bolder with bright colors you can simply squeeze out onto your palette rather than have to mix. It might not otherwise occur to you to mix a magenta for a

reflected light in the dark brown form shadow of a tree trunk, or to put a light blue-violet reflected light in the shadow side of a white house. These creamy-textured colors are great for making dark transparent colors slightly lighter and more opaque without resorting to white, or as complementary colors in higher value ranges.

ADDITIONAL TRANSPARENT COLORS

Besides the transparent colors already on your palette, certain others will enhance the underpainting and glazing techniques covered in chapter 19. Almost indispensable are:

- *Permanent Indian yellow.*
- *Burnt sienna.* A semitransparent, intense rust color that is great for underpainting washes. Its intensity and grainy texture, though, keep it off my palette otherwise.
- *Transparent oxide brown, Stil de Grain brun* (Rembrandt), *burnt umber*, or any other transparent brown. When buying a brown, always check on the tube label for its transparency rating, or unscrew the cap to look at the paint. Transparent browns are dark and glistening, while opaque browns are dull, muddy-looking, and a little lighter in value.
- *ACRA violet* or *Thio violet* (Grumbacher). Pure red-violets that make beautiful fuchsias with the addition of a little white.
- *Thalo red rose* (Grumbacher). Similar to Liquitex's ACRA reds.
- *Blue-green* (Rembrandt). A gorgeous bluer blue-green that can be mixed from phthalo blue and phthalo green.
- *Permanent sap green.* A good all-purpose color.

Any color will become reasonably transparent if you thin it out with enough medium, but it will not glow with the same reflected light from the white canvas ground as these true transparent colors will. You can mix two transparent colors to obtain other colors that are not available. For example, you can create your own transparent orange by mixing Indian yellow with just a bit of ACRA red or crimson.

No matter how many tubes of paint you own, it is still sound practice to limit the colors in a painting to just a few important hues rather than to go for color overkill.

ADDITIONAL MATERIALS NEEDED FOR PART THREE

Besides adding new colors to your palette, you will need a few more supplies as you advance:

- *Winsor & Newton's Liquin.* Perhaps you've already been using this medium to thin your paints slightly when working with a filbert brush. Now you'll be using it to thin out transparent colors for the glazing technique.
- *Gesso.* Buy a small can of this brilliant white ground, which you can use to experiment with texture on your canvas.
- *Liquitex's Soluvar.* This is a final picture varnish; it comes in gloss and matte. Buy a small bottle of gloss and a larger bottle of matte, as we will be mixing them.
- *Brushes.* Add to your flats and filberts a fat synthetic round brush, size #8. Look for "R" or "Round" printed on the handle. I recommend Grumbacher's Bristlette series #4720. No other brush picks up and deposits so much thick paint on the canvas as a round. Although harder to control in tight areas, a round brush does allow you to loosen up when painting clouds and other soft-edged forms. Also buy three hardware-store brushes: two inexpensive ones about one to two inches wide, one for applying gesso, the other for applying thin washes; and a better-quality, 1½"-wide soft-bristle brush for applying the final varnish to finished paintings.

LAYING OUT A FULL PALETTE

From now on, whenever you start to paint, always lay out a full palette, always in the same sequence. Sometimes a student will squeeze out a few random knobs of paint in the mistaken belief that he or she needs only a few colors to touch up just a couple of areas

in a nearly finished painting. But remember, you will need the complements and adjacent hues of those few colors as well.

I suggest that you lay out your palette this way, beginning with the basic colors. Place cadmium yellow pale at the upper left corner, then move across the top of the palette with a sequence that follows the color wheel counterclockwise, as in the illustration shown here. Fill in any gaps in your twelve hues with mixed colors—for example, mix yellow and cadmium red light to get both yellow-orange and pure orange; mix ACRA red with Dioxazine to get red-violet; and so on. The optional colors you add to your palette can replace the mixed colors.

If you buy some of the lighter, "candy-store" colors, place them under their parent colors. For instance, put bright aqua green under viridian or phthalo green; light blue violet under ultramarine blue; and medium magenta under ACRA crimson. Yellow ochre and any other earth colors should line up along the left edge of the palette with the ochre at the top.

White, in a huge mound, is best placed at the bottom left or right corner of the palette, away from all other colors.

Some teachers advocate separating the warm colors from the cool. If you're accustomed to a different layout system, by all means continue to use it. Just be sure to arrange your colors the same way consistently. Some of the dark transparent colors look alike, and you'll want to know exactly where they are on the palette every time.

Try to let setting out your palette be a meditative time in which you prepare mentally and physically for the creative session to follow. Concentrate on the beautiful colors, the creamy mounds of good-smelling paint, and the orderly sequence in which you place them. Pour clean turpentine into a can, tear off a stack of paper towels, turn off the telephone, and turn on some of your favorite music. Then start to paint with serenity and joy. If your life is more hectic, just seize every moment you can to paint. Your effort will pay off more ways than you can imagine now.

cadmium yellow pale · cadmium yellow light · cadmium orange · ACRA Crimson · ultramarine blue · phthalo blue · viridian · Permanent Sap Green

cadmium red light · Dioxazine Violet

Indian yellow

Medium Magenta · Light Blue Violet · Brilliant Blue · Bright Aqua Green

yellow ochre

burnt sienna

Transparent Oxide Brown

Here is a recommended layout for a nearly full color palette. The chromatic colors run across the top in a sequence from lighter and warmer on the left to cooler and darker on the right. Place lighter tints under their parent colors, earth colors down the side, and white (not shown) at the bottom. Hues listed with first letters capitalized are specific brand colors; lowercased hues are generic, that is, you will probably find that they are pretty much the same across all brands.

Chapter 15
ADVANCED COLOR THEORY

By now you have already had a lot of experience in working with the four characteristics of color—hue, value, intensity, and temperature—in both the still-life lessons and their accompanying color charts. Now let's gather the parts into the whole.

REVIEW OF BASIC COLOR THEORY

As discussed in chapter 9, the spectrum can be sliced into six broad areas—red, orange, yellow, green, blue, and violet—or twelve hues, adding the six intermediate colors— yellow-orange, red-orange, red-violet, blue-violet, blue-green, and yellow-green. We could continue to create even further divisions, but the twelve-hue color circle is the most widely used. Typically, the warm colors appear on the left side of the wheel (yellow through red-violet) and cool colors on the right (yellow-green through violet). But as we've already seen, the warmth or coolness of any color is always relative.

If you have done your homework throughout Part Two, working with complements—colors that lie opposite each other on the wheel—should be well within your grasp. At least four complementary pairs should be rooted firmly in memory (the only two we didn't cover are red-violet/yellow-green and yellow-orange/ blue-violet), and the analogous sequences should be a matter of logic.

The four characteristics of color are, coincidentally, the four major contrasts that make for good, rich color in a painting:
1. one color versus its opposite hue
2. intense versus muted color
3. light versus dark color
4. warm versus cool color—including warm light versus cool dark and bright cool versus muted warm

Beware though, for such maximum contrasts are best saved for important centers of interest in a painting. They will catch the eye by virtue of their very oppositeness, as you will see in chapters 16 and 17.

THE COMPLEMENTARY COLOR WHEEL AND WHAT IT TELLS US

Most color wheels are formulated with black in the dark shades of each hue; my version is unique because it relies not on black but on mixtures of complements, hence the name Complementary Color Wheel (Fig. 15-1).

Here is how the four color categories are arranged in the different rings of the Complementary Color Wheel:
- **Ring #1.** On this outermost ring are the *standard*, *spectrum*, or *chromatic* colors, interchangeable names for the most intense colors you can find from among your paint tubes. I will also refer to them as the "parent" colors, because their "children" fall in segments of the inner rings.
- **Ring #2.** These are the *tints*, or *pastels*. A pure tint is a mixture of a standard spectrum color and white, and thus is always lighter in value than the parent color.
- **Ring #3.** These are the *shades* of the spectrum colors, found through the mixture of opposite colors. Shades are always darker than the standard color, and therefore you can use this ring as a handy reference for finding acceptable cast shadows for each parent color.
- **Ring #4.** I call these the *lifted complements*, for lack of an official term, because they are found by adding white to the shades. These muted colors are among the most important aspects of your color

vocabulary. In landscape painting, you will use relatively few intense colors and a great many middle-value grayed colors like these, especially in distance. Indeed, the colors in Ring #4 could be thought of as distant versions of the chromatic colors in Ring #1.

- **Center.** This should be as neutral a gray as possible, ideally a mixture of spectrum red, blue, and yellow lifted with a little white to a #4 or #5 value.

MAKING YOUR OWN COMPLEMENTARY COLOR WHEEL

How easy it would be to do the color wheel if we could buy a dozen tubes of accurately calibrated paint to match the spectrum colors named above, and with all complementary pairs instantly neutralizing to a perfect gray. Unfortunately such a set of paints is not currently available. Colors are often named according to their chemical content, and all you need to do is become familiar with them.

Fig. 15-1. The Complementary Color Wheel. Ring #1 contains standard spectrum colors, and Ring #2 contains their tints. However, the dark shades in Ring #3 are found through mixing complementary colors across the color wheel, rather than adding black to darken the spectrum colors. In Ring #4, the shades are lifted with white so all are the same value. These "lifted complements" are a necessary part of good color in representational painting, especially in regard to distant subjects.

Because more and more manufacturers of artists' colors are adhering to the international color standards established by the American Society for Testing and Materials, your results should be similar to mine in the Complementary Color Wheel in Fig. 15-1, no matter what brands of paint you have.

Almost all color wheels are based on the three unique pigment colors red, blue, and yellow—the hues you cannot mix from any others. You must have these three to approximate all other colors. However, a color wheel painted with just primary colors, or even a set of double primaries, would result in some loss of brilliance compared to using a full palette of colors. I suggest that you use all the chromatic colors that you own when doing this color circle—*except* the earth colors yellow ochre, raw and burnt sienna, raw and burnt umber, and any that have a heavy black content like olive green, dirty green, and Payne's gray. The whole idea of mixing chromatic colors across the color wheel is to find the muted colors they can produce.

Color Mixing Clues

Before you proceed, read the following to save yourself a lot of wasted time and paint:

1. Do not be tempted to lay in all of your bright standard colors around the outer ring first, and then do all of the tints next, then shades, and so on. Work *across* the color wheel, creating one pair of pie-shaped complements at a time.

2. Squeeze out generous mounds of paint before you start a pair of opposite colors. You will need quite a lot of paint and it is frustrating to have to mix the spectrum colors over and over again. Even after you finish a pie-shaped section of, for example, yellow-orange, some of that parent color is still needed to complete the blue-violet section across the wheel.

3. For a neat, uniform look, brush the color in first and then flatten the strokes with a painting knife; conversely, you can lift a knifeful of paint to the section and then brush it carefully into the corners.

4. To make the twelve colors on the outermost ring flow with even intervals between them, you will need to adjust some values. This does not mean adding white, which would reduce the colors' intensity. When your yellow, yellow-orange, and orange are very close in value and you then find you must make a big value jump down to red-orange, adjust the proportions of yellow and red-orange in those hues to find a good value sequence. On the other side of the circle, the sequence from yellow to yellow-green to green can be hard to achieve, because green is naturally much darker in value than yellow-green, and adding more yellow to the green, or vice versa, results in two similar colors. Just do the best you can to find the smoothest flow.

5. In Ring #2, the pastel ring, don't make the common mistake of adding white to a pile of a bright parent color to find its tint. You will end up with a mound of paint large enough to paint a wall before arriving at a pale tint. Instead, *start* with a pile of white and, with the tip of your knife, add the tiniest smidgen of pure color. Mix well, and then repeat if necessary. It is better to underestimate than to go overboard.

6. When working with the dark transparent pigments, note that they come out of the tube below their potential intensity. Add a little bit of white to bring them up to their natural brilliance, at the same time bringing them to the degree of opacity of other colors on the circle.

Mixing the Spectrum Hues (Ring #1)

Since the names of the twelve hues listed above and the names on the tubes in your paintbox rarely coincide, you will have to mix pigments to arrive at most of the standard hues. The following suggestions are made with reference to the basic palette colors, but if you have more exotic colors, by all means use them.

- *Yellow (Y).* A pure yellow should not lean toward its yellow-green or yellow-orange neighbors. Ignore the names on your paint

tubes and just mix the various yellow pigments until you find the purest, most brilliant yellow possible.

- *Yellow-orange (YO)*. Mix the pure yellow and a tiny bit of cadmium red light—or, if you have it, use a cadmium yellow medium straight out of the tube. You are looking for a rich marigold color.

- *Orange (O)*. Again, mix pure yellow and cadmium red light, finding an orange midway between the two. If you have cadmium orange, it may work perfectly, but some brands are too close to red-orange for a comfortable sequence.

- *Red-orange (RO)*. Cadmium red light is always a true red-orange (except for Bellini's muted version), one of the few spectrum colors that can be used just as it comes out of the tube.

- *Red (R)*. Think of pure red as being more crimson and darker in value, more like blood than fire-engine red. Find as beautiful a cool red as you can with your pigments, making sure you have a clear value and hue difference from the red-orange above it.

- *Red-violet (RV)*. Mix your red with a bit of Dioxazine violet and then add a little white to bring this dark color up to its maximum intensity. Use a red-violet straight out of the tube if you own one. Be sure its value is darker than red's value.

- *Violet (V)*. Use Dioxazine violet, or mix as true a violet as you can, one that is neither too red-violet nor too blue. It should be the darkest value of all, so add the least bit of white when you make it opaque.

- *Blue-violet (BV)*. Ultramarine blue plus a smidgen of white is all right for this hue, but a trace of violet added to it makes it even better. Look for a deep-cornflower or bachelor's-button blue.

- *Blue (B)*. Find the unique blue that doesn't have a hint of its blue-violet or blue-green neighbors. Cobalt blue is as close to a pure blue as we can get in a single pigment, even though it does have a slight violet cast. A mixture of ultramarine and manganese blue will approximate cobalt.

- *Blue-green (BG)*. Either viridian, or phthalo green with a touch of white for opacity, is fine for blue-green. Beware of using phthalo green by itself for the standard hue because it will throw off all inner-ring mixtures because of its great tinting strength.

- *Green (G)*. Look for a bright kelly green and mix it with cadmium yellow pale and viridian. You should arrive at something like the tube color called permanent green light—which you can use instead if you already own it, although its unnatural green hue often gets amateur painters in a lot of trouble.

- *Yellow-green (YG)*. Mix cadmium yellow pale with a touch of the green you just mixed. Try to find a chartreuse yellow-green that will take as good a value position between your yellow and green as possible.

Mixing the Tints (Ring #2)
Once you have achieved satisfactory spectrum hues, find each of their tints by adding a very small amount of the parent color to a mound of white. Try to adjust every tint in this ring to the same #2 or #2.5 value.

Mixing the Shades (Ring #3)
To each parent spectrum color add enough of its complement to get the shade. Do not add any white in this ring at all (ignoring the tiny bit needed to make transparent colors opaque). The values should automatically be a subtle echo of the value swing of the standard hues from light at the top of the wheel in Ring #1 down to dark at the bottom. However, don't add so much complement to a parent hue that you throw the shade completely over onto the opposite side of the color wheel. The shade of orange should be a brown, not a navy blue; the shade of blue should be a navy blue, not a brown. In other words, the shades of warm hues should logically stay on the warm side of the color wheel, and the shades of cool hues should stay on the cool side.

In a few places, such as the yellow-orange, yellow, and yellow-green sequence, the

complements in Ring #3 may stubbornly refuse to reflect their parent hues. When you try to find the shade of yellow (which should be a sort of ochre) by adding a bit of violet, you may arrive at an olive green instead. This muted green belongs next door as a shade of yellow-green, not yellow. The antidote is, as usual, to neutralize the wrong green with its complement, red. Then, because the mix will be very dark, add more of the parent color yellow to the mixture to bring it up to the ochre it should be. Each shade must reflect the dominant parent's color.

Mixing the Lifted Complements (Ring #4)

These are mixtures of the shades plus white. Here again, try to adjust all colors with the amount of white needed to bring them to the same value—about a #3 or a #4. This is the most challenging ring to achieve, and you may have to redo a number of segments several times before they are all equal in value.

Mixing the Neutral Gray (Center)

Mix this from the three primaries plus a bit of white. At first, your gray may look too bluish, so add a little more red and yellow. Then it may look too greenish, so add more red, and so on. You may chase through a series of complementary grays before you finally neutralize the center spot completely.

MORE WAYS TO REDUCE COLOR INTENSITY

There is an old saying in art circles that goes, "By your grays shall ye be known." That refers to grayed-down colors as well as to colorful grays mixed with complements—the neutrals color scientists call "lively" grays, as opposed to those mixed from black and white, which are referred to as "dead" grays. Novice painters seldom mute colors sufficiently or use enough grays in the early stages of their careers. Sometimes one little bit of a complement judiciously added now and then

to a pure color is all that you need. But sometimes even those neutralized colors and grays are a bit too colorful for moody gray-day paintings. At this point you can mix black and white to a #4 or #5 gray and use it to reduce the complementary grayed-down colors even more, if necessary. You might even use that leftover pile of mud from your last painting session, lifted with some white, as a modifier.

Some artists routinely use the brownish earth color raw umber to reduce the intensity of bright colors. Raw umber comes close to being a "mother color" neutralizer—a nondescript hue mixed from two warm colors plus one cool color. Isn't that what our complementary non-colors are too? To reduce intensity efficiently, how about just starting with a pile of achromatic gray and simply adding a little color to it as needed? Instead of finding a blue-gray through orange and blue complements for a distant mountain, why not just add some blue to neutral gray? That's a good idea on gray, overcast days. But when it comes to warming that mountain in sunlight and cooling it in the shade, starting with an achromatic gray may seduce you into adding white alone to lighten the sunlit parts. Starting with blue and orange will more likely remind you to "warm it in the light, and cool it in the shade."

In Fig. 15-1, note how all neutralized colors grow progressively closer together in hue in Rings #3 and #4. The chart in Fig. 15-2 is a comparison study of what happens when four bright hues are reduced in intensity by, respectively, an achromatic gray, raw umber, and their own complements. The results of the mixtures are shown in column 1, and then those colors have been lifted in value with increasing additions of white in columns 2 and 3. In the end the differences are not that great, especially in the lighter values.

LOCAL COLORS WITH BLACK IN THEM

Confronted with colors like tan, greige, mauve, khaki, and taupe, not to mention puce (an old-

Fig. 15-2. This chart explores three different ways to reduce the intensity of bright colors. Cadmium yellow light, ACRA red, permanent green light, and phthalo blue are the test colors on the left side. The next vertical row shows the neutralizing colors they were mixed with: an achromatic gray in the top third of each block, raw umber in the middle, and their individual complements on the bottom. Column I shows the results of the three mixtures, and Columns II and III are those colors with increasing amounts of white added. Determine for yourself what hue changes took place, if any.

fashioned brownish purple), dun (a grayish brown), and other fashionable offbeat hues, students are often at a loss to know how to match them. Some local colors do have black in them; no doubt about it. They may also have one or two colors plus some white, and a single pair of complements won't quite match them. If a local color requires a touch of black for a precise match, use it. But when modeling such colors from **light** to **dark**, remember the "cooling in the shade" theory and reach for a cool color instead of more black. For instance, suppose that for some of the greens in a landscape painting you mixed some beautiful olive greens using black and yellows. Mix generous mounds of those greens and then remove the rest of the black from your palette

before it creeps into every other color as you paint. That way you'll be forced to cool the shadowed areas, and not simply blacken them. My personal bias aside, countless contemporary artists do use black throughout their paintings. Put it back on your palette for a while, and see whether you like it yourself. After all, it is still more important that you judge values properly; how you reduce the intensity of bright colors is of secondary importance.

THE CUSTOM COLOR WHEEL

At this stage of your development, to observe that something, say a vase, has a blue local color is not being observant enough. Is it a

greenish blue, true blue, blue-gray, blue-violet, or dark blue-violet on the color wheel? Unless you are working with a very limited palette, always start with the pigment that is closest to the local color you are matching. Because the chemical and descriptive names on paint tubes are confusing and the colors on the labels can be misleading, students often seem completely baffled. For instance, would you necessarily know that despite their different names and chemical makeup, Rembrandt blue, Thalo blue, and Prussian blue are all approximately the same hue? One way to

find out is to pay more attention to the information on the newer tube labels. Another way is to make a Custom Color Wheel such as the one I've done (Fig. 15-3). It shows the position of sixty-six colors of different brands on the color wheel matrix. Over the years, every time I purchased a different tube of oil color I made a sample of it and placed it as close as possible to its proper position among the twelve standard hues.

If you start doing that right now, in time you'll be able to see at a glance that you have two or three identical yellows, as well as

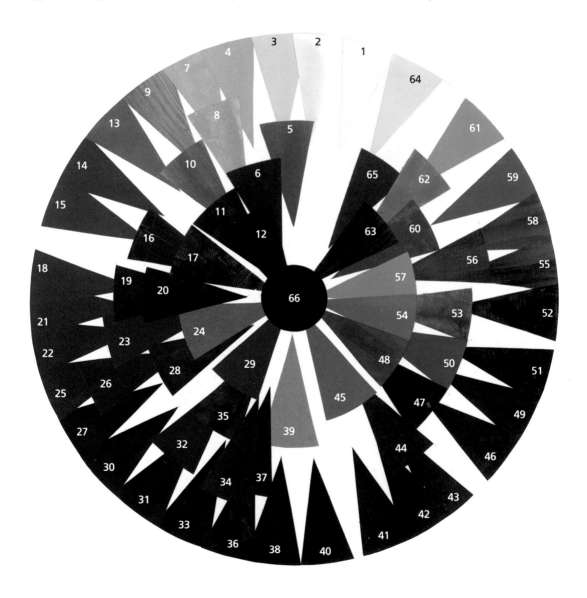

several similar blues, and who knows how many violets. Your colors will be crowded in some parts of the wheel, and there will be big gaps in other parts. Absolutely no color mixing is involved. Paint each color sample on canvas paper just as the paint comes from the tube, not altering its transparent or opaque quality one bit. When they are dry, cut the samples into swatches or pie-shaped pieces and tape them lightly in place on the circle. Use a bit of double-stick Scotch tape so you can reposition them later when you need to make room for other colors.

You may be surprised to discover that some colors cannot go in the places that their tube names would indicate. If you accept the name on the label, you may well find that you've transposed warm and cool colors—that is, you've unwittingly put warmer colors lower than cool ones on the wheel. You must always remember to compare the color's actual temperature with other color samples nearby, rather than relying on tube names. I promise that this ongoing project will be well worth your time, and will serve as a guide when you are shopping for new colors.

Fig. 15-3. This Customized Color Wheel is a reproduction of my own collection of actual paint samples from over the past eight years or so. Some were painted with a knife, others with a brush, but in all cases, they were painted "as is" with tube-consistency paint.

Legend
Paint brands:
Liq.—Liquitex
Rem.—Rembrandt
Grum.—Grumbacher
W&N—Winsor & Newton

Lightfastness ratings
All are rated Category I (Excellent Lightfastness) on the ASTM list except those labeled II (Very good lightfastness) or III (substandard lightfastness). NR means not rated.

1. Liq. Lemon Yellow Hansa II
2. Liq. Hansa Yellow Light II
3. Liq. Cadmium Yellow Light
4. Liq. Cadmium Yellow Medium
5. Liq. Yellow Ochre
6. Rem. Raw Sienna
7. Rem. Cadmium Yellow Medium
8. Liq. Hansa Yellow Medium II
9. Rem. Indian Yellow II
10. Liq. Perm. Indian Yellow
11. Rem. Asphaltum III
12. Grum. Raw Umber
13. Liq. Cadmium Orange Hue
14. Rem. Cadmium Orange
15. Grum. Cadmium Orange
16. Rem. Stil de Grain Brun III
17. Rem. Transparent Oxide Yellow
18. Liq. Cadmium Red Light
19. Grum. Terra Rosa
20. Rem. Burnt Sienna
21. Rem. Geranium Lake II
22. Liq. Chinese Red
23. Grum. Pink Madder III

24. Liq. Light Magenta
25. Grum. Red II
26. Liq. ACRA Crimson
27. Liq. Alizarine Crimson III
28. Grum. Thalo Red Rose
29. Liq. Medium Magenta
30. Rem. Rose Madder II
31. Liq. Deep Magenta
32. W&N Permanent Magenta
33. Liq. ACRA Violet
34. Grum. Cobalt Violet
35. Grum. Thio Violet
36. Grum. Ultramarine Red
37. Liq. Prism Violet
38. Liq. Dioxazine Violet
39. Liq. Permanent Lt. Violet
40. W&N Mauve (Blue Shade)
41. Shiva Ultramarine Deep
42. Liq. Ultramarine Violet
43. Liq. Ultramarine Blue
44. Liq. Brilliant Blue Purple
45. Liq. Light Blue Violet
46. Liq. Cobalt Blue
47. Grum. Cobalt Blue
48. Liq. Cerulean Blue
49. Rem. Blue
50. Grum. Cerulean Blue
51. Grum. Thalo Blue
52. Rem. Blue-green
53. W&N Manganese Blue
54. Liq. Brilliant Blue
55. Liq. Phthalocyanine Green
56. W&N Winsor Green
57. Liq. Bright Aqua Green
58. Liq. Viridian
59. Liq. Permanent Green Light
60. Grum. Chromium Oxide Green
61. Grum. Thalo Yellow-Green
62. Rem. Cinnabar Green Light
63. Liq. Permanent Sap Green
64. W&N Chrome Green Light NR
65. Liq. Dirty Green
66. Liq. Ivory Black

THE THREE-DIMENSIONAL COLOR SOLID

My late brother-in-law, the renowned color consultant Carl E. Foss of Princeton, New Jersey, maintained that the trouble with any color circle is that it is only a two-dimensional picture of color. A color solid, on the other hand, is a three-dimensional map of "color space" in which all colors in all possible intensities and values have been compressed into a contiguous whole. One of his three-dimensional models was composed of hundreds of delicately painted Ping-Pong balls, each one glued to and relating subtly in color with its neighbors on all sides.

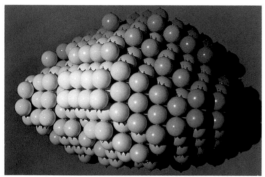

Fig. 15-4. This photograph shows a three-dimensional model of the Optical Society of America's Uniform Color Scales. The model is constructed so that it can be separated into seven distinct sets of parallel color planes by lifting them off one by one. I think you'll agree that there is visual pleasure in following any color path visible here. (Courtesy of the family of Carl E. Foss.)

Fig. 15-4 will give you an idea of how the Ping-Pong project looked. This is a photograph of the Optical Society of America's Uniform Color Scales, produced in 1977 after decades of scientific research. The problem that took so long to solve was how to arrive at a uniform color difference between each of a large collection of color samples through color space. Eventually an album of loose-leaf color charts resulted, but a few three-dimensional models, like this one of painted balls, were made. The unique advantage of the O.S.A. scales is that each ball (color sample) in the collection is visually the same distance from twelve other balls in different planes throughout the collection.

Three-dimensional color theory may provide some fascinating insight into your own painting. Scientists have long conjectured what shape and volume would result if all possible color variants in the world were gathered together and arranged in sequential order. Some historic color solids were based on half-spheres, some on full spheres; others were cubes, pyramids, cones, and double cones with bases touching. No matter how such models differed in shape and structure, color scientists all agreed on two things: that the achromatic value scale should run through the core of the solid, with white at the "north pole" and black at the "south pole"; and

Fig. 15-5. This is a single horizontal plane of Munsell's Color Tree. It shows his ten hues as they would look all adjusted to the #5 value level on the central value pole. Each color goes from maximum chroma (intensity) at the ends of the "limbs" of the tree, to less and less intensity as they approach the central core at 0 chroma. Hues go around the tree's circumference, and values go up and down the trunk. Note that the two hues yellow-orange and pure violet are not included in Munsell's color theory. (Courtesy of Munsell, Newburgh, New York.)

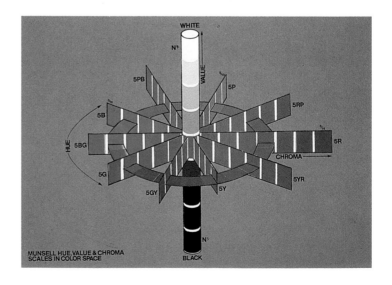

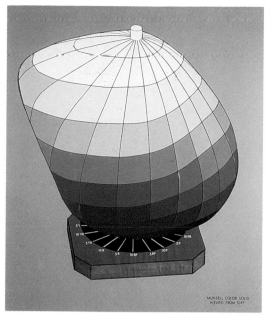

Fig. 15-6. If you can imagine that the framework of the Color Tree in Fig. 15-5 is filled in solidly with colors, then you can understand why Munsell's color solid is so irregular in shape. *Left:* Here the side with warm hues bulges out to accommodate yellow's extra intensity, and even farther out for orange

and red below it. *Right:* This side shows the cool colors and gives a better view of how they darken as they go down toward black. These color solids divide the spectrum into 20 hues, and the two missing ones seem well accounted for. (Courtesy of Munsell, Newburgh, New York.)

that the spectrum colors had to be arranged on the outer perimeter of the solid, gradually becoming neutralized with achromatic grays toward the neutral scale in the central core. In many color solids, the pure spectrum hues were arranged around an "equator."

Albert H. Munsell (American, 1858–1918) concluded that the color universe must be asymmetrical, because each pure hue has a different value relative to the central core's value scale. Moreover, the longer wavelengths of the yellows, oranges, and reds have greater intensity than the cooler, shorter wavelengths of blue-green, blue, blue-violet, and violet. This accounts for the longer and shorter limbs on his Color Tree (Fig. 15-5).

Fig. 15-6 shows two different views of Munsell's color solid, the way it would look if you filled in the Color Tree, working upward toward white at the top and down toward black at the bottom. Fig. 15-7 is a cross-section view, a vertical slice through the middle of the solid with yellow and purple-blue as opposite colors.

Fig. 15-7. This is a vertical plane sliced through the center of the Munsell color solid. We see his opposite colors of purple-blue and yellow and their progression from full intensity on the perimeter to neutral gray in the center. (Courtesy of Munsell, Newburgh, New York.)

ADAPTING THE COMPLEMENTARY COLOR WHEEL TO THE COLOR SOLID

I explained to my brother-in-law that any color solid with all colors neutralized toward the core with black is not very useful for artists who have eliminated black from their palettes. (Commercial color wheels purchased in art-supply stores have limited application for the same reason.) A few years ago, I began to wonder how I could relate the Complementary Color Wheel to the color solid for my more advanced students. Could a color solid be made that has a value core mixed from complements rather than black, and with all colors neutralized toward the core with their opposite colors? My musings resulted in Fig. 15-8. Because this representation is derived from the fixed pattern of the color wheel, all spectrum colors are necessarily equidistant from the core.

Next, I realized that I should relate the complementary color charts that we did in Part Two to this color solid. I worked out a vertical plane, similar to the Munsell plane in Fig. 15-7, showing the full range of colors and values possible by mixing the complements red-violet and yellow-green in their expanded intensity and value ranges. In Fig. 15-9, you'll note how they neutralize each other right across the central core at every value level. I managed quite well without black, thanks to intermixing the darker values of sap green and

Fig. 15-8. This imaginary color solid ended up egg-shaped simply to avoid overlapping the colors too much. The top ring shows the tints all adjusted to a #2 value. The second ring is muted only slightly and spaced farther out. The third ring down contains the spectrum hues, and the lowest ring is the shades. The gray central pole was mixed with red, yellow, and blue.

Dioxazine violet. The blue/orange, yellow/violet, and other complementary charts we've worked with up till now are compressed versions of a chart like this one. I make no claim for scientific accuracy; my charts are meant simply to show how routine classroom color theory fits into the color theories of the scientific community.

Assignment 1

On a page of your 16 × 20″ canvas paper pad, draw the color wheel grid as large as possible. With a ruler, draw an X with two diagonals that separate the concentric circles into quarters. Now divide the top space into three equal sections for yellow-orange, yellow (in the center at 12:00 noon position) and yellow-green, and the bottom into red-violet, violet (in the bottom 6:00

o'clock position), and blue-violet. Then divide the remaining left- and right-hand spaces into three equal sections so that orange, red-orange, and red are on the left, and green, blue-green, and blue are on the right. It doesn't matter whether your color wheel is perfectly symmetrical or neat. What matters is that you carry out the exercise. Before starting to paint the first section, be sure to read the Color Mixing Clues on page 204.

Fig. 15-9. Red-violet and yellow-green neutralize each other across a complementary gray central core in this representation of a vertical plane through the color solid. If the color chips on the outside of these rows were rounded off, you could more easily imagine that this is a plane sliced right down through the middle of the imaginary egg-shaped color solid in Fig. 15-8.

Assignment 2

On a large—about 20 × 20″—square piece of cardboard, matboard, or illustration board, arrange color samples for each tube of paint you own around a circle. No need to draw it this time, but at least identify in large letters the twelve main hue positions. Tape each paint sample in the appropriate place on the color circle, identifying it somehow with its brand and name. Every time you buy new tubes of paint, make new samples just as the paint comes from the tube and add them to your ongoing Custom Color Chart. You might want to paint a sample large enough to divide in half. Tape one half up on your prominently displayed color wheel, and hide the other half away from the light in a drawer. Compare them every couple of years or so to see if fading has occurred. This is a good way to investigate lightfastness for yourself.

Chapter 16
COMPOSITION

Composition is, in simple terms, the arrangement of the main masses of your subject in a pleasing, ordered, and balanced distribution, whether you are painting still-life objects, a figure, a portrait, or a landscape. Because there are an infinite number of ways to break up that blank white canvas, your first job is to decide what goes where, and why. The "why" of composition has to do with eye movement—how you guide the viewers' eyes through the imaginary three-dimensional space of your painting. Will you entice your audience to tarry and keep discovering new delights, or will they glance at your painting and pass quickly on to other things? If you scatter the elements haphazardly with no thought for guiding—trapping is a better word—your viewers on a tour within the

Fig. 16-1. *Windward View.* Oil on canvas, 24 × 36″ (61 × 91 cm). Collection of Mr. and Mrs. F. R. Peter Greenwell. *Above:* This scene has an obvious lead-in just left of center in the foreground. But before you study it, quickly cover up the diagram of its probable eye paths *(right)* and let your eyes wander through the painting naturally, noting where they go and in what order. Now uncover the diagram and compare it with your findings. In a couple of places the arrows can go either one way or another. Much of this movement is due to light and dark values.

Fig. 16-2. Here are four possible lead-ins for landscapes. *Top left:* The shadow from an unseen tree points into the scene, combining with the diagonal fence to direct the viewer's eye toward the horse and stable. *Top right:* The rocky shoreline has magically had a few boulders shoved aside so the viewer can walk into the scene with ease. *Bottom left:* You can never go wrong with something zigzagging in from the foreground as an entry into the painting, like this creek. *Bottom right:* The waves in the water are full of diagonal lines that lead you into the painting.

painting, you may lose them before they discover what you are trying to say. One look for a second or two is all you can expect of the average viewer's time . . . unless you are clever in keeping his or her attention.

PROVIDE A LEAD-IN

The first requisite of lively, attention-getting composition is a "lead-in," something that will hook the passerby and bring his or her eye into the picture from the bottom, from either side of the canvas, or even down from the top. A lead-in is usually, but not always, a diagonal movement of some kind into depth. The next step is to keep the viewer engaged by plotting his probable eye movements through the cube of space so they will dart from the front of the picture plane back through depth, across to the other side, and return to the front again. Subsidiary paths may provide momentary diversions, but if the composition is well planned, the eye will stay moving within the format. Compare my painting *Windward View* (Fig. 16-1) with the little diagram of the visual path I intend the viewer to take through my composition. A convenient "hook" in landscape painting is a road, path, or stream flowing in from the bottom of the canvas. In this case the flow begins in the lower left foreground and proceeds to middle distance via an actual footpath through the grassy fairways of a golf course. Although path, road, or stream lead-ins work well, try to find other solutions, as in Fig. 16-2. A diagonal line of overlapping trees or houses, a fence, or even a cast shadow from an unseen tree that flows in from beyond the picture plane will do all right. In still life, a diagonal table edge, napkin fold, book, or box shown in perspective, or even just three overlapping objects, will provide an entry into the painting.

ELIMINATE BARRIERS

It's a common error to erect a barrier of some sort clear across the foreground or middle ground of a composition. In landscape painting an artist confronted with a continuous hedge, a line of trees, or a fence may depict such elements by stretching them from one side of the canvas to the other. The problem can be corrected simply by leaving a gap or two in the barrier for the viewer to enter. (Compare Figs. 16-3A and 16-3B.) In still life, a barrier can materialize when all objects overlap and string right across the composition—a common occurrence when you look at your setup head-on, rather than looking down on the various objects. I call this problem, as illustrated by the left half of Fig. 16-4, the "Choo-choo Train Syndrome." Correct it simply by isolating an object or two from the rest, so that the eye can more easily move through and around them, as illustrated in the right-hand version.

Fig. 16-3A. *INCORRECT*: This scene was painted in a park high atop a mountain overlooking Pearl Harbor and the central valley of Oahu. It shows how tall the trees have grown: They almost obliterate the view! From the standpoint of composition, the trees now present an impenetrable barrier.

Fig. 16-3B. *Overlooking Pearl Harbor*. Oil on canvas, 9 × 11″ (23 × 28 cm). Private collection. *CORRECT*: I shortened some of the trees, eliminated others, and created an obvious entry just to the left of center. This version seems more inviting, more accessible than the one at left.

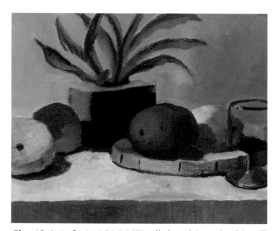

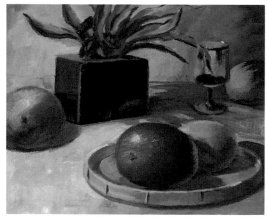

Fig. 16-4. *Left, INCORRECT*: All the objects in this still life overlap in a solid barrier right across the canvas because this hypothetical student was sitting down right in front of the table. The depth of the composition is shallow, the color harmony is not good, and the wine glass is tangent to the right-hand edge. *Right, CORRECT*: This higher viewpoint and better arrangement give more depth of field and room for eye movement. Can you see the Tomato Theory and Tapestry Principle at work?

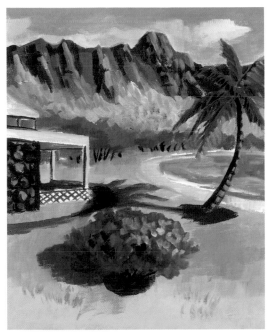

Fig. 16-5A. *INCORRECT*: The monotony of the top and bottom strips of this painting would have been even more noticeable if its format had been horizontal. Try to find ways to make lazy areas like these contribute something to keeping eye movement circulating throughout the composition.

Fig. 16-5B. *Majestic Mountain*. Oil on canvas, 10 × 8″ (25 × 20 cm). Private collection. *CORRECT*: I activated the lower foreground with tree shadows, broke up the sky with clouds, and changed the shape and position of the foreground bush so that its diagonal gesture opposes that of the palm tree.

GUARDING AGAINST FLAT, BORING PASSAGES

When there is nothing in the foreground of your painting but a flat sameness from side to side, no lead-in, no gradation, no real subject, no textural interest, as in Fig. 16-5A, you have fallen prey to an error I refer to as the "Ribbon of Nothing." In landscape painting, beware of rendering a grassy lawn, a sandy beach, or a body of water as a flat band of color across the foreground. Fig. 16-5B suggests a possible solution.

The "ribbon of nothing" can also plague a still life. Look again at the foreground of Fig. 16-4A. The lower part of the tablecloth is all one color and value and is completely devoid of interest. My solution was to eliminate that area altogether, but I might just as well have retained the side drop of the tablecloth, adding a subtle vertical fold or two and some gradation along that bottom edge to keep things lively.

Watch out for the top border of your paintings, too. The background of a still life will always be enlivened by a lateral gradation of some sort, which keeps the eye moving across the passage. In landscape, rather than painting a solid band of blue sky, break the top edge with a cloud going up and out, or run a warm-to-cool gradation away from the sun. Or both.

Although all compositions need rest areas for the eye, many square inches of plain paint along the top and bottom borders of your canvas are not where you want them.

DIRECTIONAL SIGNALS

Once you have lured the viewer into your painting, give directional signals so he or she knows which path to follow. In still life, obvious signs might be the pointing spout of a teapot, the tilt of a pear, or the swirl of a drapery fold. In landscape, a bending branch,

leaning tree, or diagonal contour of a mountain are equally obvious. Other signals are more subtle. For instance, any sequence of color that goes from bright to less intense to dull, or from warm to neutral to cool, says, "Go that way." I am not speaking of gradations on a flat plane, but of disconnected areas through the painting. Due to what is termed "closure," the eye will leap the intervals and continue along the organized path. In most cases, though, it's best to be shamelessly obvious in directing the viewer's eye. A sophisticated viewer will know how to read subtleties, but the uninitiated must be led by the hand.

Corners present natural escape routes for the eye if there is the least bit of attention-getting bright color or value contrast in those areas. Heaven forbid that any directional signal should even hint at pointing toward the corners! They are best kept somewhat muted in color and relatively quiet.

PROVIDING A STOPPER

Sometimes nature provides unavoidable lines that lead out of your painting, an unforgivable sin in composition. Suppose that cliché road

or stream flows into the foreground, turns, and runs straight out of the painting on the right side, as in Fig. 16-6A. What should you do? The answer is, invent a "stopper." A tree, a bush, or a building strategically placed near the edge of the canvas will turn the eye back into the picture. In Fig. 16-6B, note the trees I pulled into the right-hand side of the scene. If there had been no hill in the background, I might instead have turned the stream back into the composition in a meandering curve. An S or Z configuration zigzagging back into space is a sure-fire, though shopworn, compositional device.

Then there is the ubiquitous road that leads straight as an arrow into the center of the painting, usually through a bower of trees. The resulting tunnel in Fig. 16-7A is awkward on several counts. Besides dividing the space in half with two equal areas on either side, it leads the viewer's eye into a trap from which there is no exit. Instead of rewarding the viewer for traveling it, the road leads only to a void. If you must use the tunnel composition, invent a house, a figure, or something at the end of the tunnel, plus a clever way to bring the viewer's eye back to the front of the composition. I offer one solution in Fig. 16-7B.

Fig. 16-6A. *INCORRECT*: The forceful sweep of the creek from the foreground to its exit on the right has the effect of shooting the eye out of the picture as if it were shot out of a cannon.

Fig. 16-6B. *Icy Creek*. Oil on canvas, 8 × 10″ (20 × 25 cm). Private collection. *CORRECT*: This time I pulled a couple of trees into the picture to act as "stoppers." The branches of these new trees point back in and toward the pine trees in the upper left, while their cool shadows on the snow bring the eye back down to the creek. As a rule, any time there is a long line of something, find a way to break its monotony.

Fig. 16-7A. *INCORRECT*: Although the trees on both sides seem to propel you along toward the middle, note the dull void at the end of the road, and the strong pull toward the lower left corner because of the brighter colors there. Furthermore, the first tree on the left aggressively points out of the picture— a serious flaw.

Fig. 16-7B. *Country Lane*. Oil on canvas, 7½ × 9½" (19 × 24 cm). Private collection. *CORRECT*: Just a little further down the same road was this little house nestled in the trees. The shadows in the road sweep toward the house. The fence then carries your eye to the left, where it is drawn to patches of sunlight that bring you back to the beginning of the tour.

THE CENTER OF INTEREST

Effective composition calls for a center of interest and, perhaps only slightly more specific than that term, a focal point. A stand of trees on a hill could be the center of interest in a painting; the sunstruck spot on one area of their foliage would provide a specific focal point. Whatever the distinction, the center of interest is a place in the painting that commands the viewer's attention more than any other. Accomplishing that task requires one or more of the following: brighter colors (usually warmer) than surrounding areas; lighter values than anywhere else, and maybe darker darks; sharper edges; and greater detail. The center of interest may also occur at a confluence of planned directional lines. As often as possible, find ways to lead the eye toward the center of interest in your compositions.

Try these exercises. Hold your hand up in front of you, palm out and fingers splayed, and observe that you can focus on the details of only one finger at a time, while the others are seen peripherally. Next, starting with your thumb, look at each fingernail in a sequence, then go backward toward the thumb again. Do it again, this time skipping around arbitrarily from finger to finger for a few seconds, noting

the darting movements of your eyes. I think you will agree that it is much easier to follow a sequence than to endure the visual hopping about, the indecision of where to look next. So it is with a well-arranged composition that leads comfortably to a focal point, moves through subordinate areas, and returns again and again to the beginning of the tour. Even in busy, dizzying compositions in which everything seems to demand attention, sometimes it takes only one quiet little spot, perhaps a face, in that swirl of activity to serve as the focal point.

THE VIEWFINDER

The first decision you have to make when starting any new composition is whether it is going to be horizontal or vertical. Do this with the help of a viewfinder, a simple piece of cardboard measuring about 5 × 7" with a rectangular window cut out of the middle. It should have at least 2" margins on every side. (You can also use a 2 × 2" slide mount, or even peer through the lens of your camera.) When you are out on location, holding the viewfinder close to your eyes gives you a panoramic view through the little cutout window. Extending the viewfinder at arm's

length and squinting one eye will narrow your view to a specific area within the panorama. Make several little horizontal and vertical thumbnail sketches in your sketchbook to explore compositional possibilities. Be sure to draw little oblong formats of the same proportions as your canvas on the page first and then fit the subject within those constraints. Working with boundaries will keep you aware of how much space you actually have to fill. No matter what subject you are tackling, solve your compositional problems in the sketchbook before you get into serious trouble on your canvas. It will be five or ten minutes well spent.

Fig. 16-8. As you start planning a painting, divide each margin of your canvas roughly into thirds and imagine where the extended lines from those points would intersect. If your center of interest is somewhere in the ballpark of one of those four intersections, your composition will be off to a good start.

RULE OF NINE

After making several thumbnail sketches, next decide what your center of interest will be and where to put it. Although I am not much for formal geometric divisions of the canvas, the "Rule of Nine" is a simple concept for finding the best place for the center of interest. Before beginning to draw on your canvas, divide each side roughly into thirds. Make a small mark at each division and visualize where the lines would intersect. If you were to rule the lines, you would have nine squares, hence the name. The intersections of the lines, as shown in Fig. 16-8, are favorable positions for a center of interest. This grid also tells you to stay out of the center of your canvas, and keeps you from placing a focal point somewhere along the borders of the format.

AVOIDING THE CENTER

What's wrong with placing the center of interest, or anything else, smack in the middle of the canvas? I submit that it's because both eyes are riveted by that bull's-eye and can't easily be persuaded to continue to move throughout the painting. A scheme based on a central focal point where everything is equal, balanced, and symmetrical on all sides is handsome in quilt designs, and in geometric or concentric-oriented abstracts. But in

realism, uneven intervals, free-form organic shapes, and asymmetrical compositions are the desirable norm.

One of the worst errors of symmetry in composition is placing the horizon in a seascape or barren landscape right across the center of the canvas. This results in an equal division of sea and sky, a boring, unacceptable situation. Place the horizon either well above the middle or well below it. Students on location will sometimes draw the horizon about a half inch above or below the middle of their canvas, but that really won't solve the problem. The optical middle is a big place, not just a line or a spot, which makes it hard to avoid having something fall into that center area. But a minor something, without color and value contrasts, is better than a big empty spot in the middle of a composition with all landscape elements arranged in a circle around it, like covered wagons on the prairie. Sometimes artists' conscientious efforts to stay out of the middle are worse than the problem itself.

CHAOS VERSUS ORDER

To convince you that some sort of order is necessary when composing paintings, let's

toss out the rules and see what happens. Without a designated focal point, everything in the painting will have equal emphasis, demanding attention in the same loud voice, so to speak. The viewer's eye will jump wildly from one thing to another, just as our eyes did when skipping fingers out of sequence.

Two equal attractions on opposite sides of a composition compel the eyes either to bounce back and forth like a ball in a tennis match, or

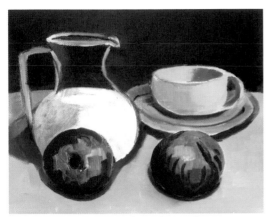

Fig. 16-9A. *INCORRECT*: The twin peaches are equidistant from the sides of the canvas, and they have that same interval between them. They are also equidistant from the bottom edge of the canvas and centered below the objects above them! Do your eyes ricochet between them?

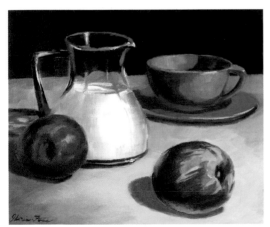

Fig. 16-9B. *Pitcher of Milk with Peaches.* Oil on canvas, 8½ × 10″ (22 × 25 cm). Private collection. *CORRECT*: This time there is more depth on the table plane and a definite eye path. The peach on the right now has vibrant Tomato Theory color, while the left-hand peach is smaller and has weaker, cooler color. The tablecloth has a subtle warm-to-cool gradation that enforces the eye movement from the bright peach to the duller one.

to try to look simultaneously in opposite directions—hence the term "walleyed" composition, a very uncomfortable situation. Even something like the two twin peaches in the "wrong" still life in Fig. 16-9A should be avoided. Make one of them the center of interest, and downgrade the other to an echo of the first. It helps to have some connecting movement to guide the eye from one to the other, as the cast shadow from the right-hand peach does in Fig. 16-9B. Repeat some aspect of the main center of interest elsewhere in the composition. State that element's colors, values, or shapes again, but subtly. If you're working on a fairly large canvas, try for a double or triple echo in other areas. In Fig. 16-9B, *Pitcher of Milk with Peaches*, note the darker echo of the peaches' color in the background at left, and even more subtle touches of it in the cup at right.

VARY POSITIVE SHAPES AND NEGATIVE SPACES

The two identical peaches in Fig. 16-9A remind me that it is not good compositional practice to have equal intervals (negative spaces) anywhere in the format. That means that no two objects should be equidistant from any of the four edges of the canvas. It also means that two, three, or four objects should not have the same interval between them; nor should they be the same height, width, or precise shape. (Look again at those two peaches.) Nothing should be precisely the same as anything else, period. Just as you should avoid symmetry in still life, beware, in landscape painting, of "Bobbsey Twin" trees and three-peas-in-a-pod clouds. The key word in composition is variety. We'll cover more of this in the next chapter.

CROPPING

With photography came informal, candid "slice-of-life" imagery, a radical concept to painters. No more did still life, or indeed any subject, need to be completely composed

within the borders of the canvas. Painters began to crop objects, landscape elements, and even people in their compositions just as photographers did. Much of the new compositional freedom that pervaded the work of the Impressionists was due to the influence of photography, and to the popularity at the time of Japanese prints, whose startlingly non-Western points of view were eye-openers for artists eager to break the bonds of academic tradition.

As you compose still-life subjects, try cropping a few elements. Expanding beyond the boundaries of your format keeps you from miniaturizing the objects in your composition to make them all fit in the space, and from having too much empty space around them. As you have perhaps discovered already, empty space is far more difficult to paint well than the subject itself. Cropping also helps you attain interesting negative shapes along the borders of your composition.

When cropping compositional elements along the frame edge of your canvas, keep in mind the following:

1. It works all right to push about one-third of something out of the picture, leaving two-thirds still in. Half in and half out is much less desirable, and one-third in and two-thirds out won't do at all. A frame would reduce that fraction to almost nothing.

2. Absolutely unacceptable is something that is tangent with the edge of the canvas or frame. The viewer's eye will inevitably be drawn to that area, and the edge of the canvas is not where you want the viewer to look. Be decisive about expanding out of the format, or staying within it, so that it doesn't look as though you ran out of room.

3. If you crop part of an object on one side of the canvas, your sense of balance should tell you that something must be cropped on the other side too. Just don't be symmetrical about it; crop the element on one side higher or lower than the other rather than painting them exactly parallel. Compare the cropping of still-life objects in the two halves of Fig. 16-4. Balancing top and bottom edges is less of a problem. Leaves or branches that extend upward from a vase out beyond the top of the canvas don't require that you crop something else at the bottom of the canvas too. You can always rationalize that the table the vase stands on runs out of the composition, thus providing balance.

4. Wherever an element in your composition breaks the edge of the format, that is, appears to extend beyond the canvas, keep the values between subject and background as close as possible. Why draw the eye to that spot with the aggressive

Fig. 16-10. *River of Light.* Oil on canvas, 9 × 12″ (23 × 30 cm). Private collection. This composition has organized values that reinforce its L-shaped configuration: dark values along the left side and bottom, and light-to-middle tones in the airy sunlit space beyond. I've carried the viewer's eye across the top with leafy branches, and they in turn point to the river and the base of the red rock hills, both of which carry the eye to the front again. The color harmony is based on the secondary triad of orange, green, and violet.

light and dark contrasts we reserve for the center of interest? By the same token, bright colors should be muted at those points. It would never do to let a supporting actor near the wings steal the spotlight from a star on the stage, and the same holds true in composition.

COMPOSITIONAL CONFIGURATIONS

Certain traditional compositions are recognized as winning configurations. A triangular arrangement of the main elements was, and still is, beyond reproach. The Renaissance device of placing a divine figure at the apex of a triangle automatically commanded attention, while eye movement around the triangle was assured. Arranging still-life or landscape elements in a triangle, preferably an asymmetrical one, will be successful every time too.

A popular nineteenth-century format for landscape was an L-shaped configuration, which we don't see very often today. In such a scheme there is a tenuous but acceptable balance between elements arranged across the bottom and all up one side of the format. This balance is usually contingent upon the positive shapes, whatever makes up the two sides of the L, as being quite dark in value compared to the remaining light to middle tone airy space. The painting *River of Light* (Fig. 16-10) is an L-shaped composition. It is always a challenge to get the eye to span the negative space between the upper left corner and the lower right corner, or vice versa; here the leaves of the tree, the river, and the red hills help a lot.

I have already mentioned S- or Z-shaped compositions, which, in contrast to L-shaped configurations, automatically move the eye through space. We could talk about an X-shaped configuration, but it is seldom used in realism. Not only does it have the bull's-eye problem, but it is difficult to move the eye from one point of the X around the format to the other three. Avoid even accidental X's in your compositions—two dark stems of

flowers, two tree trunks, or two branches that cross conspicuously.

In a juried art show, the judge or jurors review the hundreds of entries very rapidly at first, usually rejecting half of them after a scrutiny of only one or two seconds. Now, what in a painting could possibly be recognized as good or bad in one instant? Composition and design are the factors that, more than any other, turn a mundane subject into a noteworthy painting. Always think about arranging the masses in your composition in such a way that you lead your viewer into the picture and give him a fine tour.

When no thought has been given to eye movement, emphasis on one area above others, and a strong value pattern, the result is no more interpretive than the mechanical eye of the camera. Emotional content, of course, is also terribly important, but expressing your personal vision works only after you have learned keen observation, solid basics, and good technique in your chosen medium.

Drawing Assignment

Using tracing paper and a pencil with soft lead, trace the main compositional lines of paintings that you find in art books or art magazines. Do at least eight of them, if possible, from paintings of different periods in art history—old master, Impressionist, Cubist, and contemporary realism. When you can detect an obvious path for eye movement, place arrows (with a red marker) on your drawings to indicate them. Analyze whether the artist planned a focal point or any sort of eye movement at all. Then, looking only at your tracings and absolutely ignoring subject matter, decide which compositions you think work best.

Chapter 17
DESIGN

Design and composition work hand-in-glove to develop interest in a work of art beyond the mere reporting of visual facts, no matter whether you work semiabstractly or in a realist style. If composition is the arrangement of the main masses in the format, design is the abstract support system for the composition, its underlying architecture. It is often said that a well-designed work suffers if anything is added to it or taken from it. That means that every element in the design should have a reason for being there, or it shouldn't be there. A well-designed work is pleasing and satisfying to look at, and complete in every way.

We all understand what design is when someone speaks of the design of a dress, a teapot, or a chair. We also understand what is meant by the design *on* the dress, teapot, or chair. Presumably it is a decorative

embellishment of some sort. Yet the design of two-dimensional works of art seems to baffle many. There are numerous books on industrial or graphic design, but very few that cover design specifically for the painter. Edgar A. Whitney's *Complete Guide to Watercolor Painting* (Watson-Guptill Publications, 1974) is an exception, a gold mine for artists working in any medium. Whitney sets forth eight *principles* of design: unity, conflict, repetition, alternation, dominance, balance, harmony, and gradation. He also lists these seven *elements*: line, value, color, size, shape, direction, and texture. All eight of the principles can apply to each of the seven elements, and vice versa.

Total involvement in subject matter produces a simple reporting of visual facts, of "That's the way it was." While that was sufficient for the beginning lessons of this book, it is time now for you to build your

Fig. 17-1. *Honolulu Harbor I.* Oil on canvas, 9½ × 11½" (24 × 29 cm). Private collection. This is a fairly representational view of the waterfront and city of Honolulu with its mountain backdrop. The design has a dominance of verticals with subordinate diagonals and a few rounded shapes. It is dominantly cool in color with contrasting warm areas, and its tonality is mostly middle values. A small triangular motif repeats in the diagonal cast shadows on buildings. Look for this shape in the mountains too.

Fig. 17-2. *Honolulu Harbor II.* Oil on canvas, 9½ × 11½" (24 × 29 cm). Private collection. The same design principles are at work in this semi-abstract painting as in *Honolulu Harbor I,* but with one major exception. Now the dominant lines are dynamic diagonals rather than the stable verticals of the buildings in the first version. Observe the way the mountains and buildings dissolve into each other, compared to the clear overlapping of trees, buildings, mountains and clouds in the first version.

Fig. 17-3. *Honolulu Harbor III.* Oil on canvas, 9½ × 11½ × (24 × 29 cm). Private collection. Here the recognizable objects have been almost totally obliterated. The design still has the original version's dominance of cool colors with smaller warm accents, and it is alive with the dynamic oblique thrusts of the second painting. A painting like this one may intrigue you longer than the scene you can visually memorize after a brief encounter or two.

paintings with equal concern for your subject and for certain design principles.

DESIGN PRINCIPLES DEFINED

As you read my definitions of Whitney's principles, refer frequently to Figs. 17-1, 17-2, and 17-3, my Honolulu Harbor series. Check to see how I have applied some of the principles, or failed to do so. These rules are helpful guidelines, but remember that no one painting can encompass all of them. To attempt that is to stifle spontaneity.

1. *Unity:* Unity of concept; a theme with related objects or ideas; an esthetic whole with nothing irrelevant or superfluous.

2. *Contrast:* Opposition or conflict; major design elements should be countered by their opposites:
 - warm *colors* with cool colors
 - light *values* with dark values
 - curved *lines* with straight lines
 - large *sizes* with small sizes
 - free-form *shapes* with geometric shapes
 - smooth *textures* with rough textures
 - major *directional* lines or movements with opposite directions
3. *Repetition:* Echoing major elements at least two or three times in a design, but with variety, so that no two elements are quite the same. Paradoxically, repeating a particular motif throughout a work ensures that the picture will hold together as a unified whole. The motif might be a series of triangular shapes, rainbowlike arcs, or serpentine S shapes; just remember to create variations on it.
4. *Dominance:* One element in a contrast should be dominant in a painting, the others subordinate. Let either warm or cool colors dominate, either straight or curving lines, and so on.
5. *Balance:* A comfortable state of equilibrium, in which the distribution of all parts of a composition can be formal and symmetrical, or informal and asymmetrical. (Asymmetry is usually more interesting.) All of the seven elements can contribute to the balance of a painting.
6. *Harmony:* Achieved by repeating a few elements and varying them rather than introducing many different elements and using each only once. Harmony is also ensured when elements flow into one another in a logical sequence. Shockingly juxtaposed extremes, on the other hand, are dissonant, although a little dissonance is welcome in a design that might otherwise be too bland.
7. *Gradation:* Transition between opposing elements:
 - light melting into dark *values*
 - warm *colors* becoming cooler; bright colors dimming until they are muted
 - large-*size* objects or compositional areas leading to middle sizes and then to small sizes
 - geometric *shapes* or volumes dissolving gradually into free-form shapes; in still life this might translate into creating a transition object to reconcile a tall, slim, rectangular form and a short, bulbous pot
 - the *directions* of vertical lines (or planes) becoming more and more slanted until they are finally horizontal
 - *textures* can go from smooth to slightly rough to very rough; this would also apply to rendering certain details of a form in sharp focus and gradually softening those areas to mere suggestions. Imagine how the pattern of a red brick path would recede into distance gradually, or how tree shadows on the ground would become less and less obvious farther back in space.

EDGES

Edges, or borders, refer to the all-important meeting between positive and negative shapes. Edges between an object and its background need to vary from soft and fuzzy to firm and crisp, from nearly lost to clearly found. If all edges between two shapes are hard-edged, as they tend to be in most beginning students' work, the principles of contrast and dominance are negated. Either crisp or soft edges should dominate, but both need be there.

A watercolorist who works wet-in-wet on a soaked paper will automatically have a dominance of soft, blurry edges. But without decisive strokes added later when the paper is nearly dry, the design will be weak. Oil and acrylic painters, on the other hand, tend toward a dominance of hard edges and must look for opportunities to soften them, to destroy an edge and then recover it slightly— or even to lose an edge completely.

"When you've got a line going, keep it going" is a good rule to follow. Imagine a cloud that appears at the left of a mountain peak but doesn't continue on the right side, or a road that runs behind a stand of trees and doesn't continue on the other side of it. The viewer senses such things as unfinished; therefore, always keep a line (the cloud, the road) going on the other side of an obstruction.

Here are some examples in painting when "lost" blurry edges and crisp "found" edges along an extended contour would be helpful, if not essential. When a range of mountains meets the sky across the width of a painting, avoid the monotonous handling of its edges against the sky that you see on the top in Fig. 17-4. Note on the right how the mountaintop has been softened with some wispy clouds at one point, and the whole ridge has a variety of value contrasts as it meets the sky and clouds. In seascape painting, avoid having the horizon cross from one side of the canvas to the other without any variation along its width. To break the monotony, interrupt it however you can, with trees, a sailboat, or an enormous, crashing wave. You might also soften the horizon with cloud reflections on the water at one point, leaving a sharper edge at other points. In some geographic locations air pollution all but obscures the horizon; in

Fig. 17-4. *Top, INCORRECT*: The peaks on the mountain ridge, which are too dark to begin with, all meet the sky with the same value and edge contrast from one side to the other. The suggestion of grasses, scrubby brush, trees, bare dirt, and rocks all need to be modeled to conform with the big light and shade planes. *Bottom, CORRECT*: Analyze the changing value contrasts along this mountain ridge, as well as the alternate softening and firming up of edges from the left side to the right side. Particularly notice how the mountain peak on the left is dark against light clouds, but there is a light peak against a dark cloud on the right. Cloud shadows are a boon in landscape because they allow us to focus on some areas more than others.

Hawaii we frequently see a hard, crisp line, usually quite violet, that stretches across miles of ocean. In either atmospheric extreme, your painting will be enhanced by some edge interest across that long, boring line where ocean meets sky.

Nothing is more amateurish in portraiture than when the whole outer contour of the head meets the background with the same value contrast and degree of hard edge, as if the head were a silhouette cutout. Instead, let the negative background and the positive head share a variety of edges and value interchanges along the contour of the head. Analogous hue and value gradation rather than flat color in the background helps too.

DESIGN LESSONS FROM CÉZANNE

Cézanne's working method was to start with the design on the canvas before he painted a subject. Each time the artist put down a paint stroke on a blank canvas to indicate a value or a partial contour of some form, he balanced it with opposing marks in other parts of the canvas. If he put down one color note, he immediately balanced it with two or three related color notes elsewhere in the format. He continually worked all over the canvas in this manner, upsetting the balance momentarily and then reestablishing it, eventually gathering his strokes together until they became subject matter—fruit, plates, bottles, drapery, statuary, and so forth. Instead of painting things overtly, he crept up on them covertly from the standpoint of design principles. This is the Gestalt concept, the idea that the whole must be greater than the sum of its parts.

If you paint one component, say, an apple, until it is finished, and then another object, you may end up with unrelated parts that do not necessarily add up to a successful whole work of art. It's important to keep your mind on the "big picture." Developing all parts of the canvas at the same rate will also keep you from overworking the painting, or beating one element to death.

Fig. 17-5. *Keukenhof Reflections.* Oil on canvas, 9½ × 8½" (24 × 22 cm). Private collection. This little painting and the next two are views of Keukenhof Gardens in Lisse, Holland, a must-see in spring when the tulips are in bloom. This one illustrates a design with a dominance of verticals extremely well. It would do so even without the reflections of the trees in the pond, but with them, it becomes a compelling vertical pattern with great stability.

Fig. 17-6. *Morning Mist.* Oil on canvas, 8 × 9½" (20 × 24 cm). Private collection. Everything in this painting is horizontal, save for the three large trees—but even their foliage is quite lateral. Without the opposition of the vertical trees, the horizontal bands would be quite monotonous.

Fig. 17-7. *Keukenhof Flower Beds.* Oil on canvas, 8 × 9½" (20 × 24 cm). Private collection. Ah, good, the sun is shining again in this painting, a dominantly diagonal composition. With all flower beds and cast shadows from trees angling down from the upper right side toward the lower left, our eyes would exit the canvas if it weren't for the countermovement of the path.

LINEAR DESIGN ELEMENTS

Try to conceive of your subject and its design right from the beginning. Let the linear design convey the right mood for your painting just as colors and values do. A painting with a dominance of verticals conveys strength, stability, even majesty. Consider Fig. 17-5, a painting of Keukenhof Gardens in Holland. Compare its vertical design with the predominantly horizontal design of Fig. 17-6.

Horizontals convey feelings of restfulness, calm, tranquility. A dominance of diagonals usually results in a sensation of dynamic activity, excitement, even agitation. A wintry storm at sea could not be expressed with horizontals any more than a placid, mirrorlike lake scene should have a preponderance of jagged diagonals. (I have to admit, though, that despite its diagonals, the garden scene in Fig. 17-7 is tranquil, not dynamic.)

Fig. 17-8A. *INCORRECT*: When we change values abruptly without any thought for the light source or a larger abstract value pattern, the result is a spotty painting like this.

Fig. 17-8B. *Burst of Foam*. Oil on canvas, 6 × 8″ (15 × 20 cm). Private collection. *CORRECT*: By linking the light values together in the foaming water and the beach, and also tying together the darks in the rocks, I simplified the value design. Both flow from lower left to upper right.

Fig. 17-8C. There are just three major values here. When you make such a sketch, tie the light values together, and then the darks, and don't worry about the supporting middle values.

ABSTRACT VALUE PATTERN

In chapter 4 I explained the need to organize the various light, middle, and dark values in a painting into an underlying abstract pattern. Working with larger pieces of value rather than hundreds of little ones results in a strong pattern, one whose impact can be read clear across a room. When little shapes of similar value are linked together to form the larger overall pattern, the painting is simplified and strengthened. Tying the darks together and connecting the light passages will usually do it. The middle tones automatically serve as transitions.

Squint at your subject to see the big pieces of values. Study the two seascapes shown here. Note the difference between Fig. 17-8A, in which values are broken up, and Fig. 17-8B, in which they are arranged in a simplified scheme. You can avoid painting a spotty picture by working out the big value pattern in a thumbnail sketch, as in Fig. 17-8C, before starting to paint. Imagine making a simple collage out of light, middle tone, and dark papers for the subject you are about to paint.

KEYING A PAINTING WITH DOMINANT VALUES

A painting is further strengthened when its big value pattern has a dominance of either light, middle tone, or dark values. The following three paintings, from my Sedona (Arizona) series, illustrate different value schemes. In *Last Light* (Fig. 17-9), I deployed small patches of light in a large amount of dark values. *Weeping Willow Guardian* (Fig. 17-10) relies on a dominance of middle values with just a few small patches of light and dark values strung through them. *Rock Creek Canyon* (Fig. 17-11) features predominantly light, sunny values punctuated by small patches of dark.

ODD VERSUS EVEN NUMBERS

I've always heard, but can't recall seeing in print, that in a design you should avoid having

Fig. 17-9. *Last Light*. Oil on canvas, 14 × 18″ (36 × 46 cm). Private collection. This painting illustrates a dominance of dark values with small pieces of light value. When you look at this and the next two paintings, try to imagine how they would look in black-and-white photographs.

Fig. 17-10. *Weeping Willow Guardian*. Oil on canvas, 18 × 14″ (46 × 36 cm). Private collection. This example has mostly middle values, and that is usually a deadly quality in a painting. But if those predominant middle values are punched up with a few very light ones and some dark accents, as you see in this case, it will survive nicely. The important thing is whether the values fall into interesting overall patterns.

Fig. 17-11. *Rock Creek Canyon*. Oil on canvas, 16 × 12″ (41 × 31 cm). Private collection. A strong morning light shining in from the left has blessed this scene with a lot of warm, light values, and that is a great deal of its appeal. Without some middle tones and dark accents here and there to provide some contrast, however, this painting might be too pastel, too bland, to hold your interest for long.

Fig. 17-12A. *INCORRECT*: An even number of things fall easily into a geometric square or diamond-shape as these four identical chrysanthemums do in this flower study. (I call it a flower study because this is not a still life with a vase, table, and other objects.)

Fig. 17-12B. *Spider Mums.* Oil on canvas, 6 × 8½" (15 × 22 cm). Private collection. *CORRECT*: This time the same four flowers have been grouped and turned in such a way that their number is much less noticeable; the foreground flower has "star status." Be aware of the need for variety among multiples of one thing.

an even number of anything: two apples, four flowers, and so on. What's wrong with even numbers? Nothing, if you handle them cleverly. We've already covered the problem of two identical pieces of fruit, the peaches in Fig. 16-9A, and how two of anything similar vie with each other for attention. Four of anything tend to fall into a square or a diamond shape. Avoid such geometry by overlapping a couple of the similar components and varying their positions and the intervals between them, something art students are disinclined to do at first. Compare the four equidistant chrysanthemums in Fig. 17-12A with Fig.

17-12B, which offers a possible solution to the design problem they pose. The best way to convince yourself of whether there is indeed virtue in using odd over even numbers is to do the design assignment at the end of this chapter, in which you will work out effective ways to handle two, three, four, five, six, seven, and eight multiples of the same item in a format. (Beyond those quantities, I don't think odd or even numbers of units matter much.)

Dominance in Color Intensity

In the painting of gladiolus in Fig. 17-13, no one would bother to count how many stems or flowers there are, or care, yet in the ikebana arrangement in Fig. 17-14, four flowers would indeed be out of place. However, these two paintings illustrate more than just the question of odd versus even numbers. They show the difference between a dominance of bright, intense colors, the explosion you see in *Gladiolus Bouquet*, and a dominance of muted hues and just a few accents of pure color, as in *Lilies with Dried Mossy Branches.* Fig. 17-14 has the spare look of some styles of ikebana, while the gladiolus painting has the look of Western abundance and exuberance in flower arranging.

Not until I was well into learning about design principles many years later did I realize how much design my elderly Japanese ikebana *sensei* had taught me—by example rather than words, since she spoke very little English. The uneven triangle of floral materials, on which almost every school of ikebana is based, carries over handsomely into two-dimensional painting. If in following the rules of good design you find yourself repeating a color, line, value, or shape two or three times (three is always better), I'll wager that you will spot these elements in a triangle of some sort. Just avoid the static symmetry of an equilateral triangle. Besides leaving different intervals between them, you should vary each of the three elements from the other two in size, shape, intensity, value, and so on. In

ikebana, if we used three similar flowers, one would be a bud, one would just be opening, and the third one would be fully opened, as you see in Fig. 17-14. The larger flower would always be placed at the bottom, middle-size ones in the middle, and the bud at the top. We learned that a top-heavy arrangement is an esthetically uncomfortable imbalance that seems to defy natural laws.

DESIGN SUMMARY

If you feel overwhelmed by all of these principles and elements of design, rest

Fig. 17-13. *Gladiolus Bouquet.* Oil on canvas, 30 × 18″ (76 × 46 cm). Private collection. Here is a major-key painting with a dominance of bright, intense colors, and with subordinate grayed-down colors for contrast. It is also primarily a warm painting, with only subtle cool touches. The mood and movement are joyous, upbeat.

Fig. 17-14. *Lilies with Dried Mossy Branches.* Oil on canvas, 26 × 16" (66 × 41 cm). Private collection. Living in Japan gave me an appreciation for the quiet beauty called shibui. The hand-thrown rough compote, the dried mossy branches, the muted background, the few spots of pure color in this otherwise muted painting all speak of that quality. The painting's mood is quiet, understated, and undemanding. The color intensity of this flower painting and the preceding one could hardly be exchanged without damaging their moods and characters.

assured that in time your grasp of them will become instinctive. I offer you here a brief summary of what we've covered just for the sake of reference. The name of the game in art is, learn the rules but then bend, twist, distort, and break them as creatively as you dare.

- When you state one element in a composition—line, value, color, shape, size, and so on—echo it elsewhere.
- Always vary any element you repeat in some way—in value, color intensity, quantity, and so on.
- Counter the dominant direction in your composition with a lesser degree of the opposite direction.
- In a well-established color harmony, introduce a spot or two of alien color to provide sparks of excitement.

- Don't place major elements in the center of the canvas, or let them cut the canvas visually in halves, thirds, or quarters, either horizontally or vertically.
- Balance your dark values throughout the canvas rather than isolating them in one area.
- Create transitions between light and dark values, except possibly in focal point areas, where you might want dramatic juxtapositions.
- Add small touches of cool color to a predominantly warm painting, and vice versa.
- A painting that shouts with bright, saturated color needs the contrast of some quiet neutralized areas.
- To busy little shapes all over the canvas, add the welcome opposition of larger shapes.
- Avoid equal areas of light and dark values, warm and cool colors, or a fifty-fifty division of any contrasting element.

A beneficial side effect of studying design should be your greater appreciation for its application to every art form, whether two- or three-dimensional, representational or abstract, functional or decorative. Paintings, Eskimo baskets, Indian blankets, logos, and innovative furniture are all subject to principles of design. You will begin to see that even the nonobjective painter is guided by the same principles of design as the representational artist. If you stay with realism, at least let the very word "design" nudge you to stop when you find yourself painting many square inches with boring sameness. Immediately find variations within that flat area. And if you have multiples of any one component in a painting, suggest some, nearly lose others, detail a few carefully in the light, change their postures, cut one in half, elongate, foreshorten, and so on. We all tend to paint sameness, to have little pet ways of doing something, and it takes a conscientious effort to break out of those grooves. Watch for those conspirators against good design principles!

Assignment

On your large drawing pad, draw a rectangular picture format that nearly covers the page. Then choose as a design subject apples, persimmons, oranges, or anything else where all units are alike. No need to buy them; you can simply cut their shapes out of construction paper. Cut eight or ten apple shapes (or whatever you choose) with a little size variance among them that will work comfortably in the picture format you drew. Also cut out about six thin strips of different lengths that you can use loosely as either table or background lines. Start by working with two of the apple shapes plus a few strips to represent the table plane in the rectangle. Make a fast $3 \times 4''$ pencil thumbnail sketch of the best arrangement for just those two apples, shading the apples so they are dark shapes on the paper. Then add one more paper apple shape and work with three, sketching them also. Next, see what you can do with four of them. Do they group better two and two, or three and one? Continue adding one more apple shape as you work with five units, then six, seven, and finally eight. When you are finished, consult your little sketches; then you be the judge as to whether odd numbers are preferable to even numbers.

Chapter 18
ADVANCED PAINTING TECHNIQUES

If you have faithfully followed along with the lessons in this book, you should have the basics of art down pat. You now have structural drawing skills, control of values, and are able to mix colors purposefully so that you can tackle any subject on your own. All that remains is to expand your use of the oil medium itself. Until now the basic approach in the previous painting lessons has been alla prima, that is, painting done mostly with buttery, "short" oil paint just as it comes from the tube. When you thinned it with a little medium to make it more fluid and scrubbed the paint on with a filbert, it became "long" paint that leveled out on the palette. Although it may have taken several layers of opaque paint to say what you wanted to say correctly, now we'll begin to layer paint for a different reason. We're going to let several transparent and opaque layers interact so that the final painting is a richer tapestry of interwoven color threads than what can be achieved with just surface color.

LAYERING COLOR:
THE FOUR-STAGE APPROACH
Try a multilayer approach in this sequence:
1. Apply a coat of gesso over the original gesso priming put on by the manufacturer.
2. Apply a wash of transparent oil color (thinned with turps) to the white canvas. Use a single, all-over color for the first few times you try it, but then experiment with two or three colors applied in large areas. Let this layer dry for ten or fifteen minutes.
3. After drawing with a thinned-out oil line as usual, paint your subject directly with thick, buttery paint, taking care not to completely cover the colorful wash underneath.

4. When the painting has dried thoroughly to the touch (in two or three days if you've used a little Liquin, or six or seven days if you haven't), apply a thin film of transparent color to some passages. This is called *glazing*. This time thin the transparent color out with a lot more Liquin. When light passages become too dark, work opaque light colors back into the wet glazes.

Before we move on, be sure you are clear about which colors are transparent. Consult the lists of transparent colors in the introduction to Part Three, as well as your own Custom Color Wheel if you've made one. When you apply a film of transparent color over another color, you are mixing colors in an optical sense rather than a physical sense. A transparent layer of Indian yellow over a light blue passage results in a more lively green than anything you could mix by blending an opaque blue and yellow. On the other hand, a too-bright green passage can be muted decisively with one pass of a brushful of red or brown glaze. If a pink color is too chalky, enhance it with a clear red glaze. Note the results of mixing color this way in Fig. 18-1, the glazed abstract exercise I call *Banners and Ribbons*.

A quick way to tell the degree of transparency of any color is to spread it out thinly with the knife across your white paper palette for an inch or so. Look to see if the color hides the white paper or is sheer enough to let the light pass through it. If you spread out viridian and phthalo green, you will find that both are transparent, but the latter is much more so than the former. Phthalo green would therefore be a better choice for underpainting washes and glazing. On the other hand, it (and phthalo blue too) might be

Fig. 18-1. The ten waving "banners" go from two pale yellows in the center to cooler colors on both the top and bottom edges. After these opaque colors dried thoroughly, I ran the vertical "ribbon" glazes across them. They are, from left to right: manganese blue, phthalo green, sap green, Indian yellow, Rembrandt's Stil de Grain Brun, Thalo red rose, ACRA violet, and ultramarine blue. When using transparent color glazes over actual passages in your paintings, you would seldom use them full strength as I have here.

too powerful if you want a subtle effect when glazing, so viridian would be better for that.

Any color can be thinned out to become reasonably semitransparent, but the most transparent colors allow the most light to pass through them. The transmitted light hits the gesso ground, the white coating on the canvas, and then bounces back to our eyes with a jewel-like brilliance that you can't get with opaque oil paints. Some of those flashes of transparent color should be allowed to vibrate under the opaque paint layer as you begin to develop your subject. If they are too brilliant and pop out of the surrounding opaque layer too conspicuously, a bit of transparent glaze will tone them down later and tie them into the overall color harmony beautifully.

Compare Figs. 18-2A and 18-2B. The first, *Moanalua Gardens Pavilion*, was painted on location. At least, the first two stages were,

the underpainting washes and the opaque passages with which I developed the subject. Later, in the studio, after I'd studied the painting for a few days, came the fun of glazing, of subduing some passages and enhancing others. I may fine-tune such a painting by alternately glazing and working back into it with light opaque touches several times in this third stage, always seeking a richer effect. Historically, by the way, artists applied countless layers of oil glazes over the tonal grisaille underpainting. During the process, the light passages were continually brought back up in value with opaque paint. Meanwhile, the dark passages grew ever deeper and more luminous, the look that we associate with Old Master paintings. The trick in reworking areas is not to smother the transparent wash that gives the painting such a lively look. Once it is covered, it is gone for good.

Fig. 18-2B is an all-opaque, basically one-layer translation of the painting in Fig. 18-2A. It is not "wrong" this time so much as it is just a factual reporting of what the Japanese-inspired pavilion and the bridge in Honolulu's Moanalua Gardens look like. I hope you will agree that it is, well, bland compared to the richness of color in Fig. 18-2A.

MEDIUMS FOR WASHES, GLAZING, AND SCUMBLING

In this context, the word "medium" refers to anything that makes paint more fluid and easy to manipulate. Turpentine, mineral spirits, and linseed oil are mediums in the sense that they will increase the flow of oil paint, but they are not as complete as those mediums formulated to increase the flexibility and durability of oil paint, as well as the flow.

Prepared mediums are composed of varying proportions of resin, oil, turpentine, and sometimes a drying agent to speed up the drying time. Most mediums are a pale liquid available in bottles, but others are a thicker gel that is sold in tubes. The gels are best applied with a painting knife; the liquid mediums should be brushed on. You may need

Fig. 18-2A. *Moanalua Gardens Pavilion.* Oil on canvas, 18 × 24" (46 × 61 cm). Private collection. This painting interweaves transparent and opaque colors into a more creative interpretation of the scene shown below. The giant monkeypod tree on the right frames the bridge and the pavilion, balances the building on the left, and serves as a compositional "stopper." It also balances the whole mass of the building and the clumps of bamboo on either side of it across the bridge.

Fig. 18-2B. Tempting though it is to fling those impressive tree branches across the upper part of the canvas out of nowhere, they are more believable and logical when the trunk is included too, as above. Also, the bridge practically runs out of the picture on the right.

a little cup that clips onto your palette for the liquid mediums, but a gel will stay heaped up on the palette by itself. Liquin is something between a liquid and a gel, and it will perform both ways. (I treat it like a gel and just pour some onto the palette.) Any prepared medium has two major functions: to thin out thick paint slightly for easier manipulation, and to bring transparent colors to a liquid state for glazing. It is a simple matter of the proportion of paint to medium: a lot of opaque paint and a little medium for normal painting, and a lot of medium and very little transparent pigment for glazing.

Because most formulated mediums make the paint on the palette irritatingly tacky in short order, I used to avoid using any medium at all until it came to glazing in the latter stages of a painting. But with Liquin, an oil-modified alkyd resin, stickiness is no longer a problem. Liquin remains workable and tack-free during the painting session, and can be used either to make the paint flow better or for glazing. It dries to the touch overnight, more or less, even in humid Hawaii. But, as with all mediums, once you start to use it in a painting session, you have to continue using it. Paint mixtures with medium in them begin to set up quickly on the palette, and those piles of color won't budge until they are activated again with more medium.

The best gel that I have found is Flex-Gel by Utrecht, which is available only through mail order. Failing that, you can mix Weber's Res-n-gel, a fast-drying, tacky, and shiny medium, and Grumbacher's Gel, a slow-drying matte medium. Combining them transcends their individual shortcomings (though they are no doubt formulated perfectly for certain purposes).

UNDERPAINTING

There are as many painting techniques as there are artists, but I think it is safe to say that most artists prefer to kill the white of a new canvas with some color as quickly as possible. The pristine white canvas is then no longer psychologically daunting. Even a little color scrubbed on quickly eliminates the need to brush carefully into the interstices of the canvas weave. If the canvas isn't colored first, distracting little white "blips" pop out of color passages in a finished painting.

Underpainting can be done with opaque pigment, or with various kinds of washes. A wash is paint that has been thinned out with turpentine or mineral spirits (or water if you are working in watercolor or acrylics). If you mistakenly add white or an opaque color to your wash, it ceases to be a wash and becomes a toned ground that must be allowed to dry first. An oil wash of transparent colors should dry by evaporation within fifteen minutes or so, depending on the amount of pigment you use.

Here are several underpainting approaches:

1. *Opaque Toned Ground.* You can apply a layer of solid opaque paint at a #5 value, against which it is possible to judge lighter and darker values easily. It might be gray, but it is more likely to be an earth color like yellow ochre, raw sienna, burnt sienna, or Indian red with a little white added for opacity. The selected hue, when left in small areas, ties all other colors together into a harmonious whole. This can, however, account for a certain monotony. And in sacrificing the white of the canvas to an opaque ground, you also give up any chance to have light bouncing off this underlayer.

2. *A Neutral Wash.* Another approach is to use a slightly thinned, gray wash, perhaps even one concocted from the opaque gray "gunk" that collects at the bottom of a jarful of dirty turps. While that works under a gray-day scene, it doesn't do much for a sunny-day subject. For a rainy day or snowy scene, I like a drippy brown/gray/blue wash mixed from a transparent brown and ultramarine blue, such as the one in Fig. 18-3A. I used this same wash combination to establish the somber mood of a cold November day in *St. Mary Lake*, Fig. 18-3B.

3. *Contrasting Washes*. To ensure that paintings have vitality, some artists draw first and then apply washes of the complementary color under everything in the painting, letting some of it show through the top layer. That means that on the white canvas you would wash in orange under the blue sky area, red under grass, blue under a brown tree trunk, and so on. The final effect, though, becomes too much of a formula after a while, to say nothing of the time involved in preparing so elaborate an underpainting.

Fig. 18-3A. For a rainy or wintry scene like the landscape below, a complementary blue/gray/brown wash sets the mood before you begin.

4. *Local Color Washes*. An underpainting technique used by many artists consists of blocking in the local colors of the subject's main masses. You begin with a quick drawing on the white canvas, then, using a filbert brush and semiopaque paint thinned slightly with trups, scrub in local colors flatly (without form). This is undoubtedly the best way to plan the abstract value pattern of a painting. The blocked-in stage of the waterfall in Fig. 18-4 already shows the major light, middle tone, and dark values. Once the light and shadows are captured, the heavier application of paint, plus the details, follow. It is a safe approach, but perhaps the least exciting one. A blue sky and clouds painted over a blue and gray block-in, such as the top example in Fig. 18-5, lacks the surprises that can happen between the underpainted areas and the livelier finishing strokes. Compare the bottom example, in which the sky and clouds have more vitality because of the burnt sienna wash underneath and, incidentally, much more warming and cooling in the cloud colors. An opposite color is always more interesting underneath something than a similar hue.

Fig. 18-3B. *St. Mary Lake*. Oil on canvas, 8½ × 11″ (22 × 28 cm). Private collection. This painting is adapted from one I did earlier of Glacier National Park. I don't consider it "finished," but this is the stage where I pause and question whether to cover the washes any more.

Fig. 18-4. The colors of this waterfall scene have been blocked in with a filbert brush. This is a safe but conservative approach. Since there are no color surprises or vibrations from underneath, it would take an effort to bring this painting up to a more colorful interpretation of the scene.

5. *Random Colored Washes*. Having experimented with all of the methods of underpainting I've just described, I gradually arrived at a method by which I cover the white canvas as beautifully as possible with colors related to the subject in a random abstract pattern. After applying two or three colors with a large brush, I react to them creatively while developing the subject on the canvas. I let the random colors show through where they work and cover them up where they don't; it's that simple.

The approach has advantages in a class where everyone is painting the same subject but each student lays in his or her own random washes and reacts to them individually. All of the paintings from that class, despite the shared subject matter, will look quite different with respect to their foundation washes. This unorthodox method gets you painting right from the first moment, working loosely on an abstract composition with a large brush.

The drawing that follows in ten or fifteen minutes with a thinned-out oil line is also loose because the wash hasn't quite dried yet, meaning that the lines are blurred a little—as is the psychological line that seems to separate the act of drawing from that of painting. As you begin to develop the subject in opaque paint, the idea of letting some of the wash remain short-circuits the coloring-book instinct to fill in shapes solidly between neat lines. Many a student who has formerly been timid with color suddenly becomes wide-eyed over the new, wondrous color happening in their work.

Fig. 18-5. *Above:* A sky scrubbed in with a blue local color of manganese first and then overpainted with blues is not very exciting. Nor are clouds painted over a gray wash. *Below:* This bit of sky was painted over a burnt sienna wash, which activates both sky and clouds. Burnt sienna under the whole painting would be too much, however, so I prefer to use two or three color washes. This version has a greater temperature range and more value contrast in the clouds than the one above.

MORE ABOUT THE FOUR-STAGE APPROACH

The first thing you can do to make your colored washes more beautiful is to apply a second coat of gesso on top of the one applied to the canvas by the manufacturer. It will become apparent when you slather the brilliant white stuff on the canvas that the manufacturer's priming was grayish in color. That tone reflects much less light than the new white gesso ground will. The second coat will also make your surface less absorbent, meaning your washes will not sink into it quite as much. Let the gesso dry for a few hours before applying transparent washes.

Applying Washes

A wash works most effectively as an underpainting when it is about a #4 value and is swished on once with fresh, clean colors and clean turps. A #2 pastel wash that is mostly mineral spirits is all but useless under the final painting. Besides, too much turps in the wash weakens the paint film so that it is not a good foundation for subsequent layers of paint. On the other hand, too little turps in a wash produces a #5 or #6 value underpainting that is usually too intense to work over comfortably. It also takes too long for that much pigment to dry. If you eventually find that you prefer brilliant, intense color underneath, put the wash on the night before you intend to use it. To ensure overnight drying, make the wash using a mixture of Liquin and turpentine (about half and half). This creates a layer that is almost an imprimatura, a traditional brilliant underpainting made of transparent colors thinned out with a hard-drying varnish, like copal varnish.

A single-color wash may be less confusing for you in the beginning. The most versatile is burnt sienna, a powerful semitransparent rust color. When you become accustomed to the one-color underpainting, then try a two-color wash, which blends to a third color where the two transparent hues overlap. Experiment

Fig. 18-6. *Above:* Burnt sienna and Rembrandt blue-green are complementary colors. It helps to balance the main colors if you anchor each of them to the edges of the canvas. *Below:* This time I used manganese blue and Indian yellow, which blend to become a green. The analogous washes possible with this combination range from yellow-orange to yellow to yellow-green to green and finally to the greenish blue of manganese blue. The daisies display a liveliness of color, by virtue of the brilliant washes showing through them, that white daisies ordinarily wouldn't have.

with a pair of complements that mix to become a muted third color, like burnt sienna and Rembrandt blue-green (Fig. 18-6, top). Then try an analogous color wash (Fig. 18-6, bottom). Be careful to put the colors on cleanly, the lighter one first, then the darker one, blending them together in some areas. Just don't cross-hatch them into a plaid or mop them into one big homogenized mess.

Brush the paint on freely; the larger the brush the better. Balance the colors so that there are several large abstract shapes of, say, Indian yellow scattered here and there, and

several other shapes of your second color, perhaps Dioxazine violet. Let them overlap in places to become brown, and keep all edges soft between color areas.

KEEPING UNDERWASHES ALIVE

Here are some techniques that will help keep your underwashes alive when you begin to paint your subject. The first one is called *drybrush* painting, and it produces broken color, color that is a shimmering combination of an upper layer and several underneath layers. Load your brush with opaque pigment, and stroke it on the canvas until you almost run out of paint, at which point, take three or four more strokes with the brush. Look at the drybrush work in the background, tablecloth, and fruit in the painting *Mango with Limes*, Fig. 18-7A. In your early paintings, you might have drybrushed a lot simply because you lacked enough paint on your palette and brush. Applied over a white canvas, it looks like poor technique, but one broken color over another is something lively, a feast for the eye. The effort to preserve your beautiful, glowing wash should help you overcome the tendency to overblend, the greatest single cause of poor color and poor paint quality. The most beautiful bunch of beets I ever saw in a class painting came about because the student had seen fit to leave some turquoise wash showing through the dull brownish-red forms. Stand back some distance from your easel occasionally to see these sparkling effects. Many a promising painting has died in its middle stage because the artist kept working too hard to "finish" it.

Another way to keep underwashes alive is to texture the gesso while it is wet by tamping it with your knife blade or a scrunched-up piece of paper towel. The exciting part comes later, when you rake a knifeful of local color (slightly thinned with gel medium) over the ridges in the gesso. This technique leaves beautiful broken color effects as the knife rides over the ridges, allowing the bright

colored washes to show through in the valleys. With a brush in hand you are more apt to do a thorough job of covering up the wash in both the high and low points of the texture. Study the transparent and opaque effects interacting with the textured surface of the painting *Milky Way*, Fig. 18-7B. They are partly due to the sand that I mixed with the wet gesso.

Fig. 18-7A. *Mango with Limes*. Oil on canvas, 7 × 9″ (18 × 23 cm). Private collection. Here we see a lot of dry-brushing over a colorful wash of ACRA violet and permanent sap green, colors that related to the subjects in this little still life. Note that I also stopped short of knitting the values together when I modeled the fruit from **light** to **dark**.

Fig. 18-7B. *Milky Way*. Oil on canvas, 7½″ × 9″ (19 × 23 cm). Private collection. I regret that you can't feel the sand I put in the gesso to create this broken color and tactile quality. I began with a bold three-color wash and then applied subdued opaque neutrals with a knife riding over the ridges. The jewel-like touches peeking through the more opaque colors are glimpses of untouched wash.

SETTING THE COLOR HARMONY WITH COLORED WASHES

For washes, use colors that are related to your subject. Are you painting a blue bowl full of white daisies with yellow centers? Use Indian yellow and either manganese or ultramarine blue (or both) and let them blend into green in a few places. Is your subject a seascape with a sandy beach and a few rocks in the foreground? Use burnt sienna and phthalo green and/or the beautiful Rembrandt blue-green. Don't put the brown wash under the rocks and the blue-green under the ocean; it is far more exciting to discover a bit of deep turquoise showing in the rocks, and some burnt sienna warming the otherwise cool color of the sea. You can see some of that in *Makapuu Surf*, Fig. 18-8. The only control I consciously exert over where random washes fall in a potential subject is to turn the canvas right-side up and upside-down before I begin to draw, to see which way presents the most contrasting possibilities. Experiment with other color combinations in washes so that you won't settle into a formula. And go back to a white canvas once in a while and start "cold."

KEEPING PAINT TECHNIQUES CONSISTENT

Eventually it may occur to you to leave your beautiful multicolored washes entirely uncovered in the background of a painting. Tempting though that is, I don't recommend it. The transparent background would be too different in technique from the opaquely painted subject. Background and subject should support each other mutually, rather than clash because of irreconcilable paint techniques. Solve the problem by putting some opaque strokes in the background, as well as leaving some of the wash showing in the subject. One way to do that is to put a transparent glaze over the washes first to darken them, and then work lighter opaque strokes into the wet glaze in some areas.

Perhaps you've seen landscape paintings in which thick paint has been slathered on with a knife on foreground rocks, grass, and tree trunks, and the distant areas and sky have been smoothed to a fare-thee-well with blended brushstrokes. Mass-produced furniture-store paintings often have the same irreconcilable look, as though one artist painted the sky and another the rough rocks and grass. Let your various techniques interweave so that the total effect is one of unity. If you work with a knife in one part of the painting, repeat that technique two or three times elsewhere, just as you would any other design principle. Scrubbed-in areas, chunky strokes, knifed-in patches, all can work together in the same painting if you remember the design principles of repetition and transition. If you have already been painting for some years, see if your work has a total "signature" look about it.

GLAZING

I sometimes place pieces of colored cellophane over passages in my students' work to show them how a certain area could be enhanced by a glaze, a thin layer of

Fig. 18-8. *Makapuu Surf*. Oil on canvas, 8 × 10″ (20 × 25 cm). Private collection. I painted this with the same colored washes that you see in the top half of Fig. 18-6. The local color of the ocean in some areas in the islands is pure phthalo green, but I've used analogous colors, as well as the complement of turquoise, to show sunlight and shadow on the water.

transparent color that produces glowing effects. (Just remember, even a little bit of white or an opaque color in the glaze mixture will keep it from being transparent.) When applied the right way, a glaze can literally correct color and value mistakes in seconds that might otherwise take a lot of time to redo with opaque paint. A single transparent color can tie a too-busy area of many colors into a harmonious whole instantly. I cannot imagine not using glazes when painting in oils because they often produce little miracles. (The one miracle glazing can't accomplish is to correct mistakes in drawing.) Try perking up dull, drab paintings with a glaze or two, and if that doesn't do it, then repaint whole dead passages. If you're not sure a glaze is right, you can wipe a wet film off immediately with a soft brush or a tissue. The residue that remains is often modification enough.

Because glazing always darkens the colors underneath, as I mentioned earlier, you may need to bring light passages back up in value by going into the **highlight** and **light** areas of forms with a few opaque strokes. The result comes close to the Old Master way of making opaque light areas play off against transparent dark shadowed areas. The opaque light strokes must be laid into the wet glaze almost immediately, before the glaze sets up. Look again at Fig. 18-7A, *Mango with Limes*. In a larger composition, the mango would probably attract too much attention, in which case I might decide to subdue it with a violet glaze. Then I would put a few opaque touches of perhaps a rose color into the glaze to give it some slight warmth in the **light** areas again. The ultimate gradation in the background of a still life or interior could be a passage of light that goes from a warm, opaque light color that blends imperceptibly into a cool, transparent dark color. In the exaggerated light-to-dark gradation in Fig. 18-9, I pushed the yellow and orange opaque strokes into a wet transparent brown glaze applied right over the underpainting washes. To get a feel for the effects this technique can yield, try applying

Fig. 18-9. For a spectacular gradation in the background of a still life or interior, try going from a warm, opaque light hue to a cooler, darker, transparent composite color as this background does. The trouble is, such a color and value spread is bound to attract too much attention away from the subject. In that case, tie the values together with an overall glaze, and it may be just right.

transparent glazes and opaque strokes over the various colored backgrounds in your limited palette paintings from Part Two.

Glazing, for all its beauty, has one definite disadvantage. Paintings end up with patches of shiny and dull areas, and even worse, obvious hard edges where you stopped glazing. To counteract the latter fault, immediately "feather" the edges of the shiny passages by dragging some matching opaque paint from the adjacent area across the hard edge so that it becomes semitransparent, a comfortable transition. A soft fan-shaped brush is often used for this, but any soft-bristled synthetic or sable brush will do. When the painting is dry to the touch in a few days, apply retouch varnish, which you can buy in liquid form and brush on (a small bottle is all you need), or in spray form, using just a couple of light coats. If you're brushing on liquid varnish, lay the painting flat for an even distribution of gloss. Retouch varnish is a thin, temporary varnish that allows the painting to "breathe" while it continues to dry thoroughly underneath. In time it will sink away and the shiny spots will reappear, at which point you can apply a permanent varnish. This will be covered more fully in chapter 20.

SCUMBLING

It you inadvertently mix a little white or an opaque color into a glaze mixture, it ceases to be a transparent glaze and becomes a scumble. With scumbling you apply a light semitransparent film of paint that lightens the color beneath it, whereas transparent glazing always darkens whatever is below it. A semitransparent scumble should be called a "veil" because that is exactly the effect it has over darker colors. That name would distinguish it from another way of scumbling, a technique of dragging a brush or knifeful of opaque light color over a dark textured area, preferably when the surface paint is semi-wet. A classic use of that kind of scumbling is shown in the water splashing over rocks in *After the Rains*, Fig. 18-10.

A perfect use for veiling is to send distant mountains farther back in space, if you failed to do it in the first place. Make sure the mountains are bone-dry, then simply brush over them with a semitransparent mixture of a pale blue and some medium. The first time you try it you may be appalled to see your

Fig. 18-11. This painting looks like a three-panel triptych, but it is really a sampler of techniques. I painted the entire scene first, and when it was dry, I applied removable tape so that it separated the picture into three sections. The left one has a veil of Liquitex light blue violet over it, thinned out with Liquin. I wiped it off immediately with a soft cloth so that just a thin film remained. The right-hand side was glazed with a transparent film of phthalo blue, mixed with a lot of Liquin. The clouds had all but disappeared under the glaze, and the snow on the mountain had darkened too much, so I reinforced those areas with warm light values.

Fig. 18-10. *After the Rains*. Oil on canvas, 8 × 10″ (20 × 25 cm). Private collection. Here I scumbled semitransparent light values (in the water) over darker values (in the rocks). I added just a little medium to the light values and used both a knife and a brush to apply them. This can be done wet-in-wet, but it works better if you wait an hour or two until the rocks set a bit. Then paint the light values over them with a feather-light touch. If you inadvertently cover too much of the rocks, go back into them and paint negative dark shapes.

mountains disappear altogether, but don't panic. Just wipe most of the veil off with a paper towel or tissue, and lo, your mountains may be just the right distance back in space. Look at the left panel in the three-part painting in Fig. 18-11, which has been veiled in the way I've just described. The middle panel has the sharp colors and values that the whole painting originally had before I taped off the left and right sections for modifications. Beginning artists often paint distant mountains too dark and close, especially here in the crystal-clear air of Hawaii. Even skillfully matching the actual colors and values of mountains isn't always enough to convey depth or poetic atmosphere; a slight veiling, once the painting is dry, can help.

STYLE AND TECHNIQUE

Working with underpaintings, glazes, or alternating transparent and opaque layers of paint are certainly not the only ways to go as you express yourself and the visual world on

canvas. Here are four other, rather broad, categories of oil painting styles that you might consider trying:

1. *Calligraphic Strokes*. I greatly admire paintings that have been executed with bravura brushstrokes, that is, juicy, flowing, calligraphic strokes like those in *Bougainvillea* (Fig. 18-12), which I applied directly onto a white canvas. This is a true alla prima work, and it has a freshness about it and a spontaneous look that I value, despite my preference for multilayered transparency in oil paint. Sometime, impose upon yourself the discipline of only one shot, one stroke, for every fraction of an inch of your canvas.

2. *Impressionist brushstrokes*. A popular style still in favor among countless contemporary artists is the impasto (thick paint) Impressionist style of thousands of little opaque dabs of paint. In this technique, underpainting washes are an irrelevant step, since every square inch of a finished canvas is usually heavily encrusted with layers of paint. *Gazebo and Lily Pond*, Fig. 18-13, is an example of this approach.

3. *Simple flat shapes*. Some artists manage to express a degree of realism with an

Fig. 18-12. *Bougainvillea*. Oil on canvas, 7½ × 10″ (19 × 25 cm). Private collection. This little painting was done with juicy, flowing, opaque paint and calligraphic strokes, courtesy of a round #8 synthetic brush. Each stroke was put down cleanly with almost no overworking. Freshness and sparkling color are the virtues of this disciplined technique. Despite its spontaneous look, each stroke has to be premixed carefully and placed with precision.

Fig. 18-13. *Gazebo and Lily Pond*. Oil on canvas, 7 × 9½″ (18 × 24 cm). Private collection. I used my round brush again to dab on these short little Impressionist strokes. In most places there are layers of colorful, shimmering strokes, and each layer adds something to the total.

economy of shapes that I find admirable. Compare the clarity, the simplicity of *Tranquil Mountains*, Fig. 18-14, with the shimmering busyness of Fig. 18-13.

4. *Palette knife painting.* Although the technique of painting with a knife is commonly called "palette knife" painting, the term is a misnomer. A palette knife is a flat knife (more like a table knife) that is traditionally used to mix paint or scrape it off the palette; the tool for applying paint to a canvas is called a painting knife, a trowel-shaped implement with a bent handle. That's what I used to paint Fig. 18-15, *Houses on a Hill*, which was done on a textured gesso ground with underpainting washes. When knife painting is done well, every smear of the blade goes down cleanly with the proper color and value, and then is left alone so that it remains fresh and sparkling. An inexperienced artist, on the other hand, knifes on thick paint, lets it dry, then knifes more paint on over the old ridges. The result is a crusty, unattractive surface. My first teacher suggested that I use a painting knife instead of a brush because my paintings were too tight. I discovered that working with a knife not only had the desired loosening effect but also, to my delight, was faster, less messy, and resulted in cleaner colors both on the palette and on the canvas. I used a knife exclusively for the next fourteen years.

Wait to use the painting knife until you have proper values and color mixtures under control. Whenever a knife stroke is not right, scrape it off immediately rather than letting its ridges set up to confound subsequent layers. Better yet, learn to use the knife and brush in collaboration. You can put color swatches in place with the knife and then move the paint around with the brush, or work with the brush for a while and then flatten out an area of fussy strokes with the flat of the knife. Strive for good paint quality at all costs.

Style will depend a great deal on the tools and techniques you use to get your message

Fig. 18-14. *Tranquil Mountains.* Oil on canvas, 7 × 9½" (18 × 24 cm). Private collection. If both flowing, loose strokes and busy little strokes go against your nature, you may prefer this technique of simplified shapes of color.

Fig. 18-15. *Houses on a Hill.* Oil on canvas, 7 × 9½" (18 × 24 cm). Private collection. This painting was done with a knife, and there is broken color everywhere. I textured the canvas with an extra coat of gesso first so that the knife would ride over the ridges, allowing the burnt sienna and manganese blue wash to show through. It still has a fresh, sparkling effect, but overworking it in an effort to be more precise would probably snuff it out.

across, as well as your personal use of color and values. These are conscious choices that you have to make along the way. They will come from experimenting on your own, from working with many art teachers, and from studying the work of artists you admire. Dare to stretch your abilities, but only after you feel solidly grounded in good basics. If exotic techniques divert you from the primary goal of learning value and color control in realism, you will only be shouting your mistakes in a louder voice.

Color Chart Assignment

This assignment is a chart of glazing colors like the one in Fig. 18-1. You must do it in two complete steps, letting the first part dry thoroughly before proceeding with the second. Using a full or half sheet of $16 \times 20''$ canvas paper, paint six vertical stripes of opaque pastel colors (for instance, a #3 or #4 value yellow, peach, pink, lavender, blue, and green) starting across the narrow width of the paper and going straight down to the bottom margin. Be sure to leave

some white space between the pastel stripes. Add a little Liquin to them to hasten their drying time. When the opaque stripes are very dry, run eight or ten horizontal striped glazes of various transparent and semitransparent colors (with a lot of medium added) across them, observing the color changes that occur where the stripes intersect. The result will be a plaid chart that will serve as a reference for color mixing with the glazing colors you own. Write down the name of each transparent color as you paint it.

Painting Assignment

Apply a two-color wash on an $18 \times 24''$ canvas using a soft brush an inch wide or more. Make two large puddles on your palette, one of a warm transparent color thinned with turps, the other of a cool transparent color, also thinned out. Apply them to the canvas in large, drippy areas of about a #4 value. Be sure the colors are balanced on the canvas. When you are finished you should have a beautiful abstract painting with a number of large shapes of clear color and some blending where the colors merge. Refer to Figs. 18-6A and 6B again. Notice how each color is anchored to every edge. While not essential, letting a little of the underwash color show along the frame edges does help provide interest. Clean the soupy paint off of your palette and then draw the subject

with a brush and some thinned-out brownish paint.

Include in the still life a plate or flattish bowl of fruit with grapes conspicuously tumbling over them, a wine bottle, and a solid-color drapery pinned to the wall behind the setup. Let the drapery come forward on the table so that the plate of fruit and the bottle sit on it. The tall wine bottle will serve as a transition between the flat bowl of fruit and the high expanse of drapery. Try modeling the whole bunch of grapes from **light** to **dark** before letting your brush describe one single round grape. Make a conscious effort to let the washes show in the grapes, bottle, and drapery. When the painting is dry, apply glazes to darken some values in the grapes and drapes, and then scumble over the grapes with a "frost" of a semiopaque veil of light color thinned out with medium.

Chapter 19
COLOR IN LANDSCAPE

To me there are two ultimate goals in painting in a realist style. One is the figure (including portraiture), the other landscape painting. Living in Hawaii, with its natural beauty, has made the latter my choice. I can't think of anything more exhilarating than painting on location when conditions are optimum. There are some bad days, even here, but once students have had a few great experiences outdoors, they are usually gung ho. This chapter will explore ways to handle various situations that are typical of landscape painting in terms of composition, design, and, in particular, color.

ATMOSPHERIC PERSPECTIVE

Aerial, or atmospheric, perspective is an important aspect of landscape painting because it allows us to express spatial depth, a key element in realism. As discussed earlier, there are three major planes of depth in any landscape: foreground, middle ground, and distance. The farther into the distance landscape elements recede, the less detail and value contrast can be distinguished and the bluer they appear. Subsidiary planes may exist amid the main three in a grand panoramic view, with each farther hill or mountain becoming slightly lighter in value than the one before it. But value changes are only part of the story. This is where we put to work all of the knowledge we've gained about color's four characteristics—hue, value, intensity, and temperature.

There are three basic things you can do with color to achieve the illusion of distance: make them progressively lighter in value, less intense, and cooler in temperature as they recede in depth. These rules can, to a certain extent, apply as well to the shallow field of still life and interior scenes. No matter what the depth of your imaginary cube of space behind the picture plane—in a still life, twenty-five inches; in an interior, fifteen feet; in a landscape, twenty-five miles—you won't want that relatively deep space to crowd into the middle ground or foreground. In outdoor painting the intervening moisture and dust-laden atmosphere that surround the earth cause modification in colors. On the more intimate scale of a still life there is no environmental reason for colors to change in depth, but esthetic reasons prompt us to play down some elements in the painting in order to emphasize others.

Suppose you were to pin a bright green drapery behind a red and green still-life setup. It would look great and harmonize, but if you painted it the bright green that it actually was, it would steal the show from the real subjects in the setup. Let's handle that problem the same way we would if you happened to paint a hill in middle distance too bright a green, as in Fig. 19-1A. To make either hill or drape stay back, first add a bit of green's complement, red, to the bright green local color to neutralize it, and then add a little white to lighten it. A shortcut to this two-step procedure is to mix the green with a bit of pink that might be on your palette already. The green drape would then take a subordinate place in the still life. The bright green hill, given the same treatment in Fig. 19-1B, appears to have moved a respectable distance back in space.

So far we have lightened the value and lowered the intensity of the hill's bright green local color and, at the same time, warmed it to a muted yellow-green (with the pink). Now let's think about pushing the green hill even farther back in space. For that we need to cool

it, the third way to make things recede. I suggest adding some light blue to the already muted hill in Fig. 19-1B so that it will both cool and lighten the color at the same time. Here is a tip when you are searching for colors with which to express distance. Since you need only tiny additions, don't reach for the major colors squeezed out on the top of the palette; reach instead for colors in the center of the palette that you may have already mixed for foreground elements, picking up light, muted hues from the fringes of your puddles of color whenever possible.

Between our eyes and any distant outdoor subject, the intervening particles of dust and drops of moisture reflect some of the sky color, hence the prevalence of blue in the far distance. Equate atmosphere with imaginary pale blue curtains between you and the distant subject. The most distant green mountain viewed through the curtains would no longer be green but might be blue-green, blue-violet, blue, blue-gray, or simply gray. Note the transition from the normal local colors of the foreground green hills to the cooler, grayer colors of the rear ones in Fig. 19-2A. The lack of modeling on each plane tells us that this is a gray day. Fig. 19-2B shows how the same scene might look on a sunny day when the sun strikes the mountains and warms their local colors. Both illustrations show, in addition to the normal aerial perspective, a slight gradation at the bottom of the distant planes. This is due to the layer

Fig. 19-1A. *INCORRECT:* The hill in the middle ground of this rural scene is an example of the unnatural kelly green that comes from mixing a bright yellow with viridian or phthalo green. This causes an uncomfortable lack of transition between the bright green hill and the off-gray hills behind it.

Fig. 19-1B. *CORRECT:* I've added pink to the hill's bright green local color to reduce its intensity. There is even more pink in the hill's **light** area and then I used a muted blue-green in its **dark** form shadow. The hill has moved back spatially, its color is more believable, and the transition from it to the distant hills is much better.

of moisture that hugs the ground in river valleys and also, unfortunately, to the air pollution that gathers in all but the most remote regions of the world.

ADDING WHITE TO EXPRESS DISTANCE

Because beginning landscape students are afraid to use white for fear of having weak color, they tend to paint distant mountains that positively leap forward, crowding into an equally intense middle ground. Adding a little

white to the local colors of distant mountains will not make them chalky unless you go overboard, making them so light that they appear to be covered with snow or look like clouds. When you paint mountains think about them as being weighty and attached to the center of the earth; when you paint clouds think about them as floating above the earth. The proper values for each will tell the right story. As I remind my class when we're painting a panoramic scene, "White is all right in distance."

Fig. 19-2A. Note how these mountain planes gradually become cooler, lighter, and grayer as they recede in distance. Look at the analogous sequence on the right side that goes from dark yellow-green in the foreground, through several greens and blues, and finally to neutral grays in the distance. These colors relate to Ring #3 on the color wheel, except that they become lighter in value as they become cooler, not darker.

Fig. 19-2B. What a difference the sun makes! The local colors of the different mountains are basically the same as above, but now they've been modeled from warm **light** to cool **dark**. Note how the warm colors change from brighter yellow-oranges and yellow-greens in the foreground planes to pale greens and blue-greens in middle distance as yellow gradually disappears from the mixtures. Finally they become complementary muted peach colors in the blue and blue-violet mountains in the background with only a vestige of yellow remaining.

REDUCING CONTRASTS TO EXPRESS DISTANCE

Another way to achieve the illusion of distance is to close the intensity gap, as well as the value gap, between colors as planes recede into increasing depth. That means not only from mountain to mountain, as in Fig. 19-2A, but also in the **light**, **middle tone**, and **dark** modeling on each mountain, as in Fig. 19-2B. To show the sun striking distant mountains, you can't juxtapose a ray of bright yellow sunlight at a #3 value with a #7-value muted blue-violet mountain anywhere back there. Both warm and cool colors should be adjusted to about the same intensity, because we're looking at them through the same amount of atmosphere. In this case note the soft, muted peach color I've used to express sunlight on the mountain in the background of Fig. 19-2B. It is hard to generalize, but closing the gap in intensity contrasts in distance is a broad enough rule to apply to any situation, whatever your geographic surroundings.

ELIMINATING DETAILS TO EXPRESS DISTANCE

You can also achieve depth in your paintings by gradually eliminating details as you move back through your cube of space. In vistas like Figs. 19-2A and 2B, obviously the planes of pine-forested mountains closest to the foreground would be heavily textured compared to the most distant ones. The trees on the nearest mountain may have individual forms and even cast some shadows, while those in the distance simply become a soft blur. Visual observation should concur with the design principle that says harmony is achieved when there is transition between any two factors, in this case, heavily textured areas and smooth ones.

It might simply be said, then, that your strongest contrasts of intensity, temperature, and value should all be in the foreground, the lower third of your canvas. But this axiom isn't specific enough, because it is two-dimensional

thinking, and we have to think three-dimensionally. A tree rooted in the lower third of a painting might have foliage that extends to the top of the canvas. Should the foliage on top be painted in a blurred manner to appear more distant than its trunk because it is in the upper third of the canvas? Obviously not, since they are both in the same plane. Thus, here is the corrected axiom: Strong contrasts of intensity, temperature, and value belong in the front third of your imaginary cube of space. It follows, then, that all contrasts would diminish in the middle third of the cube of space, and become even closer together until they virtually disappear in the back third.

THROWING THE FOREGROUND IN SHADOW

As we hear throughout life, rules are made to be broken, and in landscape painting the one about strong contrasts belonging in the front third of the cube of space is broken frequently. Generations of landscape artists have used the effective device of putting the foreground in shadow, caused by an unseen tree, building, or perhaps passing clouds. Color contrasts, slightly modified by atmosphere, then are placed in the middle ground or even far distance. It makes a lot of sense, since the foreground is almost never where your center of interest is. Why waste your "big guns," your lightest lights, brightest colors, and darkest darks in that generally boring area about ten or fifteen feet in front of you?

Now look at Fig. 19-3, in which I have placed a young Plumeria tree in full bloom in the right foreground and given it full color and value contrasts, making it the undisputed focal point of the painting. By any rules of composition or design, that is a bad place for a center of interest. Let's say that I went back to the same spot because I realized that what I had really wanted to paint was the country house with its mountain backdrop. So in Fig. 19-4, I put the Plumeria tree and the foreground in shadow and then used my

major color and value contrasts for the house in the middle ground—perhaps a more appropriate place for the focal point.

But suppose I visit the same spot on a gray day, when everything is so drab that I wonder what I saw in the subject in the first place. Suddenly the sun breaks out over the distant mountains, and I am inspired to try to capture their glory. Now my center of interest is in the background, an unusual circumstance, but it can work, as it does in Fig. 19-5. Note that in each of these three paintings I used warmer, brighter, and lighter colors in the center of interest and surrounded them with more muted colors. In each case, look for an echo of the focal point's colors.

A Three-Dimensional Landscape Model
In Fig. 19-6, I have literally divided the landscape into the three major planes of

Fig. 19-3. In this landscape, I put my brightest, lightest, and darkest colors in the young Plumeria tree in full bloom in the lower right foreground. Using strong contrasts in the foreground is logical according to the laws of atmospheric perspective, but it is seldom advisable because the foreground is not usually where your main subject is.

Fig. 19-4. In this version of the same scene, the Plumeria tree has been reduced in size. Along with the whole foreground, it has been thrown into shadow. The brighter, warmer colors and value contrasts in the cottage now proclaim it the indisputable focal point of this painting. Like any major color in a painting, white should be repeated in different variations. Look for echoes of the white porch of the cottage in a few Plumeria blossoms and also in the clouds.

foreground, middle ground, and background to help clarify what I mean when I talk about such concepts as the "front third of the cube of space." It shows a logical progression in decreasing values, intensities, and color temperatures from the front third to the back third. When you are actually on location, the color changes you observe in a landscape may not be as obvious as my slightly exaggerated illustration makes them, especially if you live in an area with clear air. When you begin painting the landscape, you may find, as do many students, that you get your values and intensities all mixed up, placing spots of timid, pale color in the foreground, making colors too bright in the middle ground, and rendering the background either much too light or much too dark. Despite all of your color homework, it still takes a while to put it all together in landscape painting.

Fig. 19-5. Unusual though it is to find the focal point in the background, such compositions can be effective. The colors in the distant hill and mountains here relate to Ring #4 on the complementary color wheel. Cloud shadows allow us to manipulate the spotlight on certain elements while depressing others, just as a lighting engineer does with stage lights. To focus attention on the "star," use more intense colors, warmer temperatures, and more contrasting values; in distance, just keep colors slightly muted and values closer together than you would for a closer subject.

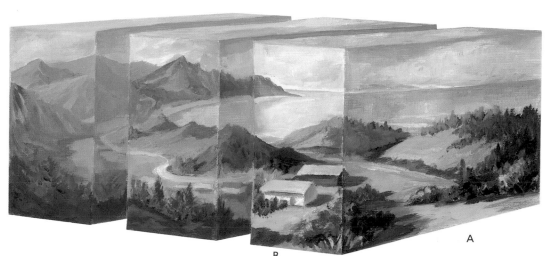

Fig. 19-6. Now you can see more clearly what I mean by the front third, the middle third, and the back third of the imaginary cube of space behind the picture plane. The artist is painting this scene from Point A, and all he or she sees is a rather confusing melange of color values. But from Point B we can more easily see how colors progressively become more neutralized, cooler, and lighter in distance.

SOFTENING EDGES

A feeling of distance is achieved instantly when edges between shapes are crisper in the foreground and become softer in distance. However, on a crystal-clear day with little atmospheric interference, a city skyline or a mountain range in the far distance will indeed have firm edges where they meet the sky. You can get away with those crisp edges just as long as there is little contrast in value at those points. An exception to this rule occurs with back lighting, when the sun is behind those buildings or mountains, silhouetting their shapes; under such lighting conditions, you need almost maximum value, intensity, and temperature contrasts.

LINEAR PERSPECTIVE

You can further suggest depth in landscape by incorporating any bit of linear perspective into the scene. Just a few converging strokes to suggest city streets, a country road, a flat, plowed field, or a crop growing on a slanted plane in the foothills will take the viewer's eye into depth. A diagonal line of trees serving as a windbreak along some fields will do wonders to make the distance believable, especially if the trees become cooler and grayer in depth. Invent linear perspective in your landscapes if you have to, but I'll wager there are perspective recessions there already just waiting to be discovered. If you are faced with vast prairies of wild grasses and weeds, and no chance whatever for linear perspective, let the wind part this vegetation into an irregular path that leads into the third dimension.

PROPORTION

Let proper proportions suggest distance in landscape painting. Colors, values, and sizes of compositional elements have to recede very quickly on an average-size canvas of, say, 18 × 24″. Two or three miles of actual distance may have to be accounted for in just a few vertical inches on the picture plane. A common problem in student landscapes is that the foreground and middle-ground planes are not well enough established, so that the proportions of small elements then go awry. A house, a horse, or a person too big for its position in space on the canvas betrays artistic inexperience. Also suspect is any reverse in proportions that defies the law of diminishing sizes in distance. A small house in the foreground and a very large house farther back is difficult to carry off spatially. The same is true for small trees in the foreground and larger trees in distance, even if that's how they were. Just reverse their proportions.

DESIGNING OVERLAPPING SHAPES

Overlapping shapes will convey depth even if you fail to achieve good aerial and linear perspective. Imposing order on nature's seeming chaos by reducing every compositional element to a manageable shape solves all kinds of problems in landscape painting. Don't be in such a big hurry to paint when you're on location that you fail to draw, to design sufficient shapes in all parts of the canvas. If you do leave blank areas in the drawing, you'll probably wonder what was there when you attempt to finish the canvas at home. If you're prescient, you'll have taken some on-site photos and done some preliminary sketch-pad work for reference.

Draw shapes for everything, not lines. Notice how the pine trees are mere lines in the left half of Fig. 19-7A, while those on the right are composed of many little shapes that make up whole shapes. The first example resembles a young child's sticklike drawings, which give little information about the shapes of objects. It is much better to draw shapes first, then model them as forms, and finally shape them up even more with negative painting. An initial drawing of sticklike lines will not prompt you to think of either positive or negative shapes. Look for this kind of positive/negative pushing back and forth in *Sierra Majesty*, Fig. 19-7B.

Fig. 19-7A. *Left, INCORRECT*: Sticklike lines do not tell enough about the overlapping shapes that work so beautifully to convey distance. This drawing is on a manganese blue wash, and it represents the left half of the landscape below. *Right, CORRECT:* This drawing is the other half of the landscape, and it is on a two-color wash of burnt sienna and manganese blue. Even these too-crowded shapes, drawn on a very small format, tell me a great deal about the composition.

Fig. 19-7B. *Sierra Majesty.* Oil on canvas, 8½ × 11" (22 × 28 cm). Private collection. It will help your early landscapes if you work with positive and negative shapes to reduce the natural chaos of nature into an organized, readable image. Later on, when you have more landscape experience, break loose into a riot of strokes, colors, and values if you like. Note that there are very few hard edges in this painting.

CHOOSING COLORS TO EXPRESS DISTANCE

Your color wheel and the series of complementary charts can help you find the colors that best convey the illusion of distance. On any complementary chart, all but the parent colors, the two outermost vertical rows, can be called "distant" colors, because they are all muted to some degree. When a mountain range in middle to far distance appears to be a nondescript color, that should trigger an instant reaction: "I need a pair of complements." But which pair? Remember, you'll need to warm the sunlit areas and cool the shaded planes of that mountain. First, find the mountain's local color on your complementary charts, then use a complementary split, colors found along a diagonal path across the chart, for warming and cooling. Perhaps a soft peach or even pink seems right for the distant sunlit parts of the mountain. Or, you might choose to combine complementary pairs, warming a blue-violet mountain with rosy-pink sunlight.

In time your eyes will tell you what colors to use, but I hope they will corroborate the "warm it in the light, and cool it in the shade" theory. It really doesn't matter which warms go with which cools—as long as the values are right. By now your hand should automatically reach for a warm color when the values are light, and a cool color when the values are dark. But on those gray days when you can't change color temperatures to model forms or even to cool colors in distance, add the achromatic grays in the middle and lighter values to your local colors, as I did in Fig. 19-2A. On a gray day you can ignore the rule about cooling distant colors, since cloud cover prevents the reflection of blue sky in the earth's atmosphere.

According to John F. Carlson's *Complete Guide to Landscape Painting*, yellow is the first hue that drops out of the picture as the distance increases. The second primary color to disappear is red, leaving only blue. In terms of the twelve-hue color wheel, this means:

- To convey a sunny day use plenty of yellow green, yellow, and yellow orange in the front third of your cube of space, and model forms with analogous sequences.
- In the middle third, rely less on the three sunny colors and move down the color wheel on both sides. Use orange, red-orange, and red in sun-struck areas, and green, blue-green, and blue in shaded areas. Those colors will need to be muted slightly by their complements, with a little white added for the intervening atmosphere. Model forms with muted analogous sequences or complementary splits.
- In the back third, work mostly with cool colors from the bottom of the color wheel—blues, blue-violets, violets, and red-violets, all grayed down even more with their complements and lightened with a bit more white. Model forms with complementary sequences that barely change value.

CLOUDS

A sky filled with billowing cumulus clouds, some overlapping others as they recede in depth toward the horizon, is a glorious sight. On a fine day the colors and values of clouds seem to change only imperceptibly, but it's wise to reduce any contrasts in distance anyhow. White objects traditionally break the "cooler in the distance" rule, and instead become warmer as they near the horizon. They can be warmed by a touch of pink, peach, or ochre, and modeled with very close values. As for colors in the clouds closer to you, using warm, creamy white in the **light**, pearl gray in the **middle tone**, and cool blue-gray in the **dark** is a good starting point. However, the local color of clouds really changes all day long, varying from the warm pastels of sunrise to the warm brownish-grays of midday to the vivid oranges and roses of sunset. At midday clouds seem pearly beige, their form **darks** brownish, warm colors that

play much better against the cool blue sky than a lot of blue-grays. You can make the form shadows on clouds blue-gray, but use the brownish warm colors as **reflected light** on their back or bottom sides.

Sometimes clouds respond to the sun with actual form-building values; other times values are scattered, making no sense. As with any other compound subject, organize the values in a few major clouds. Paint billowing cumulus clouds as definite volumes, the rest as wisps fragmented by high winds, using their irregular, abstract shapes where you need them compositionally in your skies. Keep large cloud shapes simple.

COLOR GRADATION IN THE SKY

The sky has a great deal of gradation in it, both laterally toward the sun, and vertically from the zenith to the horizon. Give the illusion of the sky coming over the viewer's head like a vault by using as deep a blue as you can at the top of the painting. Ultramarine is the best choice, but modify it with a touch of orange or a bit of violet, plus a little white. Then drop lower in the sky with a sequence of cobalt blue and/or manganese blue; down toward the horizon use viridian. Add a little

more white to colors as they near the horizon. Do you recognize that as an analogous sequence from blue-violet to blue-green?

If you live in an urban area with smog and haze, begin adding complements to the blues overhead so that as your colors approach the horizon, they'll be a warm orange or rosy-gray haze. Remember, use analogous sequences for strength, complementary sequences for weakness. In either case, find a sequence to convey the optical truth of looking up vertically through the relatively narrow band of the earth's atmosphere into a deep blue.

PAINTING THE SUNSET

If I could be so frank, my advice would be, "Don't," so as to avoid the risk of producing work that may be disparaged as "calendar art." Paint the *effects* of the setting sun, rather than the sun itself. Look at the marvelous peachy, rosy colors on the landscape and in the sky at that magical hour. As you can see in *Mountain Dwellers* (Fig. 19-8), this is one time of day when even local colors go haywire briefly and must be modified with yellow-orange, orange, red-orange, or red, depending on how high the sun is above the horizon. Capture that glow with your back to the sun.

Fig. 19-8. *Mountain Dwellers.* Oil on canvas, 20 × 24″ (51 × 61 cm). Collection of Phyllis Soble. I set up my easel to paint this scene about 5:30 P.M. one afternoon and painted rapidly for the next hour or so until the sun set. Note how even green local colors are altered by the rosy sun at this time of day. The peach-colored patches on the mountains are bare patches of Oahu's red dirt along the sharp ridges. They set up a rhythm that leads your eye around this painting, letting it pause for a moment on the cluster of homes in the sunlight on the lower right before swinging up the mountain ridges again.

COPING WITH GREENS

It seems to take a lot of experience to handle green grass, green shrubbery, green trees, and distant green mountains and still come up with a beautiful painting. The beginning student usually ends up with a monotonous painting in kelly green mixed inadvertently from yellow and viridian or phthalo green—the equivalent of the manufactured color called permanent green light. Avoid that trap entirely by mixing ultramarine blue and all yellows as your basic greens. Should you find a large puddle of kelly green on your palette, render it harmless with a little orange, red-orange, red, or even red-violet. I would bet that 90 percent of all greens can be improved with a touch of some sort of red to bring them back into the range of greens more common in nature. However, I do find kelly green and viridian useful in their pure states as reflected colors in cast shadows.

Beautiful though it is, sap green can seduce you into not finding the variety of greens that will make your painting look more natural. Nature has dozens of greens, and in the lush foreground of a summery landscape you will need to find pink-greens, gray-greens, blue-gray greens, olive greens, ochre greens, chartreuse greens, blue-greens, dark blue-greens, violetish-greens, and, yes, even a few intense kelly green sparks. The ultimate solution is to push entirely away from green as often as you can. Make something frankly yellow, orange, blue, or any other color that you can get away with.

Notice in art books and magazines how most professional artists steer clear of chromatic greens. For hundreds of years European artists opted for ochre or olive-brown trees or some other off-color. In any case, don't let dependence on sap green keep you from exploring every nuance in your

Fig. 19-9. In each block mixed from the parent colors, the large area in the middle is a sort of half-and-half proportion of the two colors. The side bar on the left has proportionately more yellow (and a little white), and the bar on the right side has more blue in it. Think of them as **light**, **middle tone**, and **dark** values on forms lit from the left. The greens sweep from brighter chartreuses and kelly greens in the upper left to muted olive greens and olive-browns in the lower left. That's because the yellows and blue-greens more nearly analogous on the color wheel yield the brightest greens, while the colors further apart on the color wheel provide muted greens because they are near-complements.

Fig. 19-10. This four-part exercise should be read from right to left—from east to west. It is all one landscape, the view from my studio, and I originally divided it with narrow tapes so that I could paint four different times of the day. I worked on the first (farthest right) panel from about 7:30 to 8:00 every morning for three or four mornings when the mountains were almost silhouetted against the sun in the east. High noon is the second panel, with its uninteresting colors and values. Next we see the rosy colors of the late afternoon sun. The night scene with implied moonlight in the left panel was fun to do because the lights in the homes on the hill, and the reflections in the water, were colored washes that I preserved carefully. The foregrounds are invented because I could not see that area.

particular garden or jungle. Save it mostly for underpainting washes and glazes. Do some homework in mixing greens, preparing a chart like Fig. 19-9—which is just a starting point, since any of those little squares with analogous sequences could be modified with their complements, or cooled with more blue and a bit of white, and sent off into distance.

When I see monotonous green paintings developing as my class paints in a beautiful botanical garden, I can't resist scooping up from the student's palette a bit of pure orange, magenta, or turquoise and applying it to the painting to pep it up. The student usually reacts with shock first, then a delighted grin as he or she sees that it worked. When next I circulate back to that easel, I almost always find that the student has happily applied the accent color in about fourteen places. A painting does need a spark or two of pure color, sometimes a dissonant color, but only in moderation.

VISUALLY MATCHING LANDSCAPE COLORS

Each time of day has its own peculiar color and value range, as I discovered when I did the four-part painting in Fig. 19-10 some years ago. Although it shows four times of the day, it is all one scene. Like Monet, I took my post in the window of my studio at 7:30 A.M., 12:00 P.M., 5:30 P.M., and 10:00 P.M. every day for three or four days. I literally mixed and remixed some colors over and over, holding the knifeful of paint up to the windowpane until each mixture became as accurate as possible (except at night). I found that I was obliged to

keep muting and lightening the colors to account for just how much atmosphere exists out there.

Here is another helpful tip for finding the colors to convey distance when you go out on location. When you think you have mixed the right hue for a certain area, add a little pale blue to it to represent the imaginary blue veils of atmosphere. It is better to err on the side of too much atmosphere rather than not enough. (Of course, you can always veil the passage later on if need be.) People generally seem to admire hazy distance in a landscape, rather than the feeling of being threatened by mountains that loom too close and are forebodingly dark. Paint them that way only if that is the mood you intend to convey.

Let nothing keep you from seeing the big, simple value statement of the scene before you. In *The Complete Guide to Landscape Painting*, John F. Carlson divides the visible world into four basic planes, each one receiving a different amount of light:

- The sky, being the source of light, will have the lightest values in the painting.
- The horizontal ground plane receives light from the sky, but cannot be as light in value as the source.
- The slanted planes, the hills and mountains, receive less light than the ground plane and are thus darker in value.
- The vertical planes, mainly trees, walls, and steep cliffs, receive the least amount of light from the sky and are therefore the darkest values.

One could immediately cite hundreds of exceptions to this general theory—white limestone or granite cliffs, white aspen tree trunks with light yellow-green foliage, snow on the ground with a dark, lowering sky overhead—but on the whole, it works admirably well, even if only to remind us not to fling our values like confetti into the wind. Carlson's theory should also keep you from painting landscapes almost completely in the middle range of the value scale. While you may paint with bold value contrasts, more timid students produce paintings that suffer

from a malady I call "middle-toneitis," limiting themselves to values that range only from #3 to #6 or so. Boldly expand your values so they encompass the whole scale, whenever it is appropriate to the time of day and the weather. Although I still advocate finding local colors throughout the painting first, set that theory aside for a few moments and punch in a few strokes of the lightest lights (clouds, white houses) early in the painting's progress. Then sock in the darkest darks (tree trunks, dark shadowy areas) right away so that you can measure all values against those extremes. Cézanne was known to have spread a white cloth and a black cloth on the ground in front of him so that he could measure all values against them. Exaggerate your bright local colors a little too. Now is the time to start being creative with color, if not with value. When you start a landscape too conservatively, painting what you actually see, you will find it much harder to bring the painting up to its maximum possibilities; start boldly, because it is much easier to temper any initial excesses of color. You can always glaze down or soften with a veil, but to rescue a painting that has been stricken with middle-toneitis takes heroic measures.

ACHIEVING THE ILLUSION OF DEPTH IN LANDSCAPE: A SUMMARY

Conveying three dimensions on a two-dimensional picture plane can be accomplished with the following:

1. Colors become progressively lighter in value as the distance from the viewer increases.
2. Colors become progressively cooler in distance, except for whites.
3. Colors become increasingly muted, less intense.
4. Color and value contrasts are reduced in each succeeding plane as it recedes away from the viewer.
5. Detail diminishes in distance.
6. Edges become softer in distance, as though slightly out of focus.

7. The slightest hint of linear perspective in the landscape moves the eye back in space.
8. Proportions of every compositional element must diminish in a logical progression from foreground to background.
9. Overlapping shapes and forms will succeed even if all else fails.

That's a tall order to fill in any one painting, but as with composition and design principles, don't worry too much about them on site. Paint with keen observation and inspiration when you are there, and later consult this checklist when it is time to self-critique what you've done. Happy painting!

Color Chart Assignment

Make a chart of various greens by systematically mixing all of your yellows with all of your blues, blue-greens, and black. Line up all the warm colors on the left side of a half sheet of canvas paper, and all the cool colors across the top, and then find the intermixes, as I did for Fig. 19-9.

After finding each green color, split out its components so that you have a warmer, lighter version (using more yellow and adding a bit of white to it) on the left, and a cooler, darker version (using more blue or black) on the right. Pretend there is a light source on the left and that these little blocks of color literally are "warmer in the light, and cooler in the shade."

Landscape Painting Assignment

Paint a scene you can see from one of your own windows, preferably a vista with some depth, mixing the right local colors for houses, buildings, trees, hills, mountains, or whatever else is there. Actually hold the

knifeful of paint near the window through which you see your subject. Squint and compare your mixture with it. Although it seems like a silly way to match things, you may still see, as I did, that your color is not reduced enough in intensity, or that your value is too light or too dark.

Chapter 20
PRACTICAL CONCERNS FOR THE EMERGING ARTIST

Let's take stock: By this time you have the basics of drawing, values, and color theory behind you, and using them has become second nature. Your dilettante days are behind you, and you no longer wonder what to paint or find excuses to keep you from your easel. You've taken quite a few art courses, have entered several juried art shows, and were accepted at least once. Perhaps you've already sold a painting or two. Your spouse suddenly pays more attention to what you are painting and wholeheartedly supports your efforts. You feel like an artist and are pleased with this new identity. Quitting is the farthest thing from your mind, no matter how discouraged you might get sometimes.

At this point, you should be working on at least three or four paintings at a time. When you first start a new subject, take it as far and as spontaneously as you can, covering the canvas in the first session. Then study it for a few days, letting the oil dry to the touch before you resume work. Place it upside down and look at it in a mirror to analyze its composition, design, and distribution of colors and values. Begin painting again, working on the canvas in short sessions of perhaps thirty minutes or an hour every few days. In the first ten minutes of a session in which you're resuming work on a dry painting, do these four things:

1. Scrape off old ridges of paint in areas you intend to rework. Literally shave them off with the edge of your knife. (Be sure the blade isn't bent so you don't accidentally slice the canvas.)
2. Redraw with a thinned paint line any poorly executed areas, or where you want to move something to another spot. Be ruthless in revising at this or any later stage for a better composition. Oil paint can still look fresh if you scrape down between sessions, though you will lose your underpainting washes.
3. Glaze (or scumble a veil of color) wherever possible to enhance color in some areas or subdue it in others. You must do this while the painting is still dry. Once you start to paint opaquely, it's too late to think about glazing in that session.
4. Drybrush here and there when repainting old passages so that some of the underneath layer serves to enhance the top layers of paint. This is especially effective when you paint a whole new background in a still life.

THE "FAT OVER LEAN" RULE
There is one technical rule unique to oil painting that must be observed: working "fat over lean," which means you must always apply fatter paint (more oil in it) over leaner paint (more turpentine in it). Lean paint is brittle, while fat, oily paint is flexible. This means that if you apply a layer of lean paint on top of an oilier layer, it is apt to crack and flake off as the lower layer expands and contracts. When you use Liquin (or any other medium) to thin paint for blocking-in techniques in the initial layers of a painting, it is a good idea to dilute the medium with turpentine. It is recommended, however, that such a solution contain no more than 25 percent turpentine or mineral spirits. Then proceed with tube-consistency pigment as you paint your subject, using medium at full strength from then on for subsequent layers.

The better known you become professionally and the higher the market value of your work rises, the more concerned you must be with the permanence of your paintings. To learn more about how to preserve your work, I recommend that you buy *The Painter's Craft* by Ralph Mayer (Viking, 1975). This excellent reference is a compilation of material from Mayer's very complete technical manual, *The Artist's Handbook of Materials and Techniques* (Viking, 1966), which I suggest you borrow from the library when you need more in-depth information.

PRESERVING EARLY PAINTINGS

On the whole I would say, "Don't bother," but for two exceptions: Every now and then keep a canvas in its original state as a milestone marking your progress, a means for comparing new work with early work to see how far you've come. Set aside one or two promising paintings that will make the trip with you on that path to professionalism. Hide them from sight for at least six months, then pull them out and work on them again in the light of your ever-developing critical eye. Eventually those paintings will be heavy with paint, but several years later they should emerge as testaments to your growth and hard work.

RECYCLING OLD CANVASES

As you progress you will probably want to recycle some of the paintings you've outgrown. You may try to paint right over the old painting, but will find that it is confusing and the result less than fresh. Applying gesso over the old paint is worse. Gesso, as we know it today, is formulated from acrylic polymer emulsion, and it is bad technique to put acrylic over oil at any time. The old flexible oil painting under the lean acrylic gesso would continue to expand and contract, stressing the gesso above it and the new painting on top of that, a disaster. Commercial paint remover will take off not only old oil paint but gesso,

but in my opinion is too dangerous a chemical to fool with for so small a gain. It's better to discard the old canvas and simply reuse the stretcher bars.

CROPPING UNSUCCESSFUL CANVASES

Occasionally a passage in a painting is so choice that you hesitate to discard the whole canvas. Well then, don't. Remove the canvas from the stretcher bars and cut out the successful part or parts. You may get a great $8 \times 10''$ or one or two jewel-like $5 \times 7''$ miniatures out of a less-than-successful $18 \times 24''$ landscape. If you are asked to donate works for worthy causes, cropping is one way to create small, bazaar-type paintings. After cutting out the chosen area, either stretch it on small stretcher bars, or mount it with white glue (the kind sold in a plastic squeeze bottle) onto a piece of Masonite cut to measure. Squeeze out almost continuous lines of glue, smooth out all air bubbles, and then place the mounted canvas under heavy books overnight.

RECOMPOSING ON A LARGER SCALE

Discover what great compositional lessons can be learned by moving a $9 \times 12''$ or $12 \times 16''$ cardboard mat (you can purchase ready-cut mats in art stores) around an average-size canvas, say $22 \times 28''$, to find good, better, and best compositions within it. It could be either a still life or a landscape. When you do find an interesting composition, try blowing that little picture up onto a much larger canvas, perhaps $24 \times 36''$ or a $30 \times 40''$. Working on an enlarged scale will be a challenge of a different sort involving fewer, larger shapes. The small painting thus becomes a jumping-off point into a different style, a more semiabstract view. You might try that approach when you want to enter something less conservative for a juried show. There is nothing quite like a call for entries from an art organization to start an artist's creative juices flowing.

STRETCHING YOUR OWN CANVASES

Perhaps you need a custom-size canvas to fit a certain space or a beautiful old frame you found in an antiques shop, or perhaps you want to try an unusual format. Stretching your own canvases is the answer, and is quite easy, as you can see in the photos shown here. Yet another benefit is that you'll be working on canvas that's of a better quality than the prestretched kind.

You can buy plain or pre-gessoed canvas by the yard or by the roll, plus a stock of stretcher bars in different sizes (two pairs per painting). When purchasing long stretcher bars, sight along their length to see if they are warped or bowed. You'll need five tools to get started:

- a carpenter's square to square up the four dove-tailed stretcher bars
- a hammer to tap the corners of the bars into each other
- a large scissors to cut the canvas
- a canvas pliers to pull the canvas taut over the assembled frame
- a light-duty staple gun and $5/16''$ staples to fasten the canvas to the frame

Note the canvas pliers just behind the scissors in Fig. 20-1. Available in art stores, this is the one tool you must have to do a good job. Don't even try to use ordinary pliers or pull canvas with your fingers; you'll end up with a floppy canvas. When you buy stretcher bars, be sure to get some keys, flat, triangular wooden pegs of various thicknesses that are used to tighten a slack canvas. (Plastic keys sold with ready-made canvases are almost worthless.) You shouldn't need them, though, if you follow the instructions given here.

As perhaps you can see in Fig. 20-3, canvas pliers have a protruding knob on one side of the jaws but not the other. To use this tool properly, hold it so the knob is down and braced against the stretcher bars; the knob's function is to provide extra leverage as you pull the canvas very taut.

In Fig. 20-2 I am trueing up the assembled frame with the carpenter's square.

Alternatively, you can tap the stretcher into the upper corner of a squarely built door or window opening. Should you decide eventually to work on larger canvases, say $24 \times 30''$ and above, additional strengthening of the wooden frame is necessary. A flat plywood triangle glued and nailed onto the back of each corner is a simple way to keep it square and strong. For extra-large canvases you may need a middle stretcher bar, called a spreader, which will keep the long sides of the frame from bowing in under the tension created by the taut canvas.

Stapling the canvas onto the frame comes last and is easy. When you're finished there is nothing quite like the satisfaction of giving the canvas a few thumps on its back and hearing it go "boom, boom," or something to that effect. If you've stretched a canvas and it doesn't sound resonant, it is not taut enough and you'll have to key it up with the triangular wooden pegs. In that case, remove the first staples you put in across the joints in back. Then tap two keys into the two slots in each corner, which will force the stretcher bars apart enough to take up the slack in the canvas. Always place the longest side of the wooden triangle against the stretcher bar, even though that doesn't look right. That way the keys won't split when you hit them with the hammer.

TEXTURING THE CANVAS

I find it easiest to stretch two or three canvases at a time, then gesso them later all at once. It takes only a few minutes to spread the gesso on, as I am doing in Fig. 20-4. Allow the canvas to dry for three or four hours or overnight before applying washes.

If you want to work on a textured surface, wait about fifteen minutes, then begin to work into the creamy white stuff before it sets up. You can stipple it by tamping with your knife laid flat, or add a light sprinkling of sand, taking care that all grains are rolled around until they are thoroughly coated. (Note: When

Fig. 20-1. The tools necessary for stretching a canvas are laid out here. I have already cut the canvas to size from a six-yard roll 54″ wide. This piece is about 1½″ larger all around than the 18 × 24″ stretcher frame. I am tapping the last dove-tailed joint together with the hammer. Sometimes they fit together loosely and other times you have to hammer them into each other with a few solid blows. If that threatens to split the groove on one of the bars, reverse it and try fitting opposite ends together.

Fig. 20-2. Normally the four corners will be true if you tapped them together neatly, so that all edges of the tongue and groove joint are smooth and flush. But occasionally one of the four bars may be slightly mismatched, and you may find one corner that won't square up, even though the other three are true. That usually means that you have to leave a slight gap in that dove-tailed joint. Once you are sure the frame is perfectly square, shoot three staples kitty-corner across the joints on just one side of the squared frame, as I already have here. They will help keep it stable temporarily while you're attaching the canvas on the other side.

Fig. 20-3. Now lay down the canvas gesso-side down with the frame on top of it, corner staples up. Staple the canvas loosely to the frame in the middle of each side. Then, standing the frame on edge with its back facing you, pull out and reset each of these "basting" staples, this time pulling the canvas very tautly with the canvas pliers, knob side down. There should now be a diamond-shaped pattern of tension on the front like the one shown here.

With the canvas pliers in one hand and the staple gun in the other, shoot staples about every 1½″ or so, alternating among all sides. Stop about 2″ short of each corner. The front face should now be taut without any serious puckers. Next make a hospital bed fold-over of the extra canvas on each left-hand (or right-hand) corner, tucking the extra material *inside* the fold and stapling it diagonally. (See the lower left edge of Fig. 20-4.)

Fig. 20-4. The canvas is as taut as a drum now, and I am putting on an extra coat of gesso. It is as easy as spreading frosting on a cake, and it is fun to texture it in different ways as the gesso begins to dry. With a conventional subject, such as flowers, I may leave the center of the canvas smoother, and texture the sides more interestingly. Do avoid making a long ridge with the blade of your knife. Once the gesso has dried hard, it is impossible to remove such ridges. Incidentally, it is also impossible to remove dry gesso from clothing, so wear a smock or wash out stray gesso on your clothes immediately.

painting on a sand-textured surface, use only old, beat-up brushes.) Try imprinting the semi-wet gesso with a scrunched-up piece of newspaper, or with a piece of coarse burlap laid down here and there for a few moments.

FINAL VARNISHING

A final varnish is a must, at least on paintings of professional caliber. Apply varnish only when every layer of the painting is thoroughly dry—which may take three to six months for a thinly covered painting, six months to a year for a moderately thick painting, and well over a year for heavy impasto. Applying a final picture varnish—usually damar—used to be a tricky thing that required low humidity, a dust-free environment, a soft brush, and long deft strokes across the whole width of the canvas without lifting the brush. The results were often apt to be streaky and would remain tacky for days, attracting dust. Today's synthetic varnishes are far easier to apply. Liquitex's Soluvar can literally be scrubbed every which way across a painting's surface and will cover every ridge and groove thoroughly, drying within an hour or two to an absolutely seamless, streakless surface.

Both the organic damar and synthetic Soluvar come in matte and gloss varieties. Soluvar matte varnish is cloudy (because it has wax in it), and dries extremely dull and flat, while the clear gloss varnish dries so shiny that you can see your reflection in it. A mixture of both kinds creates a beautiful compromise.

To apply Soluvar, I pour the varnish out of the jar and dribble it back and forth across the surface generously, one half of the painting at a time. Then with my wide, soft hardware-store brush, I spread it all out evenly without delay. In ten minutes I am finished. All that remains is to clean my brush, which will harden like a rock in about an hour if left alone. Soak the brush in clean mineral spirits first, then wrap it tightly in plastic wrap. It stays soft indefinitely that way and is always ready when you need it again. "Goop" or some other waterless petroleum hand cleaner will take care of your sticky fingers.

Why bother to give your paintings a final varnish? These days many artists don't, but that seems shortsighted, given the fact that paintings can darken in ten or twenty years, thanks to air pollution, home heating systems, and airborne chemicals that in time can change the hue of certain pigments. Varnishing will protect your painting from these hazards (though not, unfortunately, from fading), and, unless you've used copal, can be removed decades later when it's become darkened and grimy. The painting will look miraculously new again. Valuable paintings should be cleaned only by professional conservators. Never attempt to clean an oil painting yourself with soap and water; an accepted, if odd, method is to take bread from the center of the loaf and roll it into balls, then rub them over the painting surface.

Aside from needing a protective layer, all oil paintings benefit from varnishing because as oils dry, the colors become dull and sink into the canvas over a period of months. You will be absolutely astonished when you apply a final varnish to your paintings to see the colors leap alive again to a lustrous wet look. But what if you have already sold unvarnished paintings? If possible, borrow them back after a year or so and varnish them for your collectors. It is a good way to keep in touch with them, and who knows, they may be impressed enough with your professional concern to purchase another painting.

CULTIVATING PROFESSIONALISM

When you begin to achieve success, make a list of your collectors and other potential buyers. Begin to cultivate a professional image. As you gain acceptance in juried shows, win prizes, or make significant sales, set about learning how to advance yourself. First, buy a good book on marketing your art (there are many), and start investing in yourself as you would in any other business. Have business cards and a brochure about

yourself printed, preferably designed by a professional graphic artist. Then learn to photograph your paintings expertly with a quality camera and proper lighting, or if you can afford to, have them photographed professionally. Develop a handsome portfolio showing your recent paintings in $5 \times 7''$ or $8 \times 10''$ enlargements so that you'll eventually be prepared to approach galleries, interior designers, architects, and so on. Slides are cheaper and are acceptable in your presentation, but holding a page of slides up to a lamp isn't terribly impressive to a potential client.

THE MIRACLE OF A GOOD FRAME

By all means, frame your paintings well and simply. Avoid fussy or massive carved frames that overwhelm the work. Any painting in a quality frame is more likely to impress a potential buyer than exactly the same painting in a tacky, cheap frame that is all wrong for it. Invest in a number of simple, standard-size frames (such as $18 \times 24''$, $20 \times 24''$, $24 \times 30''$) and paint on canvases in those sizes at first. That way you can switch paintings from one frame to another when you are entering new work in an exhibit. One of the most versatile frames is a "floater," which has a wide linen mat, a deep-set black margin around that, and a narrow band of either gold or silver metal attached to a wood molding around that. As a rule, the wider the mat, the narrower the wooden molding should be. Conversely, the wider the wood outside molding, the narrower the mat should be.

SIGNING AND PRICING YOUR WORK

When you feel ready to sign your paintings, learn to print or write your name on the canvas in a professional manner. Avoid cute, clever, or attention-getting signatures. It is best to use your full name written or printed legibly but subtly in a lower corner. Let the viewer enjoy your painting first and then have to search a little for your signature.

Pricing your work will be a problem when you first begin to exhibit. The solution is to do a little research by visiting outdoor and/or mall exhibits, juried shows, and one-person shows. You will probably conclude that your work is as good as much of what you see on display, and you may even be shocked at the high asking prices. The time will come when you will hang a show of your work, perhaps in a restaurant, a bank, or a booth in a fair of some sort. You may feel there are some paintings you can't part with, and you'll mark those NFS (not for sale). But by doing this you may be limiting yourself, thinking that you might never do as well again. You are supposed to know that the next paintings will be better, and can therefore afford to let go of any work if a buyer comes forward.

FINAL THOUGHTS

No matter how modest your accomplishments to date may be, or how late in life you started to paint, you can still go forward with purpose and determination if you enjoy painting. Perhaps you live in a rural area and the big art event of the year is the county fair. Be competitive; go after the prize ribbons. (That's what encouraged me a long time ago.) Find your niche as a respected artist in your community, no matter how large or small. But wait. Suppose that, after giving painting a good college try, you find that you don't really enjoy it, that it gives you a headache, and you feel nothing but frustration and defeat. Well then, let it go. Become instead a patron of the arts, a position for which you are uniquely qualified because you now have some insight into what artists are trying to achieve. Support arts organizations and events in your community. More than that, become a collector. Support your local artists by purchasing from them when you see something magnificent, something unforgettable, that you can afford. The rest of us, we who will go forward with a determined fix on our goals, need the encouragement of people like you.

SUGGESTED READING

Birren, Faber. *History of Color in Painting*. New York: Van Nostrand Reinhold, 1965.

Blake, Wendon. *Creative Color for the Oil Painter*. New York: Watson-Guptill Publications, 1983.

Caddell, Foster. *Keys to Successful Landscape Painting*. New York: Watson-Guptill Publications, 1976.

————. *Keys to Successful Color*. New York: Watson-Guptill Publications, 1979.

Carlson, John F. *Carlson's Guide to Landscape Painting*. New York: Dover Publications, 1970.

Chevreul, Michel-Eugène. *The Principles of Harmony and Contrast of Colors*. Edited and annotated by Faber Birren. New York: Van Nostrand Reinhold, 1981.

Cochrane, Diane. *This Business of Art*. New York: Watson-Guptill Publications, 1979.

D'Amelio, Joseph. *Perspective Drawing Handbook*. New York: Leon Amiel, 1964.

De Reyna, Rudy. *How to Draw What You See*. New York: Watson-Guptill Publications, 1972.

Dunstan, Bernard. *Learning to Paint*. New York: Watson-Guptill Publications, 1970.

————. *Paintings in Progress*. New York: Watson-Guptill Publications, 1976.

Edwards, Betty. *Drawing on the Right Side of the Brain*. Los Angeles: J. P. Tarcher, 1979.

Gruppé, Emile A. *Gruppé on Painting*. New York: Watson-Guptill Publications, 1976.

Hawthorne, Charles. *Hawthorne on Painting*. New York: Dover Publications, 1960.

Loran, Erle. *Cézanne's Composition*. 3d ed. Los Angeles: University of California Press, 1963.

Mayer, Ralph, *The Artist's Handbook of Materials and Techniques*. 4th ed., rev. and updated. New York: The Viking Press, 1981.

————. *The Painter's Craft*. New York: The Viking Press, 1975.

McCann, Michael, Ph.D. *Artist Beware*. New York: Watson-Guptill Publications, 1979.

Mendelowitz, Daniel Marcus. *A Guide to Drawing*. 4th ed., rev. by Duane A. Wakeham. New York: Holt, Rinehart and Winston, 1988.

Robinson, E. John. *Special Moments*. Mendocino, Calif.: Candlelight Studios, 1986.

Saitzyk, Steven L. *Art Hardware*. New York: Watson-Guptill Publications, 1987.

Watson, Ernest W. *Composition in Landscape and Still Life*. New York: Watson-Guptill Publications, 1967.

Whitney, Edgar A. *Complete Guide to Watercolor Painting*. New York: Watson-Guptill Publications, 1974.

INDEX